CROSSING *the* WATER

FIGURES 1 AND 2. Eleguá, the oricha who opens the path so that communication with the spirit world can begin, is the first to be invoked in any ritual undertaking. Along with his companions Ogún and Ochosi, Eleguá stands watch behind the front door of Santiago's house.

laroye akiloye aguro tente onú

apagurá akama sesé

areletuse abamula omubatá

okóloofofó okoloñiñi toni kan ofó

omoró agun oyona alayiki

agó

SALUTE TO ELEGUÁ

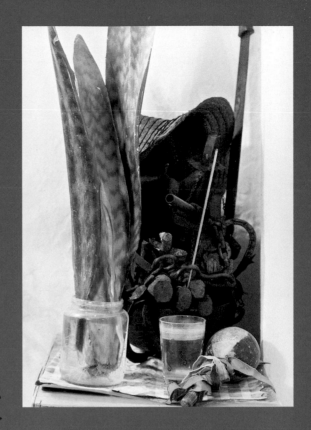

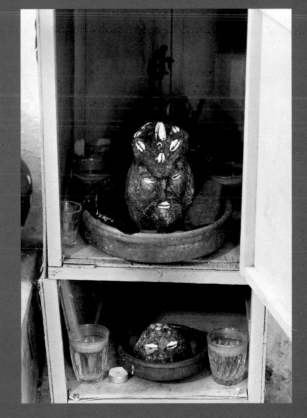

CROSSING

A Photographic Path to the Afro-Cuban Spirit World

the WATER

CLAIRE GAROUTTE AND ANNEKE WAMBAUGH

DUKE UNIVERSITY PRESS DURHAM AND LONDON 2007

© 2007 Duke University Press

All rights reserved

Printed in China on acid-free paper ∞

Designed by Heather Hensley

Typeset in Bembo by Tseng Information Systems, Inc.

Library of Congress Cataloging-in-Publication Data appear

on the last printed page of this book.

All photographs are by Claire
Garoutte and Anneke Wambaugh.
The handwritten list that appears
in chapter 3 and all drawings are
by the hand of Santiago Castañeda
Vera.

For my father,

Miles Wambaugh,

1922–2002

Water may be older than light, diamonds crack in hot goat's blood, mountaintops give off cold fire, forests appear in mid-ocean, it may happen that a crab is caught with the shadow of a hand on its back, that the wind be imprisoned in a bit of knotted string. And it may be that love sometimes occurs without pain or misery. E. ANNIE PROULX

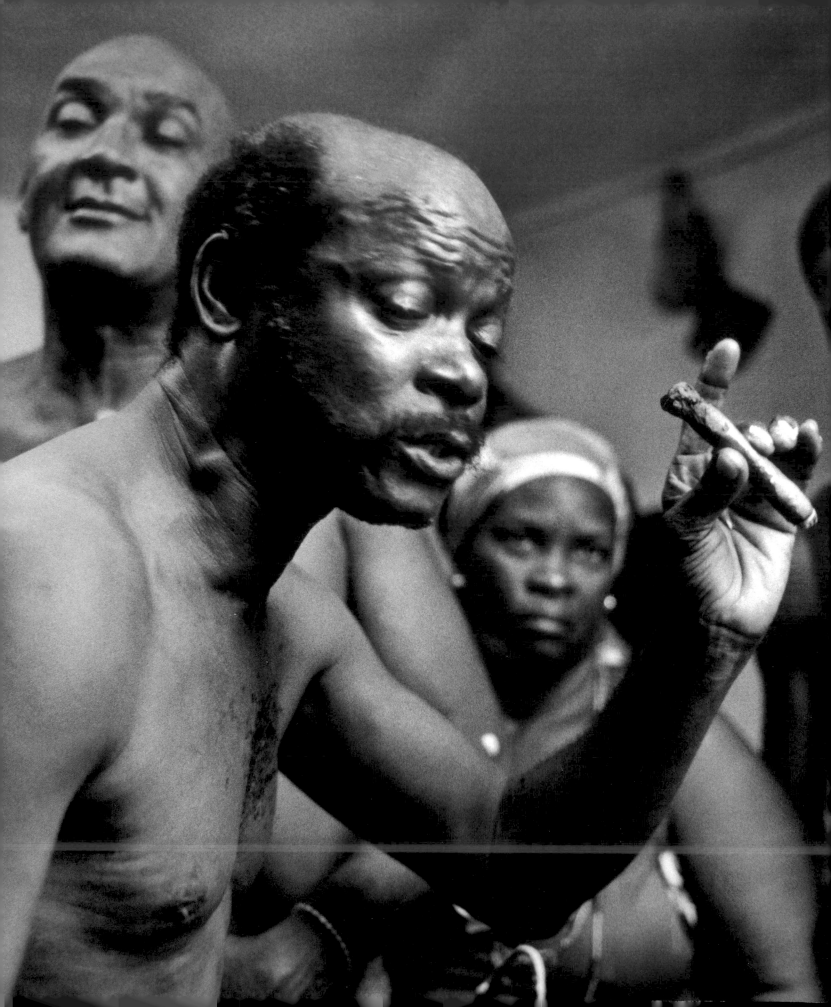

CONTENTS

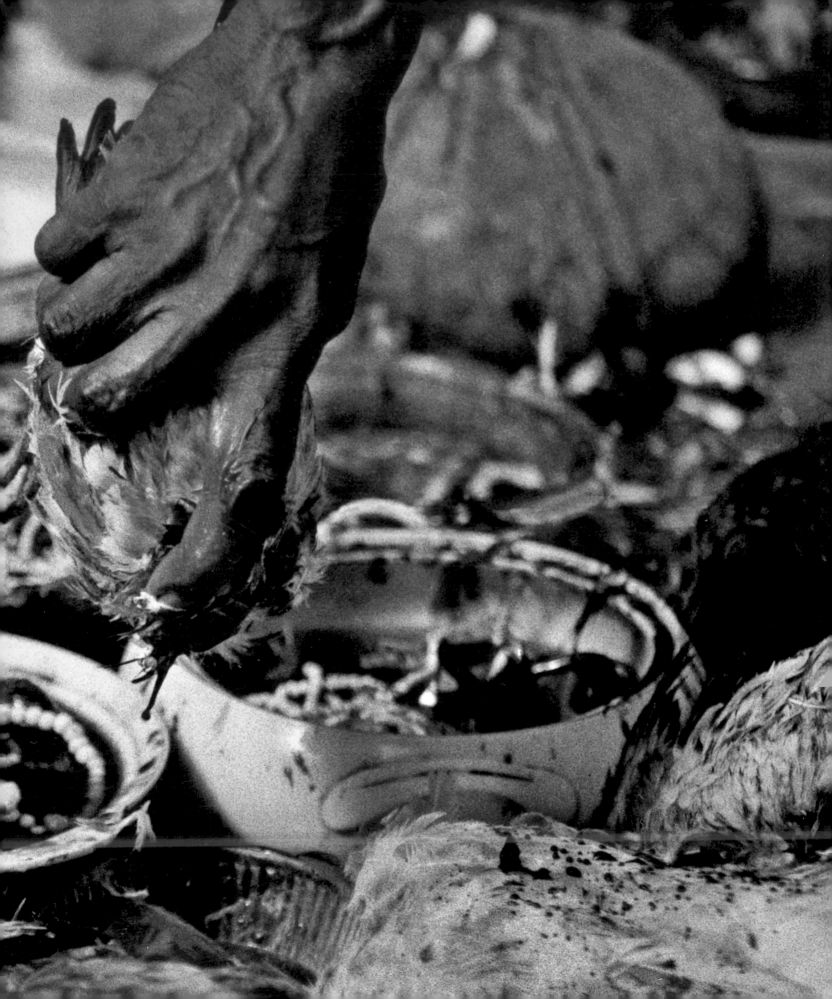

ACKNOWLEDGMENTS

The indisputable place of honor belongs to our godfather, Santiago Castañeda Vera. His extraordinary personal resources both as a religious expert and as a human being inform every aspect of *Crossing the Water*. In his role of mentor, friend, and multidimensional "informant," Santiago's generosity has been without limit. Many members of our religious family in Cuba have also enabled this book in various ways: Elvira, Mariano, Teresa, Robertico, Xiomara, and Arnaldo, to name but a few.

Life is made even more diverse and enjoyable thanks to our many Cuban friends. Emma and Ruddy, whose house in Santiago de las Vegas outside Havana is both a refuge and a place of stimulating conversation, wonderful food, 1920s jazz, and the periodic invention of yet another Cuban cocktail, have enriched our lives for over a decade. On the other end of the island in Santiago de Cuba, it is a great pleasure to be able to thank Luisito and Denia, always watching out for us in our Tivoli neighborhood; Papito and his late mother, María, our incomparable downstairs neighbors; Leonardo, a close friend willing to hang out with us through thick and thin; David, whose quiet intelligence is a godsend; Luz, our mother and soul mate in Santiago; and last, two very dear friends who have died recently, Ernesto and Ángel, one born in Jamaica and the other in Haiti, each of them an elegant reminder of a bygone era. We salute you both.

Detail of Figure 6

Bringing this many-faceted project to light involved countless hurdles. One of the most enduring (and revisited) has been the translation and interpretation of the many song texts—a number of them multilingual—included in this work. Jesús Varona Puente and Elliot Klein have helped us make informed choices at this particular crossroads; their input on our translations of Palo and Congo mambos has gone a long way toward ensuring their accuracy and has enhanced our understanding of their nuances of meaning. We take full responsibility for any shortcomings associated with this endeavor. On the home front, Fr. Josef Venker, S.J., and Fernando Alvarez Lara, S.J., of Seattle University have imbued our translations of the Catholic prayers that appear in the final chapter with a freshness and immediacy they would not otherwise have possessed. We are very grateful to all of these individuals.

Both in the writing and the prewriting stages, we have consulted the work of many scholars of ritual art in Africa as well as Cuba, Haiti, and other cultures of the African diaspora. Our thinking has been variously shaped by the writings of Wyatt MacGaffey, Robert Farris Thompson, James Fernandez, Patrick McNaughton, David Brown, Lydia Cabrera, Michael Mason, Karen McCarthy Brown, and Jim Wafer, among others. We are particularly indebted to Karen Brown, whose work on Haitian Vodou, deeply conceived and presented with singular emotional and intellectual clarity, continues to be a source of inspiration. In addition, we would like to thank René Bravmann, professor of African art history at the University of Washington, for his ongoing support and encouragement. As Anneke's mentor during her graduate years, he is responsible both directly and indirectly for instilling many of the ideas presented here.

The Photographic Center Northwest in Seattle, Washington, where the darkroom became our second home, supported the printing of all the photographs for this book. We could not easily have completed this work without the use of this extraordinary facility.

Many thanks are also due to all those who read parts of the manuscript and offered suggestions and comments, most notably Jenifer Schramm, Claire Jones, and Linda Jensen. Our editing of the photographs benefited from the discriminating eyes of the photographers Lyn McCracken and Robert Lyons and the art historian Deborah Caplow.

Finally, we have spent many months away from our families and friends in the course of researching and writing this book. Their understanding and acceptance of our long absences while in Cuba, ensconced in the darkroom, and yoked to our respective desks are deeply appreciated. We are especially grateful to Anne Calcagni for her inimitable enthusiasm and generosity.

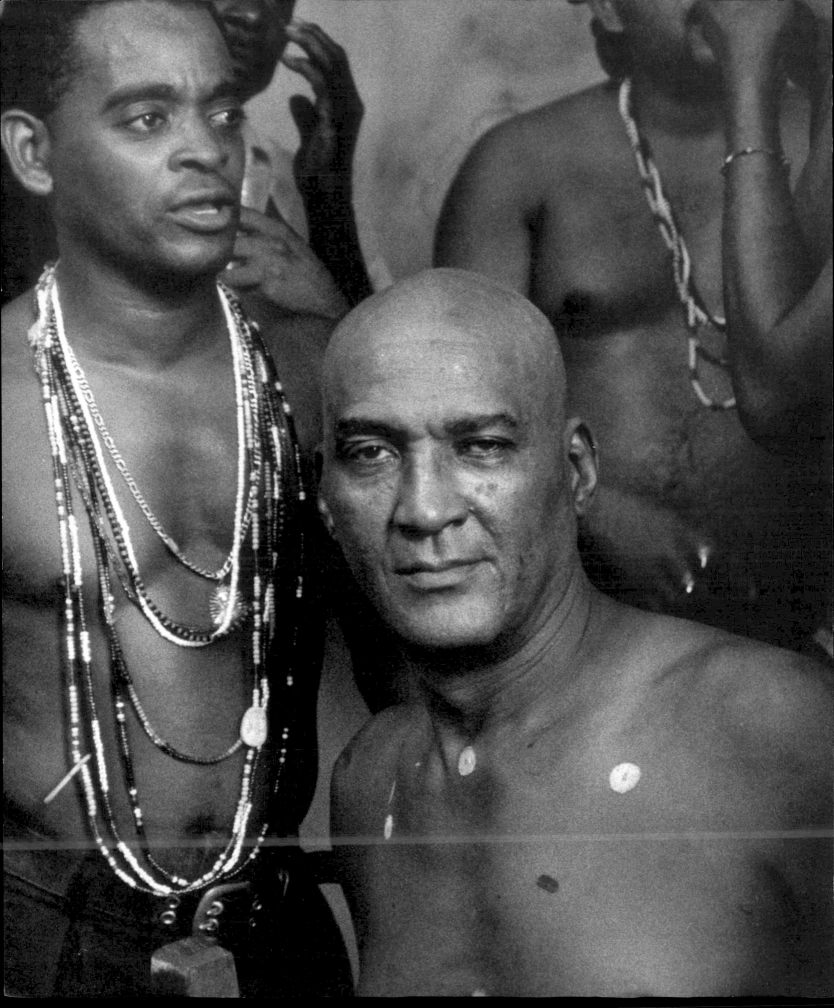

Introduction

Ethnographic research, whatever else it is, is a form of human relationship.

KAREN MCCARTHY BROWN, *MAMA LOLA: A VODOU PRIESTESS IN BROOKLYN*

We first met Santiago Castañeda Vera, a priest of Santería and Palo Monte, in July 2000. The setting was Santiago de Cuba, the hot, hilly, and vibrantly Caribbean capital city on the eastern end of the island. As so often happens in Cuba, a chance encounter led to our arrival on Santiago's doorstep one sweltering late afternoon. Earlier in the day, we had been standing in line at the cavernous entrance to the 1800 Club, a recently revitalized restaurant known for its prerevolutionary elegance and modest prices. The doorman struck up a conversation with us. While we waited for him to unlatch the velvet-covered chain separating us from an overly anticipated meal on the rooftop terrace, William passed the time by asking all the usual questions: Where do you come from? How long have you been here? Do you like to dance salsa? Is this your first time in Cuba? Our answer to the last query brought a temporary halt to the flow. We explained that we had been coming to Cuba for a number of years and that we were working on a documentary project about Santería and Palo Monte. At this point, William's polite inquisitiveness turned to genuine interest. After announcing apologetically that he could not let us into the restaurant after all—they had

FIGURE 3. Santiago Castañeda Vera seated amid his godchildren, 2002.

apparently just run out of food—William asked if we would like to come back when he got off work. He wanted to introduce us to his *padrino*, or godfather in the religion.

Later that afternoon we met William and, after rustling up a taxi, headed out to Santiago's house. The man who came to the door, impressively tall with youthful glowing skin, greeted us with a mixture of surprise and curiosity. Although we were arriving completely unannounced, Santiago seemed to take it in stride. After a very brief exchange, he motioned that we should follow him. Moving from the relative coolness and transparency of Santiago's front room to the back of the house, we entered a qualitatively different world—a close, shadowy environment that roused all the senses. He sat us down at a small kitchen table. This cramped cooking area literally flowed into another room containing a formidable cluster of Palo spirit cauldrons. The myriad smells of ongoing ritual work mingled with the aroma of goat stew and *congrí* (rice and beans), the remains of Santiago's main meal for the day.

As we talked that afternoon, carefully taking each other's measure in all the subtle and not so subtle ways that people do, the atmosphere was surprisingly familial and intimate. It was also emotionally charged. The intensity of having to explain in Spanish the web of interests and experiences that had brought us there, the heady presence of Santiago's spirit cauldrons, which projected their own mute energy, and the staggering heat in the enclosed space gave this initial meeting a disjointed hallucinatory feel. The more we reminisced about some of the individuals we had worked with in the western provinces of Havana and Matanzas, the more receptive Santiago seemed. He was further intrigued when he learned that Anneke had spent time in Haiti researching Vodou.[1] The visit ended with an invitation to come back the next day and eat lunch with him. This was to be the first of many meals that Santiago would cook for us in the years to come. *Crossing the Water: A Photographic Path to the Afro-Cuban Spirit World* was born of this chance en-

counter. Years later Santiago would tell us that our "protector spirits" had brought us to his door that day: "Sus protectores les llevaron en su casa" (Your protector spirits brought you to your home).

Un palo solo no hace monte: A single tree does not make a forest

Santiago Castañeda Vera is the forceful and dynamic head of a large religious family, most members of which he has initiated into Palo Monte and Santería at one or more levels. As this community's center of gravity, Santiago walks a resilient tightrope amid his many godchildren (*ahijados*) as well as between this world and that of the spirits.[2] This mediatory role comes naturally to him. Although he can be controlling, his authority is that of a watchful parent who is fiercely protective of his ahijados. As a godfather, Santiago issues the occasional harsh reprimand to keep members of his religious family in line. He is also a trusted advisor—psychologically perceptive and down to earth—and vis-à-vis his godchildren, capable of moments of astonishing intimacy and tenderness. Santiago navigates these intersecting worlds and personalities with circumspection, deftly avoiding situations that could in any way compromise his personal and religious autonomy.

This ethos of discretion—which in Cuba is a valued social skill and survival strategy—pervades all aspects of Santiago's life. He rarely, for instance, mingles with priests or priestesses from outside his ritual family and virtually never takes part in other people's religious activities. Nor is he inclined to volunteer information. In the proverbial wisdom of Cuba, "He who knows the most remains silent, listening, nothing more" (*El que más sabe está callado, oyendo nada más*). For Santiago, this is a credo of sorts. Although he often asks questions, thereby encouraging others to talk, Santiago himself is not particularly effusive. He is, however, an inveterate and acute observer of all that goes on around him. As we came to realize, Santiago manages to do this while maintaining an active interior dialogue with his spirits.

FIGURE 4. Detail of Santiago's Palo spirit cauldrons.

FIGURE 5. Santiago's dog Cristo looks down from the terraced rooftop, a domain he shares with a fluctuating population of other animals. A talisman of radiating buzzard feathers hangs in the foreground.

Our entry into Santiago's life-world was in some respects startlingly immediate. It was also very gradual and kaleidoscopic. When we met in the summer of 2000, Santiago had just retired from fifty-odd years of working a succession of retail jobs, at first in the private sector and, after the "Triumph of the Revolution" (January 1959), in various state-controlled enterprises. The timing for us could not have been more fortuitous. Santiago was now in a position to devote his full energy to his religious practice, which on a daily basis revolves around consulting with and treating clients. With fewer time constraints, he was also ready to entertain new possibilities. Happily, this came to include the project we were working on and, eventually, the two of us as individuals. Reflecting back on the evolution of our relationship with Santiago, it seems that equal parts intuition, curiosity, pragmatism, and a genuine enjoyment of each other's company fed the initial connection.[3]

As the project gathered momentum and we returned time and again with photographs, it became apparent that Santiago took a definite pride in what we were doing. It was also clear that as we worked together more intensively, he did not see his ability to provide information—or withhold it, for that matter—as separate from his role as our godfather and teacher. Whatever else Santiago might expect of us, the bottom line has always been that we engage with him in terms that implicate us experientially and not just conceptually. Just as our involvement with Santiago has provided us with different ways of understanding ourselves, the inherently reflective nature of the research process has also provided Santiago with a particular mirror of himself.

The choreography of give-and-take that characterizes documentary work is complex. Very quickly, we found ourselves enmeshed in a web of relationships that, with Santiago at its center, included members of his religious family as well as inhabitants of the spirit world. It goes without saying that we, as photographers engaged in a research project, and Santiago, as our primary source, all brought interests to bear on the situation: obli-

gation and counterobligation formed part of an ongoing dynamic. Reciprocity takes many forms, however. We were patrons of Santiago's house in the sense that we brought gifts—clothing, medicine, and so forth—for him and Chaguito, the grandson with whom he lives, and more frequently perhaps, presents destined for Santiago's spirits. We also contributed what we could, both monetarily and personally, to the demanding November cycle of ceremonies and other ritual occasions. Every core member of Santiago's family contributes in whatever way he or she can. This give-and-take occurs on many levels—emotional, intellectual, material, spiritual, and physical—often simultaneously. In the most basic sense, this is the nature of any relationship: the more layered and diverse the kinds of exchange, the more resonant and meaningful it is.

Gathering the primary material for this book was a cumulative, open-ended process. With information coming at us from many different directions, it was also largely unpredictable. In Santiago's house, a particularly comprehensive cycle of ceremonies takes place in November every year. Many of our photographs were taken during this period of sustained religious activity. Participating in and adding our energy to these communal rituals as well as others in the private domain lie at the heart of our experience. This kind of body-based understanding, although hard to convey, is invaluable. Over time we found ourselves helping to prepare for such ritual occasions as well: shredding leaves for ceremonial baths, plucking chickens, polishing brass, beading necklaces for the spirits, and so on. Being there as fully as possible and lending a hand before, during, and after these rituals greatly enhanced our grasp of them.

We also recorded several informal interviews with an indulgent Santiago (and the ambient death rattle of an old fan). These question-and-answer sessions were helpful in that they provided us with a pool of basic information and personalized vocabulary that we could draw on in subsequent conversa-

tions or use to incite other, livelier discussions. However, with the notable exception of the many songs that Santiago enthusiastically sang into our vintage Sony Walkman so that we could learn them more readily, structured sessions were not a natural medium for any of us. More often we would slip questions into casual conversation and later rely on hastily written notes and memory. Santiago tends to explain things by way of digression. Having asked a nominally straightforward question, we often came away with an answer that generated many more. This in short is how we learned—in fits and starts, and by degrees—often piecing elements together after the fact. Slowly we built up a base of understanding, both intuitive and more carefully reasoned.

Finally and fundamentally, we absorbed a great deal just by being around for long periods of time—talking, eating together, and observing and taking part in the conversational cross-rhythms, meanderings, and interruptions that form part of the fabric of life in Santiago's house. Although our interactions with Santiago provided the nucleus of our experience, family members would often drop by to help out with some task, impart information of one sort of another, or simply hang out. These casual visits would on occasion inspire an impromptu afternoon party alive with serious banter, graceful and more dubious dance moves, homemade beer from the house around the corner, and, invariably, tremendous laughter. The easy intimacy of this down time allowed us to get to know individual members of the extended family and through them to see Santiago in an increasingly complex human light. By the same token, an awareness of Mariano's or Teresa's roles out in the larger world gave us a more balanced foothold in Santiago's own world and over time led to a number of heartfelt friendships.

Santiago's willingness to involve himself with us, formally becoming our godfather in the process, speaks to his confident, openly inclusive approach to his life's work and to the universality of his religion. The spirits do not differentiate between Cubans and foreigners, practitioners and nonpracti-

tioners, or for that matter, believers and nonbelievers. To be present during a ritual is to actively participate; face to face with an *oricha*, a Palo *mpungu*, or a Congo spirit of the dead, you engage with that spirit. As a religious expert and bridge between worlds, Santiago takes his responsibility to help others seriously. *Tengo un pueblo que atender*, he often says: I have a community to take care of. This community is potentially *muy amplia*, boundless and encompassing. Santiago applies his intuition, ritual knowledge, and healing expertise—*his* methodology—to anyone who comes to him needing assistance.

Before delving into the particularities of Santiago's religious experience, some groundwork needs to be laid. The next segment provides a brief and necessarily selective introduction to the Cuban religious landscape.

En mi manera: In my own way

While there are a number of spiritual traditions in Cuba, we concentrate on those that form the crux of Santiago's practice: the African-inspired religions of Santería and Palo Monte and the Cuban version of European-derived Spiritism known as Espiritismo.[4] Santiago's embrace of more than one religion and the practice of combining aspects of different traditions are by no means unusual in Cuba. Over the past century and a half, there has been a great deal of symbiotic interplay between Santería and Palo Monte, on the one hand, and of these Afro-Cuban religious traditions with Roman Catholicism and Espiritismo, on the other.[5] This cross-fertilization is particularly pronounced on the eastern end of the island, where regional practices are often characterized as *cruzado*, or mixed.[6] Afro-Cuban religions are not only inherently flexible, but those who practice them are highly independent in their approaches. Santiago is no exception. Although rooted in particular spiritual lineages, he has forged his own path. Free to combine, transform, improvise, and innovate as he sees fit, Santiago practices his religion, as he is wont to say, *en mi manera* (in my own way).

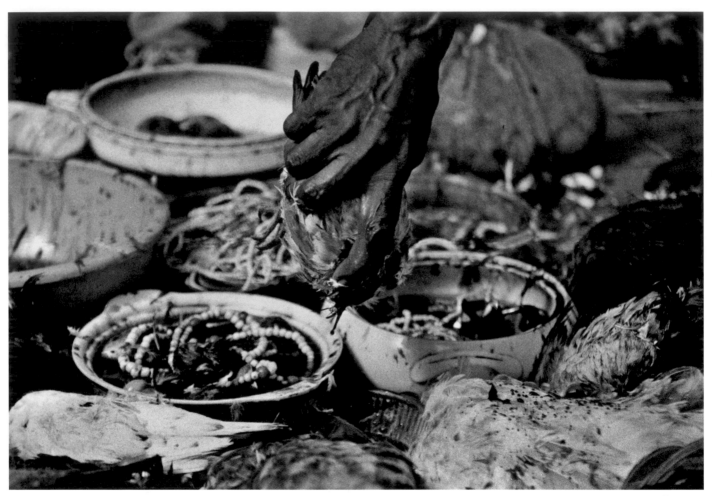

FIGURE 6. Sacrificial blood is drained over the sacred vessels of the orichas.

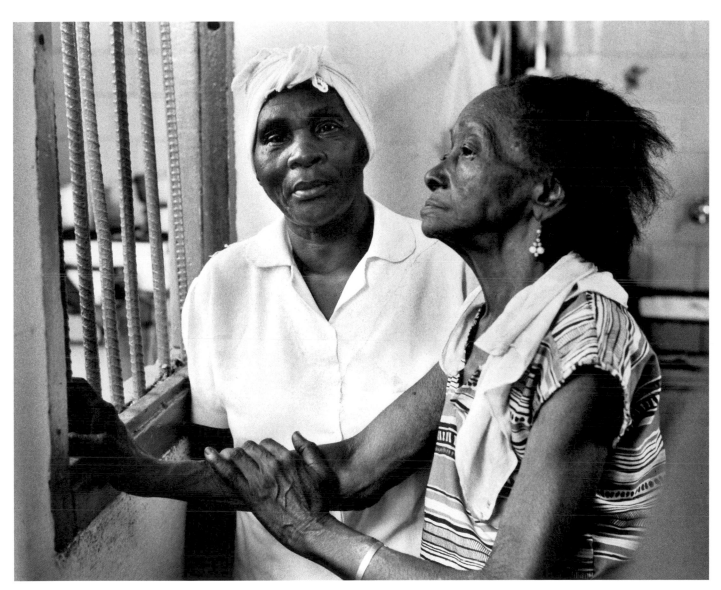

FIGURE 7. Two older women, godchildren of Santiago, on the evening of the "spiritual mass."

The Regla de Ocha (Order of the Orichas), or Santería,[7] as it is popularly known, has its primary origins among the heterogeneous Yoruba peoples of West Africa. Then as now, the urbanized Yoruba lived in a diverse network of city-states in southwestern Nigeria. During the colonial era in Cuba, the ethnic designation Lucumí became the catchall term applied to Yoruba-speaking peoples from this region as well as a number of linguistically distinct groups from neighboring areas such as Dahomey (now the Republic of Benin). The term Lucumí is still used to describe and differentiate the practices of Santería from other Afro-Cuban cultural and religious traditions.

Santería has long been established in parts of western and central Cuba. Significantly, however, the religion did not migrate to the easternmost end of the island until the early twentieth century. The general consensus is that Santería was not introduced in the provincial capital of Santiago de Cuba until at least 1912 and perhaps as late as the 1940s.[8] Congo traditions, by contrast, seem to be more deeply rooted.

Santería centers on interaction with a complex and richly defined pantheon of spirit beings who are referred to interchangeably as the *orichas* or "the saints" (*los santos*). While all of these spirits embody the *aché* or life force of the Lucumí High God Olofi, each oricha's inherent power is associated with particular aspects of nature and the cosmos as well as specific domains of human thought and activity. The spirit is said to "own" these physical, spiritual, and social dimensions of our world.[9] Although more powerful than human beings, the orichas carry on just as humans do and are subject to the same attitudes, emotions, impulses, and excesses. Taken together, these spirits mirror "the variety and possible ways of being in the world," both creative and destructive.[10] As many-sided personality types, the orichas offer practitioners a barometer of sorts, a means to weigh different existential options and strike a sense of balance in their lives. Santiago, who was initiated as a *santero* or priest of the religion in 1961, serves an impressive personal array of

orichas but has a deep connection with Yemayá, the all-embracing spirit of the sea.

The orichas' sacred objects are kept in an elegant assortment of vessels in Santiago's "room of the saints." On ritual occasions throughout the year, this space is dramatically transformed in honor of one or more of its spirit residents. Their vessels are arranged according to a particular hierarchy and amplified by yards of bunched and free-flowing decorative cloth. These resplendent temporary altars proclaim some of Santería's core values—the reciprocal bonds of family, the recognition of status, a sense of cosmic and worldly order—all cultural ideals linked to human behavior and achievement. These dimensions of Santiago's religious life are more fully explored in chapter 1, "*I Bow My Head to the Ground*: Santería Thrones and Rituals."

The sister Afro-Cuban religion of Palo Monte Mayombe is rooted in the cultural, linguistic, and ritual practices of Bantu-speaking peoples from Kongo and Angola in the western portion of Central Africa.[11] Palo Monte, as it is more commonly called, means "trees of the forest." Unlike Santería, the religion has a number of different branches, or ramas, collectively known as the "Congo Orders" (*las Reglas Congas*). Cubans use the term Congo to identify religious and other forms of expressive behavior with origins in this part of Africa.[12] Palo Monte is steeped in the powers of the dead and the practical and mystical forces that charge the natural world (*la naturaleza*). These energies coalesce in Congo-Cuban ideas about *el monte* (the forest). This sacred ancestral terrain is rich both physically and conceptually. It is the source of all the materials—leaves, plants, trees, and other substances—essential to Palo religious practice and home to the powers that infuse the Palo universe.

The focus of ritual attention in this Kongo-descended religion is the *prenda* or *nganga*, a cauldron densely packed with forest branches, animal remains, stones, different types of earth, human bones, and other primarily organic elements.[13] This potent concentration of forces is energized by a spirit of the

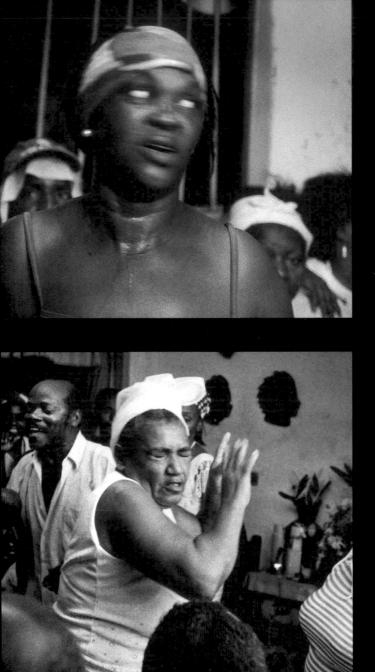
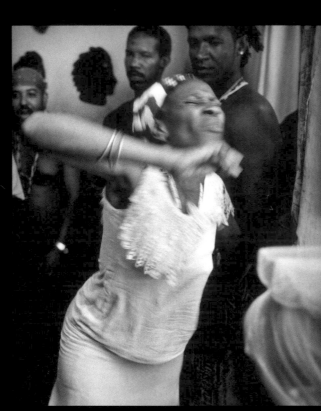

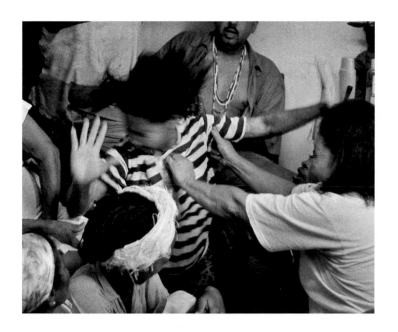

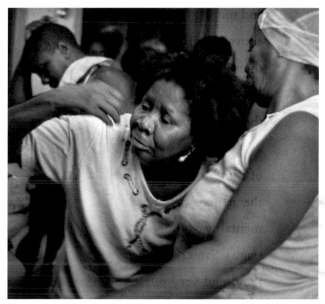

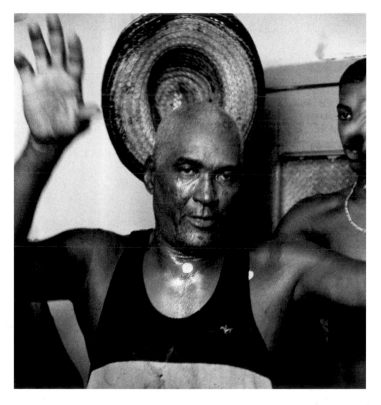

FIGURES 8 THROUGH 13. The moment of impact: Spirits come down to possess or "mount" their human "horses."

dead, who, in exchange essentially for room and board, has been contracted by a *palero* or Palo priest to live in the prenda and carry out the palero's wishes. Santiago has three of these awe-inspiring power assemblages. Each cauldron is also the home of a particular Palo spirit. Called *mpungus*, these entities are intimately associated with the natural world: the earth and its waters, the plant- and animal-rich forest, the moon-ruled night sky, and atmospheric phenomena such as the whirlwind, bolts of lightning, or shooting stars. A fully consecrated Palo priest at a young age, Santiago communicates with and mobilizes these spirit forces by means of his prendas. Palo spirituality is, above all, intensely pragmatic. Skilled practitioners of the religion provide their clients with concrete means to address immediate issues in their lives. People with serious problems often consult Santiago in the hope of resolving them quickly and effectively.

Chapter 2, "*Ver Para Creer* (Seeing Is Believing): The Prendas and Ritual of Palo Monte" focuses on Santiago's Palo practice. As will become apparent, the artistry associated with Palo ritualizing and sacred objects is, in fundamental ways, opposed to Santería's aesthetics of expression. Although Santiago's Santería and Palo altars are both embodiments of spiritual power, they send very different messages. The first champions an ideal, balanced, and, because the human imprint is writ large, accessible universe. The second is about raw power. Visually chaotic and materially unrefined, Palo spirit cauldrons project an aura of confrontation and spiritual energies at war. The contrasting outlooks that characterize Santería and Palo Monte can to some extent be understood as distinct yet complementary ways of apprehending and being in the world.

Cuban Espiritismo is based on the mid-nineteenth-century metaphysical explorations, teachings, and publications of the French spiritist Allan Kardec. His most influential work, *The Spirits' Book* (*Livre des Esprits*), considered the principal text of spiritist tenets and philosophy, appeared in 1857. Shortly

thereafter the movement made its way to Cuba and the rest of the Caribbean, where it was enthusiastically received.[14] Broadly defined, Spiritism is a body of doctrines and clairvoyant techniques aimed at summoning spirits of the dead to interact with the living. This is generally achieved with the help of a human medium who directly or indirectly channels the energy of these spirits. A central objective of the religion is to free dead souls from the base "material" world and help them attain successive degrees of enlightenment. In return, the departed guide and empower the living. An eclectic movement from its inception, Spiritism assumed many guises in its new creole or Cuban environment.

Although a variety of spiritist practices took root in Cuba, the African sector of the population was ultimately drawn to its pragmatic, healing-oriented forms. Practitioners of both Santería and Palo Monte appropriated and adapted doctrines and techniques from Cuban Espiritismo for their dealings with the dead.[15] The influence on Palo has been particularly strong, especially on the eastern end of the island. It is widely maintained that Espiritismo reinforced and in certain ways enriched existing Congo-Cuban beliefs in the importance of the dead and the benefits of manipulating their power to practical effect. While this is no doubt true, the influence was profoundly mutual. Espiritismo provided a loose conceptual framework that Afro-Cuban practitioners could use to organize their spiritscapes and, perhaps more important, a common Spanish vocabulary with which to think about and articulate interactions with the spirit world.[16] Practitioners of Palo Monte, on the other hand, firmly grounded Espiritismo's metaphysics in the here-and-now, in problems of this life and this world.[17]

Santiago manipulates relations between the realms of the living and the dead with great dexterity and on several religious fronts. The main focus of his spiritist activity, however, is a luminous altar dedicated to his ancestral and other protective spirit guides. Included within this rather lofty category

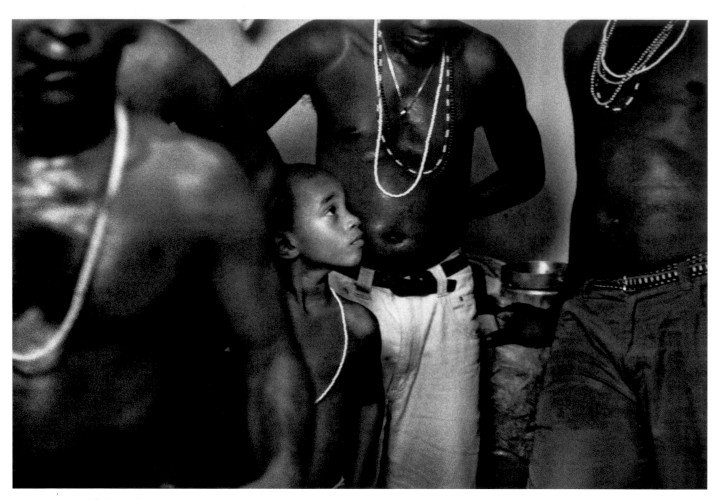

FIGURE 14. Godchildren of Santiago's house.

are Santiago's Congo spirits of the dead, strong spirits of superior healing energy who operate largely and often boisterously in the material world. The final chapter of *Crossing the Water, "I Am Not from Here*: Espiritismo and the Congo Spirits of the Dead," considers the entire spectrum of spirit beings associated with Santiago's spiritist beliefs and details how they are invoked in a ritual context.

Flexibility, improvisation, and synergy characterize Santiago's approach to the three traditions that form the cornerstones of his religious practice. Although he distinguishes between them in thought and in many aspects of ritual performance, the degree to which he experiences them as discrete belief systems is less certain. It *is* safe to say that Santiago lives the religions he practices as essential parts of a coherent whole.

Nací dentro de eso: I was born into this

In the declaration that forms the title of this segment,[18] Santiago is referring to the fact that he was born into the physical and spiritual world with specific God-given abilities. He says, "Aside from everything that has to do with being a palero and a santero, I am a spiritist. Not everyone has the gift that I was given, to help with bad situations. With Palo and Santería, the control is in your hands . . . but the ability to 'grab the dead' [to be possessed by spirits of the dead] depends on nature. They may send you to earth to be a santero or a palero but not to receive the dead."[19] Santiago anchors his priestly authority and sense of self in this innate ability.

Santiago was born on a farm, or *finca*, in the Sierra Maestra Mountains of eastern Cuba in 1939. His father, Cornelio Castañeda, was a highly regarded Palo priest and traditional healer with his own *cabildo*, or religious house. Santiago's mother, Tomasa Vera, "had her things [ritual objects]," according to her son, but practiced privately. People of Haitian descent had long lived in the area, and somewhere down the line there is Haitian blood on San-

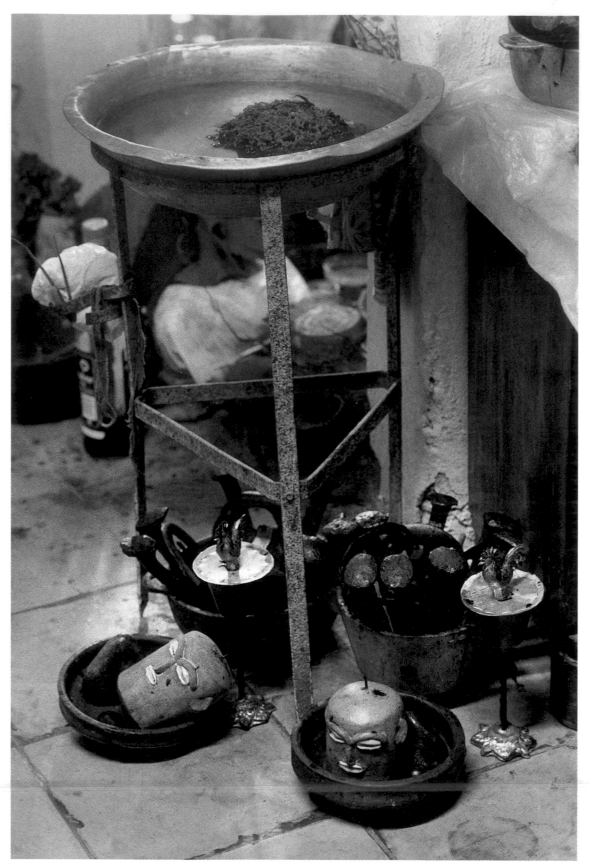

FIGURE 15. Enamel basin containing leaf-infused, purifying water.

tiago's mother's side. All seven of Cornelio and Tomasa's children were born in their father's cabildo. As Santiago dramatically declares, "I opened my eyes and there was an altar."

"The first *muerto* [spirit of the dead]," Santiago continues, "came down when I was eight years old." The muerto possessed him with such force that he lost consciousness. In part as a result of this incident, Santiago was fully initiated in Palo and presented with his *fundamentos*—his prendas or spirit cauldrons—by the age of ten. Already consulting with people a year later, Santiago readily admits that at this early stage he "worked" the spirits much more violently due to his lack of experience. However he soon mastered essential aspects of Palo religious practice: "At fifteen," Santiago says euphorically, "I was flying . . . I was flying," in the mystical sense of planing high above the earth like the all-seeing black buzzard, a powerful bird reputed to have an uncanny grasp of the unknown. In 1961, at the age of twenty-two, Santiago "made saint," the highest form of initiation into Santería, thereby becoming a priest of the orichas as well. At around the same time, he also apprenticed himself to an accomplished *espiritista* (a practitioner of Cuban Espiritismo) with whom he formally studied this religion's doctrine and spiritual techniques.

"There are few people who work like I do," Santiago emphatically declares (*Son poca la gente que trabajan como yo*). This simple statement actually covers quite a bit of ground. Santiago is alluding to the fact that he works idiosyncratically; that because of his natural abilities and life experience, he is an expert priest and healer; and that he works *hard*, with a depth of commitment that other practitioners cannot match. This unstinting work ethic informs all aspects of his life.

In 1953, when Santiago was fourteen, his father died. The family subsequently moved to town, where Santiago started working as a courier, collecting payments from people buying furniture on installment. To support

her younger children, his mother went to work as a maid in the private sector. Santiago soon graduated to a job in a hardware store. Several other stints working for white-owned retail establishments came next. Santiago's self-possession, heightened sense of responsibility, and business acumen invariably landed him a position of authority. In the decades following the Triumph of the Revolution and the elimination of private enterprise, Santiago worked for the state in a dry goods store. During these years he married twice and had a total of five children, two of them with the woman to whom he is still married.

After the collapse of the Soviet Union and the evaporation of its subsidies in the early 1990s, an economically devastated Cuba entered its austere, belt-tightening "special period." At the start of Cuba's effort to rebuild the shattered economy by developing its tourist industry, Santiago was transferred to a hotel, where he worked as an accountant until his retirement in the late 1990s. Sadly, at about this time, Santiago's wife suffered a debilitating stroke. Due to the intensive care she now requires, she is with her sister. None of Santiago's children currently lives anywhere near him. While most migrated to Havana years ago, the one son we did meet back in 2001 subsequently left for the United States. Santiago lives with his teenage grandson, Chaguito, whom he has raised from birth, and at this point in his life manages to support his immediate family, and to some extent needy members of his ritual family, through his religious work.

Chapters 1, 2, and 4 of *Crossing the Water* are devoted to Santiago's practice of Santería, Palo Monte, and Espiritismo, respectively. The multiple healing dimensions of his ritual work are specifically addressed in chapter 3, "*It's My War Now*: The Private Sphere of Santiago's Daily Practice." Healing, however, is the primary focus of all religious activity in Santiago's house. As such, it is the powerful thread linking all parts of this book. Whether in the form of communal ritualizing, religious initiation, or the one-on-one spirit work

that characterizes his private practice, Santiago's ability to help others engages him at his full potential, as a gifted and versatile practitioner of three remarkable and, on various levels, intertwined religions.[20] Through photographs and text, this book provides a visual and emotional entry into Santiago's world and evokes the dynamism and spiritual resonance of life as lived in his ritual family, a family that to an extent we now claim as our own.

Each time we return to Santiago's house after an extended absence, one of the first acts he performs for us is a ritual cleansing (*limpieza*) with leaf-infused water. He begins by vigorously brushing our bodies, from the crown of the head on down, with leafy, perfume-sprinkled branches. This purging action chases away harmful energies that may be lingering about the body. As he does this, he asks the spirits to protect and confer blessings on each of us. Health, strength, tranquility, and spiritual growth are always mentioned in his invocations. At different times during the cleansing ritual, Santiago twirls each of us, first to the right, then to the left, then to the right again. This mirrored movement echoes the motion of the world itself. As Santiago turns you, he is centering you within a larger cosmological whole. The initial cleansing with forest branches is followed by a full-fledged ritual bath in the privacy of Santiago's tiny bathroom. Pails of cool water, prepared with shredded leaves, chalk, perfume, honey, and other soothing ingredients, revitalize both mind and body. Flecked with leaf fragments and liberally dusted with talcum powder, you emerge feeling refreshed and curiously empowered.

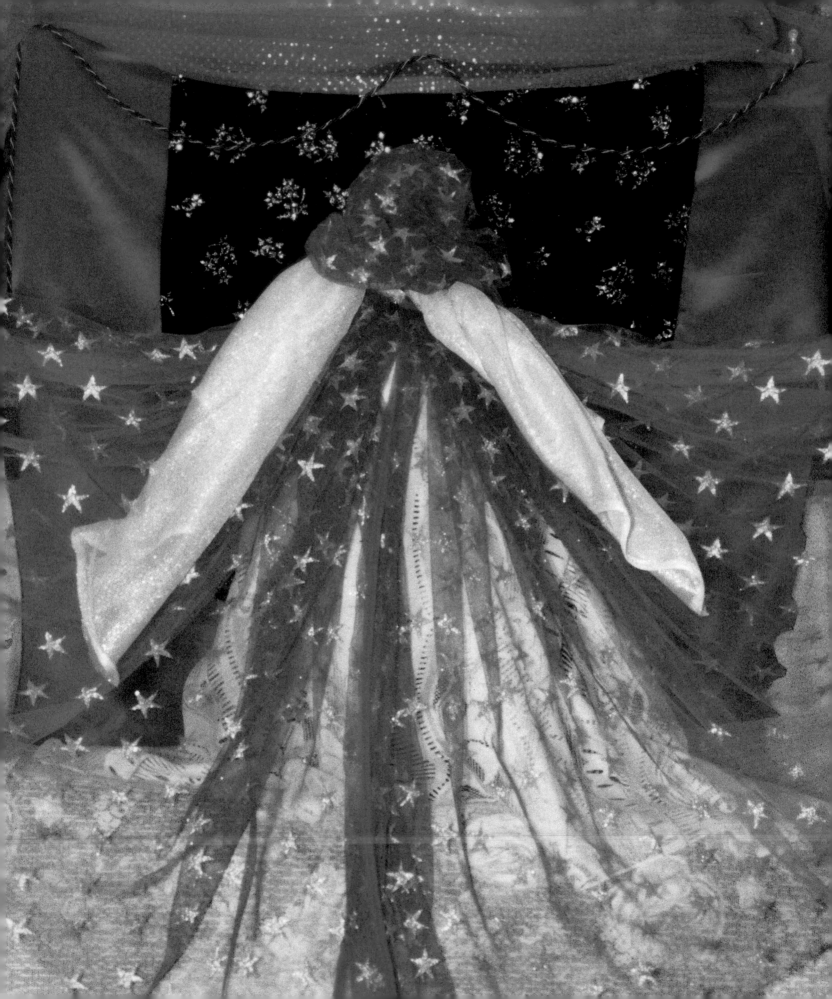

I Bow My Head to the Ground SANTERÍA THRONES AND RITUALS

The stars are the jewels
of Yemayá's mantle.

LYDIA CABRERA,
YEMAYÁ Y OCHÚN

Santiago lives in a brightly painted house on the corner of an animated intersection in a barrio near the outskirts of town. Architecturally insignificant and quite poor, the neighborhood is well off the beaten path for most non-Cubans. After walking down to Santiago de Cuba's main square, we often make our way out to his place in a *coco*, a moped equipped with an open-air fiberglass "coconut" shell that seats two passengers. As the driver negotiates the pitted street leading up to the white house with blue trim, you cannot help but notice the lush greenery of the plants that poke through the grillwork enclosing Santiago's front porch. Once inside this *portal*, a typically Cuban, fortresslike door provides access to the interior.

Santiago's front room (*sala*), simultaneously spacious and cluttered, has an air of timeworn formality. Multiple elaborately dressed dolls sit enthroned on the overstuffed sofa and chairs of a red vinyl living room set. Wooden sideboards harbor teetering stacks of ornate china and glassware. Every available surface is crowded with mass-produced decorative objects: chinoiserie, genteel porcelain figures in courtly dress, ashtrays in the form of Soviet-era tanks, and vividly painted plaster sculptures of animals, Catholic saints, Spanish dancers, and a stereotypical cigar store Indian. A fishless aquarium filled with incongruous floating objects lines the wall beneath a stairwell leading up to Santiago's rooftop. The tank's mirage-like contents include pieces of lacy fan coral, a rubber duck bound with elastic bands, glass fragments, and

FIGURE 16. Making of a throne
altar for Yemayá (detail).

various disembodied doll parts. In the middle of the furniture-laden room, a large inflated giraffe stands sentinel between two rocking chairs.[1]

For Santiago, many of the objects in the front room allude to some aspect of the spirit realm. As a denizen of the African bush, the plastic giraffe stands in for the powers of the forest, or el monte. Coy Louis XIV–style figurines evoke the world of the courtesan Ochún, spirit of romantic love and sweet inland waters. The militaristic ashtrays call to mind Ogún, oricha of iron and war. Other spirits are represented by the dolls in color-coded dresses, while the seemingly derelict fish tank is in fact an arcane personal tribute to Yemayá, spirit of the sea and mother to all human beings. She is the patron oricha of Santiago's house. Because this parlorlike room is the most accessible to the outside world, it is not surprising that references to the spirit world are veiled or, alternatively, hidden from public view. Vessels belonging to the all-powerful guardian orichas Eleguá, Ogún, Ochosi, and Ósun are concealed in a cabinet behind the front door.[2] When members of Santiago's religious family first enter the house from the street, they pause to ritually greet these spirit brothers.

A wide hallway leads from the sala to the back of the house. This transitional space accommodates an unwieldy Soviet TV surrounded by mismatched chairs and furniture overflow from the front room. Toward the end of the corridor, turquoise-blue shuttered doors open into a windowless inner chamber devoted to Santiago's orichas or saints (santos). The warrior spirits, responsible for guarding the entrance to the house, and Babalú Ayé, the oricha owner of illness and "specialist in the domain of the . . . dead,"[3] are the only spirits who habitually live outside this inner sanctum. Because access to its sacred contents is restricted, the doors are usually closed.[4]

Inside the "room of the saints" (*cuarto de los santos*), a cabinet (*canastillero*) stands against the back wall. Lined with foil, it houses the porcelain soup tureens and attributes of some of Santiago's orichas (see figure 37). These ornate

lidded vessels, called *soperas*, are hierarchically ordered, with the wise and generous spirit elder Obatalá on the top shelf. Identified with ritual whiteness and peaceful tranquility, Obatalá is considered the "owner of all heads," having fashioned human beings prior to their sojourn on earth.[5] His assistant Oke, the stable spirit of hills and mountains, shares this privileged perch. Ochún, the flirtatious oricha of love and fresh river water, is situated directly beneath these stalwart companions. The third shelf is occupied by the small but powerful Ibeji twin spirits and Inle, healer and advocate for all those who live from the sea.[6] The bottom of Santiago's canastillero is reserved for two orichas who play significant roles in the death cycle: Oyá, gatekeeper of the cemetery and turbulent ruler over wind and storm, and Obba, the patron of marital fidelity, who lives within the cemetery walls and "notifies Iku [Death] when an individual's allotted time on earth has expired."[7]

A pair of large earthenware pots (*tinajas*) sits on top of another, smaller cabinet. Embellished with images of the Virgin in two of her Cuban incarnations, they belong to Yemayá and Ochún, respectively.[8] Yemayá is associated with the black Virgin of Regla (la Virgen de Regla), who protects the Bay of Havana, while Ochún is identified with the Virgin of Charity of Cobre (la Virgen de la Caridad del Cobre), the patron saint of all Cuba.[9] Other vessels of terra cotta, ceramic, and wood crowd the floor in various corners of the room. Many of these earthbound containers are painted with bold organic or geometric motifs. Each represents the *asiento* or "seat of power" of a particular oricha. Although the spirits' receptacles and emblems of authority— metal crowns, ornate fly whisks, decorative fans, ritual swords, and dance wands—are visually striking, the most sacred of an oricha's objects are in fact concealed within his or her vessel. These consecrated stones, shells, and metal or wooden tools are called "secrets" or "fundamentals" (*fundamentos*).[10] Potent yet unassuming, they distill each oricha's presence. Santiago received these personal sets of power objects in the course of various complex initiations.[11]

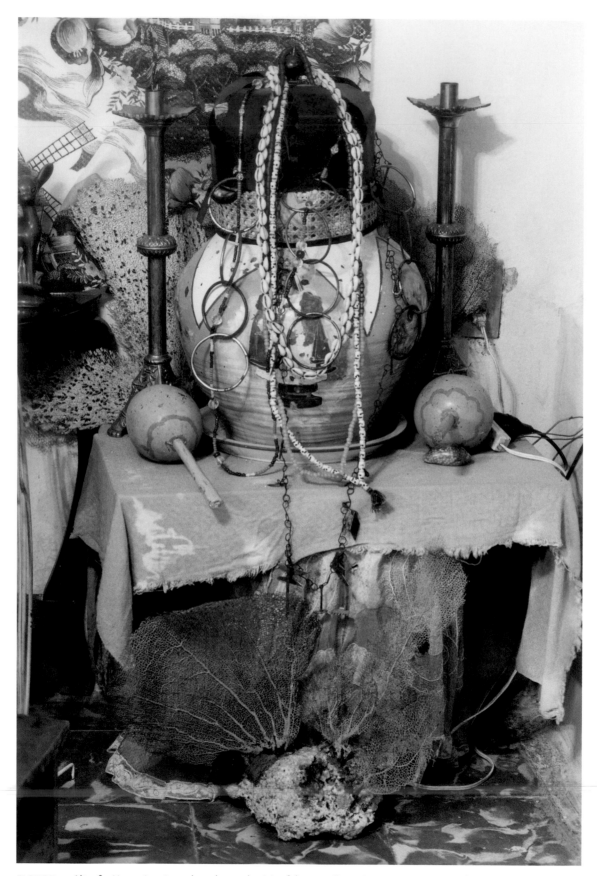

FIGURE 17. Altar for Yemayá, universal mother and spirit of the sea. She is Santiago's primary oricha.

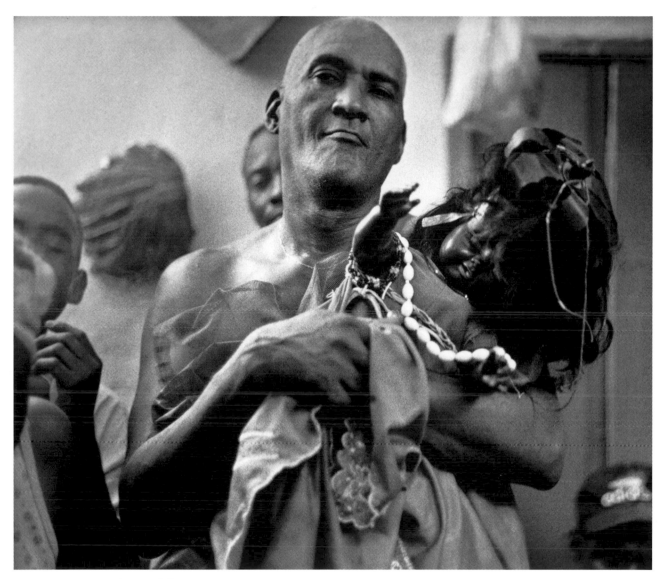

FIGURE 18. Santiago clasps a doll representing Yemayá.

Yemayá: *Dueña del mundo* (Owner of the world)

They say Yemayá is the owner of the world because all countries are surrounded by her. . . . She's a champion, a goddess. She has given me good health and saved me from a lot of sadness. . . . Because of her, I've got good relations everywhere in the world. But she can be dangerous. Yemayá can kill. When she gets stormy, she can turn the world upside down.

SANTIAGO CASTAÑEDA VERA, 2002

Santiago was born a child of Yemayá, the female oricha identified with the ocean and its myriad life-giving properties. As his guardian angel (*ángel de la guardia*), she has guided and protected him all his life. This special bond was physically and emotionally reinforced when Santiago was initiated as a santero, or priest of the orichas, in 1961. Although his paramount spirit has certain core traits shared by all Yemayás, she has others uniquely her own.

Like their human devotees, the orichas are living, multidimensional beings capable of doing both good and bad. As an expression of their inherent complexity, each spirit manifests himself or herself in a variety of ways.[12] These complementary and at times conflicting aspects of an oricha's identity are called *caminos*, literally "paths" or "roads."[13] Yemayá, for instance, is formally recognized as having seven distinct life paths. She is both one and many. At the time of his initiation, Santiago was consecrated to a particularly fierce camino of Yemayá known as Okute. During the ceremony's key ritual, Yemayá Okute's life force (*aché*) was physically placed or "seated" (*asentado*) in Santiago's head, making of his body a spirit-enclosing vessel.[14] As at home in the forest as she is beneath the surface of the sea, Yemayá Okute is a soul mate of the fearless warrior Ogún. Iron-willed and equally belligerent, she shares his eagerness to throw himself into battle. This attraction to conflict and struggle is coupled with Okute's proven ability to help her children cope

with life's many obstacles and contradictions. A vast knowledge of medicinal plants and expertise as a maker of ritual powders only enhance her ability to defend them.[15]

Although Yemayá Okute lives most intimately in Santiago's mind and body, the external seat of her power is the earthenware pot containing her secrets (see figure 17). Okute's *fundamentos* include carefully selected stones and shells and a necklace adorned with twenty-one diminutive tools and weapons. This necklace is a power object traditionally associated with Ogún. As Santiago explains, his head-ruling oricha has "all the metal implements" (*todo el herramiento*) of this resolutely independent spirit. Despite her rough-and-ready nature, Yemayá Okute's vessel is decorated with delicate paintings of the Virgin of Regla and clusters of pink roses set against a vibrant, saw-toothed background of blue and white. A metal crown, proclaiming Yemayá's regal status, rests on top of the container.[16] The lacy fan coral, linked silver bracelets, and seashells that surround the receptacle all speak to the spirit's watery origins in the "barrier reefs of the coast."[17] Several consecrated neck-laces hang from her crown, among them a long strand of Tibetan skull beads. They remind us of Okute's volatile nature and her potential for deadly, de-structive action. If offended, her punishment can be as sudden and devastat-ing as a tidal wave.

Santiago and Yemayá Okute clearly have a dynamic, mutually empower-ing relationship. This is manifest in the way he talks about her. He says with great pride and emotion that she has provided him with good health, an ever-expanding web of personal relations, stability in uncertain times, and an enviable measure of success. Although Yemayá Okute shares her influ-ential position with other spirits near and dear to Santiago, she is in large part responsible for the knowledge and spiritual wisdom that underlie his priestly authority. In return for her ongoing guidance and protection, San-tiago sustains Yemayá both physically and spiritually. As their connection

has deepened over the years, spirit and priest have, in a sense, come to mirror each other.[18]

Visual praise poems for Yemayá

In addition to his permanent oricha vessels, Santiago creates magnificent temporary altars or thrones (*tronos*) for his spirits.[19] We have photographed several of these ephemeral installations. All were dedicated to Yemayá and her immediate spirit entourage. On the eve of her feast day in 2002, Santiago let us document the mounting of a throne in her honor. This annual celebration falls on September 7, a date that coincides with the saint's day of Yemayá's Catholic counterpart, the Virgin of Regla.

Several days prior to the festivities, core members of Santiago's ritual family come together to help prepare for the occasion. On this trip, we had brought yards of cloth—some pieces quite dazzling, others more richly subdued—as gifts for Santiago's orichas. Upon presentation, the cloth had been quickly secreted away in his bedroom. These and other luxury fabrics, including beautiful linens intricately hand-embroidered in the old style, are now brought out of storage and, if necessary, washed and ironed. One of us shares the ironing detail with a timorous but cheerful woman named Custodia while the other helps wash everything from the orichas' fancy ceramics in the front room to an assortment of empty liquor and soda bottles displayed on a decorative shelf in the hall. Everything ultimately is refreshed with water. Appropriate fruits, vegetables, and fine alcohol are bought and elaborate cakes ordered. No matter how great or small the available resources, creative transformation and renewal lie at the heart of these offerings to the spirit world.

On the eve of the celebration, as the women of the household prepare some of Yemayá's favorite foods and tend to other last-minute details, Santiago isolates himself in the saints' room with Robertico, his right-hand man

in all aesthetic matters. Although the latter's every move is subject to Santiago's approval, Robertico is the artistic mastermind behind the throne's creation. As the installation evolves, the doll representing Yemayá is lovingly prepared, her hair brushed, her body perfumed and draped in a mantle sewn with deep blue undulating sequins, and her crown adjusted. She is then enthroned on top of the canastillero. The earthenware pot containing Yemayá's secrets is elevated on an improvised pedestal in front of this cabinet shrine, where it is slowly concealed beneath artfully gathered white lace and star-studded blue tulle, her sacred colors. Layering and sculpting these extravagant fabrics is an arduous process because each piece of cloth must be secured with needle and thread. The terra-cotta pots belonging to Ochún and Olokun, intimate spirit associates of Yemayá, are subsequently lifted up to either side of her and hidden within yards of cascading fabric in their preferred colors of yellow and aqua. As Santiago and Robertico construct the altar, great care is taken to ensure a balanced, harmonious outcome. After hours of painstaking elaboration, the end result is stunning. Santiago's throne for Yemayá is literally a firmament of draped cloth. The altar not only expresses her "son's" devotion; it proclaims Yemayá's promise of earthly accomplishment and ever-deepening spiritual awareness to those who, like Santiago, serve her properly.

In the early morning of September 7, additional offerings of fragrant flowers, mounds of fruit, frothy iced cakes, and other delicacies are laid at the foot of the altar.[20] An elegant porcelain couple in eighteenth-century dress, brought from Santiago's front room, anchors the sumptuous display, which is now framed by glinting tinsel garlands. The throne sends a message about the nature of oricha power that conceals a paradox at its core. Splendid cloth, gleaming porcelain, and other hierarchically arranged prestige items trumpet their wealth and social status.[21] These outward expressions of the orichas' spiritual authority at the same time hide its true power source: the

aché-laden (and visually understated) objects deep within their respective containers. For Santiago and his ritual family, the emotional and aesthetic impact of the throne derives, at least in part, from an appreciation of what remains completely hidden.[22]

After finalizing all of these preparations, Santiago goes off to bathe. He returns wearing a brand-new athletic outfit in eye-popping blue and yellow, colors pleasing to both Yemayá and Ochún. As his godchildren (ahijados) arrive, they first present themselves at the door to the throne room, which is now glowing resplendently from within.[23] When we have all had a chance to pay our respects, everyone crowds into the hallway outside the cuarto de los santos. The intensely beautiful light spills out onto the faces of those closest to the entrance. Several neighborhood musicians, summoned by Santiago to accompany the singing of Yemayá's praises, seat themselves around the doorway. In keeping with the refined elegance of the occasion, the violinist rises to play a poignant "Ave Maria" for Yemayá on the threshold of her throne room.[24] After several achingly beautiful rounds of the melody, an older woman spontaneously adds her voice to that of the violin. Others join in the refrain. Soon everyone is involved in this joyous and intimate celebration. Suffused with Yemayá's presence and surrounded by his ritual family, Santiago is positively radiant. The sense of collective well-being is palpable.

 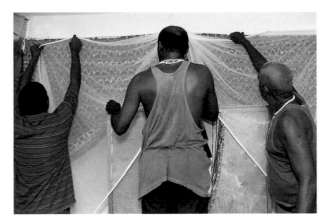

The act of throne building is a performance in itself, the primary audience of which comprises the orichas as subjects.

DAVID H. BROWN, *SANTERÍA ENTHRONED*

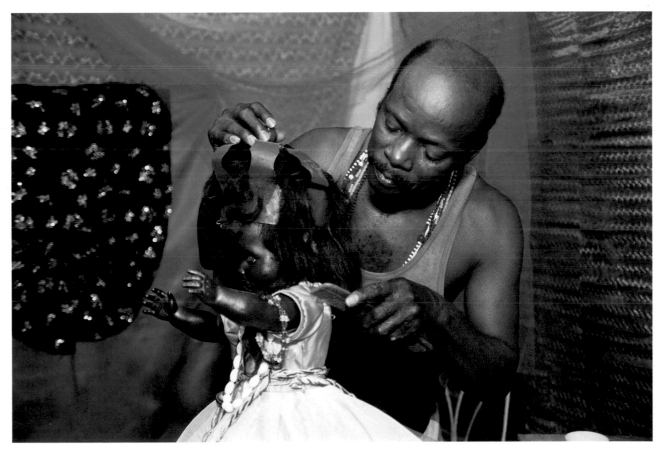

FIGURES 19 THROUGH 33. Santiago and Robertico construct an elaborate temporary altar for Yemayá on the eve of her feast day, September 7.

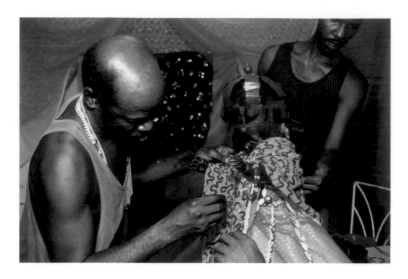

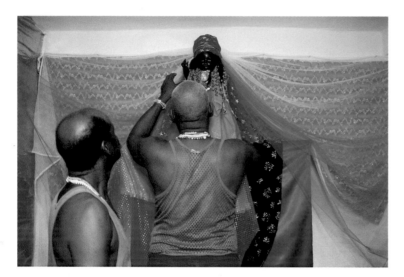

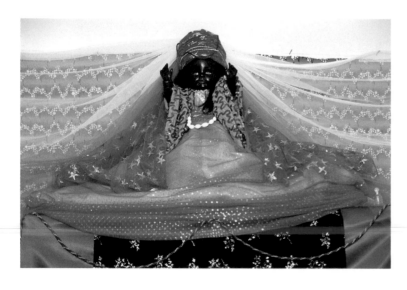

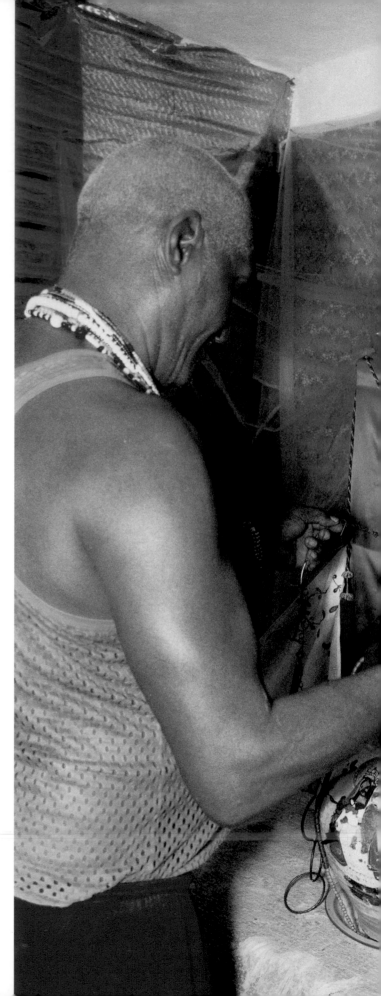

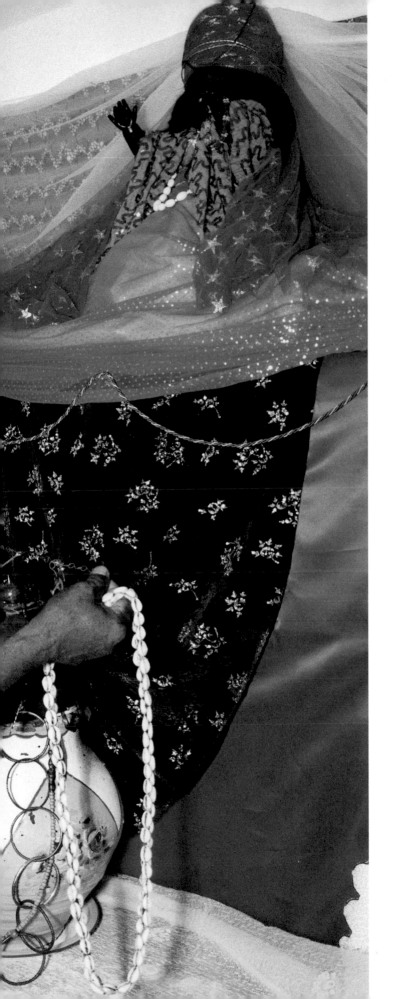
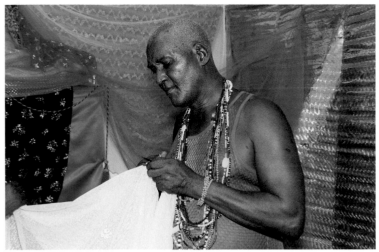
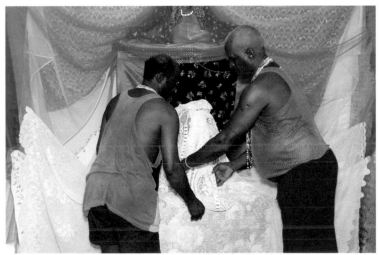
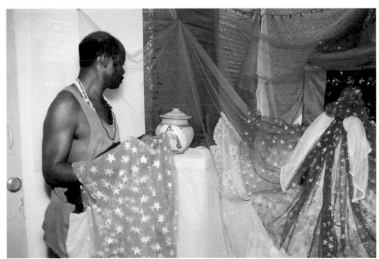

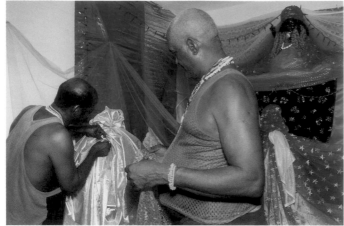

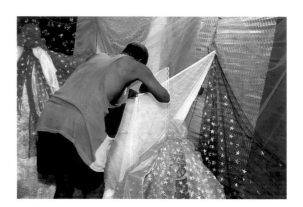

Ritual . . . is not a telling or a text. It is the performance of a world, its entities, powers, and relations.

GEORGE BRANDON,
SANTERIA FROM AFRICA TO THE NEW WORLD

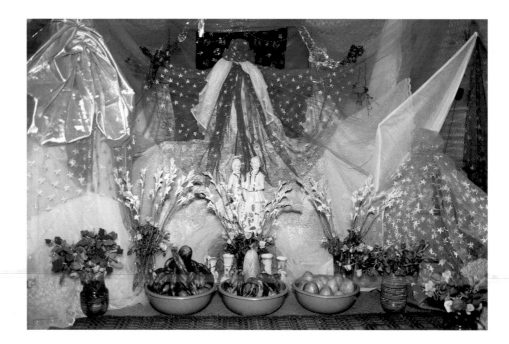

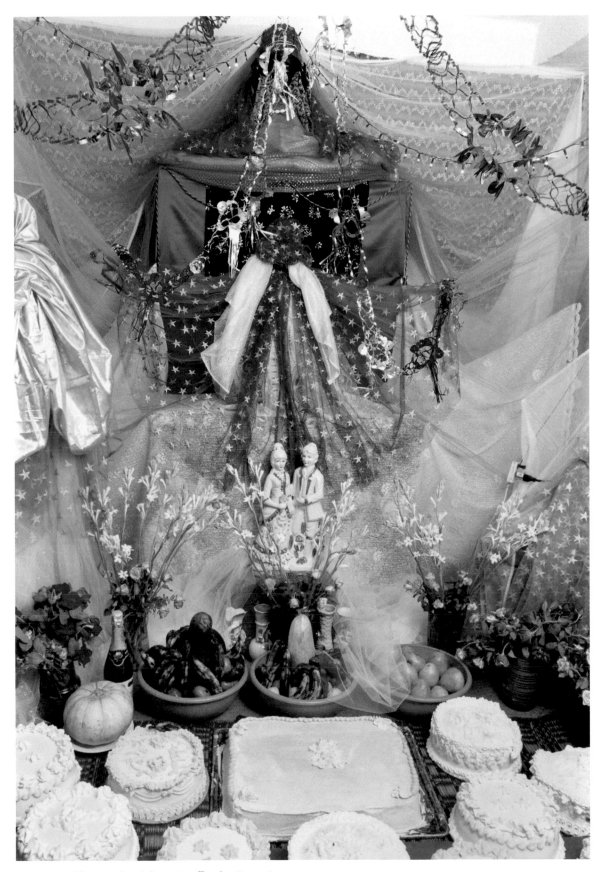

FIGURE 34. The completed throne is offered to Yemayá.

Ave, Ave, Ave María,	Ave, Ave, Ave Maria,
Ave, Ave, Ave María.	Ave, Ave, Ave Maria.
Dios te salve, María, llena	Hail Mary, full of
eres de gracia,	grace,
el Señor es contigo,	the Lord is with thee,
Bendita tú eres entre todas	Blessed art thou
las mujeres,	among women,
y bendito es el fruto de tu	and blessed is the fruit
vientre, Jesús.	of thy womb, Jesus.
Ave, Ave, Ave María,	Ave, Ave, Ave Maria,
Ave, Ave, Ave María.	Ave, Ave, Ave Maria.
Santa María, Madre de Dios,	Holy Mary, Mother of God,
ruega por nosotros, pecadores,	pray for us sinners,
ahora y en la hora de	now and in the hour of
nuestra muerte.	our death.
Ave, Ave, Ave María,	Ave, Ave, Ave Maria,
Ave, Ave, Ave María.	Ave, Ave, Ave Maria.

FIGURE 35. A violinist plays "Ave Maria" in Yemayá's honor on the threshold of her throne room. The song inaugurates the oricha's feast day celebration.

FIGURE 36. A radiant Santiago surrounded by his ritual family.

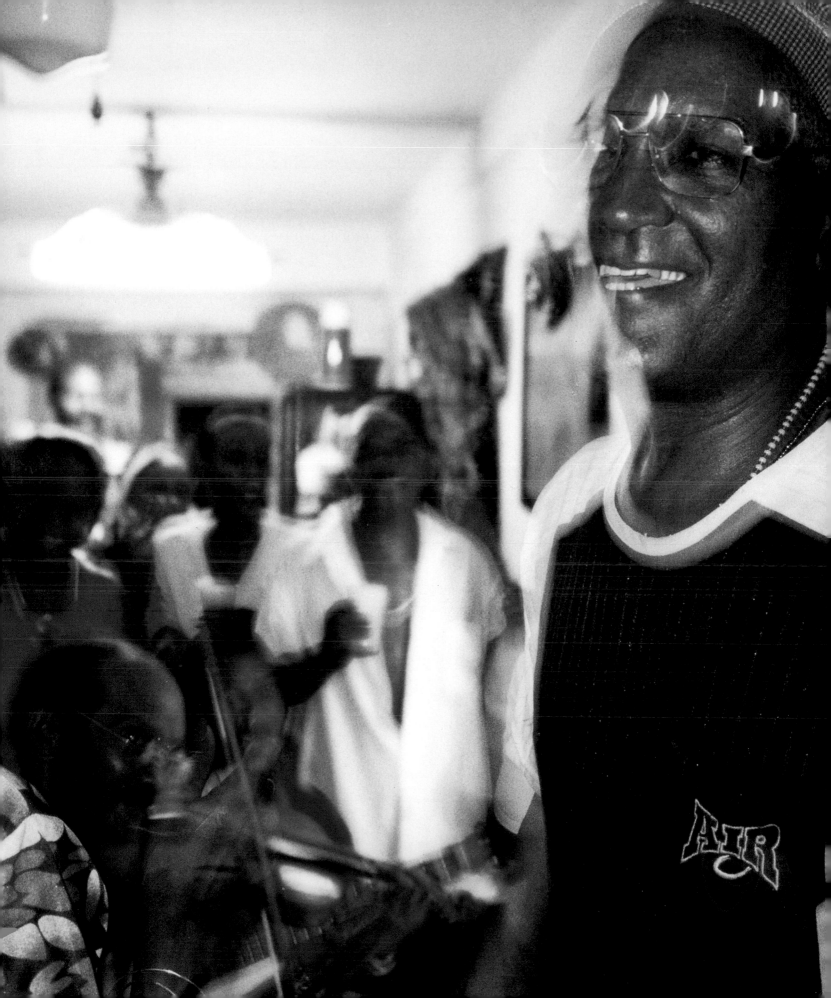

La vida de la vida (Life from life): Feeding the Orichas

Offerings to the orichas take many forms, including prayer, music, the pouring of libations, singing and dancing for the spirits, breathtaking visual tributes, small gifts of food, and periodic animal sacrifice.[25] However simple or elaborate, offerings uphold the entire ritual system because it is through these substantive acts that communication is established and maintained with the spirit world. They provide a bridge for the flow of power in the universe known as aché. Definable as vital force or energy, aché is present in all people, spirits, things, and natural phenomena to a varying and ever-fluctuating degree.[26] Huge reservoirs of this mercurial power, however, circulate in the spirit realm. Offerings ensure that it is constantly moving, back and forth, between our world and that of the spirits. While all ritual actions emit aché, the blood of sacrificial animals is particularly potent with this energy because the taking of life is involved. Santiago "feeds" all of his orichas once a year. This large-scale slaughter or *matanza* inaugurates an intensive cycle of ceremonies that Santiago performs in November. Everyone and everything is strengthened as a direct result of these blood offerings.

Pigeons, doves, and assorted scrawny chickens roam Santiago's rooftop throughout the year, but their ranks swell enormously in the days leading up to the matanza. Feathered animals of every description—guinea fowl, ducks, geese, doves, pigeons, and countless chickens—join the fold. On the morning of the ritual feeding, Santiago's roof is the scene of a frenetic avian roundup as different sets of birds are chased down, their sex determined (no easy task), and their feet bound to facilitate transportation down below. In the course of a single afternoon, the orichas of the house will be offered at least twenty-five birds, collectively known as *plumas* (feathers). For several days now, godchildren have been coming by to drop off their ritual necklaces (*collares*), each one beaded in the colors of the oricha to whom it is dedicated.

Santiago parts these out according to the "hot" (strong, aggressive) or "cool" (gentle, sweet) temperament of the spirits they represent and places them in separate gourd bowls. Collares must also have their aché replenished from time to time.

Four members of Santiago's religious family, all santeros and santeras in their own right, are on hand to assist with different aspects of the matanza, which is performed in the confined space of the cuarto de los santos. The ritual's structure and emotional tone are quite formal, with great emphasis placed on proper etiquette and sequencing. Gestures of respect—the repeated touching of fingertips to the head and floor, for instance—abound.

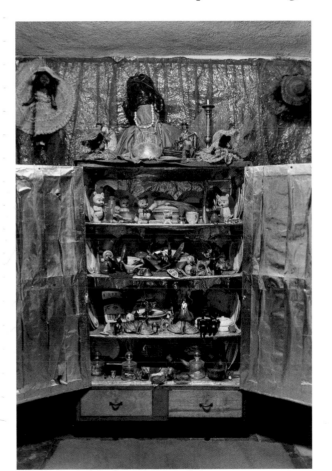

FIGURE 37. Wooden cabinet (canastillero) housing the porcelain vessels of some of Santiago's orichas.

The lead role during the first part of the ceremony is given to Xiomara, an elegant woman well versed in Lucumí, the sacred language of Santería.[27]

The matanza officially begins with a lengthy prayer and divination session. Her words punctuated by the shaking of a maraca and the tinkling of a small brass bell, Xiomara invokes each oricha individually and lists the animals that will be offered him or her. She then asks whether the proposed sacrifice is acceptable and casts four rounded pieces of coconut to the floor, a popular form of divination known as *los cocos*. The spirits speak through these coconut fragments.[28] As they land in different configurations (with the white, meaty side either up or down), the cocos reveal the oricha's response. If the answer is negative or unclear, the offering may have to be adjusted. The questioning continues, and the cocos are rethrown until the spirit agrees to accept. Toward the end of this divinatory process, Xiomara tries to determine the outcome of

critical cleansing rituals that are to be performed in the coming days. Now that the lines of communication with the spirit world are open, the physical sacrifice can begin.

Although each oricha has his or her own food preferences, certain spirits routinely eat together. Others, due to individual temperament or long-established interspirit dynamics, are notoriously incompatible and would never be fed at the same table. Clustered according to these relationships, the orichas' vessels sit on the floor of the saints' room. Some fundamentos have been removed from their customary containers and placed in covered plastic or enamel basins.

Before a bird or set of birds is sacrificed, it is first presented to the oricha for whom it is intended. Because, as Michael Mason perceptively notes, there is no absolute separation of the physical orichas from those that live in the heads of ritual elders, Santiago stands in for many of the spirits being fed. The animals are first touched to his head (the forehead and the nape of the neck) and other significant places (elbows, hands, knees, and feet) before being swept down the entire length of his body. Once consecrated through prayer and physical contact, the birds are swiftly dispatched. As their life's blood is drained over the appropriate vessels and ritual objects, aché courses through the tiny room. Its contours seem to expand to accommodate it.

The orichas receive their offerings in a prescribed order. The Warriors, brought from their home behind the front door of Santiago's house, are the first to be fed so that they will "open the way" to communication with the other world (*el mas allá*). Eleguá, the universal messenger and wayward trickster, eats alongside his lifelong companions: Ogún, denizen of the forest and owner of iron and war; Ochosi, the hunter and avenger of injustice; and Ósun, the oricha linked to one's personal destiny. Vigilant cowrie-eyed clay heads sit amid cauldrons studded with metal weapons, rustic tools, railroad spikes, animal horns, and links of chain. They constitute a formidable line of defense.

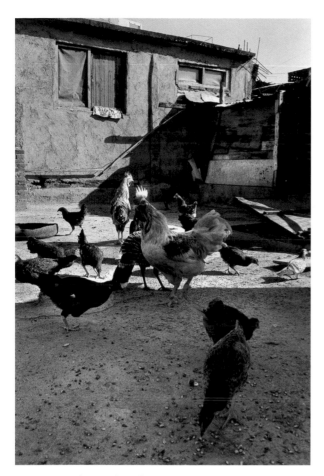

FIGURE 38. The number of feathered animals on Santiago's rooftop increases dramatically in preparation for the feeding of the orichas.

A second cluster of vessels includes a number of the orichas enshrined in Santiago's canastillero: the dignified and levelheaded Obatalá; the steadfast mountain oricha Oke; and two different caminos of Ochún, the sensuous owner of river waters. Gourd bowls brim with necklaces dedicated to these cooler, calmer spirits. They too reap the benefits of the animal sacrifice. Xiomara and the other santera present during the matanza kneel and bow their heads to the ground as their paramount orichas, Ochún and Obatalá, are fed.

Yemayá Okute, Santiago's head-ruling oricha, is among the last to eat. She does so in the company of kindred hot-tempered spirits. They include the mischievous Ibeji or twin spirits; Changó, the virile oricha of thunder and lightning; Olokun, mysterious ruler of the ocean depths; Oricha Oko, identified with the land and agricultural fertility; Oyá, guardian of the cemetery and tempestuous woman warrior; Obba, graveyard resident and long-suffering wife of Changó; and Inle, the oricha-physician and patron of fishermen. Once these spirits have been fed, San Lázaro, the oricha who can heal or bring about disease; Agayu, associated with the volcano's fiery eruptions; and Yemayá Okute receive their offerings.[29]

This demanding sacrificial sequence is carried out with remarkable efficiency. In less than two hours, a retinue of twenty-five or more plumas is offered up. The birds' severed heads are often left to crown the receptacles. As the orichas absorb the blood's spiritual essence, candles are lit and placed before each cluster of vessels. In a final ritual gesture of identification, everyone present tears feathers from the bodies of the dead birds and showers them over the spirits' fundamentos.

The sacrificed animals are taken away to be butchered and cleaned, a phase of operations that Santiago refers to as "clearing the table" (*quitando la mesa*). Careful note is made of which birds were offered to each oricha so that specified portions can be set aside. Key body parts are immediately presented to the spirits, while other internal organs must be specially prepared. These dishes, charged with aché, are then placed on or near the appropriate spirit vessels. The lion's share of the meat, however, is used to feed Santiago's ritual family over the next couple of days. After the heat of the blood sacrifice, the sacred contents of the orichas' soperas are washed down with a cooling herbal solution. The newly fortified necklaces belonging to Santiago's godchildren are also refreshed with leaf-infused water before being meticulously sorted and returned to their owners.

Con la bendición de Olofi y Olodumare, [With the blessing of . . .][30]

Con la bendición de mi padre, Cornelio Castañeda,

Con la bendición de mi madre, Tomasa Vera,

Con la bendición de mi padrino, Ángel Felipe Guibel Ocha Omí Yale,

Con la bendición de mi madrina, Mitelia Gaibe Ocha Ochún Okaranké,
 timbelese Olodumare,

Con la bendición de todos los santeros mayores y menores que estan
 presentes y ausentes,

Moyuba egun, [I pay homage to the dead . . .]

Omí tutu, ona tutu, tuto laroye, tuto ilé, ariku babagua,

Ibayén tonú todos babalochas y iyalochas y ayafá y egun que estan timbelese
 Olodumare

Ibayén tonú Abicola Okaranké Batalla, Rigoberto de Madruga, . . .

Ibayén tonú Omí Lana Otorosimi, Esmeralda Ati Changó, Lumi Ocho Toro,
 Omí Sa Idé, . . .

Ibayén tonú Clarita Loya, Pablo Vicente Obá Bi Chemera, Vicentica Echu
 Eleguá, Noris Oyá Gadé, Habana Par Nilo, Lázaro. . . .

Moyuba kinkomaché, [I pay homage to the living . . .]

Kinkomaché Obí Iyalé Akeremi, Ocho Tolú, Abicola Okaranké, Omí Sayé,
 Omí Kaleko,

Ogún Leti, Obí Ara, Obá Nyoko, Adé Anya, Bonba Kilona, Omí Oso,
 Obara Ché, Leri Tonyá, Ekeleñi . . .

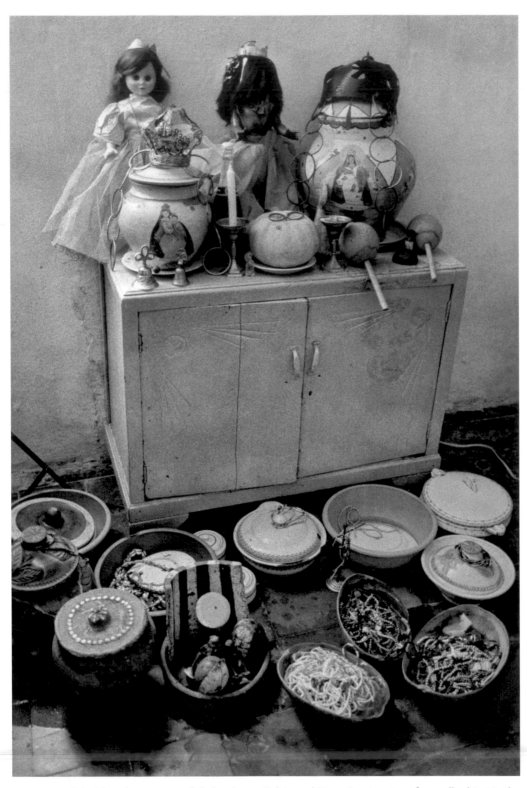

FIGURE 39. Painted earthenware vessels belonging to Ochún and Yemayá rest on top of a small cabinet in the saints' room. Their sacred contents have been removed and placed in covered plastic bowls on the floor where they sit alongside the fundamentos of other orichas, left in their original containers. Ritual necklaces belonging to Santiago's godchildren fill the half-gourds in the foreground.

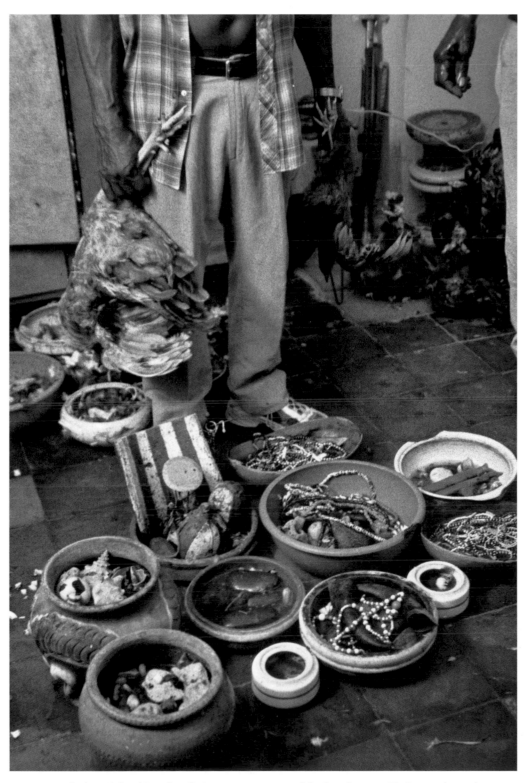

FIGURE 40. Each spirit has his or her distinct temperament and food preferences. Their sacred vessels are clustered and fed accordingly. This strong "hot-tempered" grouping includes Changó, Yemayá, Oyá, Olokun, Oricha Oko, Inle, and the Ibeji or twin spirits.

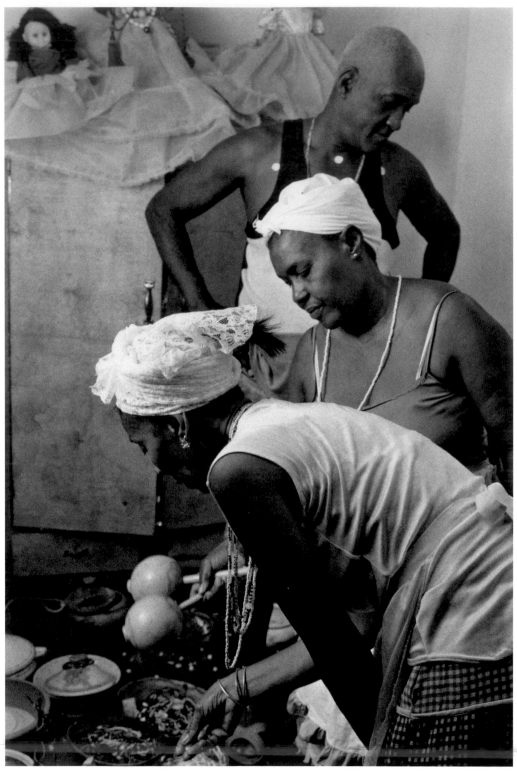

FIGURE 41. The matanza formally begins with a lengthy divination session as Xiomara invokes each of the orichas in turn. She determines whether a proposed sacrifice is acceptable by casting four pieces of coconut to the floor. The resulting configuration reveals whether or not the oricha is satisfied with the offering.

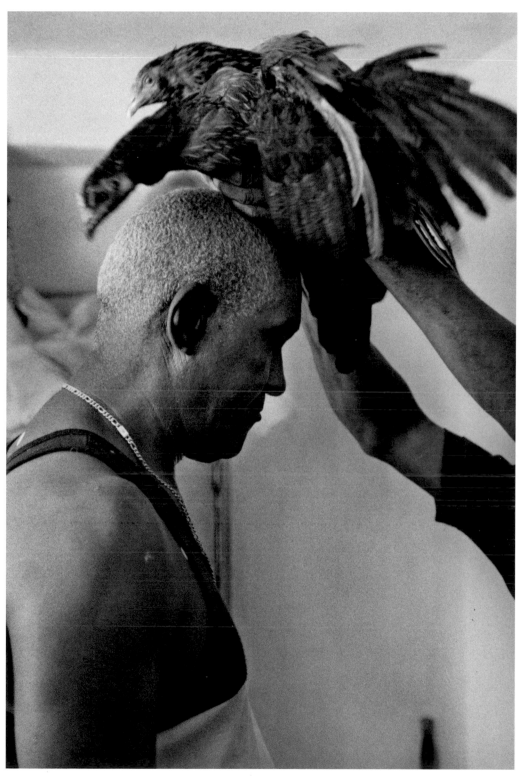

FIGURE 42. In an act of consecration, two chickens are presented to Santiago's head and touched to other ritually significant areas before being swept down his body.

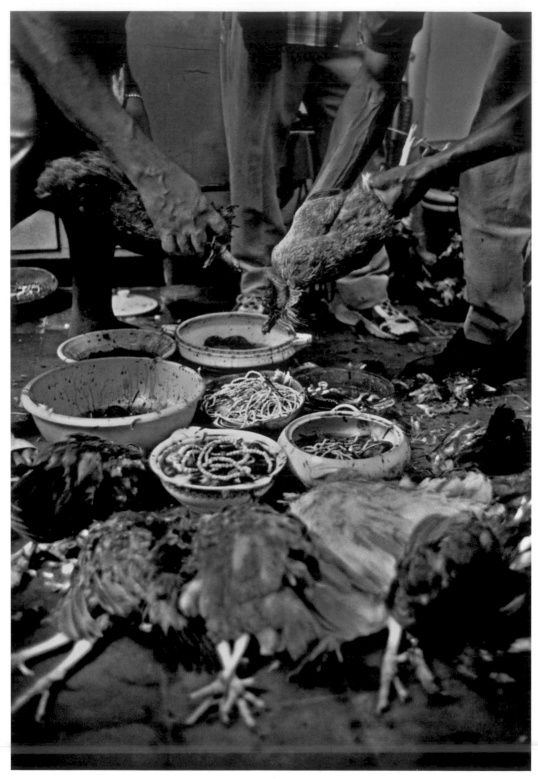

FIGURE 43. Each bird or set of birds, once sanctified through act and prayer, is quickly sacrificed. In the course of the afternoon, a steady succession of hens, roosters, pigeons, doves, guinea fowl, geese, and several ducks is offered up.

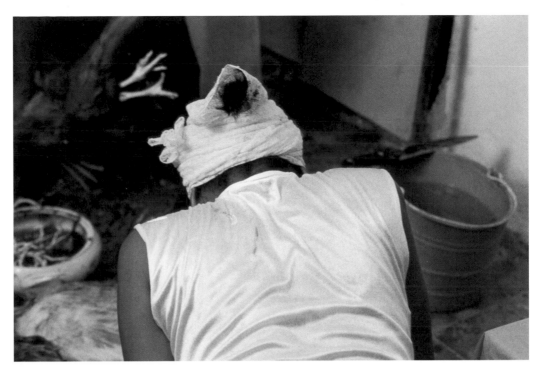

FIGURE 44. Xiomara kneels and bows her head as white chickens are offered to her principal spirit, Ochún.

FIGURE 45. Feathers are torn from the bodies of the dead birds and showered over the orichas' sacred objects.

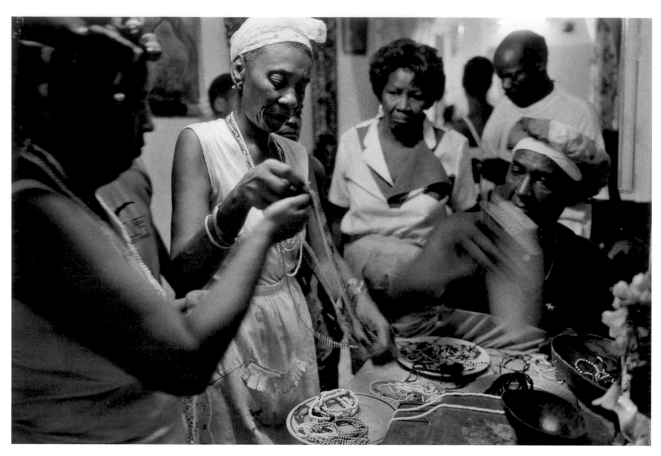

FIGURE 46. The newly fortified beaded necklaces belonging to Santiago's godchildren are refreshed with fragrant, leafy water and returned to their owners.

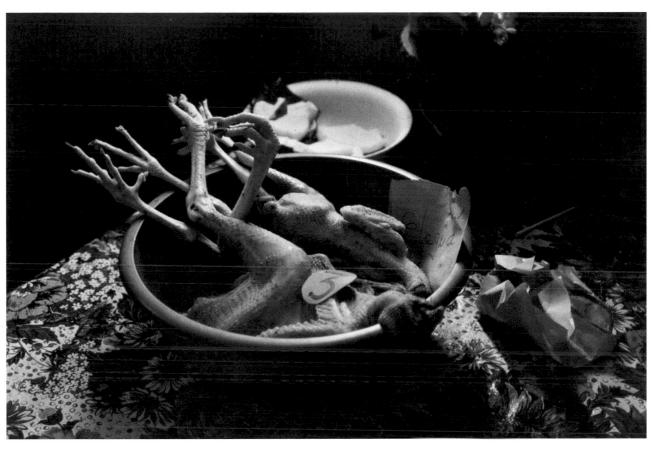

FIGURE 47. Three roosters sacrificed to Eleguá. The name tag assures that ritually specified parts of these particular birds will be set aside for the oricha.

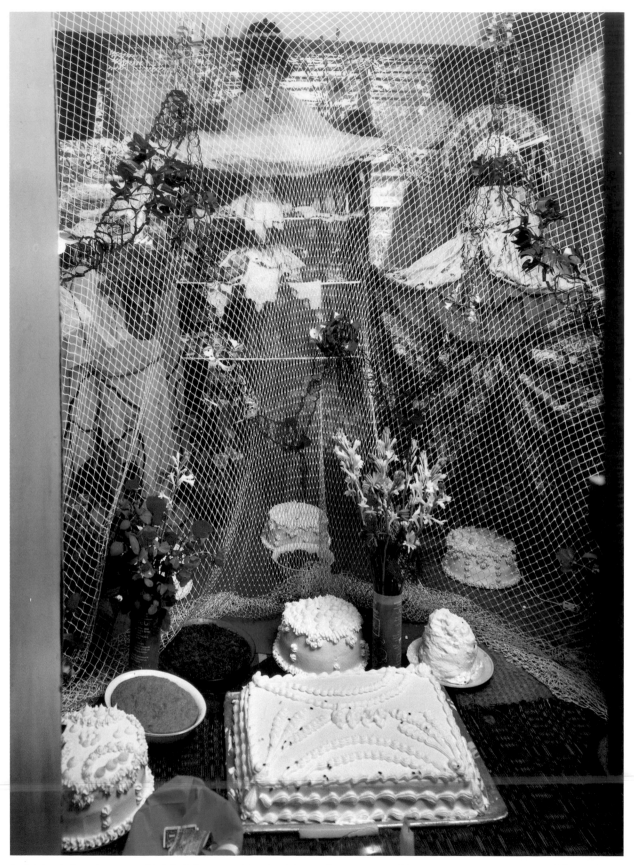

FIGURE 48. Cumpleaños or "birthday" throne marking the thirty-ninth anniversary of Santiago's initiation as a priest of the orichas.

Omí Yemayá (Water is Mother): Santiago's Birthday-in-Saint

The matanza for the orichas marks the beginning of Santiago's November ritual cycle; the anniversary of his initiation as a santero brings it to a close. Santiago's *cumpleaños* or "birthday-in-saint," as this annual celebration is called, once again inspires a complete transformation of the cuarto de los santos. Assembled with new creative flourishes every year, these birthday thrones honor all of Santiago's orichas while reserving a special place for Yemayá. They also serve as visual testaments to his spiritual growth in the religion. A large expanse of cascading fishnet veils the altar created for Santiago's year 2000 anniversary. Suggesting an "underwaterscape," this magnificent throne brings to mind one of Yemayá's praise names: "Mother of the Children of Fishes."[31] In the course of the afternoon, any paper money left in honor of Yemayá is proudly tucked into the intermeshed strands of the fishnet. The resulting display makes a concrete statement about the life-sustaining circuit that unites Santiago, his head-ruling oricha, and the larger ritual family.

We have participated in two of these lavish birthday celebrations. The throne is the focal point of a daylong tribute as guests kneel or, if fully initiated, prostrate themselves before the hidden presence of the orichas. This act of respect is called *moforibale* (literally, "I bow my head to the ground"). As Michael Mason suggests, when individuals perform this bodily act of submission at the foot of the throne, they are honoring the orichas in general as well as those specifically "crowned" in Santiago's head.[32] On these consummately social occasions, Santiago's charisma and generosity, expressions of his personal aché, carry the day. In the course of receiving, feeding, and interacting with his many godchildren and guests, Santiago "raises the life energy" (*levanta el ánimo*) of everyone who comes into contact with him.

Mother of the Children of Fishes

Drives death away; he flees for safety.

Six times long life to the elder she is (strong) like a man.

Yẹmọja [Yemayá] sank into the sea and mixed to exist as water.

My mother we search for water to be born.

JOHN MASON, *ORIN ÒRÌSÀ: SONGS FOR SELECTED HEADS*

The cumpleaños festivities in 2002 were unusual for several reasons, one of which requires a bit of background information. Santiago seldom brings in outside musicians to perform at ceremonies because he knows they will attract undue attention to his religious activities. The promise of live music spreads rapidly in Santiago de Cuba and is a potential draw to all kinds of people, both opportunistic and well intentioned. As things start heating up, passersby are lured in off the street. If not carefully monitored, the situation can get out of hand. Because Santiago likes to maintain a low profile, he usually relies on impromptu music making by members of his ritual family on important occasions.[33] In 2002, however, he made an exception. On this forty-first anniversary of his initiation, Santiago decided to offer the spirits a *tambor*, or ritual drumming. Professional musicians were hired to play the sacred *batá* drums.[34]

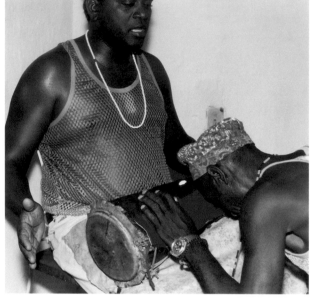

FIGURE 49. The lead singer of a group of professional musicians salutes the smallest of the sacred batá drums (the okónkolo).

The presence of the drummers and their consecrated instruments changed the dynamic of Santiago's cumpleaños celebration in another electrifying way: Yemayá herself made a rare appearance. Once the musicians had eaten, the three drummers in the group positioned themselves at the entrance to the saints' room and started to call Santiago's orichas, each with his or her own rhythmic patterns (*toques*).[35] As the focus of honor, Yemayá was the last to be instrumentally invoked. The batá drummers then moved to the front room, where they resumed playing, this time accompanied by the group's formidable lead singer (*akpwón*). After Eleguá had been saluted, songs for each of the orichas followed in a ritually specified order.[36] With each new spirit being praised, family members initiated under the auspices of that oricha would come forward to dance in his or her honor.[37]

L'ari oke, l'ari oke	Raise your head, raise your head
Oke oke Yemayá l'odo	Up, Up, Yemayá in the water
L'ari oke	Raise your head[38]

The energy of the lead singer, Sarabán, was astonishing. As the evening progressed, the drumming and singing intensified until they became a deliberate call to Yemayá to come down and "mount" Santiago. When Sarabán sensed that possession was imminent, he focused all of his "vocal aché" onto Santiago,[39] throwing out praise songs to try to force the oricha's descent. Santiago had been dancing for Yemayá; within moments of this powerful outpouring, he became Yemayá. Santiago's primary oricha, unlike the Palo and Congo spirits he works with, rarely possesses him. Her arrival not only galvanized the crowd; it signaled the unequivocal success of the tambor.

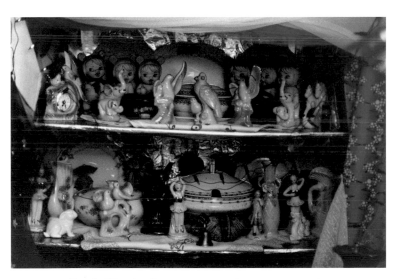

FIGURE 50. Detail of Santiago's canastillero.

Once Yemayá had settled in, she was gently escorted back to a spare room off the kitchen and dressed in a magnificent costume of deep sea-blue satin. The ensemble—a loose-fitting tunic encrusted with sequins and pearls, three-quarter-length pants, and a densely bejeweled cap—had been specially created for Yemayá in anticipation of her next appearance. Sparkling wave-like motifs, applied to the tunic in a dynamic, free-form design, suggested a foam-capped, turbulent sea. Otherwise, the entire front of the shirt was covered with Cuban peso notes, tacked on like so many random fish scales. A handful of U.S. dollars and Cuban *divisas*, their monetary equivalent at the time, were sewn onto the uppermost reaches of Yemayá's costume. This paper money

had been culled from the spiritual payments (*derechos*) left at the foot of the cumpleaños throne in the course of the day.[40]

By now, the drums were beckoning insistently from the front of the house. As seven vibrantly colored scarves were tucked into the sash encircling Yemayá's waist, she started to fan herself impatiently.[41] Then, just as she seemed about to answer the call of the batá, Yemayá suddenly pulled up a chair and took us, one by one, onto her lap. Enveloping each of us in her oceanic embrace, Yemayá rocked us gently from side to side as she whispered advice and made various visionary pronouncements. The intimate healing power of this unexpected interaction took us by surprise. Yemayá then rose and swirled majestically into the front room to greet the rest of her adoring public.

Propelled by the rhythms being played for her, Yemayá began to slowly spin and turn, her body mirroring the heave and swell of the open sea. The spirit's movements were ponderous as though weighted down by her watery medium. After dancing for a while, Yemayá took time out to offer bits of advice and bless all those who approached her. She then abruptly shifted her attention to the lead singer and started to vocally challenge him. No sooner would he initiate a praise song than she would counter with one of her own. As their voices began to overlap, the passion was at times unbearable. The body of Yemayá's human horse was by now thoroughly drenched with sweat. Caught up in the vocal torrent, everyone was singing and moving on the crowded periphery of the dance floor. After a time, Yemayá paused to tear money

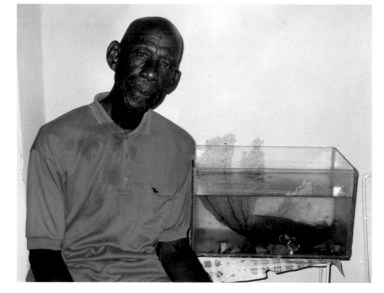

FIGURE 51. Ángel Felipe Guibel, the priest who initiated Santiago as a santero some forty years ago, poses beside a fish tank dedicated to Yemayá.

from her tunic and cap, throwing it out to her devotees—a potent form of blessing. Shortly thereafter, the spirit took her leave. Santiago crumpled into a chair, exhausted. Once he had recovered sufficiently, he was led away to change out of Yemayá's ceremonial clothes.

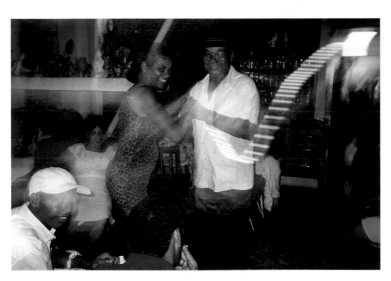

FIGURE 52. Partying on the evening of the cumpleaños celebration.

With the departure of the batá drummers and their lead singer, most guests who were not closely affiliated with Santiago's house wandered off into the dimly lit streets. Unwanted hangers-on were politely but firmly eased out the door. After turning off the overhead lights, core family members disappeared into the depths of the house to unwind, leaving a strangely surreal scene in their wake. Santiago's small, artificial Christmas tree, which had been plugged in all day, was now singularly audible. Equipped with blinking lights and a tired computer chip, it filled the void with a warbling medley of Christmas songs. After a suitable interval, godchildren straggled back into the front room. A salsa tape was slipped into Santiago's boombox and cranked up to quasi-deafening volume. Fueled by sugary pieces of cumpleaños cake, shots of rum, and the undeniable success of the tambor, we all started talking animatedly. People jumped up to dance. This more relaxed but jubilant partying continued well into the evening.

FIGURE 53. The earthbound Oricha Oko, connected with the land and all of its produce, sits at the foot of the elevated Yemayá.

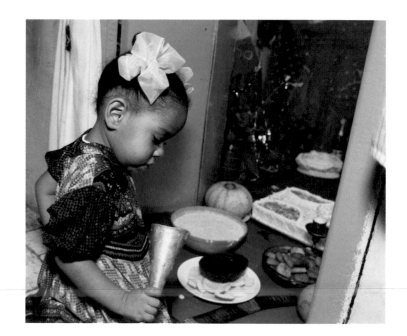

FIGURE 54. Santiago's cumpleaños throne is the subject of a daylong tribute. Kneeling to pay her respects, a child is momentarily distracted by the bell used to invoke the spirits.

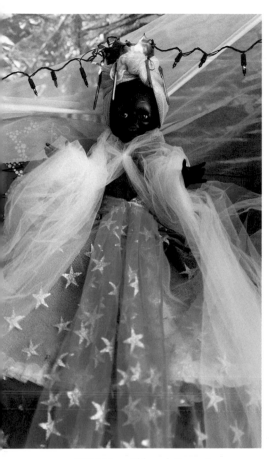

FIGURE 55. Although Yemayá occupies a privileged position, all of the orichas Santiago has received in the course of his life are honored on the anniversary of his initiation as a priest.

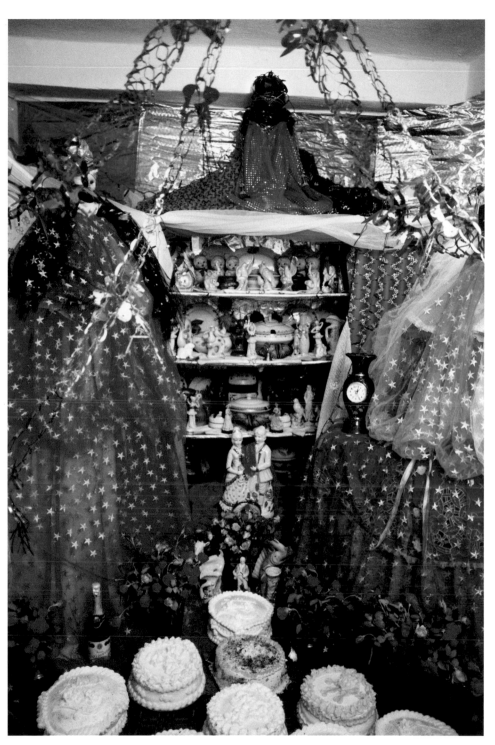

FIGURE 56. The emphasis in this 2002 throne is on the formal display of the orichas' porcelain soperas, surrounded by their attributes and other prestige objects. Ochún (left) and Yemayá (right), hidden beneath airy crinolines of star-spangled cloth, flank Santiago's canastillero.

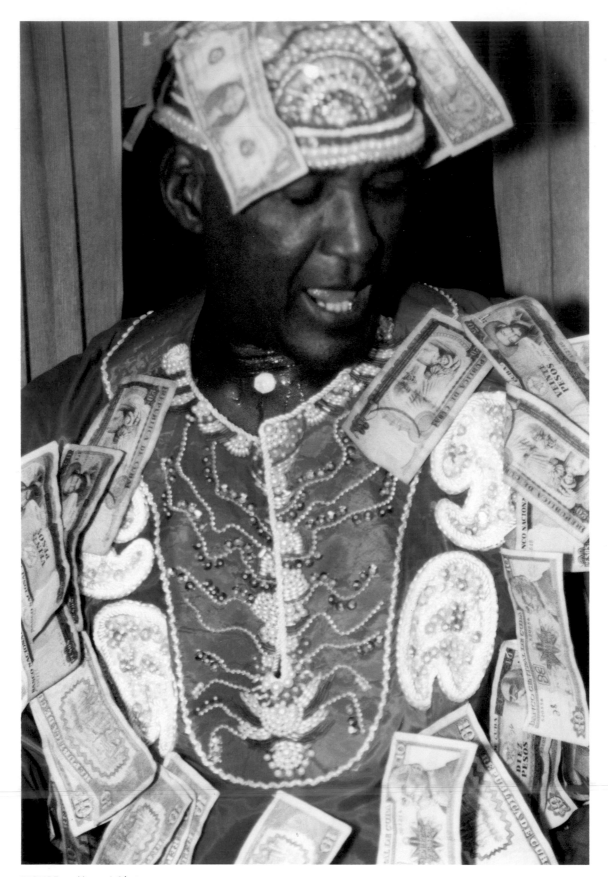

FIGURE 57. Yemayá Okute.

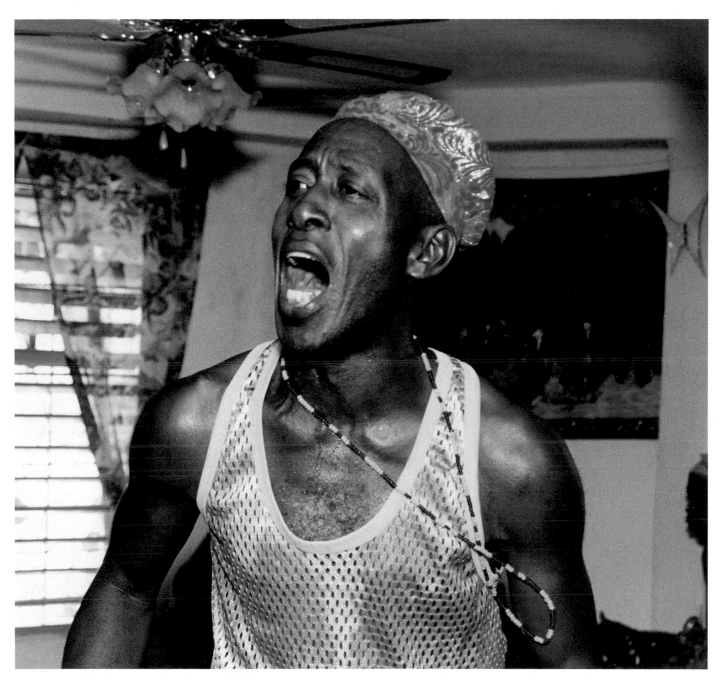

FIGURE 58. The lead singer Sarabán focuses all of his vocal energy onto the spirit Yemayá, who now occupies Santiago's body.

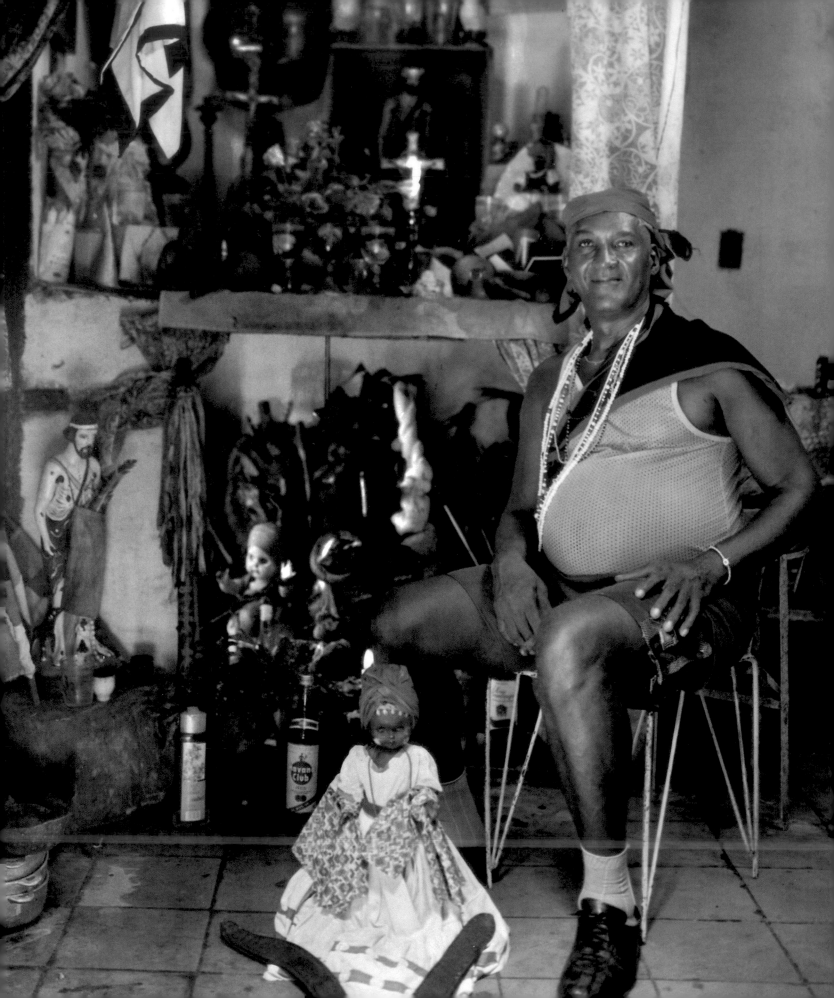

Ver Para Creer (Seeing Is Believing)

THE PRENDAS AND RITUAL OF PALO MONTE

The prendas

The ritual core of Santiago's house is the *nso-nganga*, the room in which his prendas, or spirit cauldrons, are kept.[1] Massed inside a dimly lit corner alcove the vessels house individual Palo spirits known as mpungus. Santiago's prendas are prickly and aggressive, their powers drawn from the untamed energies of *el monte* (the forest).[2] Machetes, bundles of feathers, animal horns, and forest branches explode from the mouths of the larger vessels. Iron chains bind each one as though bringing potentially dangerous forces under control. A decomposing goat's head studded with horseshoes crowns the central prenda. In its shadow, the dried remains of a snake coil around the figure of a woman on horseback. Various dolls representing the spirits straddle or stand sentinel beside each vessel. Those perched on top of Santiago's prendas look like they are slowly sinking into their respective containers. Beneath the pervasive earthy aroma there is a faint smell of alcohol-infused decay. Augmented over the years by offerings of sacrificial blood, rum, and other substances, the blackened vessels pulsate with life. Evidence of ongoing ritual work crowds the foreground: encrusted bottles, gourd bowls filled with mysterious ingredients, objects arranged in temporary power

FIGURE 59. Santiago seated before his spiritist (above) and Palo (below) altar alcoves, 2000.

configurations, flickering candles, and enigmatic, tightly bound packages. Through the spirits that empower his prendas Santiago is able to access and direct occult energies on behalf of and against other human beings. In turn, Santiago's prendas safeguard their owner and his extended ritual family— "like Fidel, who has an army."

Santiago describes the mpungus that live in his cauldrons as Palo manifestations of specific orichas, the multifaceted spirits honored in the sister religion of Santería. He says with a rhetorical flourish, "They are orichas on the path of *crillumba* . . . the Palo path . . . the path of sentiment."[3] Given Santiago's spiritual lineage in Palo, this system of correspondences is not surprising. He is closely affiliated with two branches of the religion, the Regla Brillumba, into which he was initiated as a boy, and the Regla Kimbisa.[4] Both of these Congo orders (reglas) are considered "crossed rites" (*ritos cruzados*), that is, Palo traditions that have interacted with and absorbed elements from other religions: Santería, Espiritismo, folk Catholicism, and, in the province of Santiago de Cuba, Haitian-derived Vodou. The parallels between the mpungus and the orichas are general in nature.[5] Santiago's Palo spirits do not, for instance, mirror aspects of the human experience, nor do they approach the emotional complexity of their oricha counterparts. Characterized as *muy bravo* (ferocious and wild), the mpungus are overwhelmingly identified with elemental natural forces. Although these spirits command a great deal of respect, the heart of Palo Monte's power lies unequivocally with the dead.

The fundamental animating force of each of Santiago's prendas is an *nfumbi*, the captured soul of a deceased person with whom Santiago has forged a ritual contract forcing the spirit to submit to his will.[6] He refers to the nfumbis that fuel his cauldrons as "messengers," intermediaries that transmit information from the land of the dead and can be sent on far-ranging occult missions. Santiago's description of these spirits downplays the asym-

The law of the prenda is to guard, protect, look after you as though it were a security force, as though it were . . . like Fidel, who has an army.

SANTIAGO CASTAÑEDA VERA, 2002

metrical nature of the relationship between a palero and his nfumbis. It is more of a one-way master-servant dynamic, with Santiago giving the orders and exacting strict compliance. An nfumbi clearly expresses its subservience in the following Palo song:

L'amo me manda la fin del mundo	The master sends me to the end of the world
Amo me manda, yo voy	Master sends me, I go
Si Ndoki vuela yo vuela con Ndoki	If *ndoki* [sorceror] flies, I fly with ndoki
Si él entra la finda, yo entra la finda	If it enters the forest, I enter the forest
L'amo me manda, yo buca ndiambo.	The master sends me, I seek out *ndiambo* [the problem].[7]

This practical and imaginative focus on communicating with and exerting control over spirits of the dead is richly intertwined with the powers of el monte: there is a profound metaphorical connection between the realm of the dead and the natural world.

Santiago's altar arrangement speaks directly to the importance of the dead in his life. He has situated his spiritist altar, dedicated to ancestral and other highly evolved protective beings, right above the alcove containing his nfumbi-powered prendas.[8] Although both spaces mediate his dealings with the world of the dead, the spirits invoked play different roles, ranging from intensely pragmatic to manifestly transcendent, and are usually engaged on separate ritual occasions.[9] Santiago acknowledges this working distinction when he refers to the upper level as the "spiritual part" and the earthbound prendas below as the "sentimental," in a sense hands-on portion of his altar ensemble. A brief description of the Palo spirits embodied in Santiago's cauldrons follows. Chapter 3, which focuses on Santiago's private practice, ex-

A prenda is like the whole world in miniature, a means for you to dominate; that's why the ngangulero [priest and owner of the prenda] puts all the spirits into his cauldron: he has the cemetery in there, the forest, the river, the sea, the lightning, the whirlwind, the sun, the moon, and the stars. A concentration of forces.

LYDIA CABRERA, *EL MONTE*

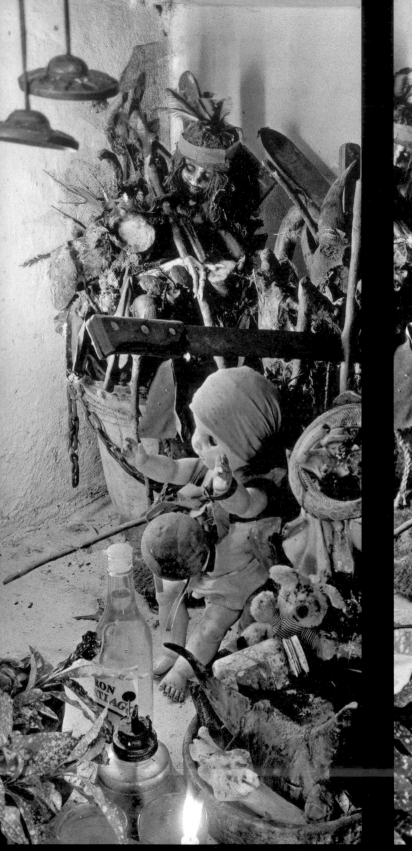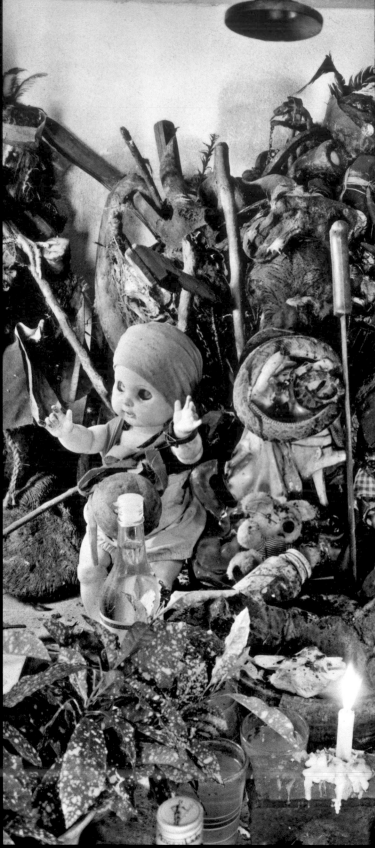

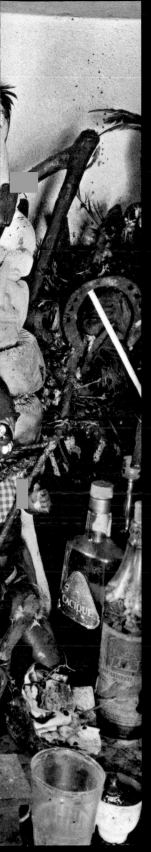
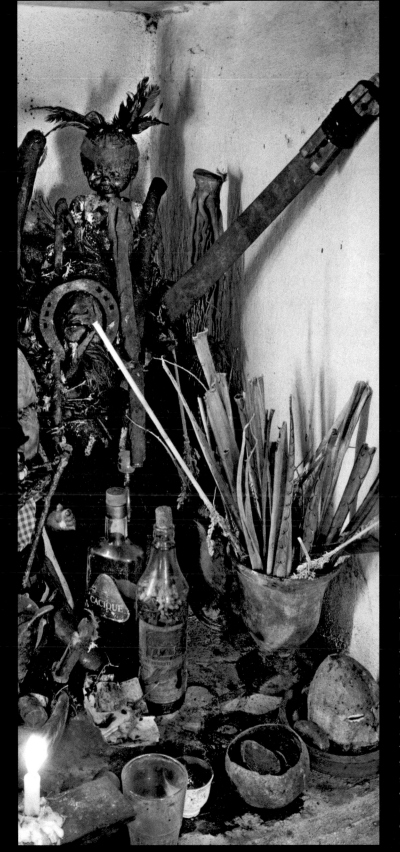

FIGURES 60 THROUGH 62. The female Palo spirit Madre de Agua, "Mother of Water," is housed in a bucket visible in the far left corner. This is Yemayá in her Congo aspect. Sarabanda occupies the center of the alcove and is the Congo avatar of Ogún. The smaller vessel glowing in the candlelit foreground is Lucero, meaning "Evening Star." This prenda is based on Eleguá, the all-seeing guardian of the crossroads. Each of these Palo spirit vessels is animated by a force from the invisible land of the dead. Pa Francisco is housed in a container in the far right corner. He is not a Palo spirit but rather a Congo spirit of the dead with whom Santiago has a long-standing and intimate relationship. A patina of blood and other sacrificial materials serves as a visceral reminder of the shrine's ongoing ritual history.

plores some of the principles that underlie a prenda's composition and ritual activation.[10]

Santiago's main prenda is home to Sarabanda Brillumba Acaba Mundo Buen Ndiako (Sarabanda Brillumba Powerful Sorcerer [Who] Brings the World to an End).[11] This is also Santiago's defiant praise name as a priest of Palo Monte. He considers his primary mpungu to be a Congo incarnation of Ogún, the oricha of iron and war. Like Ogún, Sarabanda is a mountain man and warrior who lives in the forest and knows the secrets of its plants and animal life. Heralded as "the man who cuts," he oversees all Palo initiations in Santiago's house.[12] The spirit's prenda is a fierce testament to his powers. Sarabanda's association with iron and the transformational energy of fire, birds that kill, the healing and mystic properties of the forest, and the rigors of war make him an aggressive and invaluable ally. In ritual action, Santiago's identity and that of his major mpungu often merge.

A bluish metal pail to the left of Sarabanda houses the powerful female spirit known as Madre de Agua Brillumba Quita Peso (Mother of Water Brillumba [Who] Takes the Weight Off). She is the Congo embodiment of Yemayá, universal mother and spirit of the sea. But when she gets angry, Santiago warns, "¡Bin-ban! She can turn the world upside down."[13] Madre de Agua's name and iconography, which includes large sea turtle shells, lacy branches of fan coral, and the skeletal remains of long-necked aquatic birds, situate her healing powers (and her wrath) in the realm of water.

In the foreground of Santiago's Palo shrine, a clay head crowned with animal horns sits beside a mirror fragment in an earthenware dish. This smaller candlelit prenda belongs to Lucero, the Congo answer to Eleguá, the all-seeing guardian of the crossroads and master of destiny. Lucero's essential nature is reflected in his praise name, Lucero Que Toque Mayimbe, or Evening Star That Touches Mayimbe. Mayimbe is the Congo-Cuban name for the carrion-eating black buzzard or turkey vulture. Known as the "messenger of

An *nkisi* [Kongo power object] can be thought of as a sort of portable grave in which a spirit personality from the land of the dead is present.

WYATT MACGAFFEY, "THE EYES OF UNDERSTANDING: KONGO MINKISI"

death," this high-flying scavenger is also admired for its "prodigious sense of sight."[14] Mayimbe are reputed to see everything everywhere. This clairvoyance is an ability shared by Lucero's counterpart, Eleguá.[15]

Individual Congo spirits of the dead are housed in an iron pot raised up on a three-legged platform in the far-right corner of the alcove. Santiago refers to this vessel as his "cauldron of the dead" (*caldero de muertos*). Bristling with forest branches, feathers, hooked sticks known as *garabatos*, the long seedpods of the flame tree, pieces of iron, and animal remains, it resembles the prendas that surround it. Despite this visual similarity, Santiago maintains a strong separation between his Palo prendas and the cauldron containing his *muertos*, the old souls of Congo and other Africans brutally enslaved in the New World. Santiago's ties with these reappropriated ancestors run deep. Although he has worked with many Congo dead in the course of his life, he enjoys a particularly intimate relationship with a spirit by the name of Pa Francisco.[16]

In Santiago's view, los muertos are not created equal: they operate on different levels of the invisible world. For this reason the dead are able to intervene in and affect one's life in a variety of ways. When Santiago talks about them, he is basically describing a continuum of spirits that ranges from extremely luminous beings to dark, potentially malign entities.[17] The more radiant the muerto is, the more dematerialized, spiritually transcendent, and physically inaccessible. In Santiago's house, these "dead of light" (*muertos de luz*) are only invoked in a spiritist context.

As one moves down the scale of luminosity, one approaches the emotional heat and ambiguity of lived experience. This is the plane on which the less enlightened but more tangible and efficacious spirits of the dead come into play. Because they remain attached to this world, these muertos are more susceptible to manipulation by humans. They have a reputation for getting things done quickly and are often called on to resolve real-life crises.

Santiago's Congo dead seem to roam at will between the pragmatic, this-worldly end of the spectrum and a kind of spiritual middle ground. The purchased souls (nfumbis) that animate Santiago's prendas, on the other hand, are considered *muertos oscuros*, "obscure" beings that occupy the lowest rungs of the metaphysical ladder. His spiritual-sentimental distinction can thus be understood as describing the two poles of a dynamic continuum of forces from the invisible land of the dead.[18]

To maintain their life strength and capacity for work, the spirits housed in Santiago's Palo shrine are periodically revitalized with fresh coatings of blood, feathers, and other empowering substances. This occurs in its most concentrated form during the November ritual cycle when a number of animals are offered up to Sarabanda, Madre de Agua, Lucero, the nfumbis, and the Congo dead. The annual Palo matanza, or slaughter, is an intense, energy-renewing ritual that invariably brings on possession by one or more of the spirits being fed. As Santiago fulfills his religious obligations, he boosts the aché or life force of his entire ritual family. This kind of exuberant, communal ritualizing diminishes the distance between people, spirits, and things and has a profound integrative effect.

We have participated in three November ritual cycles. While the sequencing and basic structure of the ceremonies remain the same, there is a great deal of room for improvisation. This is especially true of the Palo matanza and the celebration of the Congo dead that takes place the next night. From year to year each of these ceremonies has its own dynamic, one that is determined by the fluctuating needs of human beings and spirits alike. As with all the rituals that make up this yearly cycle, the matanza's success hinges on an incredible amount of hard work. The following account is largely based on our experience in 2002.

The matanza

Menga va a corer (Blood is going to flow)
WORDS FROM A PALO CHANT

Acquiring the items needed for the November ritual extravaganza is difficult, expensive, and inordinately time-consuming. In the weeks leading up to it, Santiago is overwhelmed with practical concerns: Will he be able to find the appropriate offerings and sacrificial animals, and if so, at what cost? What if the powers-that-be impose yet another series of blackouts? Not having light is one thing, but *no fans!* The heat in the windowless backroom will be unbearable. How about eggs? Will there be any available to make the cakes for the cumpleaños celebration? And candles? There haven't been any on the market for weeks. We can't call the spirits down without them. The litany of actual and potential headaches is endless. The economic situation, which has gotten worse in recent years, is in large part responsible.

By late October 2002, Santiago has already managed to stockpile certain food items with the help of some money we had given him the previous month. Crates of sugary soda and locally brewed beer, large jars of imported Mexican mayonnaise, and staples such as cooking oil, beans, rice, and spaghetti are stacked in a back room. The bird population on Santiago's roof has also increased dramatically. But there is still a great deal left to buy. Since this includes all of the larger animals for the Palo matanza, the heat is definitely on.

Having a rental car for this period makes transportation less of a problem, but it also means that we shop around a lot more. In Cuba, even at the best of times, it is hard to know when you are going to stumble across a much-needed (or long-desired) item. A trip to buy floor fans at the *chópi* (state-controlled dollar store),[19] for instance, becomes an eleventh-hour opportu-

nity to stock up on freezer-burned chicken and perfume for the upcoming rituals. Santiago's fear of not having enough to feed his ritual family and guests is heartfelt, and scarcely a day goes by without padding the larder. As the search for animals intensifies, serendipity often dictates where we end up. The last of these expeditions is particularly memorable. Although two pigs and one of the male goats needed for the Palo matanza have already been tracked down and purchased, finding a second goat proves to be a much greater challenge.

With all known avenues exhausted and less than two days left before this all-important ritual, we still have not found the appropriate animal for Sarabanda. Early that morning we set out with a somewhat anxious Santiago and a godchild named Arnaldo who knows of someone raising goats on the periphery of an amusement park. Although we eventually find the person in question, none of his animals are old enough. So at this point we start pulling over whenever a goat is sighted, whether it happens to be in someone's front yard or grazing the grassy interior of a freeway cloverleaf on the edge of town. Following yet another lead, we head out to a village in the country. After a thorough review of all available goats, Santiago determines that none meet his sex, age, and color requirements. We do manage, however, to pick up a hefty adolescent boy who thinks he can help. Given the sweltering heat, the five adult bodies crammed into our low-slung economy car, and a road that has degenerated into a boulder-strewn riverbed, the expedition is taking on a decidedly madcap momentum. After about five hours of this, Santiago dejectedly decides we should go back home. Apart from three fairly decent heads of lettuce, he has found nothing in the area worth buying.

The ultimate (and very welcome) irony is that we at long last find what we are looking for in a semirural barrio about a mile from where Santiago lives. After making inquiries in the neighborhood, Santiago and Arnaldo head off down a cactus-lined path. A half hour later they emerge triumphant.

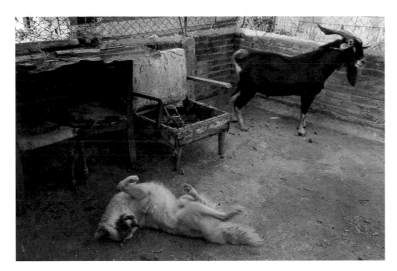

FIGURE 63. As Santiago prepares to feed the Palo spirits, a magnificently horned goat is purchased.

Although the owner is reluctant to sell, they have found an enormous black billy goat. Santiago, visibly relieved, waxes rhapsodic about the animal's strength and magnificent set of horns. The catch is that its owner is asking the peso equivalent of US$60, an exorbitant sum, and Santiago has only $40. Knowing where this is going, we manage to scrape up another $15 for what turns out to be the largest, most majestic, and rankest smelling goat either of us has ever experienced. Luckily, it is so huge that transporting it in the car is out of the question, and the goat is walked on a tether to Santiago's house. Once it has been wrestled up the interior stairs, the animal joins the rest of the rooftop menagerie.

Aside from offering a crash course in the struggles of everyday life in Cuba, these shopping forays provide us with rare moments of insight into some of Santiago's emotional concerns. The car serves as an odd kind of safe zone where, removed from his immediate environment, Santiago can begin to let down his guard. One occasion in particular stands out. It is the actual morning of the matanza and we are driving Santiago from one dollar store to the next in a last-ditch attempt to find a couple of battery-powered lights. He is still afraid there will be a blackout during the evening ritual. As it turns out, we do not find the lights and there is indeed a blackout. Making the rounds that morning, however, Santiago is obviously preoccupied. At some point he starts to talk about his feelings of responsibility toward his religious family. It emerges that he is deeply concerned about specific godchildren (ahijados). Without citing any names, Santiago implies that certain individuals are neglecting important spiritual work. Others are guilty of disrespect, and one person in particular has made a series of disastrous life decisions that

are jeopardizing her future. Santiago is feeling a strong moral imperative to get them back on course. Life in Cuba is not only a constant struggle; it is full of contradictory realities. For those with no access to the dollar part of the dual economy, the outlook can seem quite bleak. It is tempting, especially for young people, to be seduced by quick-and-easy, if illegal, ways to get ahead. Although we were unaware of it at the time, talking about these concerns is Santiago's way of preparing us for what is to happen that evening. Having discussed the matter with his spirits, Santiago has a dramatic ritual cleansing in mind.[20] He wants to make sure that we do not misunderstand or misinterpret his actions.

In the hours leading up to the Palo matanza, Santiago's house is alive with activity. Conversations are animated and raucous laughter bursts from different corners as godchildren go about their assorted tasks. Traffic in and out is constant as bundles of forest leaves and other essential materials are dropped off and designated for specific ritual purposes. Santiago's prendas and cauldron for the Congo dead are removed from their alcove and placed in the center of the nso-nganga. There they are richly anointed with palm oil (a substance beloved by Sarabanda) and fortified with cigar smoke, spittle-laden rum, and a fiery ritual concoction known as *kimbisa*

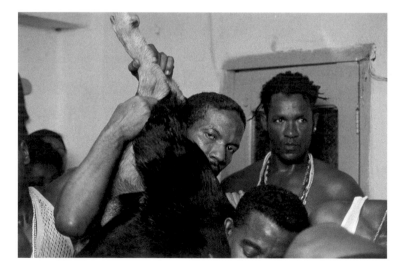

FIGURE 64. The matanza.

(cane alcohol laced with roots, hot peppers, and other stimulating ingredients).[21] As a final poetic gesture, Santiago wedges two lit cigars between the clenched teeth of the skeletal goat heads crowning his Congo cauldron and prenda for Sarabanda. Enlivened by these ritual attentions, his vessels are primed for the large-scale sacrifice to come. As the time to initiate the ritual

slaughter approaches, a nervous tension pervades the house. The weight of what is about to occur affects everyone.

The matanza formally begins with the parading of the sacrificial animal throughout the house. This is called *paseando el nino*, or "walking the child." A song commemorating the child's passage and praising its courage is sung as the animal is presented to each member of Santiago's ritual family. Male godchildren touch their foreheads and groins to the head of the animal. Female godchildren touch their foreheads and breasts to the same. Both then kiss the creature's brow. This is a means of identifying with the sacrificial victim and also a form of consecration, transferring vital energy to the animal so that its life can in turn be taken to feed the spirits. Once blessed through prayer and incantation, the animal is offered up.

Although on some level we are dreading its demise, the magnificent goat purchased for Sarabanda is remarkably quiet throughout its ordeal. As the animal's life force flows from it, raining down on the prendas below, two things happen in rapid succession: the power flickers and goes out, plunging us briefly into darkness; Santiago, in the process of severing the goat's head, is overtaken by a particularly vehement spirit. Sarabanda has chosen this moment of life-taking transition to make an appearance. Although the immediacy of the spirit's descent into Santiago's mind and body catches us all off guard, it is an extraordinary affirmation of the ceremony's success. The tension that has been building since the start of the matanza is momentarily eased.

As a vessel for the redoubtable spirit Sarabanda, Santiago in effect becomes a mobile, flesh-and-blood altar or prenda. The embodied spirit rushes to gorge himself on the blood, still warm and potent with aché, of the goat sacrificed in his honor, absorbing it directly from the animal's severed head. Person, spirit, and prenda are one, inseparable in thought as well as physical being.

Sarabanda's arrival generates tremendous excitement. A member of Santiago's inner circle rushes over to provide the spirit with appropriate accoutrements. These include white and red scarves tucked around his waist, the leafy branches of specific trees, a bottle of crude rum, and a cigar. Musical instruments—whether actual drums or percussion improvised from pots and pans, plastic buckets, and kitchen utensils—are quickly assembled. Soon the nso-nganga is awash in the driving rhythms of Palo drumming. As songs celebrating Sarabanda's arrival are belted out, often led by the spirit himself, the energy level in the room becomes explosive.

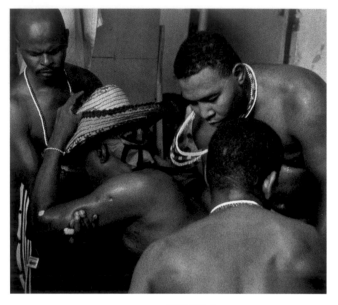

FIGURE 65.
Santiago becomes possessed.

It is up to Santiago's ritual family to greet Sarabanda properly. As many as thirty godchildren—a vibrant mix of young and old, male and female—are crowded into the nso-nganga and adjacent kitchen. Most are familiar with the appropriate Palo songs (*mambos*), greetings, and choreographed movements required of them. Family members with in-depth knowledge of Palo practices furnish Sarabanda with anything he needs and intervene to protect Santiago and others should the spirit inhabiting his body threaten to get out of hand. They also call out the requisite mambos, prepare essential ritual concoctions, and remove and butcher the sacrificed animals.[22] The success of the ceremony depends on this collective alchemy.

Once Sarabanda settles in and greets his children with an ebullient *Sala malekum*,[23] he charges around the room exchanging angular, bone-crushing salutations with members of the congregation. Although the spirit comes and goes several times in the course of the evening, he manages to engage each person in turn. As Sarabanda makes his rounds, he alternately berates,

teases, comforts, and advises his children. Like many Afro-Cuban spirits, he expresses himself in *bozal*, a creolized form of Spanish peppered with Congo-Cuban words.[24] While this can make him difficult to understand, there are people available to interpret if necessary. Over time, one becomes attuned to a given spirit's idiosyncratic speech.

As the night unfolds, Sarabanda will discipline individuals that he feels are guilty of disrespect or some other transgression.[25] The spirit zeros in on them without warning, his expression clouded and stern. Pacing nervously about the room, he may launch into a caustic but indirect description of the offense, thereby shaming the targeted individual into submission. Alternatively, we have witnessed Sarabanda roughly throw a godchild to the floor and then walk on the offender's prone body or smack it ruth-

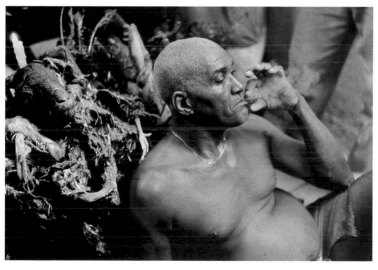

FIGURE 66.
The Palo spirit Sarabanda.

lessly with the flat edge of his machete. The objects of this corporal punishment are almost always younger men. By asserting his authority in brute physical terms, Sarabanda makes it clear that the person needs to straighten up *now*. The tension in these one-on-one confrontations is very real. Although the godchild may at first protest, he ultimately resigns himself, if only to prevent any escalation of the spirit's anger. Sarabanda responds by softening his approach. He will exhort the young man to be more honest with himself and others, to work hard, and to steer clear of situations that invite trouble.[26]

Sarabanda's presence also offers direct access to his charismatic healing powers. The spirit's ability to see deeply into people ensures that everyone is eager to speak with him. A good part of the evening is spent counseling

his children about difficult relationships, work and health problems, legal snafus, and money-related issues. Sarabanda will occasionally startle someone by revealing information unavailable through regular channels. Despite his uncompromising nature, he can be surprisingly sensitive to his children's emotional needs. We have seen this volatile spirit comfort distressed individuals at great and compassionate length. Although we do not have the same sustained access to his physical presence, Sarabanda has proclaimed to us that he is everywhere and that we can call on him wherever we happen to find ourselves.

Depending on the energy of the group, the number of spirits who choose to make an appearance, and Santiago's personal stamina, the celebration that follows the matanza may continue until dawn. The Congo muerto Pa Francisco, for instance, always transits in and out in the course of the evening, his antics many and unpredictable.[27] Sarabanda's presence, however, looms large. Swaggering around the nso-nganga, the spirit downs half a bottle of crude rum in one sustained guzzle and then bites the top off the empty bottle. He bestows blessings on his children by spraying a mist of pepper-laced alcohol over their heads (which induces a paroxysm of coughing and sneezing) or squirting them with flammable "perfume" that they hesitantly rub over their bodies. Pouring gasoline on the floor, Sarabanda ignites it and then generates spark-filled whooshes of fire by spewing alcohol across the flaming pool or strikes it repeatedly with resounding whacks of his machete. The spirit claims all things fiery as his own.

At some point in the dead of night, Sarabanda dashes out of the house to perform covert rites at a nearby crossroads, a juncture that represents the point of intersection between the human and the spirit worlds. On the heels of these mystical transactions, he careens through neighboring gardens, violently snapping branches off trees and shrubs. Obscured beneath a swaying mass of leaves, Sarabanda then bursts wild-eyed back into the house. Making

feral "brrr . . . brrr . . . brrr" sounds, he rushes headlong to the nso-nganga. Once there, the spirit sinks to the floor, enveloped by leafy branches. Holding court from this position, he barks out commands, makes entertaining off-color pronouncements, vigorously initiates Palo songs, or just sits as the powers of the forest flow through him.

As the ritual starts to wind down, Sarabanda often gathers his children around him, pulling them forcefully to the floor until he is surrounded by a sea of intertwined bodies. It is a moment of powerful communion for everyone. When Sarabanda withdraws for the last time, Santiago is left looking rather bewildered and, after hours of serving as the spirit's medium, completely exhausted. Despite the physical abuse that Sarabanda has inflicted on his "horse," Santiago shows no signs of being inebriated and has no conscious memory of being possessed. The spirit's descent has nonetheless taken its toll. Santiago's godchildren gather protectively around him. As he resurfaces, it is especially important that he feel their support and physical closeness. Exhaustion slowly gives way to a deep sense of relief and accomplishment.

¡Dió!	God![28]
¡Mambe!	Listen to me!
Santo Tomás,	Saint Thomas,
Ver para creer,	Seeing is believing,
Tres personas distintas	Three separate persons
Y un solo Dios verdadero.	And only one true God.
¿Somos o no somos?	Are we or are we not?
¿Juramos o no juramos?	Do we take the oath or do we not?
Mpaka con mpaka,	Mpaka with mpaka [magically charged horn]
Ndúndu con ndúndu,	Spirit with spirit
¡KRA!	So be it!

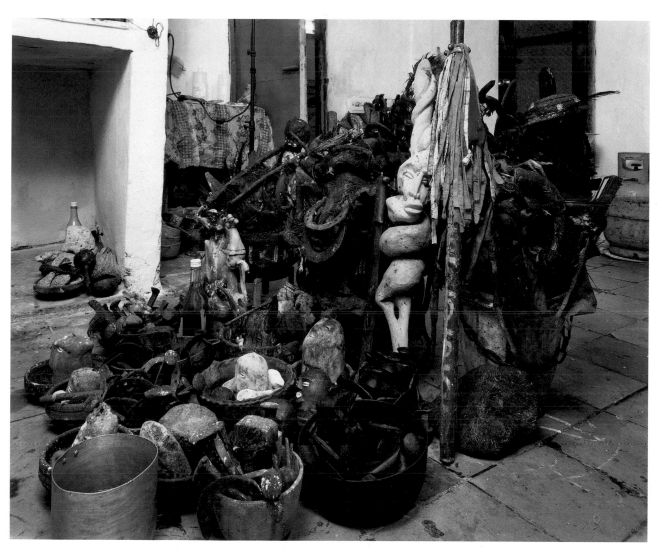

FIGURE 67. In preparation for the matanza, the ritual sacrifice that will replenish their energy, the Palo prendas have been brought out from their customary alcove and massed in the center of the room. The smaller, iron-studded cauldrons clustered on the floor in front of the prendas are Guerreros, or "Warriors," belonging to Santiago's godchildren. They are here to reap the benefits of the animal sacrifices to come.

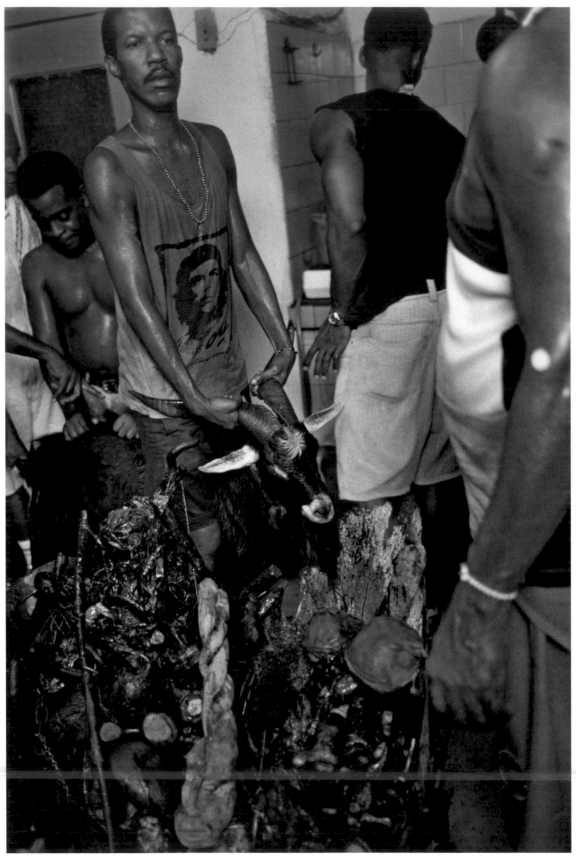

FIGURE 68 AND FIGURE 69. The matanza begins with the parading of the sacrificial animal throughout the house. This is called paseando el niño.

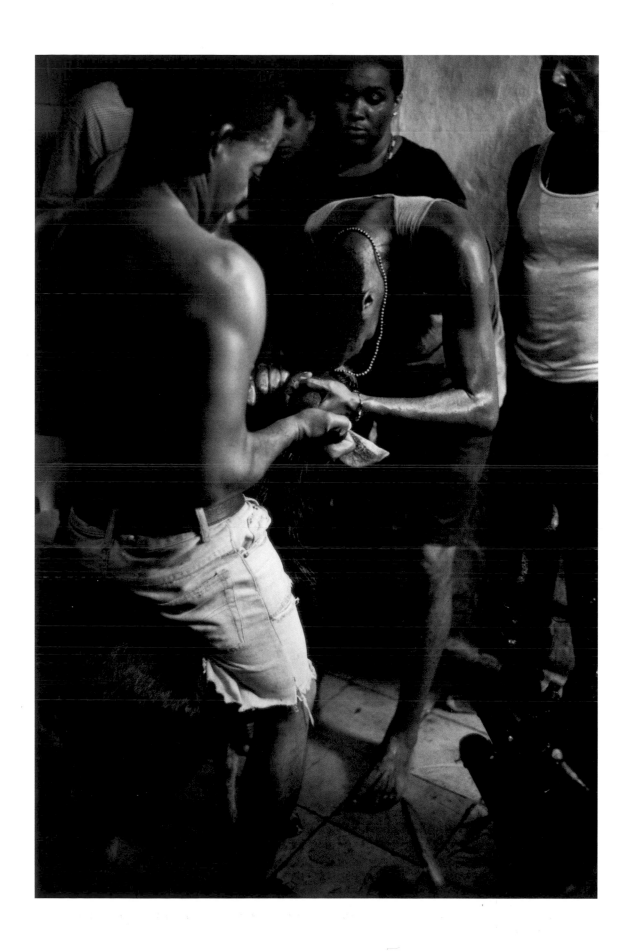

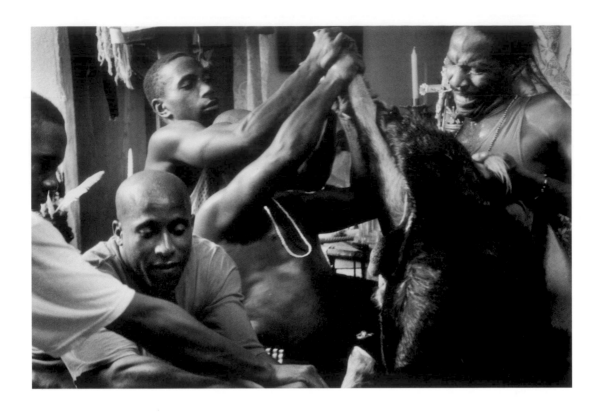

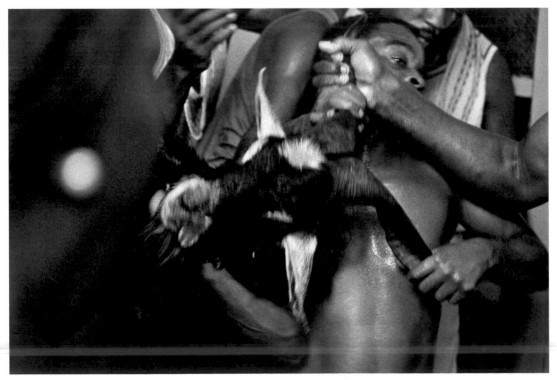

FIGURE 70 THROUGH FIGURE 72. The struggle during the matanza can be intense. Ritual obligations are emotional, spiritual, and often strenuously physical work requiring the combined efforts of every member of Santiago's extended family.

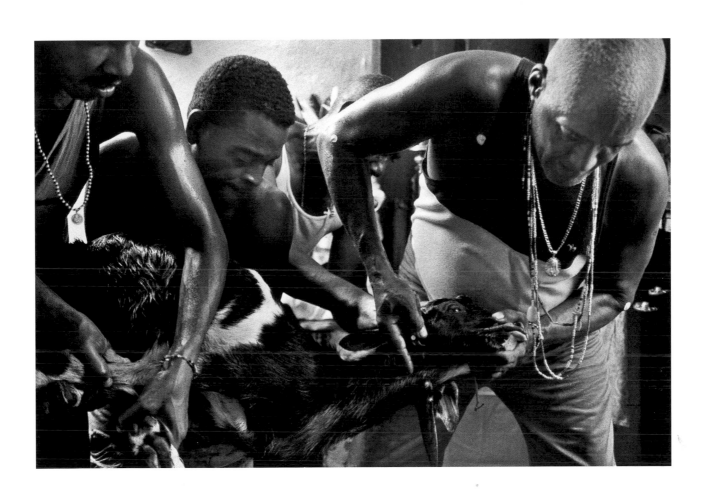

La buena noche, mi lemba,	Good evening, "my people,"[29]
La buena noche, mi lemba,	Good evening, "my people,"
Mundo nuevo carile,	New world of the dead,
Mundo nuevo carile.	New world of the dead.
La buena noche, Sarabanda,	Good evening, Sarabanda,
La buena noche, Lucero,	Good evening, Lucero (Evening Star)
La buena noche, Siete Rayos,	Good evening, Siete Rayos (Seven Lightning Bolts),
La buena noche, Tiembla Tierra,	Good evening, Tiembla Tierra (The Earth Shakes),
La buena noche, Kuaba Ngenge,	Good evening, Kuaba Ngenge,
Centillita, buena noche,	Centillita (Little Lightning Flash), good evening,
Buena noche, mi lemba,	Good evening, "my people,"
Buena noche, Madre de Agua,	Good evening, Madre de Agua (Mother of Water),
Buena noche, Mama Chola,	Good evening, Mama Chola,
Buena noche, sabana ngombe,	Good evening, savanna,
Cuatro nsila, buena noche,	Four paths, good evening,
Buena noche, mi lemba,	Good evening, "my people,"
Buena noche, campo nfinda,	Good evening, cemetery,
Buena noche, a todo nfumbi,	Good evening, all spirits of the dead,
Todo perro de casa, buena noche,	All "dogs of the house," good evening,
Buena noche, mi lemba.	Good evening, "my people."
La buena noche, mi lemba.	We bid good evening, "my people."

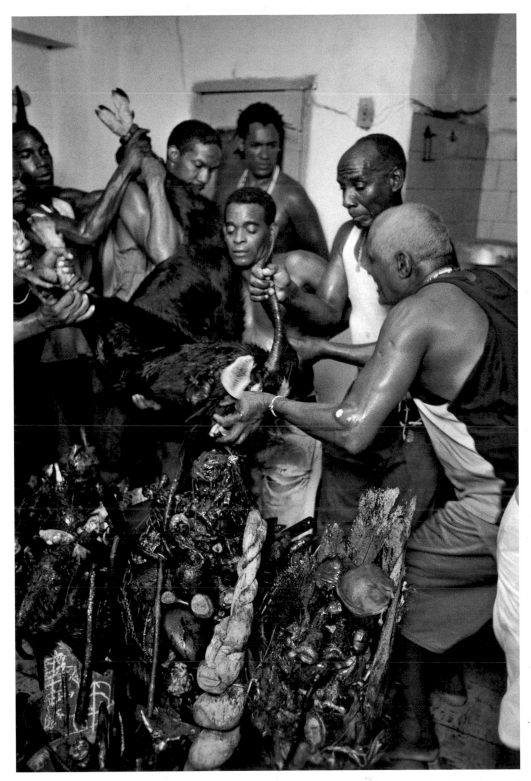

FIGURE 73 THROUGH FIGURE 76. During the killing of the large male goat for Sarabanda, the most important of the animals to be sacrificed, Santiago starts to fall into trance as the goat's head is severed. This sequence shows the undeniable physicality of the spirit's descent into Santiago's mind and body. There is often a brief period of struggle during which the spirit tosses the body he or she wants to occupy back and forth. Eventually, Santiago sags drooling to the floor, overcome by Sarabanda. This newly arrived spirit gorges himself on the blood, still warm and potent with aché, of the animal sacrificed in his honor.

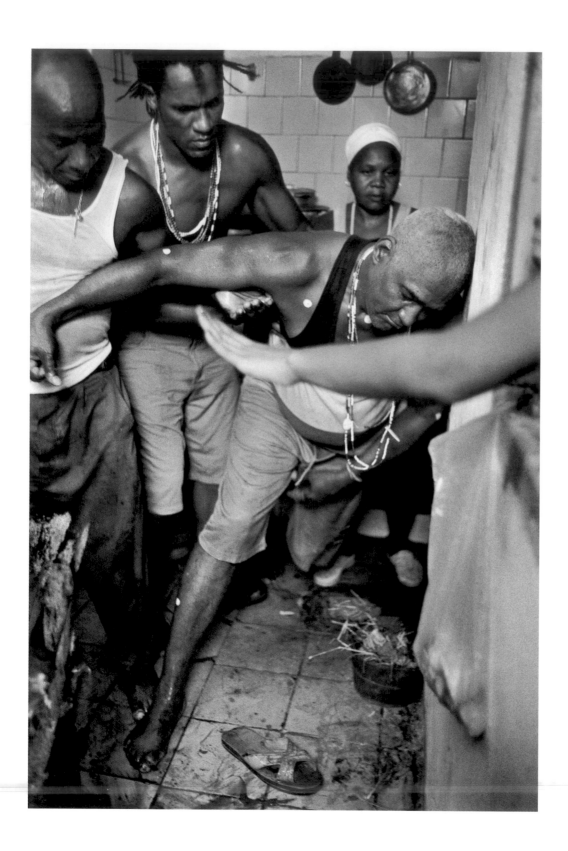

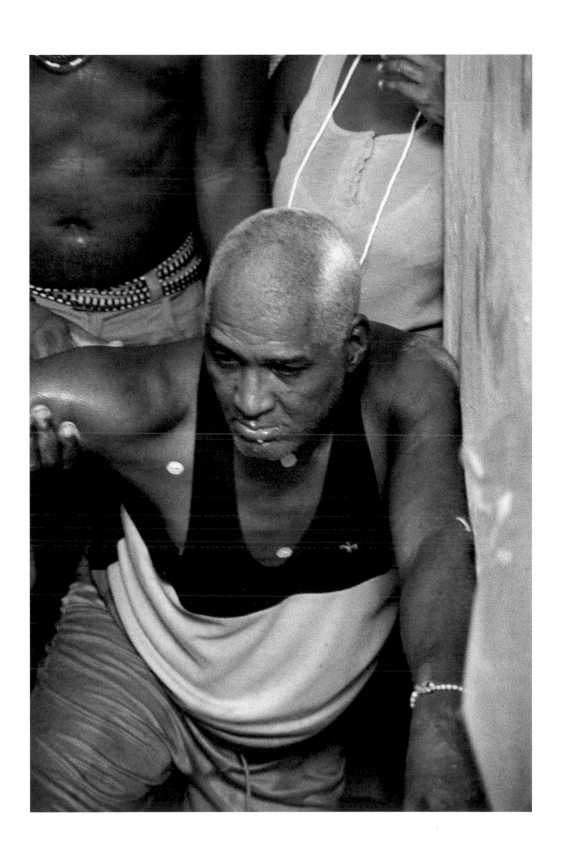

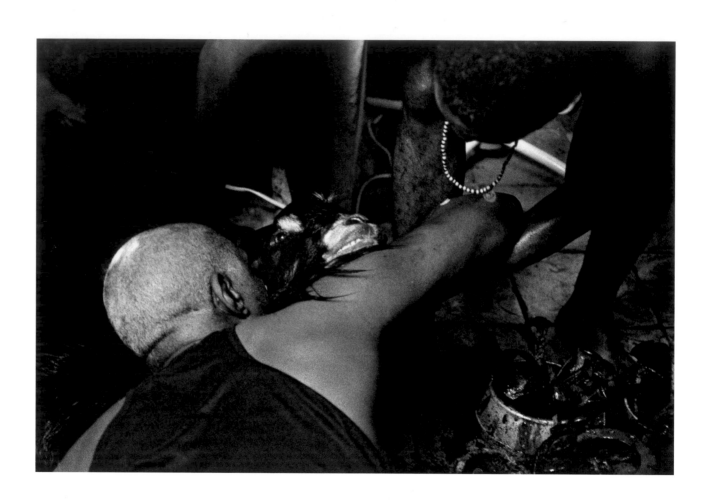

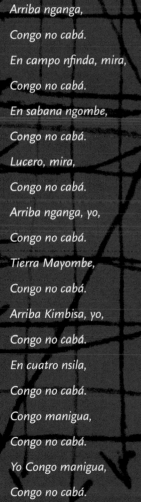

Arriba nganga,	Above the nganga,
Congo no cabá.	Congo never ends.[30]
En campo nfinda, mira,	In the cemetery, look,
Congo no cabá.	Congo never rests.
En sabana ngombe,	In the savanna,
Congo no cabá.	Congo never stops.
Lucero, mira,	Lucero, look,
Congo no cabá.	Congo never ends.
Arriba nganga, yo,	Above the nganga, yeh,
Congo no cabá.	Congo never ends.
Tierra Mayombe,	The land of Mayombe,
Congo no cabá.	Congo never ends.
Arriba Kimbisa, yo,	On top of the Kimbisa, yeh,
Congo no cabá.	Congo never ends.
En cuatro nsila,	At the crossroads,
Congo no cabá.	Congo never ends.
Congo manigua,	Congo of the forest,
Congo no cabá.	Congo never ends.
Yo Congo manigua,	I am a Congo of the forest,
Congo no cabá.	Congo never ends.

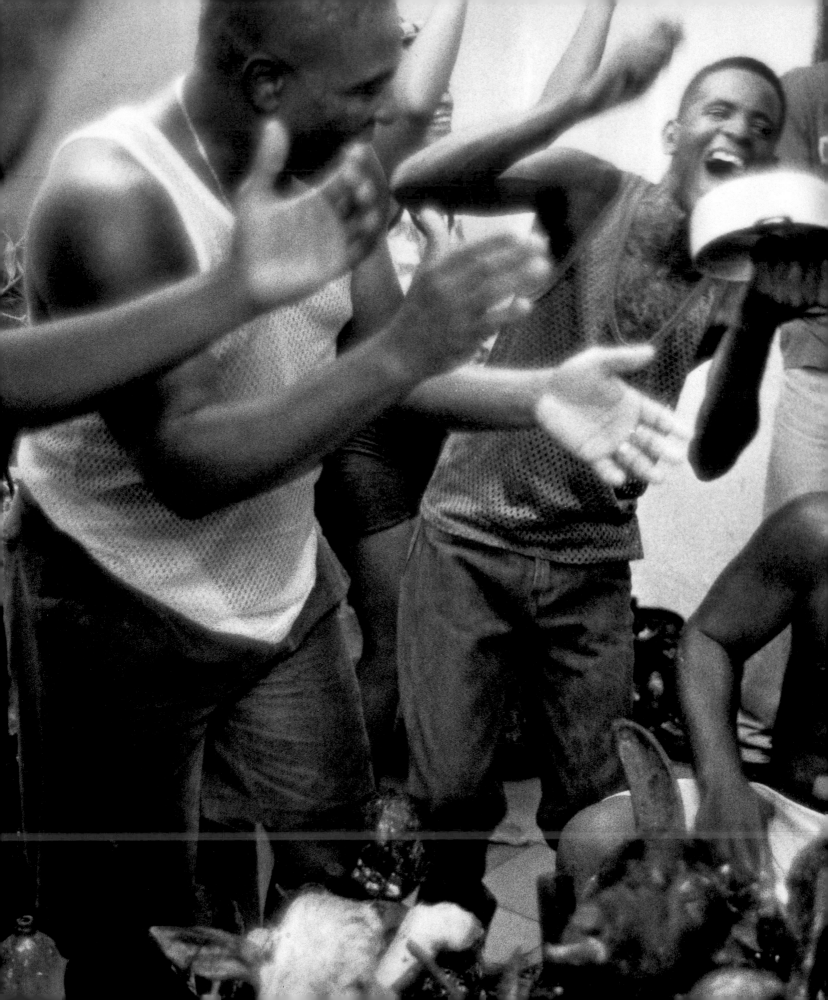

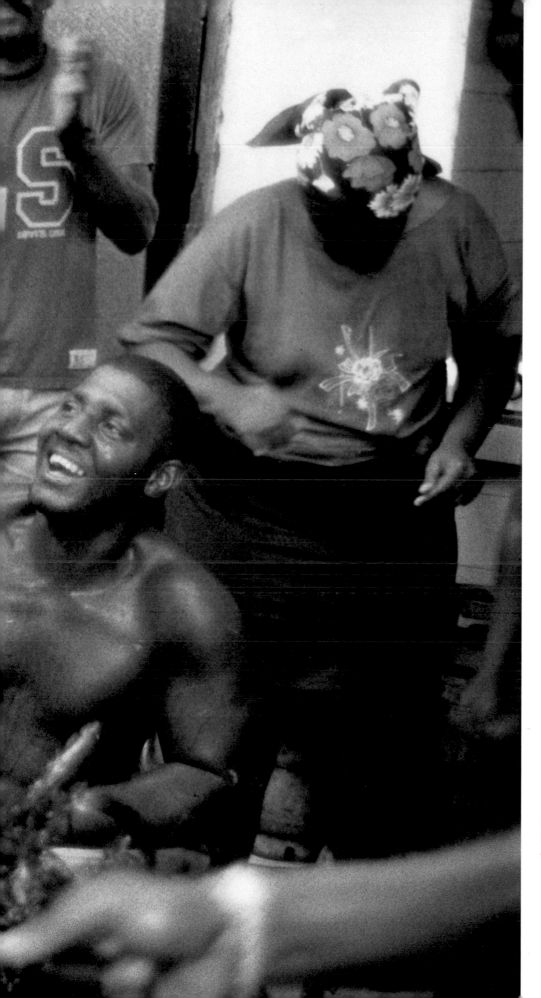

FIGURE 77. The energy level in the room becomes explosive as the congregation celebrates Sarabanda's arrival.

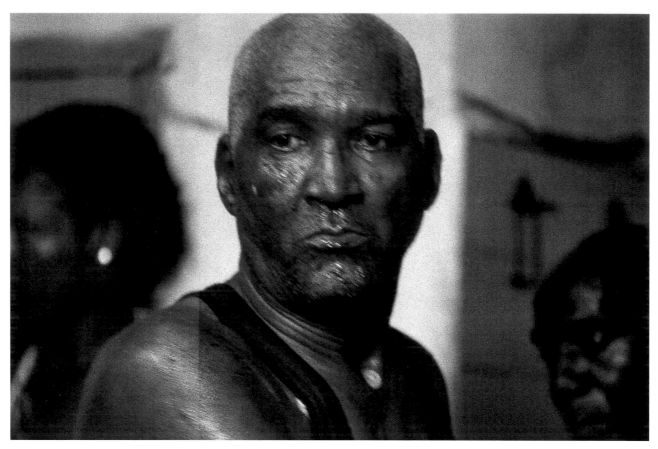

FIGURES 78 AND 79. The identification of Sarabanda, incarnate in Santiago's body, with the prenda that belongs to the spirit is complete. Any distinction between person, spirit, and ritual object has disappeared. They are mirror images of each other.

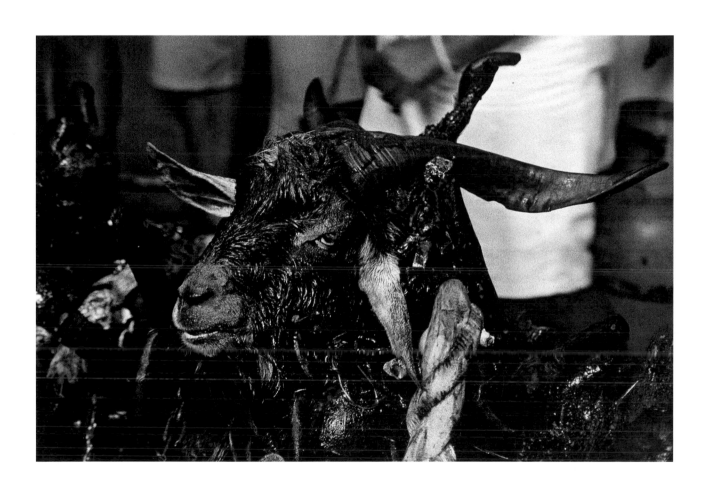

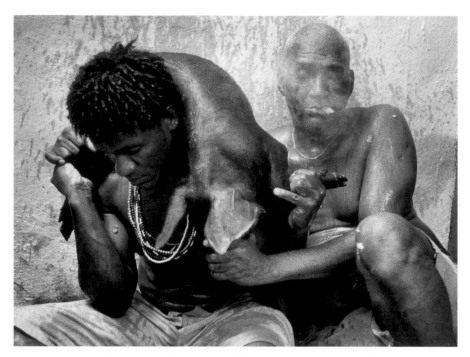

FIGURE 80. One of Santiago's godchildren shoulders a young pig in an initial transference of energy before it is offered to the spirits.

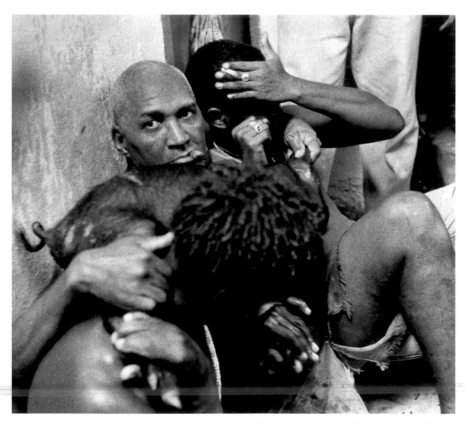

FIGURE 81. Sarabanda keeps a firm grip on the animal as another godchild tries to fend off possession by pressing his hand to his forehead. The forehead is considered the point of contact between the physical world and that of the spirits.

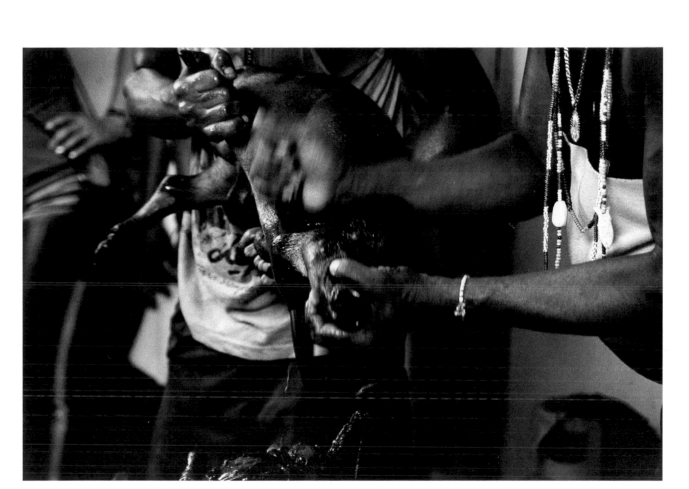

FIGURE 82.

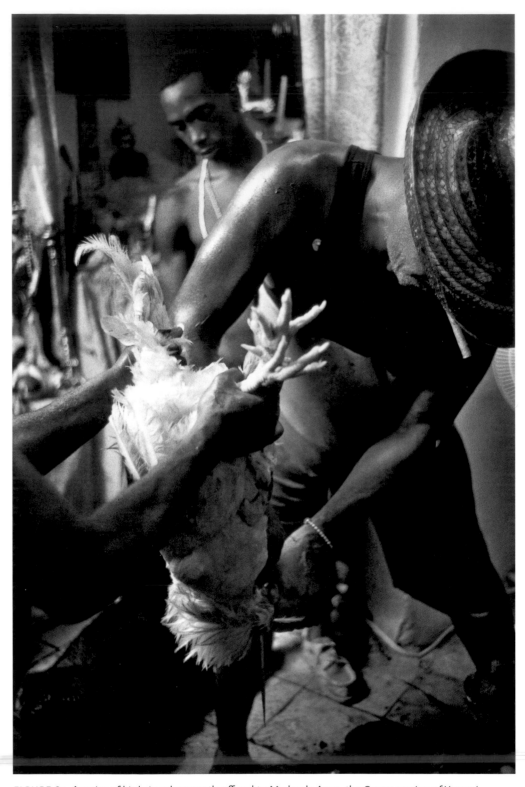

FIGURE 83. A series of birds is subsequently offered to Madre de Agua, the Congo version of Yemayá.

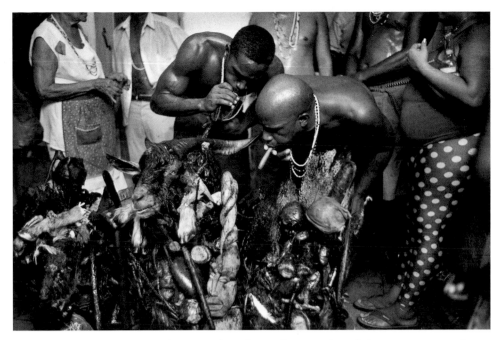

FIGURE 84. Blowing concentrated cigar smoke on human beings and ritual objects is a common form of offering. Spraying rum from one's mouth, the traditional African method of sacrificing alcohol, is another. These ritual gestures are vitalized by the breath or saliva of the person making the offering. Breath, spittle, and sweat all contain a measure of one's personal aché.

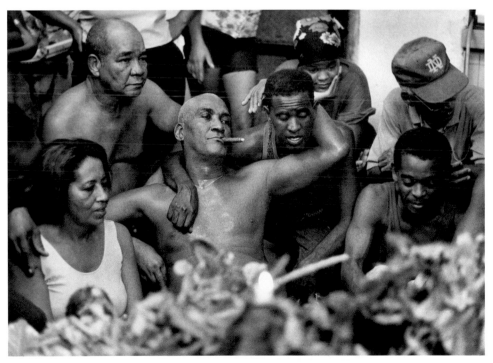

FIGURE 85. The intertwined bodies of Sarabanda and the "children" of the house capture the powerful, collective intimacy of these rituals.

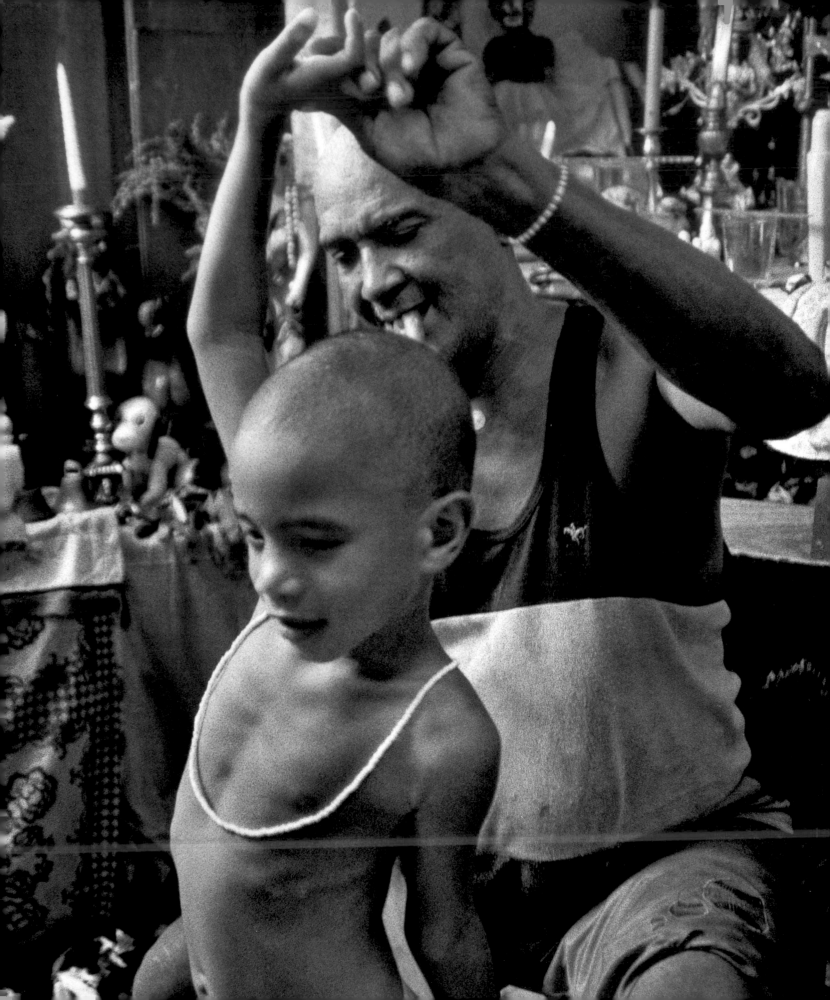

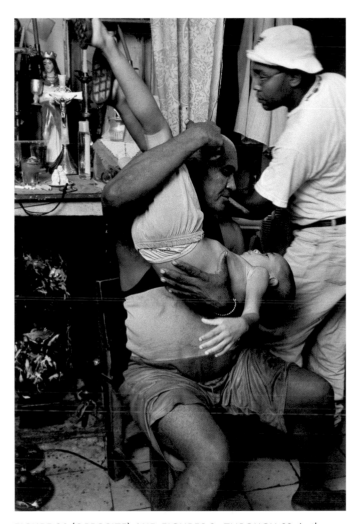
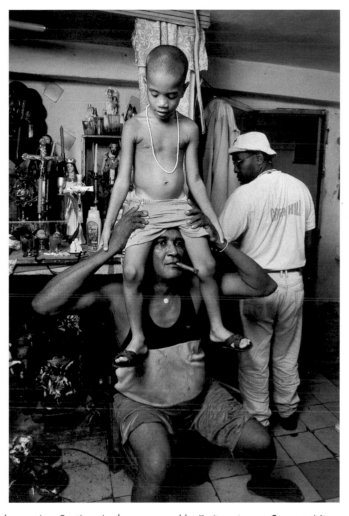

FIGURE 86 (OPPOSITE) AND FIGURES 87 THROUGH 88. In the course of the evening, Santiago is also possessed by Pa Francisco, a Congo spirit of the dead. As Pa Francisco ritually twirls and turns a young boy, the spirit not only reproduces the motion of the universe but seems to center the child within it in a form of ritual blessing that is at once cosmologically powerful and irresistibly playful.

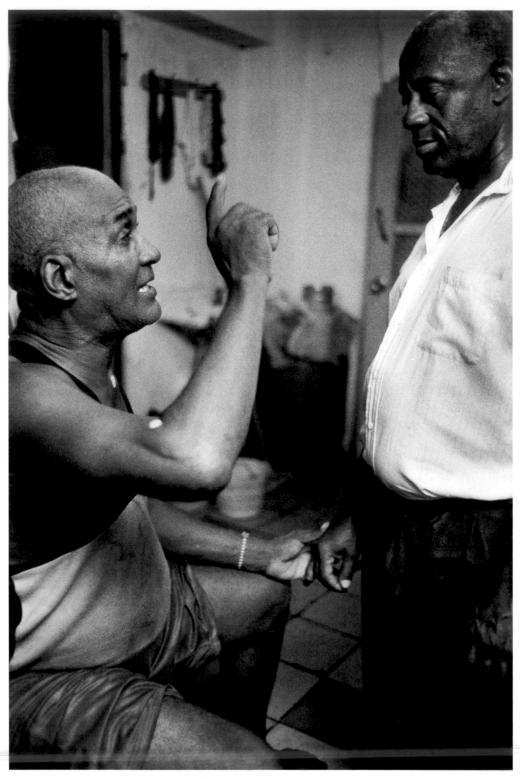

FIGURE 89. Pa Francisco counsels a middle-aged member of the congregation. No matter the age of the person interacting with a spirit, he or she is as a child in relation to that spirit.

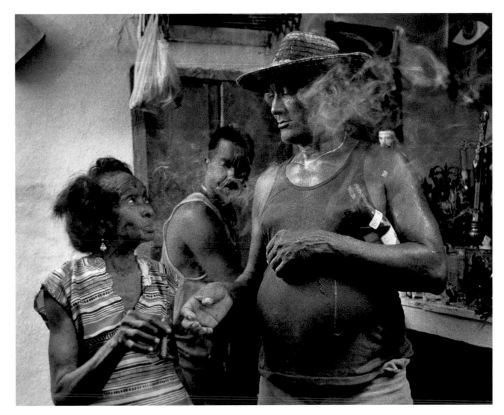

FIGURE 90.

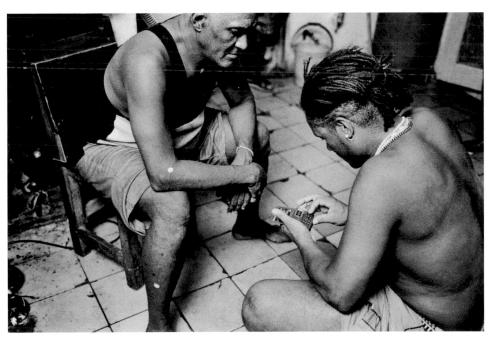

FIGURE 91. A godchild resorts to modern technology to calculate the costs of an upcoming initiation. Pa Francisco is perplexed by the gadget.

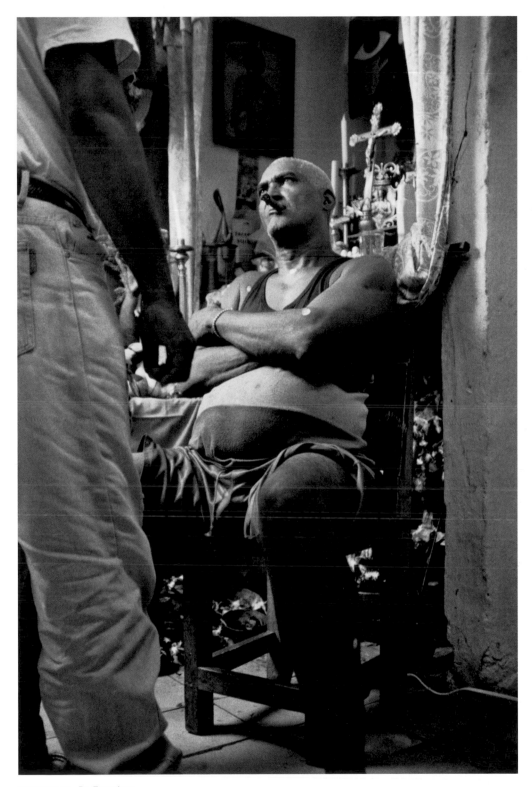

FIGURE 93. Pa Francisco.

FIGURE 92.
A firma drawn by Santiago.

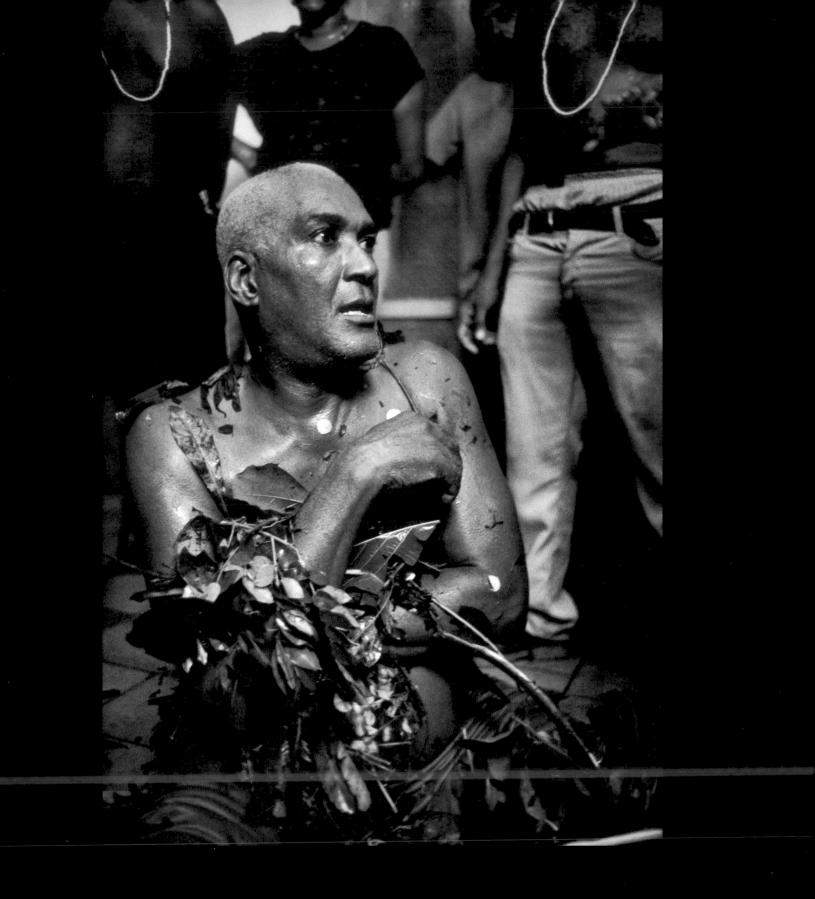

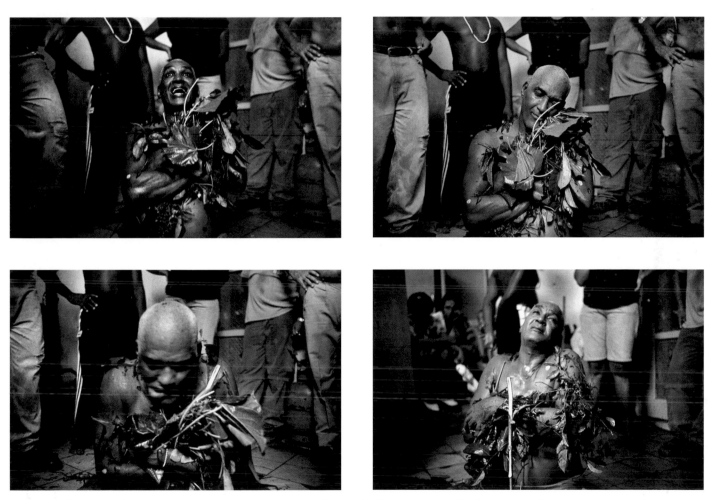

FIGURE 94 (OPPOSITE) AND FIGURES 95 THROUGH 98. Toward the end of the evening, Sarabanda possesses Santiago once again. Changes in facial expression are lightning quick: they range from wide-eyed astonishment, to a state of rapture, to poignant supplication. The spectrum of emotion is itself mind-altering. Leaves, essential to all forms of Palo ritual, appear in abundance.

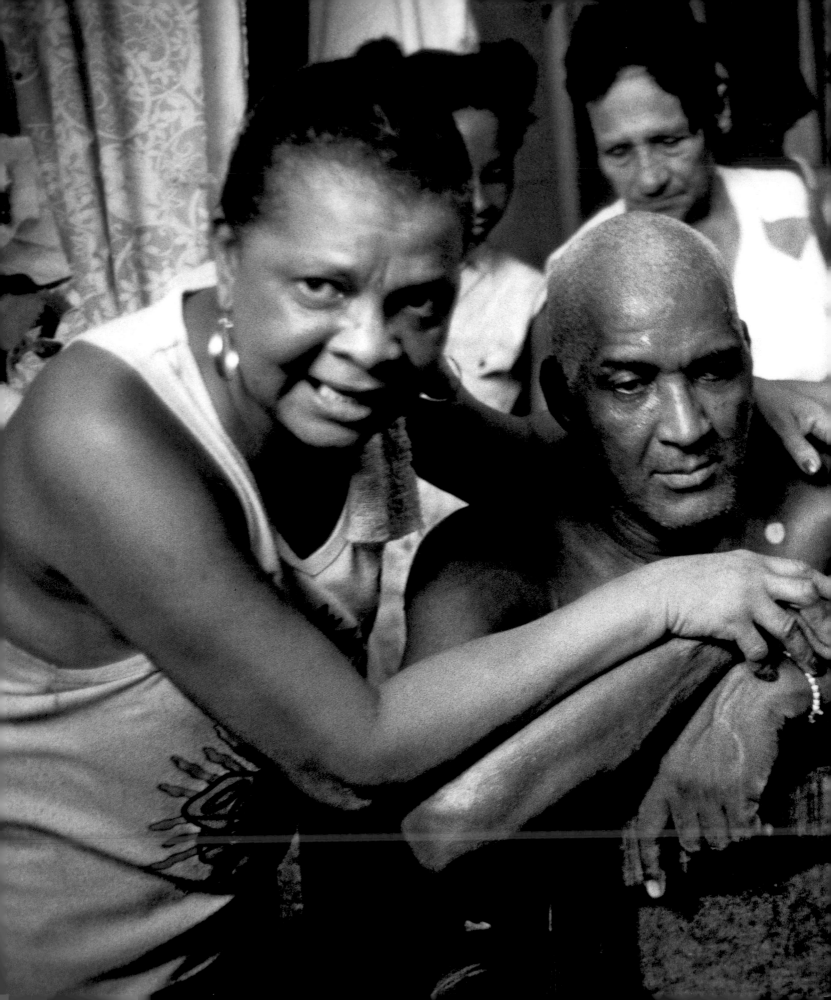

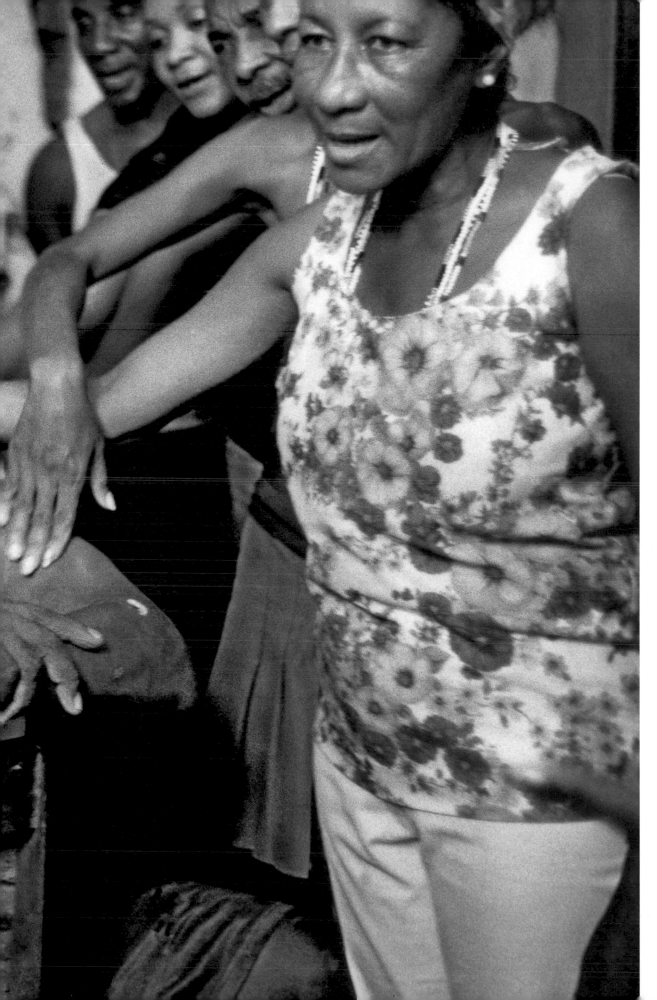

FIGURE 99. After hours of intense ritualizing during which Santiago became possessed a number of times, the spirit Sarabanda finally leaves his body. Exhausted, Santiago emerges surrounded by the protective energy of multiple godchildren.

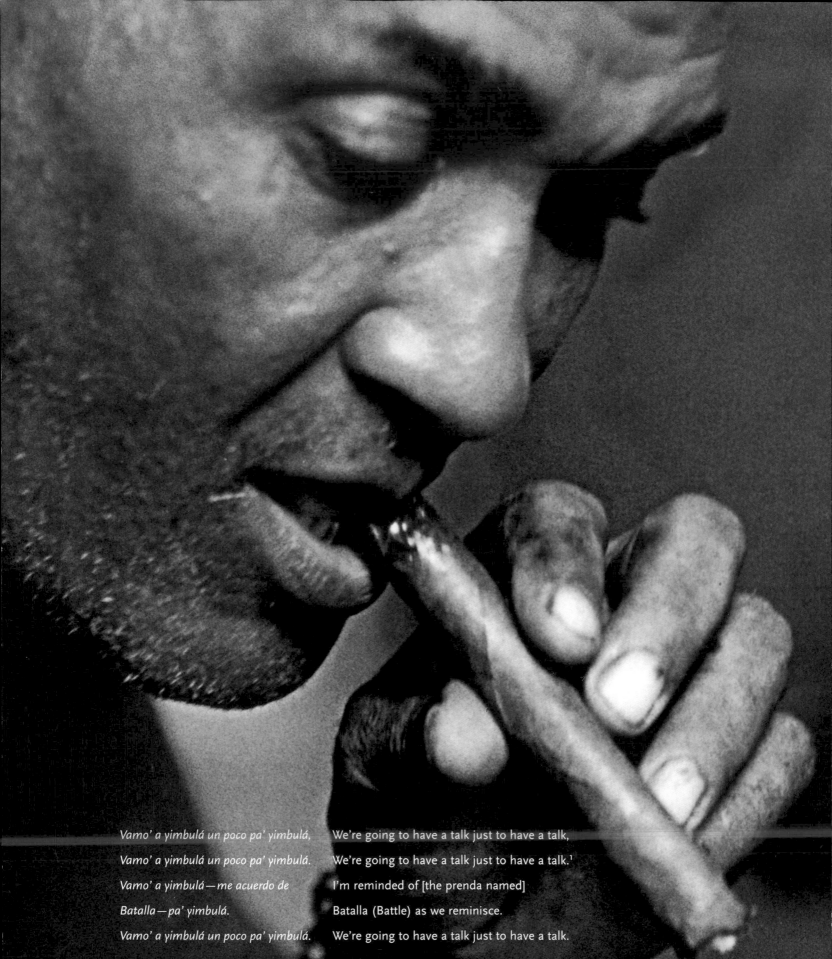

Vamo' a yimbulá un poco pa' yimbulá,	We're going to have a talk just to have a talk,
Vamo' a yimbulá un poco pa' yimbulá.	We're going to have a talk just to have a talk.[1]
Vamo' a yimbulá—me acuerdo de	I'm reminded of [the prenda named]
Batalla—pa' yimbulá.	Batalla (Battle) as we reminisce.
Vamo' a yimbulá un poco pa' yimbulá.	We're going to have a talk just to have a talk.

It's My War Now THE PRIVATE SPHERE OF SANTIAGO'S DAILY PRACTICE

The perpetual struggle with the unseen forces that cause illness and misfortune was (and is) called "war" in Kongo.

WYATT MACGAFFEY, "THE EYES OF UNDERSTANDING: KONGO MINKISI"

In the cool of the early morning, Santiago wakes and attends to his spirits. He invokes them, talks to them, and refreshes or incites them to action as he prepares for the day. It is here in the presence of his Palo prendas that Santiago typically consults with people. The environment alone is enough to inspire confidence in his ritual abilities. The pungent, slightly sweet smell of the cauldrons, the fugitive light of one or more burning candles, Santiago's physical closeness, and the hard-to-define but undeniable presence of powers not of this world come together in mysterious and persuasive combination.

While healing is the implicit focus of all religious activity in Santiago's house, the intimate, problem-solving spirit work that forms the core of his private practice is often directed toward very specific ends.[2] During these closed sessions, Santiago uses potent words and gestures to charge different materials with meaning and healing purpose. The potential sources of aché are infinite, ranging from the energy concentrated in leaves to that inherent in the spirit world, to powers present in the human body. As Santiago manipulates natural and mystical forces to benefit his clients, the nso-nganga becomes a space in which healing transformations can and do occur. Ulti-

FIGURE 100.

mately, it is perhaps less a matter of *what* Santiago does than the ritual artistry with which he does it. He is an accomplished and deeply self-assured religious performer.

Since retiring from the active labor force at age sixty, Santiago has been able to devote much more of his time and expertise to his daily practice. Although he actively sees people until about one in the afternoon, the ritual work he does for them can extend far beyond these informal office hours. Serious or deeply troubling cases may require ongoing attention over a period of months. People consult Santiago about a wide range of personal problems. Contentious relationships, stubborn physical ailments, emotional crises, the chronic frustration of trying to make ends meet, legal predicaments, and unshakeable feelings of malaise all bring people to his door.

The son of a traditional healer (*curandero*) and Palo priest, Santiago knows the medicinal and mystical uses of plants and, in our limited but grateful experience, has a remarkable command of herbal remedies.[3] Although he applies this knowledge in every aspect of his religious practice, the treatment of body-based illness is not Santiago's primary focus. He is much more concerned with the social, personal, and spiritual dimensions of human ill-being. His approach to healing is inclusive: it encompasses both the physical and the metaphysical worlds.[4] Fortunately, Cubans do have access to a national health care system that is not only medically advanced but enviably free of charge. Even so, the objective or scientific approach to resolving a health concern may not prove adequate or even appropriate. Individuals steeped in Afro-Cuban religious culture will often seek the advice of a spiritual expert such as Santiago. Depending on the nature of their problem, they may do so exclusively or in addition to seeing a conventional doctor.[5]

Santiago is a practitioner of three healing-oriented spiritual traditions: Palo Monte, Santería, and Espiritismo. Based on these habits of mind and a life-

time of experience, he understands illness as a complex, many-sided phenomenon. Most of the difficulties that lead people to consult with Santiago have a psychological or spiritual component, one that may only come to light during the diagnostic process. Mainstream doctors rarely acknowledge these ambiguous personal issues. Even if an attempt is made to cure a patient physically, the illness tends to resist treatment. Santiago has many stories of people who have desperately sought him out because their ailments have inexplicably failed to respond to modern medical care. He takes this as proof that the underlying cause of their illness has gone unrecognized and that it lies somewhere beyond the body.

To formulate his diagnosis of a client's situation, Santiago first enlists the help of his spirits. Santiago's intuition, a subjective but finely honed tool, also plays an important role. From his perspective as a healer, there are two possible sources for a person's illness or misfortune. A problem may be *natural* in origin. This means that God is ultimately responsible. For Santiago, such cases are nonnegotiable. As Karen Brown explains, "A problem that comes from God is natural; like a rock, it simply is. You cannot plead with a rock to change or coerce it into another state of being."[6] Santiago is much more likely to find that a client's distress has been caused by one of two *nonnatural* entities: either a peeved or hostile spirit or the negative attentions of another human being. These cases require the intervention of a ritual expert who, like Santiago, is able to communicate at will with inhabitants of the spirit world. Although he may attend to a client's physical symptoms, Santiago's goal is to get at the root cause of his or her suffering. He is a healer of body and soul.

Santiago will sometimes say with a discrete nod in the direction of his prendas, *Gracias a mi gente, yo tengo un pueblo* (Thanks to my people, I have a community [a following]). In this masterfully indirect way, he is acknowledging his indebtedness to the spirit world. He often initiates a consultation

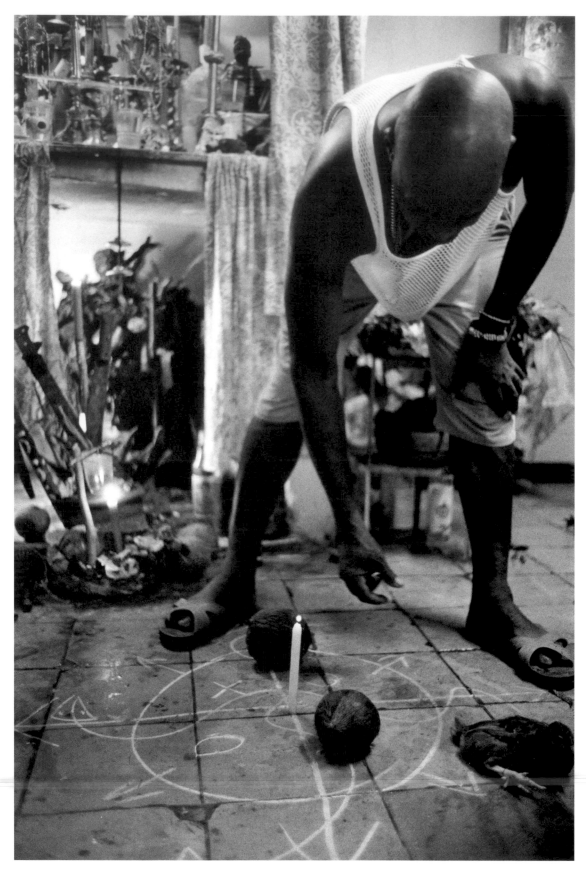

FIGURE 101. Santiago completes a ritual ground drawing or *firma* (signature). These mystical drawings are used to concentrate energy on a particular point, demarcate ritual space, and to call down individual spirits.

(*consulta*) by gazing into a glass of water while pensively smoking a cigar, one way of getting in touch with the spirits who live beneath water's mirrored surface.[7] After communicating with "his people," Santiago starts to question the client, drawing out information that will help him get to the heart of the matter. On occasion, the muerto Pa Francisco or the Palo spirit Sarabanda will suddenly overwhelm him and speak directly to a troubled individual. Once the hidden cause of a problem has been brought to light, Santiago initiates a specific course of action to address all relevant issues and bring about a change in the person's life.

A client's difficulties may be traced to a disgruntled or vengeful spirit. Although slow to anger, an oricha can be provoked because he or she has been disobeyed or promises made in the past remain unfulfilled. As far as the ancestral dead are concerned, feelings of neglect can breed resentment. A restless, wandering muerto, on the other hand, is capable of wreaking havoc out of sheer ignorance or spite. Whatever their motivation, spirits usually punish human beings by harassing them. Persistent unsettling dreams, personal problems, or health issues may be interpreted as a wake-up call from the other world. Proper ritual attention will usually appease an offended spirit, putting an end to the disruptive behavior. Unwanted or malign entities, by contrast, may need to be banished or otherwise subdued. Sometimes Santiago finds that a particular spirit wants to claim or has already "caught" (*agarrado*) a client. This is a clear indication that some level of religious initiation may be necessary to strengthen the human-spirit relationship. Whether undertaken as a response to illness or for generalized protection, initiation is a powerful form of healing.

FIGURE 102. A black cloth figure to be used in a charm that Santiago will construct for a client with the latter's full participation.

Social life in Cuba is profoundly complex, and many of the concerns that bring people to Santiago are rooted in on-the-ground interpersonal and material realities. Extended family members often live under the same roof. Neighbors may live side by side their entire lives. Some families fare better due to remittances from relatives in the United States, internal government connections, or a mixture of effort and luck. Others are stretched to the breaking point. This can generate all kinds of tension and, more rarely, out-and-out conflict. Whether consciously directed toward another human being or not, jealousy, anger, or envy can cause problems ranging from minor physical ailments to major existential setbacks. Negative feelings are enough to inadvertently undermine someone else's life.

Once Santiago has assessed a client's situation, he prescribes a ritual cure. Typically, it engages the person in a multistep healing process. His treatments include herbal preparations, cleansing and fortifying baths, the ritual purification of a person's home, the making of protective talismans, and the creation of figured cloth charms for working on relationships.[8] A parental figure to the bone, Santiago also dispenses a lot of good old-fashioned common-sensical advice.

Instances of outright hostility on the part of other human beings call for more assertive tactics. Santiago usually responds to this type of challenge by launching a counterattack. His intent is not to harm the "enemy" but to neutralize or defuse their power over his client.[9] Santiago refers to this mystical process as "going to war."[10] By taking on the problems of those who come to him for help, Santiago is claiming the battle as his own to fight. His healing work often engages the militant power of his nfumbis (the spirits of the dead living in his prendas), his Palo spirits, and his Congo *muertos de batalla*, or "fighting dead."[11] The spiky, visually aggressive contents of the cauldrons housing these entities embody this combative energy.[12] Through prolonged contact over the years, Santiago's spirit vessels are also formidable reservoirs of his own powers.

We rarely photographed Santiago's one-on-one work because it is extremely personal and involves closely guarded forms of practical and esoteric knowledge. The images we have evidence the fact that work is being done rather than the process involved. This "doing of secrets" is not just a matter of following a recipe and enacting prescribed ritual procedures.[13] Specialized knowledge is an arsenal of tools and know-how that Santiago has acquired and individualized over the course of a lifetime.

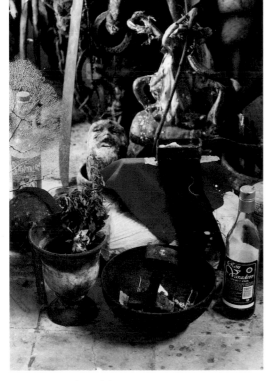

FIGURE 103. A work in progress for a client involved in a court case and facing possible imprisonment. Urgent legal problems are often dealt with under the auspices of the Palo spirit Sarabanda.

We have been present during a number of Santiago's healing sessions. Some we participated in as fledgling assistants.[14] Others we experienced firsthand as the objects of ritual. No matter what Santiago's treatments involve, his actions have a consistent objective. As he assembles and works aché in the nso-nganga, he is negotiating a better position for his client, moving the person toward greater clarity of thought and feeling about his or her predicament. This renewed sense of direction is empowering and sets the stage for recovery. The client's active involvement is a key part of the healing process. Having come to Santiago feeling isolated and overwhelmed, the person is gradually reintegrated into the larger natural, social, and spiritual scheme of things. At the very least Santiago's efforts enable his clients to gain some measure of control over their situations even if they cannot hope to resolve them in absolute terms.

"It's my war now"

When Santiago finds that the ill will of another person is responsible for a client's circumstances, he often creates an *nkange*. He describes this type of composite charm as "a Congo work by means of which your enemies — and you may not know who they are because they're not only visible but

invisible—are restrained and brought under control." Indeed, the Congo-Cuban word *nkange* means "to capture or arrest."[15] A truncated account of the making of such a power bundle to protect a godchild appears below. Because Santiago was acutely aware of our interest in his private work and the godchild in question is a close friend of ours, we were allowed to be present. As a direct result of our involvement, we were also made to participate in what became a weeklong mystical undertaking.[16] We have again used the present tense to convey the here and now of the experience.

Fun-loving but disaffected, our friend Luisito lives in Santiago's neighborhood and often drops by the house when he knows we are there. Although Santiago tolerates and often welcomes his fairweather godchild, Luisito also bears the brunt of his godfather's irritation with less dedicated members of his ritual family. This aspect of their dynamic inspires a lot of covert eye-rolling on Luisito's part, but it never seems to threaten their fundamental parent-child bond. One afternoon, to our collective surprise, Luisito starts talking about an adversarial relationship that he has tried, unsuccessfully, to put behind him. He has been feeling sabotaged of late, a state of mind that no doubt prompts the revelation. Santiago's interest is piqued, and suddenly we find ourselves moving from the kitchen into the nso-nganga, where one thing leads to another.

The impromptu consultation continues as Luisito describes the relationship's abrupt downward spiral. Santiago listens intently. He then asks specific, seemingly innocuous questions that touch on different aspects of Luisito's life in order to ensure as comprehensive a diagnosis as possible. More than once Santiago becomes extremely agitated, even angry. He begins to assume Luisito's problem as his own, to take the threat personally. The session comes to an end as Santiago writes out a list of materials with which his godchild is to return the next day:

A black or red rooster

Candles

Cigars

Perfume

7 turkey buzzard (*mayimbe*) feathers

2 sparrow hawk (*gavilán*) feathers

1 liter of aguardiente

Sulfur

2 "change direction" (*cambia rumbo*) branches

A bunch of "conquer in battle" (*vence batalla*) leaves

Earth from a cemetery

Termites (*comején*)

1 small turtle (*jicotea*)

1 coconut

2 bunches of flowers

White chalk (*cascarilla*)

The next morning we ferry Luisito around town to collect the various items. After stopping at several desultory outdoor markets and hole-in-the-wall *botánicas*, he manages to find most of the necessary leaves, powders, animals, and forest branches.[17] Acquiring the remaining ingredients, however, turns into a minor odyssey that involves forays into the cemetery, the zoo (where a reluctant guard is paid to pull several feathers from the tail of a sparrow hawk), and a city park, where we hire an adolescent boy to climb an enormous tree and kick a nest of forest termites to the ground. Despite Luisito's street savvy, remarkable even by Cuban standards, it takes us three or four hours to scare up all of the necessary ingredients.

When we return to padrino's house that afternoon, Santiago sets to work immediately. Sitting on a low stool in front of his prendas, he first traces a line drawing associated with the Palo spirit Sarabanda inside a large clay dish.

FIGURE 104. Santiago's list of ingredients for Luisito's nkange or "Congo work."

These mystically charged drawings, known as "signatures" or *firmas*, serve to focus and direct spiritual forces.[18] The volatile spirit Sarabanda is being asked to bind his intent to the "work" (*trabajo*). Santiago then arranges the "conquer in battle" leaves, buzzard and sparrow hawk feathers, portions of the termite nest, and several powders in carefully layered configurations on top of the firma.[19]

The same ideas that inform the construction and use of Santiago's prendas are at work in the power bundle he is creating for Luisito. Animal, plant, and other primarily natural substances are selected based on particular attributes and associations—not because they are "good to eat" but because they are "good to think [with]."[20] Since an nkange's efficacy, like that of any prenda, is rooted in the powers of the dead, most of the ingredients either embody or allude to their omnipotence.

Cemetery earth is shot through with the energy of the dead and imbues the charm with their unique strength and vitality.[21] The forest branches (*palos*) and leaves needed to fortify the work are chosen, at least in part, for their names. Considered powerful in their own right, names have the ability to transform reality. The "change direction" palos, for instance, state the desired outcome of the operation. Once the "enemy's" mind-set is redirected, he will stop interfering in Luisito's life and *forget* about him. "Conquer in battle" leaves, by the same token, are reputed to overcome obstacles. They boldly proclaim abilities that Santiago and the nkange charm must possess in order to tackle and resolve Luisito's problem.

Most of the animal components on Santiago's list are chosen for metaphorical reasons. Each of the creatures listed has unusual physical, behavioral, and mystical characteristics. The predatory sparrow hawk, for instance, swoops down on its prey. Incorporating the bird's tail feathers (which retain its life force) in the trabajo, Santiago tells the charm what it needs to do: swiftly pursue and attack the enemy.[22] The mayimbe, a scavenger noted for

its piercing vision and the strength of its wings, ensures the charm's ability to identify and untiringly keep the adversary in its sights.[23] The earthbound turtle evokes longevity and containment, while termites "fly like souls and spirits of the dead."[24] Other elements—sulfur, rum, saliva, red "precipitation" powder, and the coconut, flowers, and perfume—are used to spur the charm into action or to cleanse the participants. Depending on how and when these elements are used, they can mean different things or many things at once.

As Santiago composes the nkange for Luisito, he invokes the spirits constantly, urging them to go to war with him on behalf of his godchild. At significant intervals he tells Luisito to write down the troublemaker's name, often many times. Santiago then places the paper strategically within the charm. An individual's name is laden with his or her personal energy. A continuity is slowly being established between Luisito, the nkange, and the person against whom it is directed.

Singing *Ay . . . yo atiendo eh* (Oh . . . I'm dealing with you now), Santiago sacrifices the small turtle over the charm. Setting the animal's body aside, he takes from his altar an anvil-shaped segment of railroad tie that belongs to Sarabanda. He then vehemently crushes the nkange, thereby asserting the spirit's dominance. The charm becomes an extension of both Santiago and Sarabanda's will. After a few more invigorating substances, including rum, honey, and cigar smoke, are spewed, drizzled, and blown onto the work, the shattered pieces are gathered up and secured in a plastic bag.[25]

Centering this package on a freshly executed firma, Santiago pointedly sets Sarabanda's anvil on top of it. He then plunges two of the spirit's machetes into the work, creating a large vertical x, and binds a "change direction" palo to their point of intersection. This act of physical provocation tells the nkange, in no uncertain terms, what to do.[26] Hostile forces are being restrained and redirected. After igniting a trail of gasoline that he had poured on the floor, Santiago starts chanting and rhythmically pounding his ritual

"staff of the dead" into the ring of flames. Luisito is asked to kneel and repeat the antagonist's name with each blow of the staff. A glass of water bearing dental tweezers and a pair of scissors in precarious balance is then placed on Sarabanda's anvil. The two implements suggest that forces are being sent to "uproot" and "sever" the ties that bind.

A vigorous cleansing of all the participants precedes the final sacrifice. After passing the rooster over Luisito's body and quickly pulling off its head, Santiago lets the blood spill onto his prendas and the recently completed nkange. "Now the war is mine," he emphatically declares at the end of the session. The next day, we drive out into the country to bury a tightly bound packet of animal remains beneath a stand of *maya*, an aloe-like plant with menacingly barbed leaf segments. The weighted and mystically skewered nkange, on the other hand, is left to sit at the base of Sarabanda's prenda for an entire week. This will further charge it with energy and mystical purpose.

At the end of seven days Santiago decides that the remnants of the trabajo should be ritually buried in a garbage dump (*basurero*) on the outskirts of town.[27] Before we head out, Santiago gathers up various purifying and activating materials and disassembles the week-old power configuration, putting the bag containing the mystical refuse to one side. Within an hour or so of leaving the house the four of us manage to find the main dump. After paying the guard at the gate a small fee, we enter a patently surreal landscape, simultaneously molten and lunar. Because all incoming garbage is burned the ground is marbled with liquefied residue, now hardened by the sun. An old man, cooking a couple of crayfish tails over a trash-fueled fire, pays us no mind as Santiago surveys the desolate terrain and indicates an appropriate burial site some distance away. With buzzards wheeling in the sky overhead, Luisito digs a hole using a kitchen knife and a nearby toilet bowl fragment. The bag containing the mystical remains is placed in the pit along with a

token payment. Santiago then fashions a cross from two "change direction" palos and, after jamming it upright into the head of the grave, secures the latter's contents with a large stone. After cleansing ourselves with a perfume-soaked coconut and honey-laced rum, both fruit and empty bottle are violently smashed against this stone and the site covered with dirt. Santiago lights a candle and ignites a small pool of gasoline. We all blow cigar smoke over the mound. In a definitive end move Santiago pulls the cross out, turns it back to front, and once again drives it into the head of the grave. Wiping his hands with obvious satisfaction, he declares the matter buried. There is no looking back.

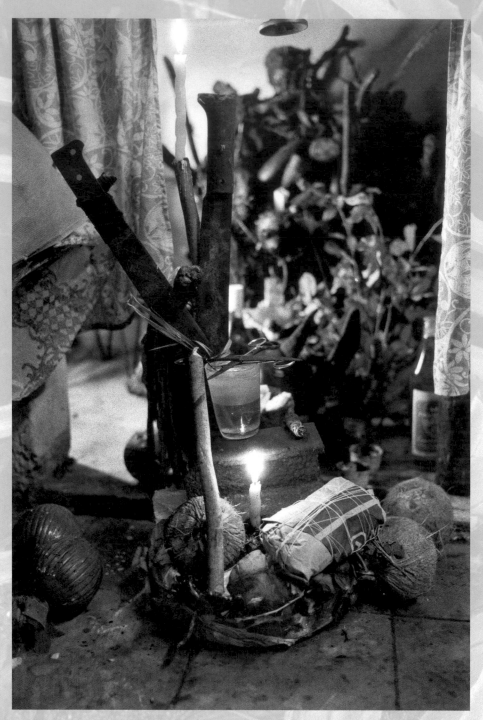

FIGURES 105 THROUGH 107. The same actions and ideas that inform the construction of Santiago's prendas are at work in this charm, made to neutralize or "tie" a person's attempts to interfere in Luisito's life. A tightly bound packet of animal remains, visible at the base of two crossed machetes on Santiago's Palo altar, is soon buried beneath a thorny aloe plant (background) out in the country. A week later, the refuse from the same magical work is ritually buried in the basurero or city dump (facing page).

Marite's healing: *Güiro, güiro mambo, lava toda' las cosas*

(Coconut, coconut speaks, washes all things)

Intensive, one-on-one healing work is usually confined to Santiago's private practice. Certain situations, however, call for the semipublic setting of collective ritual. Important cures are sometimes carried out in the context of the November cycle of ceremonies. One such treatment involved a member of Santiago's immediate family who had gotten into serious trouble in Havana. The Congo muerto Pa Francisco chose to perform a dramatic cleansing of the young woman as she stood surrounded by her religious family on the night of the matanza for the Palo spirits. Called a *rompimiento*, literally a "breaking" or "rupture," the ritual purifies by forcibly removing malevolent influences from a person's life. The healing was visually and emotionally traumatic. A brief description follows.

With a grimly determined look on his face, Pa Francisco circles an apprehensive Marite as though hunting down her illness in order to chase it away. The stomach of a goat that had been ritually slaughtered for Sarabanda earlier in the evening lies slippery and glistening in an enamel basin at her feet. It is clear that the severity of Marite's problem demands extreme measures. Considered exceptionally powerful, the organ will be used to capture and contain the forces so ruinously affecting her life. Pa Francisco grabs the innards and proceeds to rub them vigorously over her body. As the spirit does so the goat's stomach breaks, releasing a pestilential smell that drives a number of people from the room. Marite is then told to trample the mess of entrails at her feet.

Toward the end of this intense purification ritual, Pa Francisco lifts the coconut that he has been using to cleanse Marite and—the impact that of a thunderbolt—smashes it violently to the floor. *¡Alafía!* several individuals cry out as the four major pieces of the shattered fruit land white side up. This

divination pattern signals stability and positive, healing energy, at least in the short run.[28] Everyone heaves a collective sigh of relief. After being anointed with honey and blessed with successive clouds of cigar smoke, Marite goes off to bathe. The ritual detritus is placed in a large nylon bag for later disposal. In a concluding gesture Pa Francisco vehemently shreds the clothes that she had been wearing, as though single-handedly destroying her recent past, and stuffs the rags in with the rest of the debris. This rather brutal cleansing seems to have a calming effect on Marite. Her attitude loses some of its petulant, restless edge. For the remainder of her stay in Santiago's house, she takes part more willingly in household activities.

This is the ritual cleansing that Santiago had subtly been priming us for earlier in the day as we drove around town looking for battery-powered lights (see chapter 2). The nature of Marite's predicament required the emotional and spiritual support of Santiago's entire ritual family to initiate the healing process. This communal framework was critical not only for her but for Santiago as well. Through his spirit confidant Pa Francisco, Santiago was able to publicly demonstrate that he was attending to the grave problems affecting a member of his blood family. Marite's treatment was imbedded in a process both social and religious.

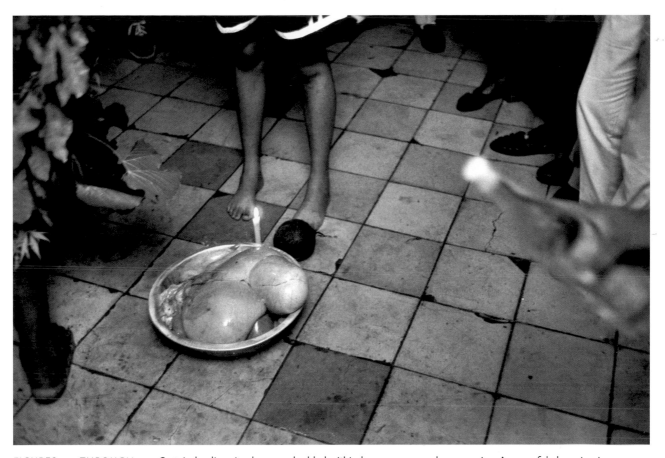

FIGURES 109 THROUGH 114. Certain healing rituals are embedded within larger communal ceremonies. A powerful cleansing is performed for Marite, a member of Santiago's immediate family. The disturbing intensity of the ritual healing, which involves the stomach of a goat recently slaughtered for Sarabanda, reflects the severity of her situation.

FIGURE 108.
The Congo spirit Pa Francisco.

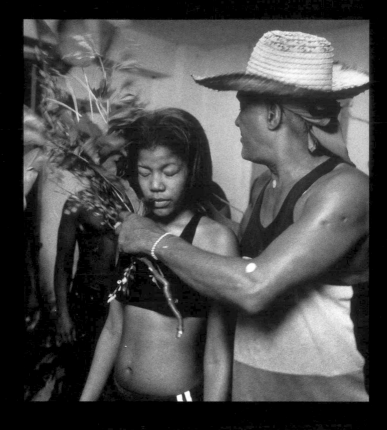

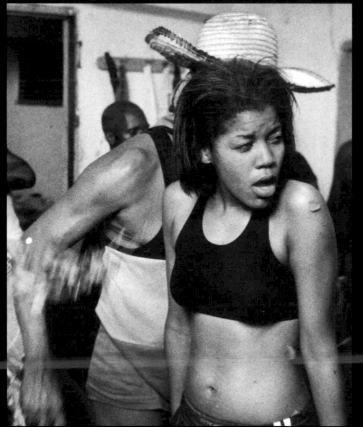

Güiro, güiro mambo,
Güiro lava toda' las cosas.
Güiro, güiro mambo,
Güiro lava toda' las cosas,
 hombre.
Güiro, güiro mambo,
Güiro lava toda' las cosas.
¡Eh! Ensala mundo tierra yesá,
Güiro lava toda' las cosas.
Dió

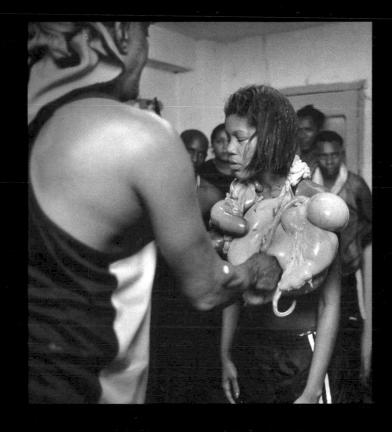

Coconut, coconut speaks,[29]

Coconut cleanses all things.

Coconut, coconut speaks,

Coconut cleanses all things,
 man.

Coconut, coconut speaks,

Coconut cleanses all things.

Heh! In all of Africa,

Coconut cleanses all things.

Lord

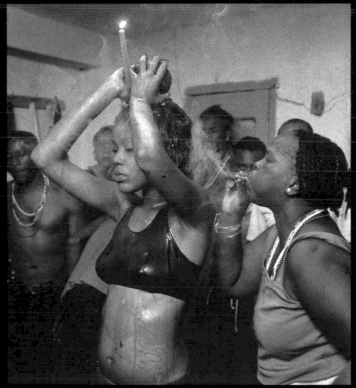

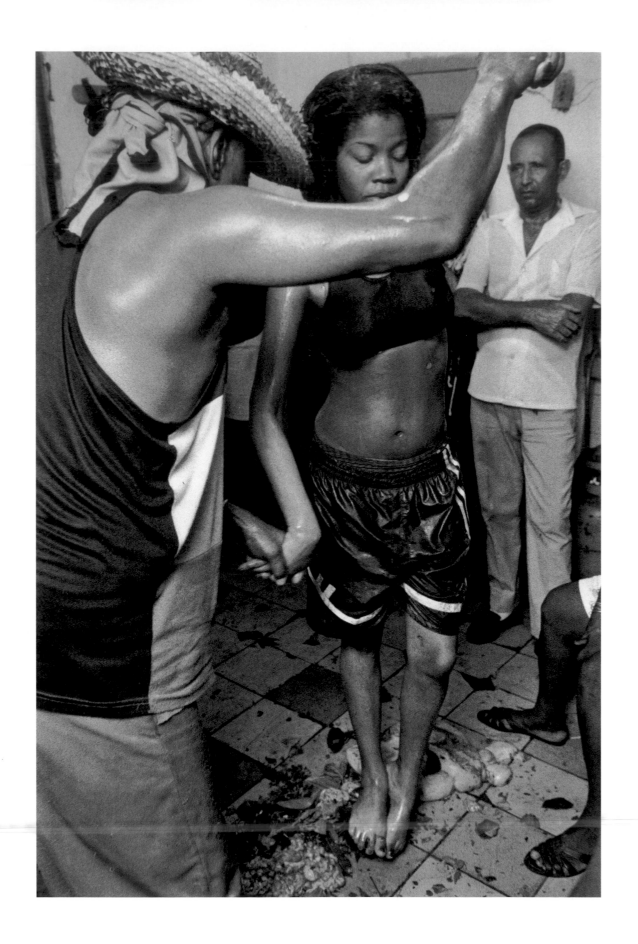

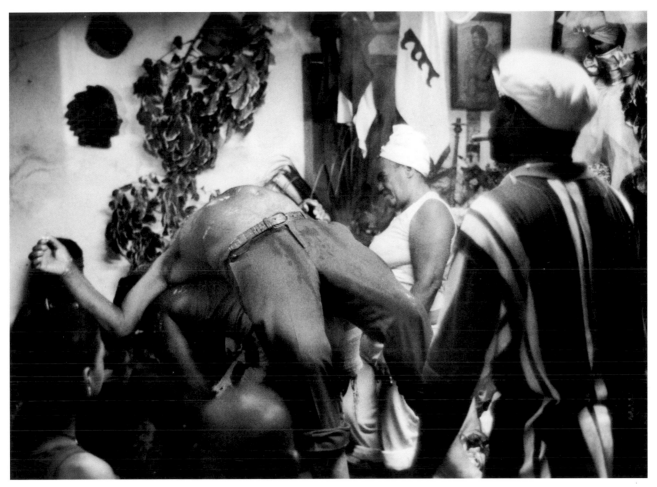

FIGURE 115. In the course of an ongoing cure, the Congo spirit Pa Francisco literally and figuratively shoulders this man's affliction. The healing work is performed on the night of the spiritual mass, when the homespun Congo dead come down to interact with the living.

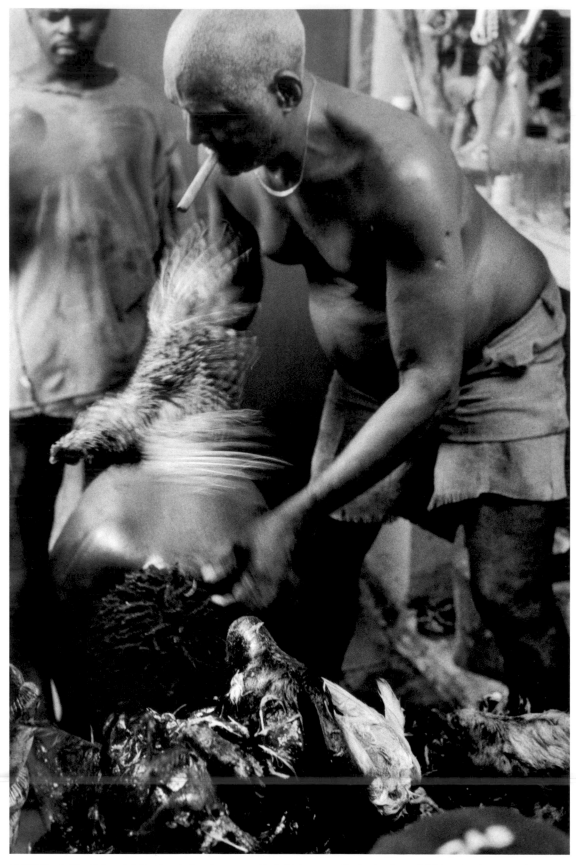

FIGURE 116. The Palo spirit Sarabanda brushes a speckled chicken over the body of a godchild, a ritual gesture that strengthens and purifies as it disperses negative influences.

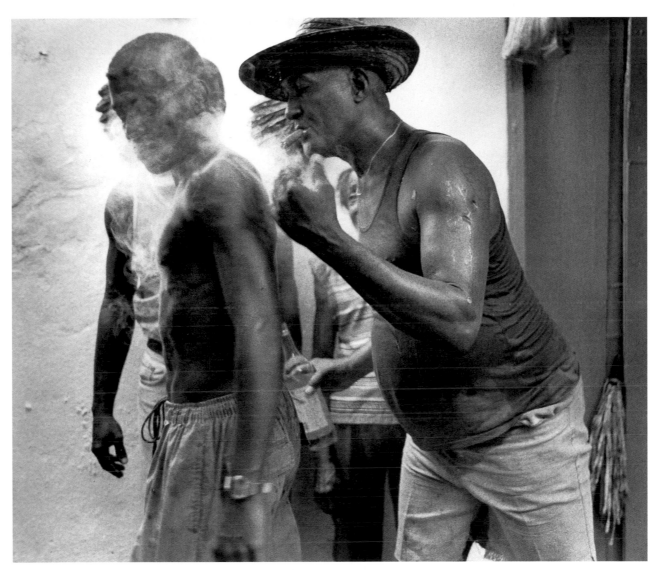

FIGURE 117. Inverting his cigar so that the lit end is in his mouth, the Congo spirit Pa Francisco blesses a godchild by blowing large clouds of cigar smoke in his ears and face and onto the nape of his neck.

Desenvolvimiento: The "unwrapping of self"

From the day we first met Santiago, he informally assumed the role of god-father (padrino) to both of us. Although it was not the first time that a practitioner of Palo Monte or Santería had tacitly proposed such a relationship, it was the first time we intuitively agreed to enter into one. The bond was formalized shortly thereafter. As our guardian and mentor, Santiago is naturally concerned that we continue to progress in our lives. This requires a measure of spiritual and emotional effort.

The Spanish word *desenvolvimiento* (development) is used to describe the gradual "unwrapping of self" in relation to the spirit world. Over the past five years we have undergone preliminary initiations into both Santería and Palo Monte. These integrative rituals anchor, protect, and strengthen the individuals who experience them. All stages of initiation can be thought of as a form of preventive medicine.[30] When undergone in response to illness, initiation constitutes a cure. Santiago watches over our well-being, even at a distance. If he senses a problem, he intervenes and takes the necessary steps to fortify or otherwise protect us.

Initiation into Santería or Palo Monte is usually approached as a series of rituals, often over a period of many years. Each step marks a deepening involvement in the religion as obligations to the spirits multiply. The highest levels can be extremely demanding, in terms of both financial outlay and ongoing commitment. Our personal experience took the following course.

Several rituals lay the foundation for full-fledged initiation into Santería. The initiate's head, considered "the seat of spiritual power and possibility,"[31] is the focus of attention in all of them. "Receiving" the necklaces (*collares*) of the five major orichas—Eleguá, Obatalá, Yemayá, Changó, and Ochún— constitutes the first step.[32] As they are formally consecrated, each color-coded

necklace becomes an embodiment of that particular oricha's vital energy, or aché. We received our collares in the summer of 2000. One by one, and after each necklace had first been dropped to the ground, Santiago placed these beaded symbols of the orichas over our heads and onto our shoulders.[33] Encircling the neck, the collares encircle you in the protective mantle of the spirits they represent. Some months later, we received the necklaces of Ogún and San Lázaro (Babalú Ayé).

Receiving the warrior orichas (*los guerreros*) carries with it much stronger obligations. These rugged forest spirits aggressively protect those who receive them and, if necessary, will go to war on your behalf. As we spent increasing amounts of time with Santiago and our relationship deepened, he felt we needed the added vigilance and security that these formidable spirit brothers would provide. Some time before we returned in the spring of 2001, he had quietly begun to prepare our Warriors. We received them in March of that year.

Although every initiate receives the same four spirits, each guerrero is specific to that person. Both of our Eleguás, individually molded out of clay by Santiago, share the same overall features: a conical head embedded with cowrie shell eyes and mouth and topped by a small iron blade.[34] Both are also manifestations of the spirit responsible for opening one's path in life and whose mischievous, discordant energy is the stuff of legend. Otherwise, they are visually and conceptually distinct. Eleguá is a multidimensional being said to have a minimum of twenty-one different roads (caminos). The mixture of herbal and other activating ingredients packed into each of our figured spirits corresponds to one or another of these roads; Santiago's perception of us as individuals no doubt played some part in this pairing process. Each of our Eleguás has not only a distinct camino but a unique praise name on that path of the oricha's aché. In the long run, however, the personalization of any spirit arises in the relationship one develops with that spirit.

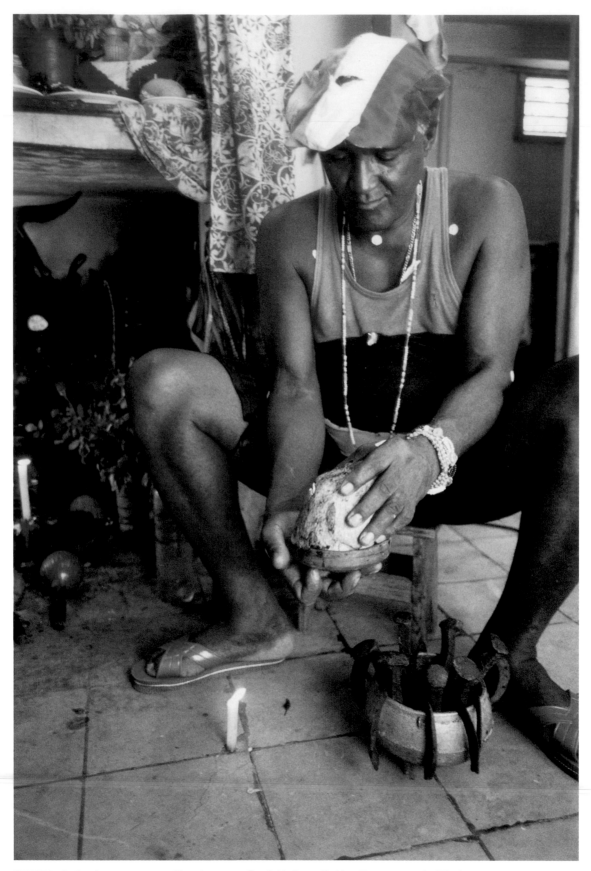

FIGURE 118. Santiago prepares an Eleguá as part of an initiation called los Guerreros or the Warriors.

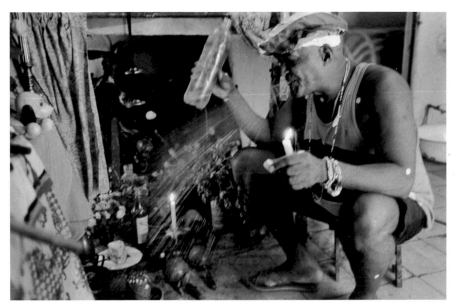

When you love Eleguá, the man who keeps your road open and clear, the enemy doesn't wage war with you but with Eleguá.

SANTIAGO CASTAÑEDA VERA, 2003

FIGURE 119. Santiago invigorates the newly molded Eleguá—charged with earths, plants, and other powerful substances—by spewing *aguardiente* (cane alcohol) onto it.

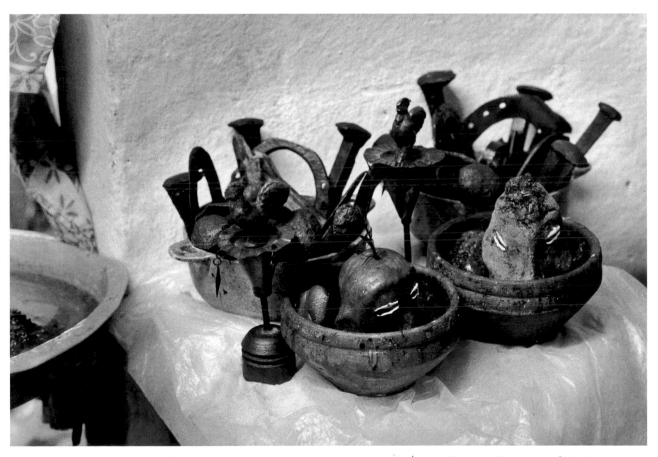

FIGURE 120. The three warriors—Eleguá, Ogún, and Ochosi—are received along with Ósun as the second in a series of initiations into Santería. Forged implements of work, warfare, and hunting signal the presence of Ogún, oricha of iron and war, and Ochosi, the hunter and champion of just legal causes. The diminutive shrine topped by a rooster is the home of Ósun.

The iron cauldrons that Santiago prepared for each of us house Ogún and Ochosi's rustic metal tools and weapons alongside carefully selected stones and other power elements drawn from el monte. Ogún is the fiercely self-sufficient oricha of iron, war, and the forest. He is the natural companion of Ochosi, the highly skilled hunter responsible for "putting people in jail and getting them out [if unjustly accused]."[35] An elevated metal cup filled with herbal medicines and topped by a rooster is the diminutive home of Ósun. Equated with the head (orí) and therefore the destiny of the person who receives him, Ósun safeguards his owner by warning of impending danger. As Santiago consecrated our respective guerreros with herb-infused water and the blood of several birds, we had a direct hand in the proceedings. Like all spiritually charged objects, our necklaces and Warriors must be cared for and periodically fed to maintain their strength.

The ultimate and crowning ceremony of initiation into Santería is known as "making saint" (hacer santo), "the seating" (el asiento), or, "putting the oricha on the head" (kariocha, in Lucumí). In the course of this elaborate series of rituals, the aché or spiritual power of a particular oricha is physically placed in the head of the initiate who, at the end of this weeklong rite of passage, emerges as a new priest or priestess.[36]

Brinca la ma': Leap over the sea

Brinca la ma,' brinca la ma,'	Leap over the sea, leap over the sea,
Cabeza en Congo, brinca la ma.'	Head in Congo, leap over the sea.

Initiation into Palo is also approached in stages. The rayamiento, a ritual during which the initiate's body is lightly scored or "cut" (rayado), is the first step.[37] Acquiring prendas of one's own, which involves a more rigorous initiation than the one we describe here, constitutes the next echelon. The ultimate level is achieved when one has established one's own nso-nganga, or

Palo house, and is qualified to bring others into the religion. Some form of apprenticeship is implicit in the last two stages of Palo initiation.

In July 2001, we were *rayado* "on top of" (*en cima de*) Santiago's prenda for Sarabanda, his primary Palo spirit. This initiation brought us under the immediate protection of an extraordinary complex of powers: Sambia Mpungu (the Creator God and Supreme Being of the Congo universe), the Palo mpungus, and los muertos (spirits of the dead), as well as Santiago and his entire priestly lineage. The process of being rayado is not a particularly drawn-out affair, but it is symbolically loaded. As the ritual gets under way, the space of Santiago's nso-nganga becomes a conceptual force field encompassing the worlds of both the living and the dead.[38] At least one other Palo initiate is present to add his or her energy to the singing and to assist in other ways. Since being rayado, we have taken part in several other initiations.

In preparation for a rayamiento, Santiago brings out specific power objects from Sarabanda's prenda. These sacred objects a large, dark stone belonging to the spirit; an *mpaka* or animal horn sealed with a mirror that functions as a clairvoyant eye for seeing beyond this world; a crucifix, a scepterlike bone, and a ritual blade—are placed on a white plate. A jar of ashes containing cemetery earth, powdered bones, and other materials associated with the powers of the dead is also brought out. Once a candle is lit and planted at the foot of Sarabanda's cauldron, you are formally presented at the entrance to the nso-nganga and then led in. Tightly blindfolded with a white cloth, you are instructed to lie down on a mat, oriented so that your head is in contact with Santiago's main prenda—with your "head in Congo," as it were. Three ritual objects—a crucifix, Sarabanda's *matari* or stone, and the mpaka—are placed on your chest. Lying face up initially and then face down, your body is in touch with the earth, the home of the dead, at all times.

Santiago starts to sing, invoking all of the forces in the Palo universe. Throughout the rayamiento, his voice never falters, not even for a moment.

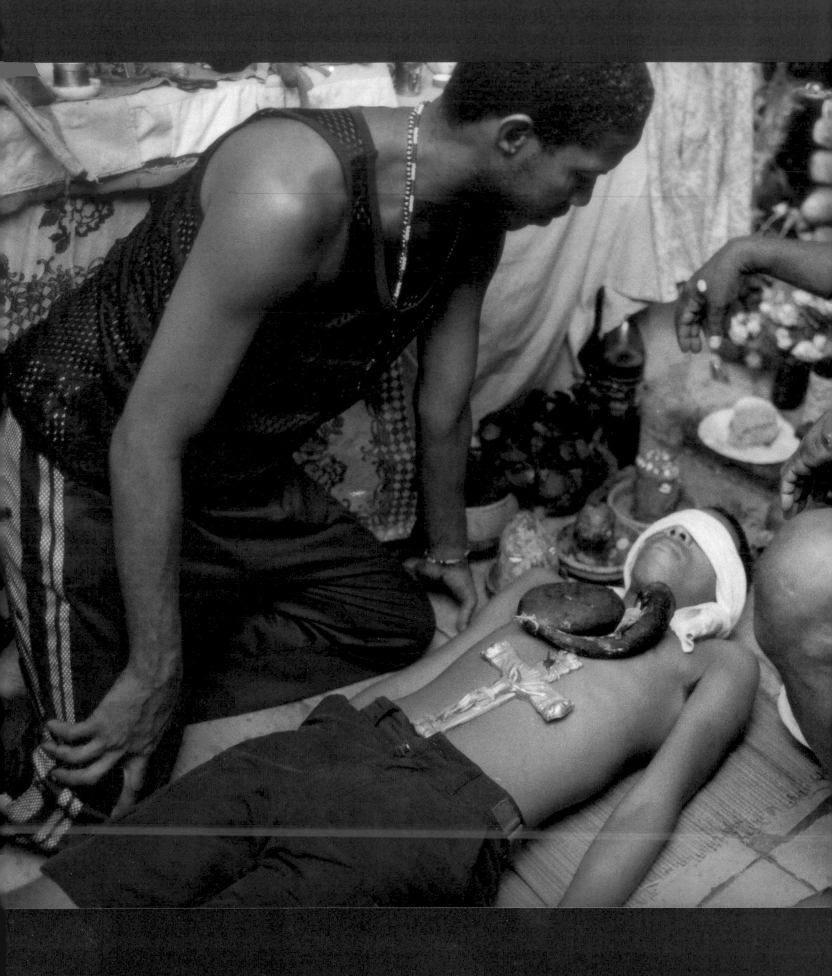

Brinca la ma', brinca la ma',	Leap over the sea, leap over the sea,
Cabeza en Congo, brinca la ma'.	Head in Congo, leap over the sea.
¡Eh! Brinca la ma', mayombero,	Hey! Leap over the sea, mayombero,
Brinca la ma',	Leap over the sea,
Cabeza en Congo, brinca la ma'.	Head in Congo, leap over the sea.
¡Eh! Brinca la ma', mayombero,	Hey! Leap over the sea, mayombero,
Arriba nganga, brinca la ma',	Above the nganga, leap over the sea,
Cabeza en Congo, brinca la ma.'	Head in Congo, leap over the sea.

FIGURE 121. Dramatization of a Palo initiation ritual known as the rayamiento.

Each song (mambo) specifically anticipates, describes, and reinforces his actions.[39] The physical part of the ceremony involves lightly scoring the body in significant places. "Mark the María [initiate] like you mark the *nganga* [prenda]" (*Pinta la María como pinta la nganga*), Santiago chants as he crosses these spots with white chalk and touches the crucifix to them. Then, while singing "Blood is going to flow like a river flows," (*Menga va correr como corre tintorera*), Santiago incises a small crosshatched design on each site.[40] The ritual cuts are superficial and must be squeezed to draw even a tiny amount of blood. As each configuration is scored on the body, the wound is quickly swabbed with a piece of cotton and sealed with potent substances that distill the authority of the dead: a bit of ash rubbed into the cuts followed by a drop of hot candle wax. The visionary mpaka and the stone belonging to Sarabanda are then pressed to the site.

The process of being rayado involves a mutual sharing of substance. It literally inscribes the secret of Palo on your body. Once charged with these evocative medicines (the ash and hot wax) and put in contact with the crucifix, mpaka, and sacred stone, your body becomes a prenda or nganga, a vessel housing the presence and powers of Sarabanda and the dead. At the same time the rayamiento is also a blood sacrifice and pledge of allegiance. Ultimately, the swab of cotton streaked with the accumulated traces of your blood is tucked away inside Sarabanda's prenda. In this way, one's life essence is irrevocably bound to Santiago's primary Palo spirit and, by extension, his entire ritual family—living and dead, human and otherworldly. In Congo-Cuban thought, the worlds of the living and the dead are separated by a large body of water.[41] The signature song of Palo initiation—*Brinca la ma,' brinca la ma,' cabeza en Congo, brinca la ma'*—urges the spirits to "leap over the sea" and get in touch with the initiate. Metaphorically speaking, it alludes to the movement from one state of being to another.[42] The initiate emerges newly charged with the energy of the dead.

However much one knows or reads about the process of initiation, it is only through bodily experience that the secret is internalized. It is felt rather than known or understood. Toward the end of the rayamiento, you are given a mouthful of kimbisa (a heady ceremonial brew) followed by a swig of raw rum and then pulled to a standing position.[43] Everyone present slaps important parts of your body, including all joints and the soles of your feet, with the spirit Sarabanda's machete. The blindfold is removed and various secrets, including a new Palo name, are imparted. This privileged information is not so much a matter of "looking at new things, but of seeing familiar objects in a new way; not of listening but of hearing."[44] Initiation is sealed with the recitation of an oath or *juramento*. Palo ritual greetings and handshakes are then exchanged with everyone present.[45]

The offspring of Santiago's Palo prendas

Nganga, mira relo',	Nganga [prenda], look at your watch,
Tu mira bien que hora tiene tu relo'.	Take careful note of the time,
En campo nfinda ndiata mundo awé.	In the cemetery the Congo fight goes on.
Nganga, mira relo',	Nganga, look at your watch,
Tu mira bien que hora tiene tu relo',	Now you had better check out the time,
En campo ndiata mundo awé.	On the battlefield the fight continues.
¡Eh! pero mira gangero (gangulero),	Heh! Better look gangulero [palero],
Tu mira bien que hora es,	Take a good look, check out the time,
Y ahora tiene tu relo' arriba nganga,	And now the watch reads above the nganga,
Y arriba nganga.	And above the nganga.[46]

A worthy palero's spirit cauldrons engender many others. In the course of Santiago's lifetime, he has fully initiated over 140 people in Palo, laying the

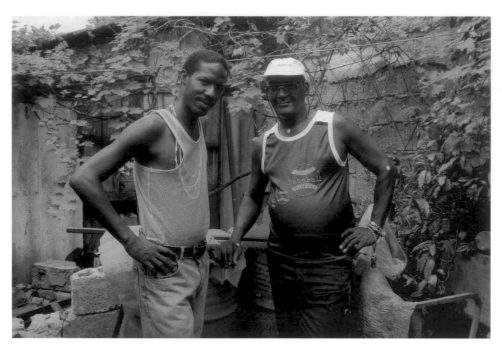

FIGURE 122. Mariano and Santiago, his tata nganga or father in Palo.

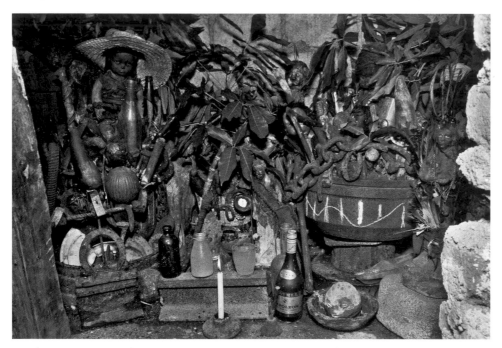

FIGURE 123. Rustic lean-to housing Mariano's Palo prendas and his cauldron for the Congo dead.

foundation of one or more prendas for each of them.[47] Based in part on materials and powers drawn from his own, the ritual vessels that Santiago mounts for his ahijados are quite literally offspring. A prenda carries within it a physical and metaphorical charge from a long line of spirit containers. The Palo cauldrons of two of Santiago's godchildren, Mariano and Elvira, are featured in Figures 123 and 126.

Alternately animated and introspective, Mariano is Santiago's primary assistant in all Palo matters. When the spirit moves him during informal get-togethers at Santiago's house, he is also a breathtakingly innovative *rumbero*, a dancer of the Congo-inflected Cuban rumba. In Haiti they would call him *zo likid* (liquid bones) because of his extraordinary physical fluidity. Although currently working as a truck driver, he is a professional dancer who in the early 1990s toured Europe with a Cuban folkloric troupe.

As Mariano mindfully states, "*El Palo se vive mucho con controversia*" (Palo is lived with a lot of contention).[48] Mariano lives around the corner from Santiago. This proximity means that he is often commandeered into service, to the detriment at times of his job and other, more personal obligations. As Santiago's apprentice, however, Mariano cannot easily refuse requests from his *tata nganga* or "father in Palo." This is the price he must pay to further develop and articulate his skills as a palero. The relationship can be a testy one. Santiago demands absolute solidarity and enforces stringent codes of conduct when it comes to his high-level Palo godchildren. Perceived indiscretions are a frequent sore point. The risk of getting shut down by his tata nganga explains in part why Mariano, ever subject to Santiago's watchful eye, is often rather subdued on social occasions. In a strictly Palo context, ignorance of proper procedure and other improprieties may be reprimanded, or worse, ridiculed. Santiago can be a tough and uncompromising teacher-taskmaster.

El Palo se vive mucho con controversia (Palo is lived with a lot of contention).

MARIANO URDANETA ROBERT, 2002

Elvira, a powerful woman with a penetrating gaze, does not suffer fools easily. When we first met her in the days leading up to Santiago's year 2000 ritual cycle, she kept her distance. Unlike other family members, Elvira seemed openly suspicious of who we were and what our intentions might be. For most of that first round of ceremonies, we found her quite intimidating. Although natural reserve and a wariness of outsiders played a part, Elvira, like many of Santiago's godchildren, is extremely protective of her padrino. Once she realized that our relationship with him was reciprocal and ongoing, she slowly warmed to us. Within Santiago's core family, Elvira is now a personal friend and a spiritual confidante who pulls no punches. As others in Santiago's fold have seen us taking part in rituals and helping prepare for them, our presence has been not only accepted but openly embraced.

Elvira and Mariano are major performers in all important ceremonies and are often called on to assist with initiations and other private healing rituals. Although both are Palo adepts, Mariano plays a more prominent role, for instance, during the large-scale November matanza for the Palo spirits and the Congo dead. The matanza is, in any case, a male-dominated affair. Elvira is a lifelong *mortera*, a woman born with the ability to be possessed by spirits of the dead—to "grab" or "seize" the dead (*coger muertos*), as this gift is most often described. She has an intimate relationship with a Haitian spirit by the name of Ma Rufina. We have interacted with this vigorous and ever-mysterious muerta on several occasions in the hours following the annual spiritual mass.

In 2004, Elvira was at long last fully initiated into Santería. She is now in a position to act as godmother to

FIGURE 124. Elvira.

Santiago's godfather in forming new priests and priestesses of the orichas. In this indispensable hands-on way, both Elvira and Mariano are acquiring the knowledge and experience that will allow them to assume full responsibility in one or more of the distinct yet deeply intertwined religions practiced by their godfather Santiago.

Mariano and Elvira house their Palo cauldrons in specially constructed sheds and alcoves in the patios behind their respective homes. While Mariano's lean-to encloses more of a wild forest environment, Elvira's two-tiered arrangement replicates that found in Santiago's nso-nganga, with the spiritual altar above and the material Palo realm of contested energies and emotions below. Mariano is not a spiritist per se, but he is a *mortero* (someone who "passes" the dead) and has incorporated aspects of Cuban Espiritismo—African "spirit guides," for instance—that conform to his Palo outlook. He has a magnificent, fully bedecked Plains Indian/Congo warrior known as El Africano (The African) in his rustic lean-to.[49] Otherwise, the Palo mpungus Sarabanda, Madre de Agua, and Lucero as well as individual Congo spirits of the dead are among the entities housed in Mariano's and Elvira's nso-ngangas.

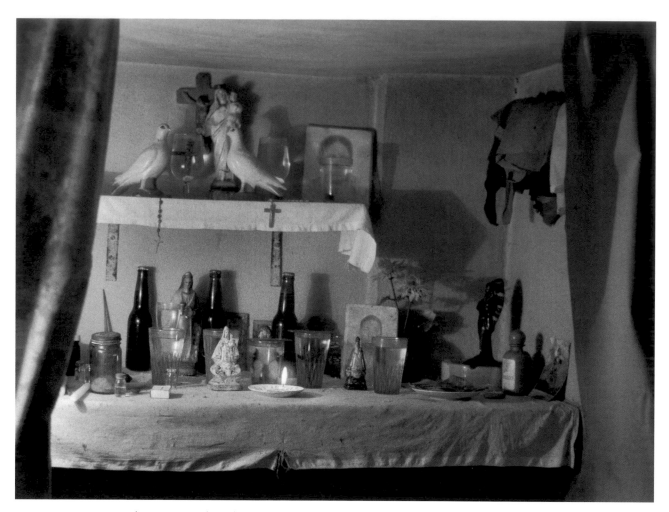

FIGURES 125 AND 126. Elvira's spiritist altar (above) and Palo alcove (opposite).

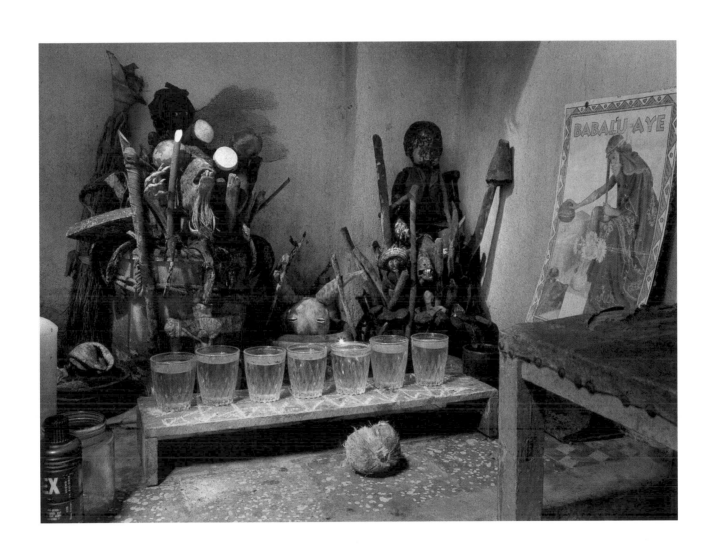

Congo mío, ven de los montes,	Congo of mine, come down from the mountains,
Yo te llamo a laborar,	I'm calling you to work,
Cuando venga, ven despacio,	When you come, come down slowly,
Paso a paso a trabajar.	Step-by-step to do your work.
Yo te llamo y tu responde,	I'm calling you and you answer,
Yo te llamo de verdad,	I'm really calling you,
Yo te llamo con tu mbele,	I'm calling you with your machete,
Yo te llamo pa' jugar.	I'm calling you to "play" [i.e., do mystical work].
Yo te veo en la maleza	I see you in the undergrowth
Trabajando material,	Working the "material,"
Con tu cazuela de barro	With your terra-cotta vessel
Y tu mpaka pa' mirar.	And your mirrored horn for "seeing."
Tu te llamas como quiera,	You call yourself whatever,
Tu nombre no quiere estar,	Your name doesn't want to be,
Lo que quiero, Congo mío,	What I want, Congo of mine,
No nos dejes de ayudar.	Do not stop helping us.
Lo que quiero, Congo mío,	What I want, Congo of mine,
No nos dejes de ayudar.	Do not stop helping us.[1]

I Am Not from Here ESPIRITISMO AND THE CONGO SPIRITS OF THE DEAD

Abre kuta, güiri ndinga. (Open your ears, listen to what I'm saying.)

CONGO RITUAL INVOCATION

The entire day has been devoted to cooking, cleaning, and ritually purifying the house for the evening's spiritual mass and subsequent celebration of the Congo dead. In honor of the occasion, Santiago's spiritual altar (*bóveda espiritual*)[2] is radiant with candlelight, water-filled glasses, gleaming crucifixes, and fresh flowers. Later on, as individuals send out beautiful, incandescent songs to elevate the souls of their dead, the alcove becomes a shimmering cathedral of light and sound. All of these tangible and intangible offerings speak to the fundamental purpose of the mass, which is to "give light" to the departed so they will continue to evolve on the spiritual plane. Lilac- and rose-scented perfumes linger in the air of the nso-nganga. It is hard to believe that the Palo matanza took place in this room less than twenty-four hours ago.[3]

Of all the rituals Santiago performs, the spiritual mass, culminating in the boisterous arrival of the Congo dead, is the most obviously hybrid or "syncretic."[4] Part spiritist séance and folk Catholic devotion, this summoning of the dead is also, when all is said and done, profoundly Afro-Cuban. Although Santería's influence is readily apparent on the altar, Santiago's spiritist prac-

tices are more firmly rooted in Palo Monte. The Congo preoccupation with accessing the powers of the dead made natural bedfellows of Spiritism (Espiritismo) and Palo Monte, especially on the eastern end of the island, where both traditions were solidly, if distinctly, entrenched.[5]

Santiago's bóveda, the mesmerizing focus of the mass, is crowded with objects that embody this fascinating interpenetration of ideas. Venerable, time-worn figures of Catholic saints rub elbows with various ethnic spirit guides (guías). Half-gourds (jícaras) and baskets full of arcane paraphernalia nestle alongside water-filled glasses and magnificent Baroque altar accessories—a finely wrought monstrance with radiating arms, candlesticks rigged with light bulbs, and several elaborate crucifixes—all with names like "The Holy Sacrament" (El Santísimo), Saint Hilarion (San Hilarión),[6] and "The Pure Christ" (El Cristo Limpio). Painted portraits of Santiago's deceased mother, father, and grandmother hang on the walls of the alcove.

The saints featured on Santiago's altar evoke their oricha counterparts. An imposing wooden sculpture of Saint Francis of Assisi (San Francisco), for instance, doubles as the wise oricha-diviner Orula, whose "divining chain" is thought to resemble the saint's rosary.[7] Without diminishing their respective powers, the spiritist setting recasts both saint and oricha as potential conductors for the healing energy of the dead. Saint Francis towers in the company of Our Lady of Charity (Ochún), cradled in a shell-shaped bénitier on the back wall; the blessed Saint Barbara (Changó); Saint Lazarus (San Lázaro/Babalú Ayé); the mantled Virgins of Mercy and Regla (Obatalá and Yemayá); Saint Peter (whose iron keys link him to Ogún); and other oricha-saints.[8]

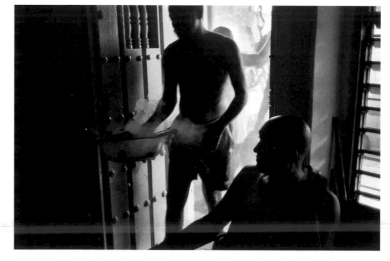

FIGURE 127. A basin of smoldering, aromatic leaves is carried throughout the house on the day of the spiritual mass. The premises become hazy with pungent smoke during this ritual fumigation.

Within this protective convoy of spirits, San Lázaro seems to play a unique role. As mentioned in chapter 1, this oricha is one of the few who are not housed in Santiago's saints' room. Instead, San Lázaro lives in the nsonganga, where he is multiply represented. On the bóveda and alongside the Palo enclosure below, the oricha appears as a painted, plaster-cast beggar on crutches, his body covered with leprous sores. On the upper, spiritual level, a spotted pair of goggle-eyed, 1950s-era toy dogs often accompanies him. When Santiago talks about this miraculous oricha-saint, patron of the poor and the sick, he blends Lucumí cosmology with the stories of two biblical personalities named Lazarus. On the African side, Babalú Ayé is associated with the earth's fetid, swampy beginnings and linked to the origins of pestilence and disease. This accounts for the oricha's identification with all things spotted or granular: speckled guinea fowl feathers, spotted dogs, eruptive skin conditions, stalks of seedy millet, and so forth.[9]

Of the two Lázaros recognized by the Catholic Church, the first is the crippled beggar from the biblical parable, his flesh wounds licked by dogs as he waits for scraps from the rich man's table. The second is the Lazarus that Jesus resuscitated from the dead and ordered to emerge from his tomb. Certainly the notion of raising or elevating the dead resonates with Santiago's spiritist-infused Palo sensibilities. According to José Millet, the veneration accorded San Lázaro in Oriente is particularly intense and differs somewhat from his cult on the rest of the island. Religious practitioners in Santiago de Cuba may conceive of him as an oricha, a Catholic saint, a *mortero* (someone who is possessed by the dead), or a muerto, a "spirit of the dead" plain and simple.[10] San Lázaro's am-

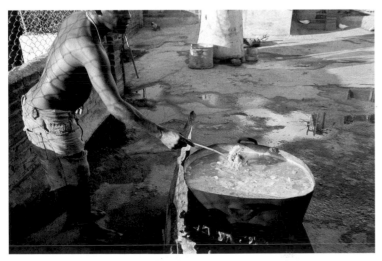

FIGURE 128. As the number of people to be fed increases, cooking moves onto Santiago's roof.

biguous status and his intimate connection with disease, healing, and the domain of the dead explain his presence throughout the nso-nganga.

Santiago's many ethnic spirit guides include a tiny Buddha, a stereotypical Indian warrior, and a mystically attuned, clown-faced doll known as "the Gypsy" (la Gitana). Seen from a historic perspective, these entities constitute a rather curious, generic inventory of peoples brought to the island to work, either as slaves or in what was essentially a forced labor capacity: Africans, Amerindians, Chinese, and others.[11] They represent a thoroughly Cuban transformation of the spirit guides recognized by Kardec, the mid-nineteenth century founder of French Spiritism.[12] A fourth figure, seated in a diminutive rocking chair in front of a mirror fragment, represents the Congo spirit, Ma Rufina. Along with other African-born spirit guides, Ma Rufina reigns from the ethereal heights of the bóveda but she references the Palo-compatible end of the spiritual spectrum. The vessel housing Pa Francisco, the Congo muerto with whom Santiago works most closely, occupies the earthbound material realm alongside his Palo cauldrons. The Congo spirits of the dead operate with at least one and more often two feet in the concrete physical world.

Several types of object on the altar suggest an underlying layer of meaning.[13] The use of reflective, water-filled glasses and mirrors, for instance, is obviously linked to spiritist notions of how to attract the luminous energy of the departed.[14] The presence of these transparent surfaces can also, however, be traced to the Kongo-derived belief that the world of the dead, essentially a mirror image of our own, is separated from our world by a body of water but that it can be "reached by going through or across this water."[15] Spiritist and Congo-Cuban metaphysics coalesce in these light-refracting vessels and objects. They serve as a medium for highly evolved souls as well as instruments of clairvoyance enabling Santiago to see beyond this world to the ancestral land of the dead. In a similar way, while the ornate brass crucifixes on the altar retain their meaning as Catholic icons, the cross form can also

The dead speak to me here like I'm talking to you. I sit down and I speak with them. And when they don't talk to me, I see them.

SANTIAGO CASTAÑEDA VERA, 2002

be understood as a bare-bones delineation of the Palo universe, with "one arm representing the boundary and the other the path of power between the worlds."[16] This critical intersection is the armature of many Palo ground drawings (*firmas*) and recurs in the crossroads, those ritually potent places for mediation between the realms of the living and the dead.

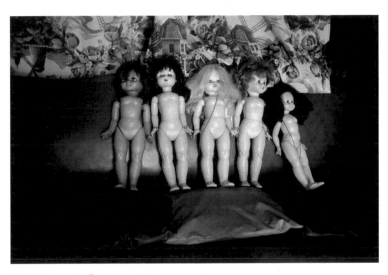

FIGURE 129. Dolls representing the orichas are denuded, bathed, and then reclothed in all their finery.

When we were first trying to get an idea of Santiago's take on the spirit world, a number of his verbal references and gestures were obscure to us. After experiencing particular ritual movements over and over again and piecing together many fragments of conversation that alluded to the spirits, one thing is very clear. Espiritismo's metaphysical concepts and the vocabulary used to express them are, in a sense, the glue that Santiago uses to hold together a wide range of his beliefs and practices. They have provided him with a flexible framework for ordering the universe and its inhabitants, the mpungus and orichas as well as the living and the dead.[17] Santiago's work as a spiritist (espiritista), however, is inseparable from his lifelong experience as a palero. His is a system of action rather than abstract philosophical ideas.

Within the parameters of "crossed" or "integrated" Espiritismo,[18] Santiago practices his own version of the popular, healing-oriented *espiritismo de caridad*, or "spiritism of charity." The basic premise of this variant, which derives part of its doctrine from the writings of Kardec, is to help humanity by "doing good works" (*hacer caridad*). Some espiritistas make a strong moral distinction between "spiritual" and "material" healing work. Santiago, predictably, is not one of them. He approaches his mission "to help with bad situations" head-on. Eminently practical, Santiago will use any of the means

at his disposal to provide people with the resources they need to better their circumstances. There is one distinction, however, that he does feel strongly about. It concerns the nature of his priestly authority.

Afro-Cuban religious traditions are largely passed on through direct experience and by word of mouth. Espiritismo, on the other hand, relies on a substantial body of written doctrine that requires intensive study over a period of years. While Santiago acknowledges the power and insight he gained during this rigorous formal apprenticeship, he values innate ability and intuition over knowledge acquired through book learning. When Santiago refers to himself as an espiritista, he is saying that he is, first and foremost, a mortero, a specialist in working and channeling the dead. Born with this gift, he is able to serve not only as an intermediary but,

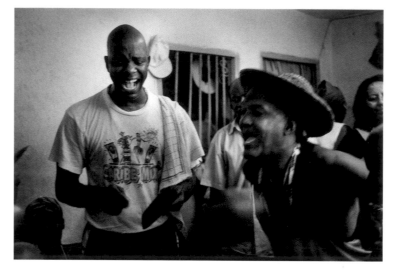

FIGURE 130. Pa Francisco, a Congo spirit of the dead.

through possession, to offer others direct access to the vivid, problem-solving energy of his spirits. His reputation as a priest and healer depends on this natural ability.

Santiago's personal muertos are an ambiguous and flexible lot. Some are light-filled, highly evolved beings. They include Santiago's ancestral dead, members of his "spiritual cadre"[19] (an ensemble of spirits that has been with him from birth), and some of the ethnic guides mentioned earlier. He communicates with these enlightened souls using clairvoyant and other indirect means.[20] Because they are no longer in touch with the material world, these spirits never physically possess Santiago. The "dead of light" (*muertos de luz*) provide advice, moral guidance, and generalized protection but rarely intervene in the convoluted day-to-day struggles of their "children." In return

for their high-minded assistance, Santiago helps them rise even further in the invisible chain of being. Espiritistas use the terms "to give" and "to get" light (*dar y coger luz*) to express this reciprocal human-spirit relationship. The disembodied radiant dead are invoked through prayer, flowers, light, and the singing of "transmissions" (*trasmiciónes*), most notably during the annual mass celebrated in their honor.

Santiago is much more emotionally involved with a spirit contingent of intermediate rank, a group of symbolic ancestors known as the Congo dead.[21] He says point-blank, "Look . . . as for me . . . my work is with the Congos . . . Pa Francisco, Pa Julian, and Pa Kanuko." These rowdy, strong-willed spirits—the souls of Congo and other African-born elders who lived, suffered, and died as slaves in the New World—are down to earth and readily accessible. They help their "descendants" tackle immediate real-life problems. Given their history of survival under the most hostile circumstances, the Congo dead are uniquely equipped to steer people through difficult times. Because these muertos remain physically and emotionally attached to life as we know it, they must be fed the blood of sacrificial animals to maintain their strength. Santiago renews their vitality and healing capacity on the night of the Palo matanza.

The paired succession of the *misa espiritual* (spiritual mass) and celebration of the Congo dead points up the complexity of Santiago's spiritist practices. While his bóveda incorporates Afro-Cuban elements, the mass itself has a decidedly decorous, churchlike feel. Toward the end of this formal invocation of the dead, there is a dramatic shift in emotional tone. As individual Congo muertos start to possess members of the congregation, the form and content of the evening's ritualizing become manifestly Afro-Cuban. When these rustic old souls come down to interact and carouse with the living, they are greeted with great warmth and enthusiasm, like sorely missed family members on a rare visit home. Despite the abrupt transition from the spiritual to the earthly plane of existence, the mass forms an integral part of the larger nightlong

ceremony. The transcendent "dead of light" are honored first, paving the way for the arrival of the less exalted but much loved Congo spirits.

¡Luz y progreso buen ser! (Light and progress, kind being!): The Misa Espiritual

It is now about seven o'clock in the evening. The mood in the nso-nganga is one of hushed solemnity. Many people, a significant number of them older women dressed in immaculate white, are crowded into the inner sanctum. Seated on wooden benches and an eclectic assortment of chairs, their heads are bowed in reverent concentration. Most puff reflectively on cigars. Other members of Santiago's ritual family spill out into the kitchen and down the hallway. When the time seems appropriate, Santiago inaugurates the lengthy prayer that signals the beginning of the spiritual mass. Many practiced voices merge with his:

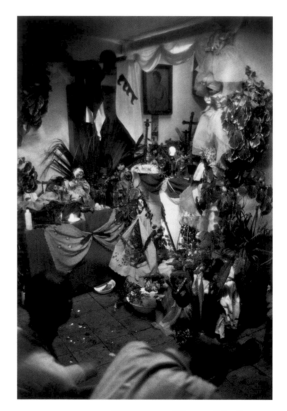

FIGURE 131. Misa espiritual (spiritual mass), 2001.

> *Rogamos al Señor Todopoderoso, que nos envíe Buenos espíritus para asistirnos, aleje a los que pudieran inducirnos en el error, y que nos dé la luz necesaria para distinguir la verdad de la impostura, Separad también a los espíritus malévolos, encarnados o desencardos, que podrían intentar poner la discordia entre nosotros y desviarnos de la caridad y el amor al prójimo. Si alguna pretendiera introducirse aquí , haced que no encuentre acceso en ninguno de nosotros. . . .*

Let us pray to the Lord Almighty, send us Good spirits to help us, drive off those that might lead us into error, and give us the necessary light to distinguish the truth from falsehood. Drive away the evil spirits, both embodied and disembodied, that may try to sow discord among us and lead us away from charity and love of neighbor. If an evil spirit should try to enter here, prevent it from having access in any one of us. . . .[22]

We all rise to our feet and variously join in reciting an Our Father, an Ave Maria, and a Gloria. As we sit back down, a member of the congregation intones a prayer in honor of the Blessed Virgin:

¡Oh Santisíma y dulcísima Virgen María, Madre de Dios, hija del Sumo Rey y Señora de los Angeles, Madre del Creador de todos. Reina de las misericordias, immense abismo de piedad! Tú nos recibas bajo tu protección y amparo a todos los que solicitamos tu favor. . . .

Oh Most Holy and sweet Virgin Mary, Mother of God, daughter of the Most High King and Lady of Angels, Mother of the Creator. Queen of Mercy, deep source of piety! Take us under your protection and shelter those who seek your favor. . . .[23]

Ángel Felipe Guibel, the priest who initiated Santiago as a santero some forty years ago, occupies a place of honor among the other lifelong (and over-whelmingly female) espiritistas. We are privileged to be in the room with this core group of elders. Although they know all the requisite hymns and invocations, Robertico, Santiago's main assistant during the mass, assumes the vocal lead. *Sea el santísimo,* he sings. *¡Sea!* we all shout in response.

Sea el santísimo.	Long live the Blessed Sacrament.[24]
¡Sea!	So be it!
Sea el santísimo.	Long live the Blessed Sacrament.
¡Sea!	So be it!
Madre mia de la caridad,	My Mother of Charity,
Ayudanos, amparanos,	Help us, shelter us,
En el nombre de Dios, Ay dios.	In the name of God, Oh Lord.

Robertico's richly cadenced voice guides the rest of us through the litany of Catholic and spiritist prayers and hymns. The aim of these steady calls

to the other world is to invoke benevolent, charitable souls while keeping potentially disruptive, "intranquil" spirits at bay.[25] This first segment of the mass is punctuated by moments of collective choreography as we all stand to turn in place—first to the left, then to the right—or to cross ourselves as specific devotional prayers are recited.

> *Criatura de Dios, yo te curo, ensalmo y bendigo en nombre de la Santísima Trinidad Padre +, Hijo +, Espíritu Santo +, tres personas y una esencia verdadera y de la Virgen María, Nuestra Señora, concebida sin mancha de pecado original. . . .*

> Child of God, I heal you, anoint you, and bless you in the name of the Holy Trinity, Father + [sign of the cross], Son + [sign of the cross], and Holy Spirit + [sign of the cross], three persons but one and indivisible, and of the Virgin Mary, Our Lady, conceived without original sin. . . .[26]

Santiago's spiritual altar is the luminous focal point of this mass in honor of the "dead of light." Painted figures of Catholic saints and more exotic spirit guides adorn the altar. Dolls representing specific orichas and an assortment of personalities from the land of the dead flank the alcove and enliven a narrow table along the wall. Freshly bathed and coiffed, they are dressed in newly laundered outfits with shimmering satin tops. The heady fragrance of white *azucena* lilies mingles with cigar smoke and perfume. Votive candles, placed throughout the room, provide fluttering pools of light. The tinkling of a small brass bell marks moments of prayerful transition. All these elements are sensory magnets for the dead. An older woman, spider thin, rises falteringly to her feet and initiates a song. Her voice, quavery at first, slowly gains in strength:

La luz, la luz, ay la luz,	The light, the light, oh the light,
Radia la luz, poder divino,	Divine Power, send us light,
Radia la luz del Salvador.	Radiate the Light of the Savior.

Santiago is exhausted from last night's Palo ritualizing and a long day of preparing for this evening's festivities. With eyes closed, head leaning back against the wall, he sits by the entrance of the nso-nganga. The rhythmic rise and fall of Robertico's voice and the hastily murmured responses of the congregation have lulled him into a somnolent state. He is not alone. The evening had begun with a communal feast of stewed goat and roast pig, the bounty of last night's matanza. The aftereffects of this huge meal in combination with the heat, our collective fatigue, and long bouts of uninterrupted prayer are having a hypnotic effect on many of us.

After a lengthy adoration, the focus of the mass shifts as Santiago approaches the bóveda to address his protector spirits. He calls on the dead elders of his priestly line, deceased family members, and his personal guardian spirits. The formerly dingy background of his father's portrait is now a dazzling white, having been painted along with the rest of the altar alcove several days ago. Santiago dips his hands in a basin of purifying leafy water and refreshes his upper body, following this with a liberal dose of perfume. He then extends his arms above his head, spreads his fingers wide, and starts to sing a hauntingly beautiful trasmisión in honor of his muertos de luz.[27]

La luz redentora te llama,	The redeeming light calls you,
Pero la luz redentora te llama,	Oh, yes, the redeeming light calls you,
Y te llama con amor a la tiera.	And it calls you with love to the earth.
Yo quisiera ver a ese ser,	I would like to see that being,
Oh llamando a ver el Divino Manuel.	Oh calling to see the Divine Manuel.[28]

As Santiago elevates these ephemeral beings with fragrance, light, and poignant song, the energy flows both ways. He is not only transmitting but receiving strength and illumination. Before leaving the bóveda, he makes

a series of brisk finger-slapping gestures over the altar. This sends positive, charitable vibrations (*caridad*) radiating out into space and simultaneously discourages his muertos de luz from trying to incarnate themselves in his body.[29] Once Santiago has reclaimed his seat, every person in the house comes forward, one at a time, to commune with his or her spirits. The more experienced espiritistas send tremulous songs soaring upward to further uplift their dead.

Ay que distante se veen estos seres,	Oh these beings seem so distant,
Y sin embargo los tenemos presentes.	And yet we keep them present in our thoughts.
Ellos vienen de lo infinito, madre,	They come from the realm of the infinite, Mother,
Traigando flores en un santiamén.	Bringing flowers in no time at all.
¡Eh! Coronación. ¡Eh! Coronación para los seres. (bis)	Hey! Coronation. Hey! Coronation for these beings. (twice)

Many of these older women shudder convulsively as the spirits receive their trasmiciónes. Some turn from the altar bearing messages from the beyond for specific individuals. When Santiago and his godfather, Ángel, ritually twirl each of the women, several stumble, verging on possession. Xiomara, a core family member, is the last to step up to the bóveda. As she completes her shimmering round of invocations, Santiago suddenly launches into a Congo song.[30] The tempo is slow but insistent. He is purposefully redirecting our energy and attention.

San Hilarión, comisión Africana,	Saint Hilarion, African [spirit] commission,[31]
San Hilarión, comisión Mayombe.	Saint Hilarion, Mayombe [Congo] commission.

San Hilarión, comisión Africana,	Saint Hilarion, African commission,
¿San Hilarión, donde estan estos Congos?	Saint Hilarion, where are those Congos?
San Hilarión, comisión Africana,	Saint Hilarion. African commission,
¿San Hilarión, donde estan estos muertos?	Saint Hilarion, where are those "dead"?
San Hilaríon, comisión Africana,	Saint Hilarion, African commission,
¿San Hilaríon, donde estan las Gitanas?	Saint Hilarion, where are the Gypsies?
San Hilaríon, comisión Africana,	Saint Hilarion, African commission,
¿San Hilaríon, donde estan estos Indios?	Saint Hilarion, where are those Indians?

As everyone picks up the chorus, *San Hilarión, comisión Africana*, an irreversible shift occurs. The introverted formality of the mass gives way to a renewed sense of spontaneity. As people start clapping the rhythm, the singing becomes more vigorous and a feeling of joyous anticipation sweeps the room. Xiomara, who had been flirting with possession as she addressed her spirits, suddenly screams and doubles over as if in pain. She lurches forward and several godchildren rush to prevent her from falling. A young man grabs a maraca off the altar and shakes it urgently, driving the spirit down into Xiomara's head.[32] With repeated high-pitched shouts, the incoming spirit throws her body first against the wall then out into the crowd before finally settling in. Several people shout *¡Luz y progreso, buen ser!* (Light and progress, kind being!) in acknowledgment of our otherworldly visitor. Santiago smiles for the first time all evening, visibly delighted to have this familiar and rather wild Haitian spirit in our midst. The female spirit starts to sing:

Yo no soy de aqui,	I am not from here,
Ni me parezco a nadie.	Nor do I look like anyone else.

¿Quien en Africa me esta buscando,	Who in Africa is looking for me,
muchacho?	muchacho?
Yo respondo en Haiti.	I answer in Haiti.
Ay, yo no soy de aqui,	Oh, I am not from here,
Ni me parezco a nadie.	Nor do I look like anyone else
Y en Africa me andan buscando,	And in Africa they go looking for me,
Yo respondo en Haiti.	I answer in Haiti.
Y si en Haiti me andan buscando,	And if in Haiti they go looking for me,
Yo respondo en Africa.	I answer in Africa.
Y si en Africa me estan buscando,	And if in Africa they are looking for me,
Yo respondo en Haiti.	I answer in Haiti.

Although Xiomara's muerta sings in Spanish, she speaks a highly animated language that is totally incomprehensible.[33] No matter—her giddy pronouncements energize everyone. Suddenly, as precipitously as she had come, the Haitian muerta takes her leave. Looking dazed, Xiomara staggers back to her seat to recover. Now that a spirit of the dead has made an appearance, there is a pronounced surge in activity. Drums are brought out and chairs shoved back against the wall. People start pressing into the nso-nganga from all corners of the house. Although the space is becoming more congested, it feels less claustrophobic. The drummers strike up a song. We pour our hearts and souls into it.

¡Bombo siré!	*¡Bombo siré!*[34]
¡Yo bombo naya!	*¡Yo bombo naya!*
¡Bombo siré!	*¡Bombo siré!*
¡Ay! Yo bombo naya.	*¡Ay! Yo bombo naya.*

Yo estaba buscando un Congo	I was looking for a Congo,
Que vira Siete Rayos,	Who works with "Seven Lightning Bolts."
Y yo estaba buscando un Congo	And I was looking for a Congo,
Que vira Siete Rayos.	Who works with "Seven Lightning Bolts."

Throughout the mass, the two of us had been standing in a back corner of the nso-nganga, sandwiched between Santiago's bathroom and a crowded cement stoop that leads up to his grandson's room. Mesmerized by the hypnotic repetition of the service, we had drifted into our own separate worlds. Now that the rarefied, churchlike atmosphere has lifted, both of us experience a sense of relief. The evening has crossed over into emphatically Congo territory and we are now free to move around. This untrammeled part of the celebration promises to last until well after daybreak. As the drumming intensifies, Santiago jumps up and belts out a fast-paced mambo:

¡Ah! Güiri, güiri, güiri, ngó,	Ah! Listen, listen, listen, *ngó*,[35]
¡Ah ! Güiri, güiri, ngó.	Ah! Listen, listen, *ngó*.
(bis)	(twice)
Ando buscando un Congo,	I'm looking for a Congo,
Que pueda ma' que yo.	Who's more powerful than me.

Halfway through this ebullient song, Santiago is overcome by his primary muerto, Pa Francisco. This playful Congo spirit is by now quite familiar to us. When he appears, it is like greeting a favorite uncle. From the moment Pa Francisco sets foot in the room, he is *candela*—high-spirited, mischievous, unpredictable.[36] While being ritually outfitted with red scarves and his signature dilapidated straw hat, he testily demands *malafo* (the Congo word for crude rum). Someone rushes over to the Palo altar to get it for him. Pa Fran-

cisco tosses back a good third of the bottle. Appropriately fired up, he turns to all of us with a song of greeting:

Congo de guinea soy,	I am a Congo from Africa,
¡Buena' noche' criollo'!	Good evening Creoles![37]
(bis)	(twice)
¡Ay! Congo de guinea soy,	Oh! I'm a Congo from Africa,
¡Buena' noche' criollo'!	Good evening Creoles!
Yo deja mis huesos allá,	I leave my bones over there,
Yo vien hacer caridad.	I come to do good works.
Yo deja mi tierra allá,	I leave my homeland over there,
Yo vien hacer caridad.	I come to do good works.
Yo deja mi tumba allá,	I leave my tomb over there,
Yo vien hacer caridad.	I come to do good works.
Yo deja mi cueva allá,	I leave my cave over there,
Yo vien hacer caridad.	I come to do good works.

The country bumpkin Pa Francisco loves to horse around.[38] With the remains of his bottle cinched in the crook of his arm, he surveys the crowd, sizing it up. Within minutes he has armed himself with a switch of wild forest branches and is gleefully beating a swath through the room. Everyone in his path cringes away or scurries for cover. As the dancing and singing continue unabated, the spirit Pa Francisco unexpectedly withdraws and is replaced by Piti Bonswa (Little Good Evening), one of Santiago's Haitian muertos. This is unusual given Santiago's reluctance to work these rough-and-tumble spirits now that he has gotten older. Although the intrusion lasts but a few minutes, Piti Bonswa makes a point of greeting Anneke in Haitian Creole before retiring for the night. She is delighted and wishes he could have stayed a bit longer.

"I have two muertos who are Haitian. Piti Bonswa and Papa Kenge. . . . I don't work them much anymore because they crawl around a lot on the ground, . . . and I mean . . . a lot. They get pretty out-of-control because they drink a lot of tafia [cane alcohol]." Santiago pauses as he thinks back to his younger days and says, "Man, those Haitian muertos gave me a hard time. . . . *¡Ha ha! ¡Ay! . . . guagua.*"

SANTIAGO CASTAÑEDA VERA,
2002

Pa Francisco has barely reclaimed Santiago's body when a deep, raucous laugh erupts on the other side of the room. The Congo Pa Julian has come down and possessed a short, plump woman named Nina. Even as a friend struggles to remove Nina's earthly accessories, the muerto inhabiting her body starts to swagger about the nso-nganga, establishing his macho credentials. Balls of spittle regularly appear in the corners of Pa Julian's mouth. As they start the slow slide down his chin, they are quickly wiped away by his personal assistant. The atmosphere is increasingly jovial, heady, as the dead keep coming. Pa Julian starts to sing:

¿Quien me llamo?	Who called for me?
¿Pa' que me llamo?	Why did someone call for me?
¿Quien me llamo?	Who called for me?
¿Paraque fue que me llamo?	Why did someone call for me?
Cuando yo vivo en tierra yesá, muchacho,	When I lived in Africa, muchacho,[39]
¿Quien fue que me llamo?	Who was it called for me?
¿Quien me llamo?	Who called for me?
¿Pero quien me esta llamando?	Well who's calling for me?
¿Quien me llamo?	Who called for me?
¡Eh! ¿Pa' que tu me llama?	Hey! Why are you calling me?
¿Si tu no me conoces,	If you don't know me,
Pa' que tu me llamas?	Why are you calling me?
¿Si yo no te conozco,	If I don't know you,
Pa' que tu me llamas?	Then why are you calling me?
¡Eh! Yo me llamo como quiera,	Hey! My name is whatever,
¿Pa' que tu me llamas?	Why are you calling me?
¿Pero a las doce de la noche,	But at twelve midnight,
Pa' que tu me llamas?	Why are you calling me?

There is a great deal of posturing when Pa Julian and Pa Francisco finally meet up with each other. Waggish insults fly back and forth as the two muertos jockey for position.[40] Beneath all this verbal and physical sparring, there is a certain crusty camaraderie. Nina—Pa Julian's human host—does not drink at all. Much to her guardian's dismay, however, her muerto swigs raw rum with abandon.

After pontificating at some length to the assembled crowd, Pa Julian homes in on a couple of family members whose straying personal loyalties are a subject of concern. He concentrates on two young men known to be involved with foreign women. One of Pa Julian's targets is a handsome, powerfully built computer programmer by the name of Pupo. Married to an Australian woman, he is back in Cuba to visit family, participate in the November ceremonies, and fulfill important ritual obligations.

Dici carajo . . . dici, Pa Julian growls as a lead-in (I say goddamn it . . . I say). He then starts grilling Pupo about his new life in Australia. The overseas relationship poses a potential threat. It could eventually erode Pupo's sense of personal responsibility toward family back here in Cuba. At first Pupo's answers are respectful if somewhat evasive. But after sufficient badgering on the part of Pa Julian, the exchange takes on a distinctly ribald tone. Everyone within earshot enjoys the turn their conversation has taken. The show of escalating machismo peaks when Pa Julian, never overly refined in his mannerisms, grabs his crotch provocatively and bellows *¡Tengo los cojones de siete hombres!* (I have the balls of seven men!) This display of bravado seems to settle the score for the time being.

In the adjacent kitchen, Pa Francisco sways back on his heels, arms folded across his puffed-out chest. Through a billowing cloud of cigar smoke, he fixes a young woman with his gaze. The spirit is both a caricature of pompous self-importance and a steadying, rock-solid presence. Like the bozal speech of most Congo muertos, Pa Francisco's is creolized and rather nasal.

¿Tu kuenda? he prods (You understand?). Although the young woman has no understanding of bozal, she is listening with rapt attention. Pa Francisco repeats himself, making his words more transparently Spanish, followed by an "Am I right?" in Congo spirit-speak. When necessary a seasoned member of the ritual family steps in to interpret what the muerto is saying. Pa Francisco and the young woman are soon locked in an intense whispered conversation. The otherworldly consultation lasts much longer then usual.[41] At the end of the session, Pa Francisco twirls his charge and yanks her arms downward in a socket-wrenching pull. He then releases her out into the crowd.[42]

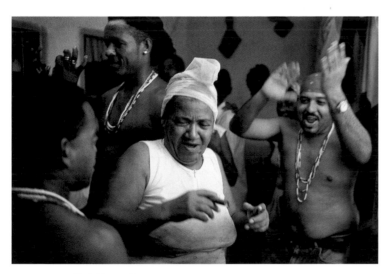

FIGURE 132. Pa Julian, a Congo spirit of the dead.

Pa Julian, meanwhile, has an important matter to discuss with Santiago's fifteen-year-old grandson and is ordering a reluctant Chaguito out into the middle of the nso-nganga. The spirit starts chastising the boy in front of an avid audience. His harangue goes something like this: Times are increasingly unstable, even dangerous. Chaguito is hanging out on the streets at all hours. His grandfather does not approve of this quasi-delinquent behavior. Who does Chaguito think he is? He should be more respectful of his grandfather's position in the community. Pa Julian is telling him this for his own good, and so on. A bevy of women closely associated with Santiago's household are lined up behind Pa Julian, hanging on the spirit's every word. From time to time, they nod their heads in agreement. Although Chaguito shrugs off the muerto's advice in an attempt to save face, he is obviously mortified by the public nature of the reprimand.

As Pa Francisco and Pa Julian occupy center stage in their respective rooms, a commotion breaks out in the hallway. Ma Rufina, a female spirit of

the dead, has decided to grace us with her enigmatic but intoxicating presence. She invariably chooses Elvira, a ritual mainstay of Santiago's house, as her human "horse." Hands defiantly on hips, Ma Rufina's body posture and expression are stern, threatening.[43] Her eyes crackle with electricity, challenging anyone who dares meet her gaze. The drummers respond to Ma Rufina's arrival by introducing a rip-roaring Congo song:

Congo, conguito,	Congo, "little Congo,"[44]
Congo de verdad.	Genuine Congo.
(bis)	(twice)
Ay mi Congo, conguito,	Oh my Congo, "little Congo,"
Congo de verdad.	Genuine Congo.
Si tu vas a la tierra,	If you go to earth,
Es pa' hacer caridad.	It's to do good works.
Congo, conguito,	Congo, "little Congo,"
Congo de verdad.	Genuine Congo.
Tu vas a la tierra,	You go to earth,
Pa' hacer caridad.	To do good works.
Mi Congo va a la tierra,	My Congo comes to earth,
Hacer caridad.	To do good works.
Pero Julian esta en la tierra,	Well Julian is here on earth,
Hacer caridad.	To do good works.
Allí esta Francisco en la tierra,	There's Francisco here on earth,
Hacer caridad.	To do good works.
Hay Ma Rufina en la tierra,	Ma Rufina's here on earth,
Hacer caridad.	To do good works.

Like Xiomara's muerta, Ma Rufina is an enormously expressive Haitian spirit. Although she rarely speaks, she uses astonishing body language

FIGURE 133. Ma Rufina, a Congo-Haitian spirit of the dead.

to communicate with her children and to otherwise convey her needs. Ma Rufina has a deep affinity for the driving percussive rhythms of the drums. Within moments of her arrival, she is energetically whipping her torso from side to side, moving with the force of a whirlwind as she dances first toward and then away from the musicians.[45] Judging from her facial expression, the performance is neither loud nor vigorous enough. The spirit bends down ostentatiously near the main drum, cocks her ear as though trying to decipher what they are playing, and then throws up her arms in a classic gesture of disgust. Already sweating profusely, the drummers redouble their efforts. Once satisfied, Ma Rufina goes back to dancing for a while, pausing on occasion to ferociously butt heads with a family member. At one point, she gazes over in our direction and hastily improvises a kind of spyglass with her fingers. The spirit's pantomime is a direct response to our camera-wielding presence. The crowd is now enthusiastically singing the refrain "Only Africa":

Africa na' ma'	Only Africa
Africa na' ma'	Only Africa
Cuando yo viene de tierra Congo,	When I come from the land of the Congos,
Yo Africa na' ma.'	I am pure African.
Africa na' ma'	Only Africa
Africa na' ma'	Only Africa
Cuando yo viene de tierra yesá,	When I come from the land of the dead,
Yo Africa na' ma.'	I am pure African.

Cuando yo viene de tierra Congo,	When I come from the land of the Congos,
Yo Africa na' ma.'	I am pure African.

The general mayhem of the dead surging around the room is reaching an all-time high. There are now three Congo *muertos* dancing, singing, speechifying, and hurling tongue-in-cheek insults at one another. A visiting Palo priest, unaffiliated with Santiago's house, adds his barbed energy to the mix. From the moment this palero arrives he plays the role of agent provocateur, aggressively challenging Santiago as well as the Congo spirits of the dead. Although no one is spared, the taunting dynamic between the visitor and Pa Francisco is particularly intense. Each of their exchanges spurs them on to even greater derogatory heights until the nso-nganga becomes a battlefield of insult and provocation. Pa Francisco, refusing to be outdone in this power play, throws out a well-known "challenge song" (*canto de puya*). It is pointedly aimed at the rival palero.[46]

Hacha con hacha,	Ax with ax,
Palo con palo,	Tree with tree,
Hierro con hierro,	Iron with iron,
No puede topar.	Must not fight each other.
Hacha con hacha,	Ax with ax,
¡Yo! Palo con palo,	Heh! Tree with tree,
Yo juega kimbisa,	I'm working *kimbisa* [Palo Monte],
Vamos a topar.	We're going to butt heads.[47]
Hacha con hacha,	Ax with ax,
No puede topar.	Must not fight each other.
Palo con palo,	Tree with tree,
No puede topar.	Must not fight each other.

As the song comes to an end, Pa Francisco turns abruptly away from his antagonist. Brandishing a replenished bottle of rum, he starts to dispense streams of the fiery liquid directly into our mouths as a form of blessing. Any attempt to stem the flow meets with a harsh reprimand. Despite brief lulls, the ceremony is again reaching fever pitch. The engulfing smell of rum, sweat, and cigar smoke; the plunging, twirling bodies; and the dynamic call and response of songs thrown out to and by the spirits are all overlapping, cascading together. The sensory bombardment is overwhelming. It is now about four in the morning. Pa Francisco initiates a rather plaintive mambo:

¿Pa' que tu me llamas?	Why are you calling me?
¿Pa' que me molestas?	Why are you bothering me?
¿Pa' que tu me llamas, Congo?	Why are you calling me, Congo?
¿Pa' que me molestas?	Why are you disturbing me?
Si a las doce de la noche	If at twelve midnight
Yo tiembla mi nganga,	I'm shaking my nganga [prenda],
¿Eh pa' que tu me llamas, muchacho?	Hey, why are you calling me, muchacho?
¿Pa' que me molestas?	Why are you bothering me?
Si a las doce de la noche	If at twelve midnight
¡Eh! Yo estoy en sabana,	Hey! I'm [busy] in the savanna,
¿Pa' que tu me llamas, manigüero?	Why are you calling me, backwoodsman?
¿Pa' que me molestas?	Why are you bothering me?[48]

Advice, both solicited and unsolicited, is flowing freely, as are blessings and intimate gestures of purification. With the burning end of a cigar inside her mouth, Ma Rufina cups a man's face in her hands and directs a steady funnel of smoke over his head and body. A few feet away, Pa Francisco wipes his

brow and then lovingly smears a child's face with his sweat. Their smoke and sweat are laden with the healing vitality of the dead. From time to time, Pa Francisco hoists individuals onto his back and then, after charging them with his energy, drops them precipitously like so much dead weight.

It is impossible to keep track of everything that is going on. Suddenly we realize that Pa Francisco is no longer in the room. As one of us is about to investigate, a powerful new voice projects a song from the front of the house:

El dia que yo me muera, nganga,	The day that I die, nganga,
No me entierren en una tumba.	Don't bury me in a tomb.
Tirame en una sabana, muchacho,	Throw me out in a savanna,
	muchacho,
Pa'que mayimbe me uria.	So that the buzzards can feed off me.

The visiting palero's relentless goading, much of it aimed at bringing Sarabanda down, has had its effect. The muerto Pa Francisco has disappeared, giving way to this volatile Palo spirit. Almost upon arriving, Sarabanda rushes out into the street. After a frenzied foray through the urban "bush," he charges back into the house. Wild-eyed and wielding branches torn from neighborhood trees, the spirit pauses to sniff the air as though ferreting out possible enemies. Unlike Pa Francisco, Sarabanda is notoriously belligerent and demanding. Even the way he greets people amounts to a challenge as he rams heads with skull-crushing force. These brutal, unexpected moves generate considerable tension at first. Once Sarabanda has asserted control, his behavior becomes less truculent.

It is six in the morning. Daybreak has by now long leached the stars from the night sky. Most of us are dazed with exhaustion. Then suddenly, out of the blue, something truly out of the ordinary takes place. Sarabanda, ever present in Santiago's body, envelops Robertico in a powerful embrace and starts to rock him . . . slowly . . . back and forth. During this spellbinding mo-

ment of communion, Sarabanda decides to withdraw for the evening. As the spirit takes his leave, an electric current passes through Robertico and he in turn falls into trance, overtaken by his Congo muerto, Pa Lucero. Pacing restlessly to and fro, the newly possessed Robertico delivers a surprisingly gentle, finger-wagging diatribe that targets members of Santiago's ritual family. His words elicit a knowing, "what have I been telling you" smile from Santiago. The spirit then disappears into the kitchen and returns with a plate of rice, flower petals, honey, and other soothing ingredients. Using these elements, Pa Lucero performs a cleansing for Santiago. The improvised ceremony is profoundly moving. As the tension drains out of Santiago's mind and body, he becomes a slate wiped clean of worldly concerns. In this state of newfound innocence, Santiago starts to sing: *Yo no soy de aqui, ni me parezco a nadie* (I am not from here, nor do I look like anyone else). The emotion in his voice is heartfelt, exhausted, and pure.

Santa María Madre,	Holy Mother Mary,
Santa Teresa de Jesús,	Saint Teresa of Jesus,
'Hora viene un misionero,	Here comes a missionary,
Y viene buscando luz.	And he comes looking for light.
¡Ay trabaja! ¡Ay trabaja!	Oh work! Oh keep working!
¡Oye! Labora media unidad,	Listen! Work your mediumship,
Laborando se recibe	It's by working you receive
Fe, Esperanza, y Caridad.	Faith, Hope, and Charity.
¡Trabaja! ¡Trabaja!	Work on! Keep on working!
Trabaja media unidad,	Work your mediumship,
Laborando se recibe	It's by working you receive
Fe, Esperanza, y Caridad.	Faith, Hope, and Charity.
¡Pero trabaja! ¡Ay trabaja!	Well work on! Oh keep working!
¡Oye trabaja! ¡Si! Media unidad,	Listen work! Yes! Your mediumship,
¡Eh! Con los muertos recibimos	Hey! With the dead we all receive
Fe, Esperanza, y Caridad. ¡Mi Dios!	Faith, Hope, and Charity. My Lord![49]

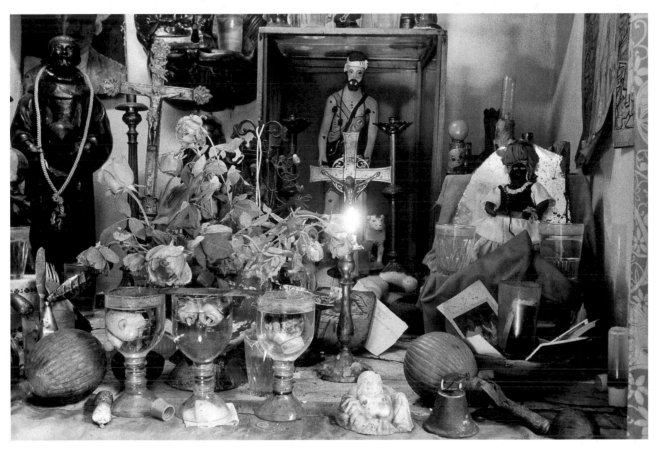

FIGURE 134. Brass crucifixes, statues of saints, and dolls representing various spirit guides mingle on Santiago's bóveda or spiritual altar. Ma Rufina, a Haitian spirit of the dead, is enthroned on the right in front of a mirror fragment. Saint Francis and Saint Lazarus are visible to left and center. Three water-filled glasses in the foreground represent Faith, Hope, and Charity, virtues central to Santiago's spiritist beliefs. Along with prayer, the tinkling of devotional bells, flowers, candlelight, cigar smoke, and perfume, water is instrumental in attracting the transcendent "dead of light."

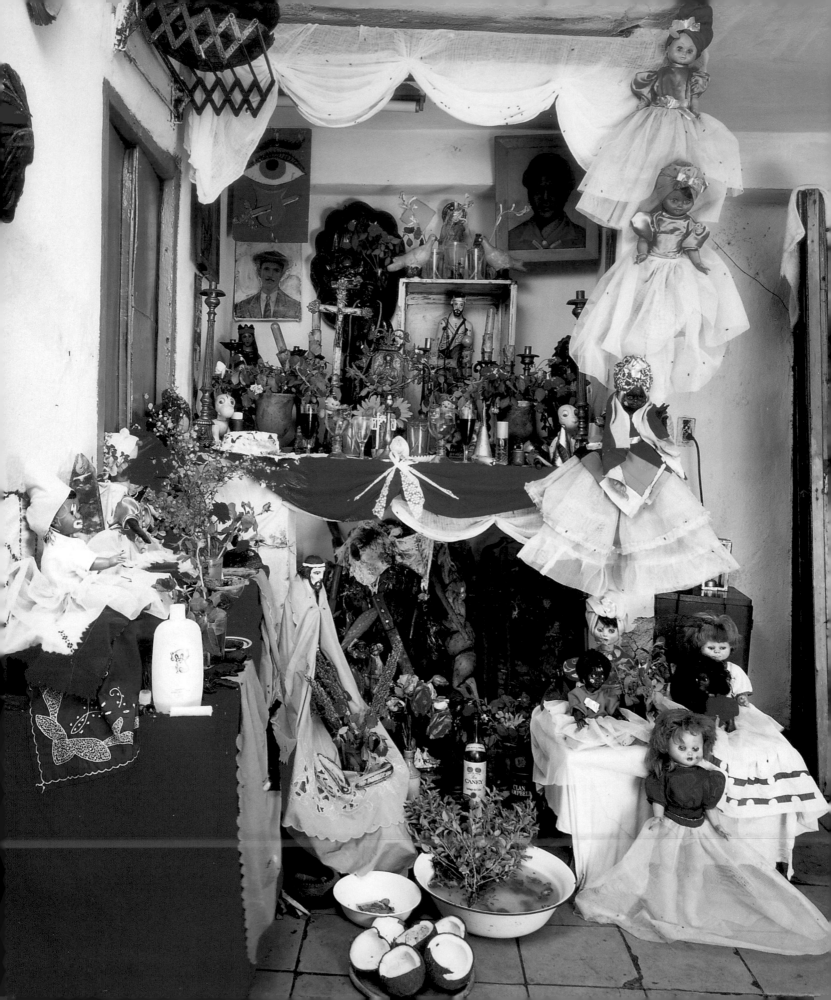

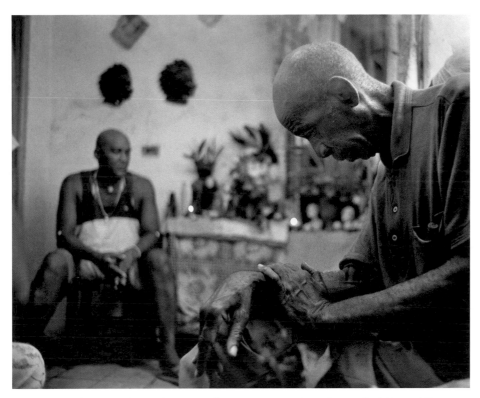

FIGURE 136. The spiritual mass begins as all present start reciting a litany of spiritist and Roman Catholic prayers.

FIGURE 135. Santiago's splendidly arrayed bóveda is now ready for the evening's spiritual mass. The many dolls flanking the altar represent particular orichas as well as protective spirit guides from the land of the dead. Portraits of Santiago's deceased father and mother hang on the back wall of the alcove. The painting of an all-seeing eye above a pierced tongue warns against indiscretion while offering protection from such "dangers of the mouth."

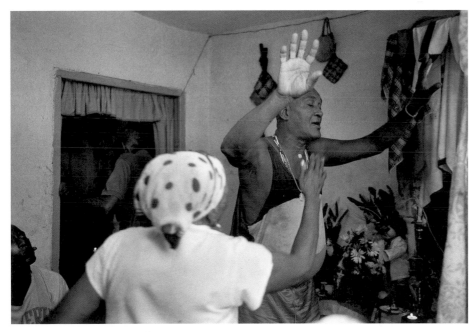

FIGURE 137. Standing at the bóveda, Santiago sends a hauntingly beautiful "transmission" (spiritist song) vibrating out into space to further elevate his "dead of light."

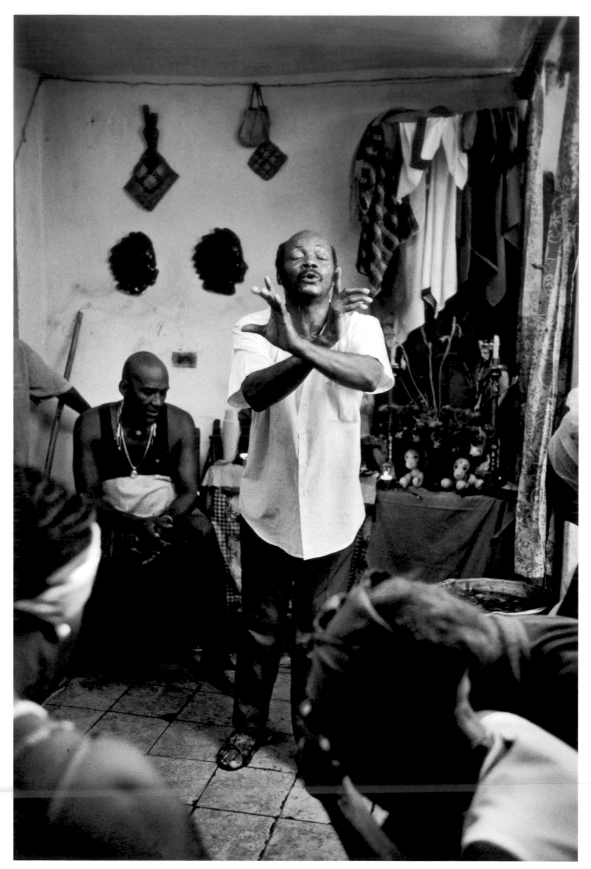

FIGURE 138. Robertico leads a song invoking benevolent, charitable spirits during the spiritual mass.

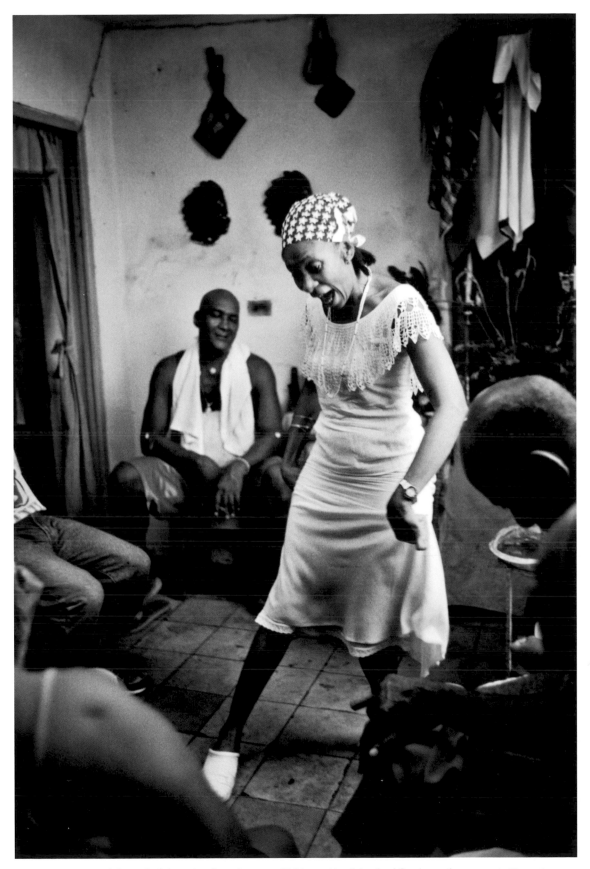

FIGURE 139. Toward the end of the rather formal mass, a Haitian spirit of the dead flamboyantly possesses Xiomara. The evening's ritualizing quickly crosses over into Congo territory.

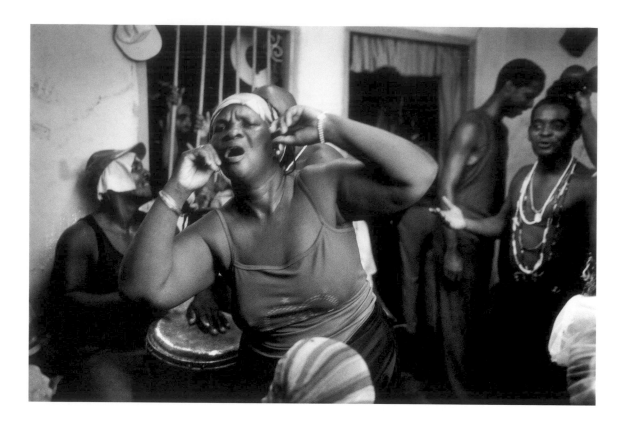

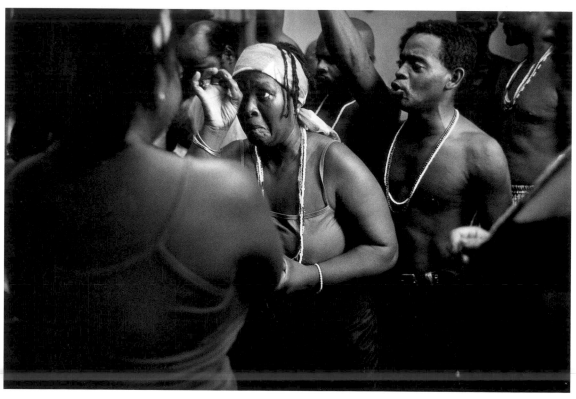

FIGURES 140 THROUGH 143. The female Congo-Haitian spirit Ma Rufina makes a highly energetic appearance. Although she does not communicate verbally, she more than compensates with her body language.

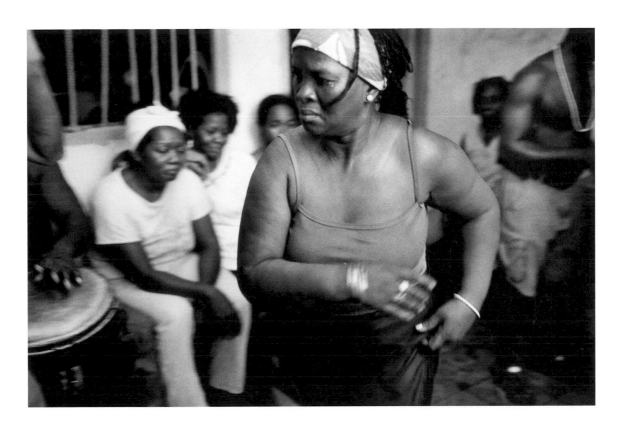

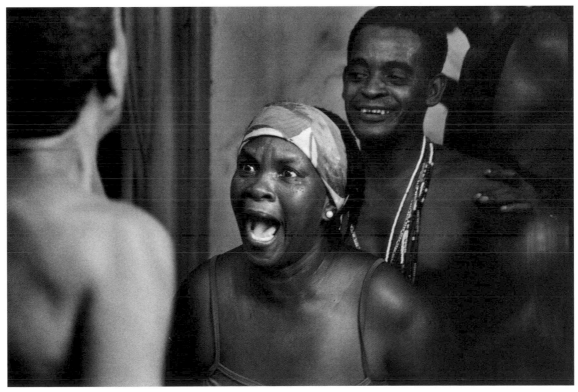

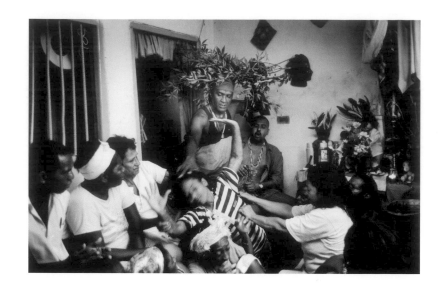

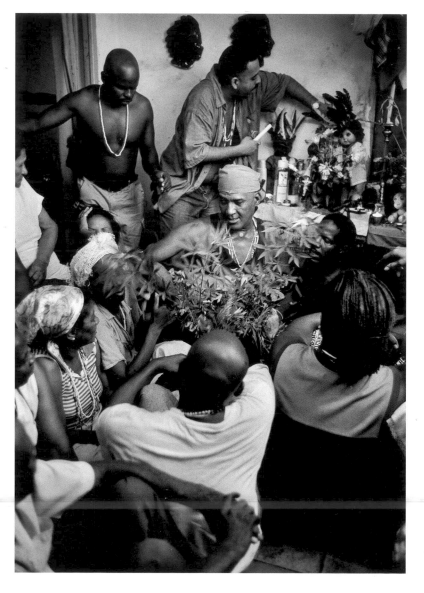

FIGURES 144 AND 145.
Bursting into the nso-nganga, Pa Francisco calms a young neighborhood woman whose sudden, uncontrolled possession is judged inappropriate. After sending the unknown spirit on its way, Pa Francisco sinks to the floor in a sea of leaves to commune with his followers.

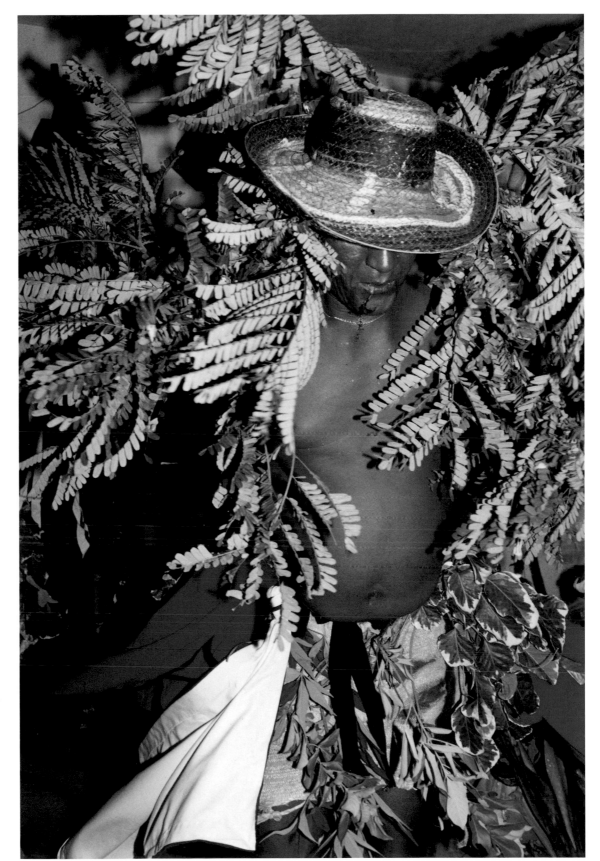

FIGURE 146. Returning from a covert mission at a nearby crossroads, Sarabanda charges in from the street wearing a mantle of forest leaves. The feathers and trail of blood on his chin signal the recent demise of a chicken. Sarabanda invariably comes down to possess Santiago during the celebration of the Congo dead.

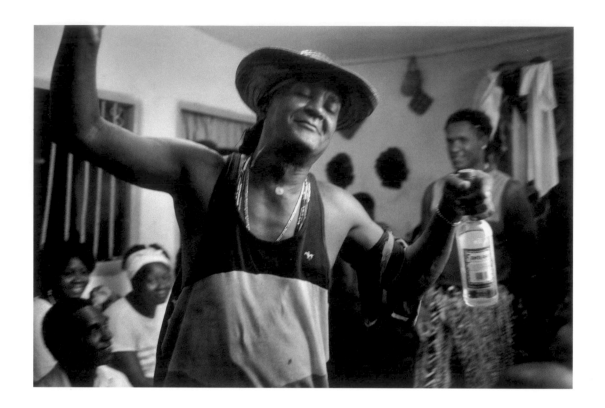

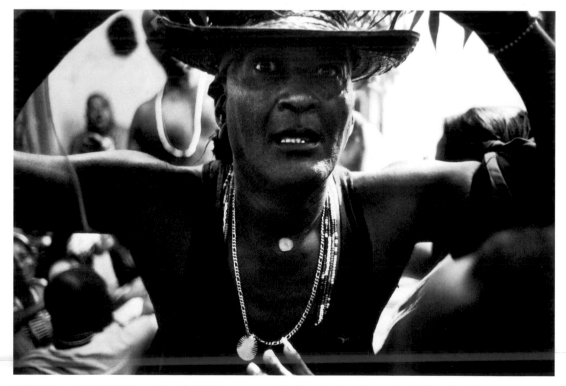

FIGURES 147 THROUGH 150. The playful Congo muerto Pa Francisco is a force to be dealt with as he carouses with the living. Given to infantile moments, he maniacally beats a path through the nso-nganga. In the course of the evening he must also contend with the taunts of a visiting palero, an outsider to Santiago's "house." Pa Francisco has no problem responding to the challenge and teasingly hurls insult for insult.

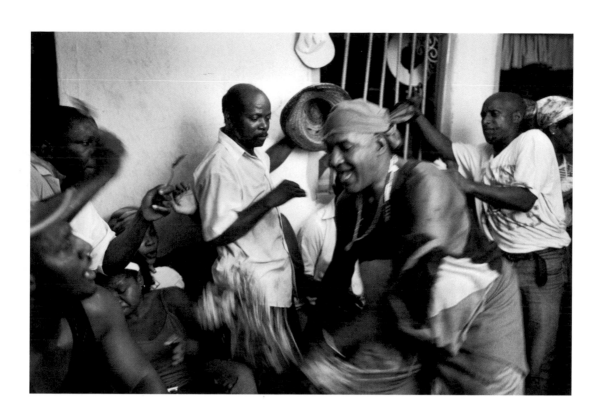

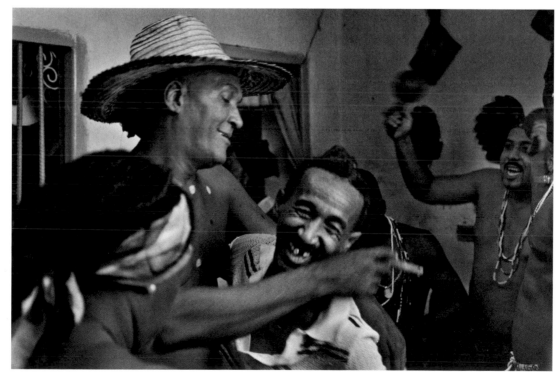

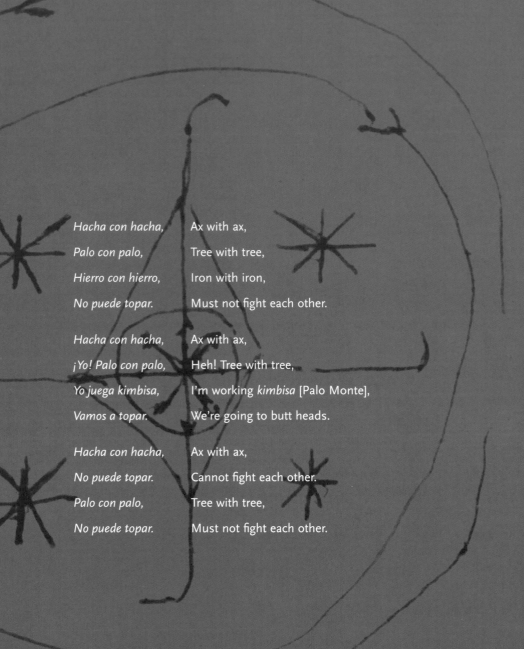

Hacha con hacha,	Ax with ax,
Palo con palo,	Tree with tree,
Hierro con hierro,	Iron with iron,
No puede topar.	Must not fight each other.
Hacha con hacha,	Ax with ax,
¡Yo! Palo con palo,	Heh! Tree with tree,
Yo juega kimbisa,	I'm working *kimbisa* [Palo Monte],
Vamos a topar.	We're going to butt heads.
Hacha con hacha,	Ax with ax,
No puede topar.	Cannot fight each other.
Palo con palo,	Tree with tree,
No puede topar.	Must not fight each other.

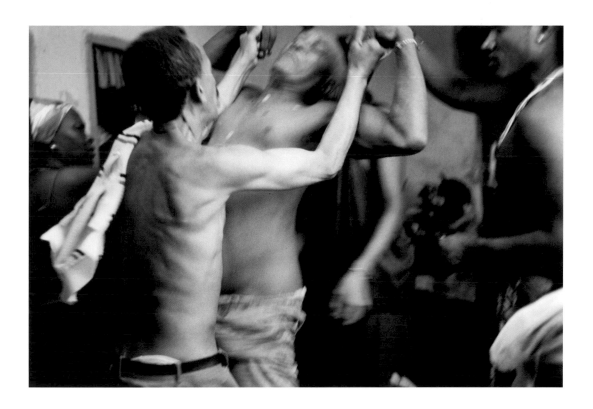

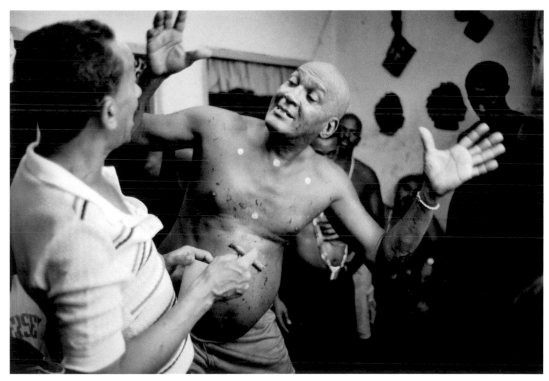

FIGURES 151 AND 152. The visiting palero finally provokes the Palo spirit Sarabanda into making another appearance. The atmosphere becomes quite tense as they challenge each other's authority with derisive songs and wilting strings of invective.

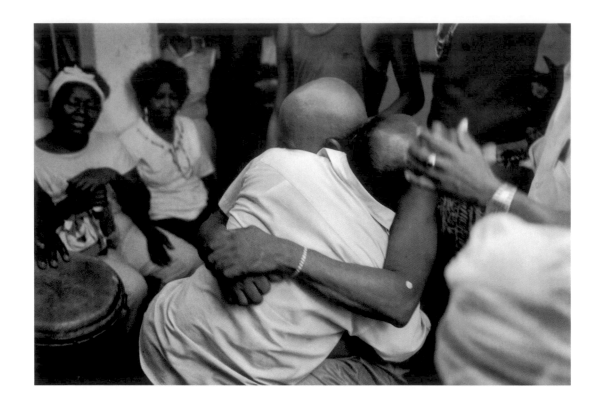

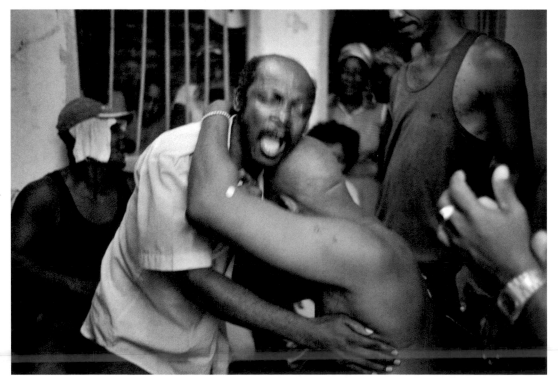

FIGURES 153 THROUGH 157. It is now about six in the morning. The Palo spirit Sarabanda suddenly envelops Robertico in a powerful embrace. As the spirit starts to leave Santiago's body, there is a startling transfer of energy and Robertico is overcome by Pa Lucero, his Congo spirit of the dead. Pacing energetically back and forth, the newly arrived muerto delivers a philosophically tinged "state of the union" address. To Santiago's great satisfaction, Pa Lucero alludes to recent instances of unacceptable behavior in the larger ritual family. Pa Lucero then performs a cleansing for Santiago. The improvised ceremony is deeply moving.

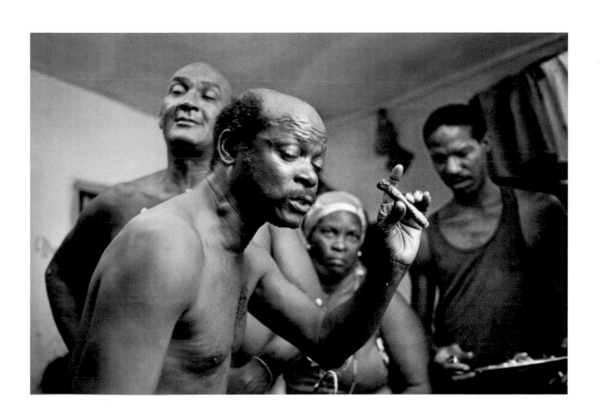

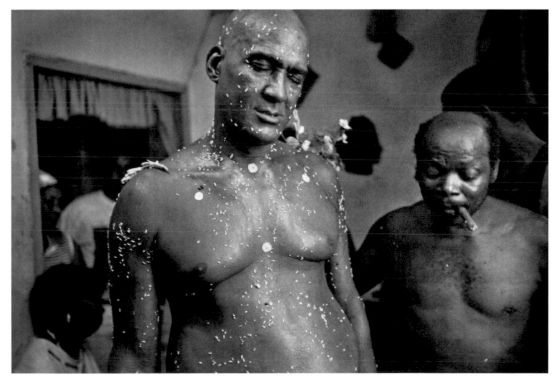

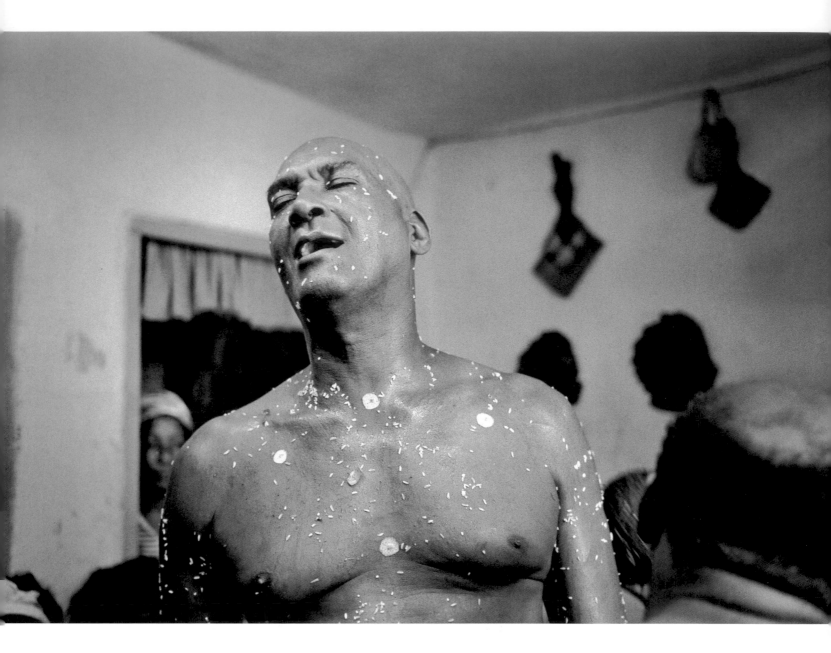

Yo no soy de aqui ni me parezco a nadie
(I am not from here nor do I look like anyone else).

LINE FROM CONGO RITUAL SONG

Afterword

¿Y LA OTRA? (AND THE OTHER ONE?):
THE NATURE OF OUR COLLABORATION

Crossing the Water is the result of a unique collaboration between the authors. There are, of course, many examples of writers and photographers who have joined forces to create visual essays and text that stand independently—in counterpoint to each other rather than one being illustrative of the other. We have from the outset envisioned a similar treatment of text and images in *Crossing the Water*, that is, as extended and complementary statements. This collaborative work differs, however, in that our tasks were not clearly delineated. We shared the roles of investigator, photographer, and writer throughout this multidimensional documentary project.

In the course of working with Santiago over a five-year period, we both shot photographs of the same rituals and would on occasion actually pass a camera back and forth between us. Gathering information in casual interviews, one of us might assume the questioning role while the other listened intently and scribbled notes. We printed together in the darkroom and jointly edited the images that were ultimately included in this book. In Cuba we seldom spent time with Santiago individually, choosing to present a united front both at work and at play. Aside from being colleagues, we are also great friends and, within the religion, sisters. This close relationship developed in the course of our collaboration and has contributed to the crystallization of our ideas into a single and, we hope, cohesive work.

While recognizing the individual strengths we brought to this undertaking, we are also aware that the way we worked makes the notion of singular authorship impossible. For this reason, we have chosen not to attach our respective names to any one part, be it photographic or written. Rather than specifying who did what, it seems more rewarding to examine the dynamics of our working in tandem and how this affected the look and final outcome of *Crossing the Water.*

Having two sets of photographic eyes allowed us to approach ritual from different perspectives, both literally and figuratively. Because the nso-nganga is small and was often crowded when we photographed, our ability to move quickly from one side of the room to the other was at best problematic and often impossible. The photographs taken from our respective corners, however, offer different views and greatly enhanced our final edits for the photo essays. Images that were taken moments apart—if not simultaneously—provide a three-dimensionality that a single photographer would have been hard-pressed to achieve. The drumming, singing, and dancing in combination with the unruly energy of the spirits make for multiple photographic opportunities. When assessing the images taken on these occasions, we would invariably find that one of us had been able to catch a particularly compelling moment while the other had been visually distracted or more actively engaged in the ritual process. In short, we were able to be in two places at the same time. Having this dual perspective allowed us to capture different aspects of a given ritual and provide a more comprehensive visual story.

Our time together in Cuba when not working directly with Santiago was also critical to our documentary process. Being able to talk about our observations and experiences helped each of us distill our understanding of Santiago and his religious practices. Occasionally, we would hole up in our apartment for days: bouncing ideas off each other as we worked through an overwhelming barrage of sensory and conceptual information, prodding one

another's memory, formulating questions, and writing up field notes. Finally and most importantly, we enjoyed each other's company. A shared sense of humor and love of life's non sequiturs helped keep things in perspective.

Writing the text for *Crossing the Water* offered its own set of challenges. While we have much in common in our photographic styles and general approach to fieldwork, this was not the case when it came to writing the text. Finding a voice for the book was particularly difficult and resulted in a lot of back and forth between us during the first half year or so. Ultimately, the text evolved from a mixture of secondary research greatly reinforced by Anneke's background in African and Caribbean art history and descriptive passages based on our individual observations and shared experiences. Once the overall content and form was established, Anneke pulled the work together, transforming and synthesizing the various elements to create a single, if multilayered, voice.

It augured well that Santiago accepted and treated us as a duo from the start. Over time, of course, we developed individual relationships with him as well as with various members of his extended family. To this day, however, on the rare occasions that one of us does show up alone, Santiago immediately asks, *¿Y la otra?*

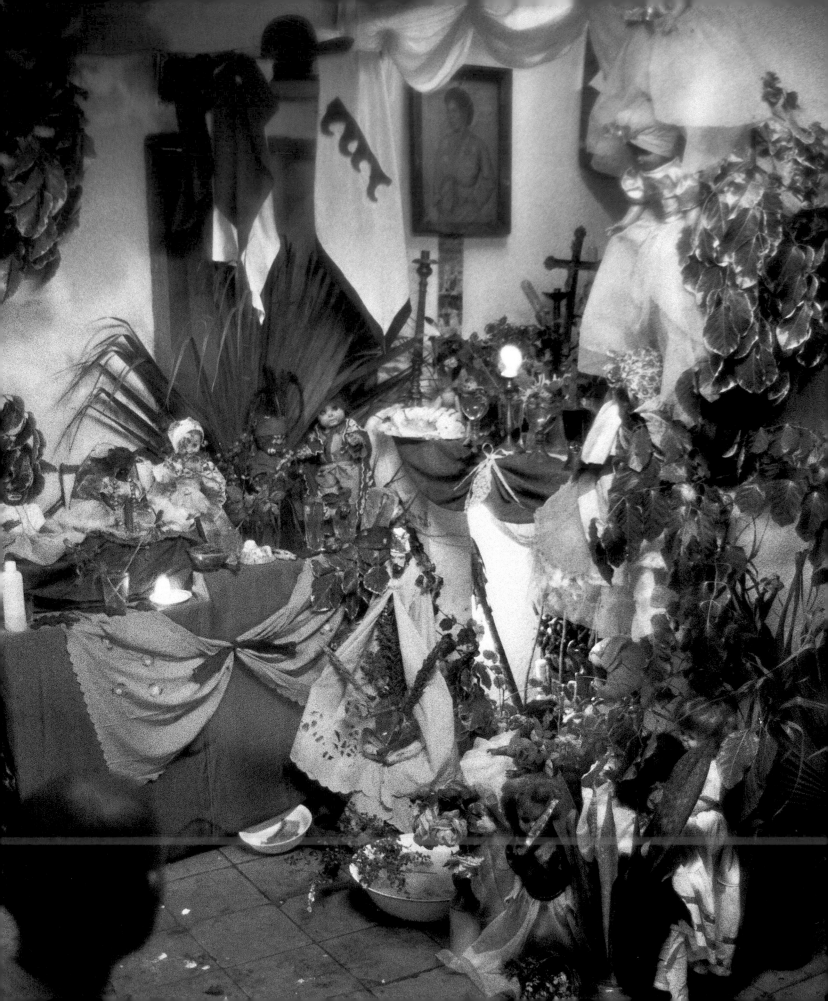

NOTES

Introduction

1. A definite mystique surrounds all things Haitian for Santiago. Given the significance of Haitian-derived religion and other cultural forces in Santiago's personal history as well as more generally in Oriente (eastern Cuba), this is not surprising. Many Cubans of Haitian descent live on the eastern end of the island, where a variant of Vodou, Haiti's traditional religion, is practiced. The Haitian factor is touched on in chapter 4.

2. This is not meant to imply that the human and spirit realms are discrete or mutually impenetrable. As K. M. Brown (1991: 347) makes clear, "Both God and the spirits operate in dimensions that permeate ordinary human life." We have borrowed the metaphor of a tightrope from Deren's (1983 [1951]: 176) deeply affecting description of the Haitian *houngan* or priest of Vodou as an expert—if at times conflicted—mediator of the human and spirit worlds.

3. Whether at work or at play, and the two were often commingled, we also offered Santiago at least a temporary distraction from the workaday reality that Cubans stoically refer to as *la lucha*, or "the struggle."

4. Two other Afro-Cuban religious traditions, although much less widespread than Santería and Palo Monte, should at least be mentioned here: the fraternal Abakuá organization and the Regla Arará (Order of the Arará). The traditions and ritual practices of the Abakuá brotherhood have roots in the Cross River region of Nigeria and Cameroon among the Efik and Ekpe, peoples with a strong tradition of all-male secret societies. In Cuba, Abakuá's many chapters (called *juegos* or *potencias*) function as both religious and mutual aid collectives—much in the style of the colonial era *cabildos*—and are concentrated in the western provinces of Havana and Matanzas. The Regla Arará has origins in the Ewe-Fon region of Ghana, Togo, the Republic of Benin (once Dahomey), and Nigeria. Similar in ways to Santería, Arará traditions are today virtually unknown outside Matanzas province. English-language sources on the Abakuá religious order include D. H. Brown (2003a), Fernández Olmos and Paravisini-Gebert (2003: 87–100), and, for a contextual account, Vélez (1998).

5. For thoughtful considerations of the notion of syncretism, see Brandon (1997 [1993]: chap. 6) and Vélez (1998: 138–142).

6. Millet (1996: 4). Unlike the religious traditions of the more populous and long-urbanized provinces of Havana and Matanzas in western Cuba, those in Oriente have, until recently, suffered comparative neglect in the literature on Afro-Cuban religion.

7. The word *ocha* in la Regla de Ocha is a contraction of *oricha*, the Lucumí word for spirit. Santería means "the way of the saints."

8. D. H. Brown (2003b: 140, 343 n.93), based on his extensive historical research and correspondence with other scholars in the field, tentatively concludes that two influential individuals, one a priest and the other a priestess of the orichas, were responsible for carrying Santería initiation to Santiago de Cuba in the 1920s, 1930s, or 1940s.

9. Thumbnail sketches of the major orichas and their salient characteristics are provided in the glossary. There are many sources, however, that offer fuller accounts of these spirits and the extensive body of myths that surrounds them. For excellent, brief descriptions of both Santería and the oricha pantheon in English see Ramos (1996: 51–76); Fernández Olmos and Paravisini-Gebert (2003: 24–77); and Matibag (1996: 45–85). A more in-depth English-language source is Edwards and Mason (1985). Works in Spanish include Bolívar Aróstegui (1990) and J. Castellanos and Castellanos (1992: 9–125).

10. Murphy (1993 [1988]: 132).

11. For stimulating discussions of Kongo history, society, religion, and art, see Thompson and Cornet (1981: 27–140) and MacGaffey (1986). For an inspired exploration of Kongo/Angolan-derived expressive traditions in the New World, see Thompson (1983: 101–160).

12. In Cuba the terms Palo and Congo are both used to describe the religious ideas and practices of Palo Monte. In this work we use the ethnic designation Kongo to refer to West Central African culture and religion, and the word Congo to describe Bantu-derived practices in Cuba. Santiago's Congo spirits of the dead, for example, are the old souls of New World slaves who traced their origins to the Central African Kongo region.

13. The Cuban scholar Joel James Figarola (2001a) proposes that the prenda, in its current form, was not introduced in eastern Cuba until the second decade of the twentieth century, apparently by Reynerio Pérez, a priest of both Palo Monte and Santería who arrived in Santiago de Cuba from the western province of Matanzas between 1910 and 1912. Figarola sees the modern version as an elaborate "urban" substitute for the original forest environment of Congo ritual practices. In support of his argument, he (29) describes some of the understated "rural" predecessors of the contemporary prenda: the "krillumba" (mystically prepared human remains), ritually "mounted" forest trees (troncos or trunks), and cloth power bundles known as macutos.

14. Fernández Olmos and Paravisini-Gebert (2003: chap. 7, 171–210) are an excellent source of information regarding Spiritism's impact on and transformation in the Spanish Caribbean. The authors also provide a cogent summary of the particular sociohistorical circumstances that attended the religion's arrival in Cuba. For a succinct account of the diffusion of Spiritism on the island, see Brandon (1997 [1993]: 85–90).

15. Palmié (2002: 192) suggests that the "syncretic" interaction between Santería and Palo Monte "may have been accelerated by the catalytic effect of spiritism."

16. Wafer (1991: 5) mentions this critical language-based point in reference to Brazilian Spiritism and its encounter with Afro-Brazilian religions in his very fine, experience-based study of Candomblé, *The Taste of Blood: Spirit Possession in Brazilian Candomblé*. See also chap. 4, n.17, below.

17. Although the history of religious traditions in Oriente is only now being actively traced, it seems feasible that the traditions of Palo Monte and Espiritismo would have met and mingled in the eastern provinces of Cuba before Santería was even introduced in the area.

18. Cuban religious practitioners of a spiritist persuasion often use the word *eso* (that, this) as a euphemism to avoid referring specifically to the "material" world (*lo materiel*)—to a Palo prenda, for instance. Some variants of Espiritismo eschew any link to the concrete, physical world. Such disavowal goes against the grain of any African-derived religion.

19. Santiago Castañeda Vera, recorded interview, 2002.

20. From 2003 to 2006 Santiago's initiatory activity increased dramatically. Since 2002, when we first

asked him how many ahijados he had fully initiated in the course of his life, the numbers have practically doubled for both Palo Monte and Santería. This represents an extraordinary expenditure of time and effort on Santiago's part as well as on the part of those being initiated (for whom the financial burden is also enormous). Some of this activity can of course be attributed to Santiago's having more time to devote to his practice and the demands of initiation. But it also seems that individuals are turning to these empowering rituals for the protection and spiritual stability they offer during a period of pervasive stress and anxiety, the fallout of ongoing hardship with little hope of improvement. Disillusionment with the system is now far more widespread—and more frequently voiced—than it was a mere three years ago. There is another source of tension, however, that for many Cubans may eclipse these economic concerns. Regardless of how individual Cubans feel about Fidel Castro—and these feelings are often deeply conflicted—trepidation over what will happen in Cuba when the inevitable occurs and Fidel is no longer around is very real. Cubans are on the cusp of a future that is hugely unknown. Initiation provides an encompassing framework within which to take charge of one's life on a personal and spiritual level, and in this way to function more wholly, even independently, in what has become an increasingly untenable situation. At least one of Santiago's recent initiates (iyawós) revealed to us that with plans to leave the country, he felt it imperative to "make saint," to center himself, before acting on his decision.

1. I Bow My Head to the Ground

The title of this chapter, "I Bow My Head to the Ground," is taken from Michael A. Mason's luminous work, *Living Santería: Rituals and Experiences in an Afro-Cuban Religion* (2002: 27). It is a translation of the Lucumí word *moforibale*, which describes the ritual prostration performed by initiates before their spiritual elders in the religion.

1. Santiago's sala bespeaks a level of middle-class comfort. Although this front room is not often used, it establishes him as a man of material and moral substance, a person who commands respect because of what he is able to offer the community. A number of the decorative objects on display in the room are in fact gifts from individuals that Santiago has initiated "in saint" (i.e., into Santería).

2. As D. H. Brown notes (2003b: 173), "In Afro-Cuban religious culture, the *puerta de la calle* (door to the street) acts as the critical threshold between 'inside' and 'outside' spheres." The oricha foursome known as "the Warriors," concealed behind Santiago's front door, guard this vulnerable entryway.

3. D. H. Brown (2003b: 262). Babalú Ayé is the one oricha that Santiago always calls by his Catholic moniker, San Lázaro, rather than his Lucumí name. The spirit lives in a terra-cotta vessel on the shelf of a low-lying cabinet in Santiago's *nso-nganga*, the room housing his Palo and spiritist altars. San Lázaro's dual ability to impose and cure illness and his close association with death account for his presence in the nso-nganga. This is where Santiago interacts with his "spirits of the dead" on a daily basis and where he conducts most of his healing work.

4. Moving through Santiago's house represents a conceptual as well as a spatial progression, from the relatively light-filled and accessible front room, to the embodiments of spiritual power hidden away in the room of the saints, to the innermost Palo realm, which is confined to the back of the house. With this trajectory in mind, Santiago's front room can be thought of as initiating a gradual transition from semipublic to private, outside to inside, objective to subjective, and overt aesthetic display to deep secrecy.

5. Obatalá is considered an earthly representative of the remote and inaccessible Lucumí High God, Olofi. "In Lucumí cosmology," D. H. Brown (2003b: 124) explains, "the creation of the world was effected through the High God's materialization and extension as Odudúa and Obatalá—the former creating the earth, and the latter, human heads and bodies."

6. Santiago's oricha twins (Ibeji) are represented by two articulated wooden dolls that sit astride a pair of stoneware sugar bowls containing the spirits' sacred objects.

7. Ramos (1996: 66). Given Santiago's extensive ritual dealings with spirits of the dead in his Palo and spiritist practices, it is not surprising that both Obba and Oyá should feature in his personal Lucumí pantheon.

8. There are two Ochúns in Santiago's saints' room. The Ochún living in a porcelain sopera in his canastillero was bequeathed to him by a santera who died many years ago. At the time of Santiago's own initiation as a priest of the orichas, he "received" (see n.11 below) the Ochún who resides in the large painted earthenware jar that sits outside this cabinet.

9. The Virgin of Regla is enshrined in a lovely church in the working-class town of Regla (named after her) that lies across the harbor from the sprawling capital of Havana in western Cuba. The Virgin of Charity, patron saint of the entire country, has her home in the small town of El Cobre (named after the copper that is mined in the region) in eastern Cuba. The basilica that bears her name is the island's most popular pilgrimage site. El Cobre is situated about twenty kilometers outside of Santiago de Cuba.

10. Stones having different characteristics of shape, pattern, and color are painstakingly selected according to the preferences (determined through divination) and sacred number of individual spirits. As embodiments of endurance, stones form the solid core of an oricha's fundamentos. Shells are considered the mouthpieces of the orichas, who speak to the initiate through them when the shells are cast in the divining process. The inherent power or aché of all these objects, the focus of lifelong ritual interaction, accrues over time. For a nuanced discussion of how "oricha presence" is created and maintained, see M. A. Mason (2002: 70–76).

11. When a person is initiated as a santero or santera, a related core group of four or more spirits is traditionally "received" along with one's primary oricha. Since becoming a priest of the orichas in 1961, Santiago has gone on to receive additional spirits in subsequent initiations. He has done so not only to strengthen himself but also, as D. H. Brown (2003b: 367) suggests, to increase his versatility as a religious expert, as when, for example, "one needs to own a given oricha in order to 'give' it to another person."

12. K. M. Brown's insightful work on Vodou, the traditional religion of Haiti, has provided much food for thought. Writing about the lwa, the spirits that animate the Haitian universe, Brown (1987: 165) describes them "as condensation points for complex and conflicting truths about different ways of being in the world." Haitian Vodou parallels the Afro-Cuban religions of Santería and Palo Monte in some significant ways. The two major spirit pantheons of Vodou, known as Rada and Petwo, are recognized as having distinct origins in West and Central Africa, respectively. In ethos and worldview (and to a notable extent, the nature of the spirits served), Rada and Petwo traditions in Haiti have much in common with Yoruba-inspired Santería, on the one hand, and Kongo/Angola-derived Palo Monte, on the other.

13. Each of the major orichas in the Lucumí pantheon carries between three and twenty-five well-known caminos, or paths.

14. This "crowning" ceremony has given its name to the entire series of rituals required to consecrate a new priest or priestess of the orichas. Full-blown initiation into Santería is often referred to as el asiento, or "the seating."

15. Cabrera (1996 [1974]: 29) was the principal source for this more detailed description of Yemayá Okute's character. For a virtually identical account in English, see J. Mason (1992: 309–310).

16. Royal and aristocratic imagery pervades the religious culture of Santería. For the ethnohistory and iconographic dimensions of this central metaphor, see D. H. Brown (1993: 54–59; 2003b: chap. 4).

17. Cabrera (1996 [1974]: 29).

18. There is a degree of transparency to Santiago and the spirit personalities with whom he maintains close working relationships. Deren (1983 [1951]: 90), who explored the nature of possession and human-spirit relationships in neighboring Haiti, poetically concluded that the spirit "partakes of the nature of the head that bears it," while the "psychic chemistry" of the individual in turn shapes the spirit that it "nourishes." Yemayá Okute is not, however, the only entity with whom Santiago has an intimate connection. The temperamental Palo spirit Sarabanda and the mischievous Congo muerto Pa Francisco also form part of the mix. Individually as well as in combination, all three of these spirit beings help articulate different aspects of Santiago's personality, just as, through his mind and body, their characters are further defined and elaborated. Even though the spirits themselves are not hard to distinguish, it is difficult to separate them completely from Santiago. He is, after all, the human vehicle through which they express themselves.

19. Once again, for a multilayered discussion of these transient altar installations, see D. H. Brown (1993: 44–59, 85–86). As Brown clearly demonstrates, the Afro-Cuban throne is a "uniquely New World altar form." We owe the felicitous phrase "visual praise poem[s]," the heading of this section, to Robert Farris Thompson.

20. The large frosted cakes are eventually carved up and distributed to Santiago's guests, as are many of the other dishes prepared for Yemayá.

21. D. H. Brown (2003b: 257) refers to the porcelain soperas used to house the orichas and other prestige ceramics as "adornments in the Creole taste," purposefully reviving a phrase coined by the Cuban anthropologist Fernando Ortíz. Brown (247) argues that particular sensory qualities combine with sociocultural associations to make these fancy objects sources of power in and of themselves, especially once they form part of an altar configuration. For an extended analysis of Santería arts and practice from a dynamic sociohistorical perspective, see D. H. Brown (2003b: chaps. 4 and 5 in particular). In this meticulously researched work, Brown traces a history of selected iconographic and ritual innovations.

22. The essays in Nooter (1993) offer thought-provoking explorations of the use of secrecy or concealment as an aesthetic strategy in African art and ritual. As Nooter (25) states in her introduction, "a dialectic between what is seen and what is unseen" is a feature of many African artworks. It is certainly a powerful aspect of Santiago's altars and ritual objects. As is often the case, the more sacred an object or substance, the less figurative and visually accessible. D. H. Brown (1993: 53–54; 2003b: 245) also comments on the strategic use of concealment and revelation in Afro-Cuban throne altars.

23. Our most important contribution to this celebration of Yemayá was probably the concealed presence of two halogen lights, reflected off the ceiling of the cuarto de los santos and back into the tiny room. Light glancing off mirroring surfaces emanates spiritual presence. In his discussion of the many roles that cloth plays in Santería ritual, D. H. Brown (2003b: 242) writes that the squares of luxurious cloth (paños) used in throne-building "should be brilloso (lustrous, shining), so they reflect light and, thus, radiate the orichas' gracia or aché, indexing their 'wealth' and status."

24. Santiago's offering of an elegant violín in honor of Yemayá is characteristic of celebrations for the female water orichas, the ultra-refined Ochún in particular. Balbuena Gutiérrez tells us that a violín offering almost always begins with Schubert's "Ave Maria." Although Santiago's intimate, familial honoring of Yemayá was less formal than the festivities described by Balbuena Gutiérrez, it had a similar musical repertoire. After the violinist played "Ave Maria," we went on to sing a succession of Lucumí, spiritist, and even Palo songs intermixed with popular Cuban songs from the forties and fifties (son, boleros, etc.). On the topic of "violins" for the spirits, see Balbuena Gutiérrez (2003: 112–117).

25. For an informative essay on sacrificial ritual as enacted by practitioners of Santería in the United

States, see Brandon (1990: 119–147). At one point Brandon (127) concludes, "The entire procedure [of sacrifice] is embedded within a metaphor of gift exchange as an expression of reciprocity between the human and spiritual worlds."

26. Margaret Drewal (1992: 27, 201), a scholar of Yoruba ritual art and culture with a strong interest in performance, defines *àse* (the Yoruba spelling of aché) as "a generative force or potential present in all things—rocks, hills, streams, mountains, plants, animals, ancestors, deities—and in utterances—prayers, songs, curses, and even everyday speech" and as "performative power; the power of accomplishment; the power to get things done; the power to make things happen." See Thompson (1983: 5–9) for additional definitions of this dynamic core concept, one that he percussively glosses as the "power-to-make-things-happen." Hagedorn (2001: 57; see also 118–119) lyrically describes the principle of aché as "that which moves us in and through the world."

27. Lucumí is the Yoruba-derived ritual language used by practitioners of Santería.

28. M. A. Mason (2002: 97).

29. Babalú Ayé (aka San Lázaro), Agayu, and Yemayá are all ancient, primordial spirits associated, in Lucumí cosmology, with the earth's creation and the "genesis of cosmic order." For a lovely summary and analysis of Pedro Arango's account of the Lucumí creation myth, see Lahaye Guerra and Zardoya Loureda (1996: 18–20).

30. The *moyuba* is an invocational prayer recited before all important ritual undertakings in the Lucumí religion of Santería. Because the moyuba "pays homage to" both the living and the dead in an individual's biological and spiritual families, each of these litanies is by definition personal and idiosyncratic. The prayer included here is a truncated version of Santiago's moyuba, written down phonetically as he recited it (July 2005). In it Santiago pays homage to both the living and the dead— blood relatives as well as spiritual kin—and asks for their blessing (i.e., permission) to proceed with the matanza, or ritual sacrifice for the orichas. In the first part of his recitation, Santiago asks the blessings of the Lucumí High God Olofi, his father and mother, and his godparents "in saint." Of these ritual elders, only Ángel Felipe Guibel, Santiago's padrino (godfather), is still living. In the second segment, he pays homage to the dead (*eguns*)—deceased members of his natural family and the dead founders and descendants of his priestly lineage—and asks their permission to proceed. Finally, he salutes living spiritual authorities (*kinkomaché*), each of whom is invoked using the name of his or her head-ruling oricha, and solicits their blessings. In the segment paying homage to the dead, Santiago mentions several individuals of interest. Rigoberto de Madruga (formally, Rigoberto Rodríguez) was the well-known priest and spiritual leader of a religious house in Madruga, a sleepy town about forty minutes inland from Havana. In the years following Rigoberto's death in the 1970s, his widow opened the house up as a museum. The authors visited this remarkable casa de santo, now known as "Freddy's Museum," in 1998 ("Freddy" is the short form of Rigoberto's wife's name). In this same portion of the moyuba, Santiago also recites the names of three individuals who are direct spiritual descendents of those responsible for carrying Santería to Santiago de Cuba in the early decades of the twentieth century: Pablo Vicente Obá-Bi Chemera, Vicentica Echú Eleguá, and Noris Oyá Gadé. In an article on religious families and Lucumí lines of descent in Santiago de Cuba, Millet (2000) cites their names in full—Pablo Vicente Mejía, Vicenta Tejeda Madariaga, and Noris Esperanza—along with the names of their head-ruling orichas.

31. "Underwaterscape" is the evocative term used by D. H. Brown (1993: 52) to describe a throne for Ochún. The praise name "Mother of the Children of Fishes" is J. Mason's (1992: 307) poetic translation of the name Yemayá, rendered as Yẹmọja in his book.

32. M. A. Mason (2002: 38, 141 n.13). The manner in which one bows one's head to the ground is gender-specific but not in the way that one might think. It is the gender of the oricha who "rules" or "owns" a

person's head that determines how he or she performs moforibale. For a deeper sense of the meaning of this ritual of respect, see M. A. Mason (2002: 38–41).

33. This ambivalence toward sponsoring live music is not unusual. Cubans on the whole, and Santiago in particular, are leery of anything that "calls attention" (*llama la atención*) to their activities. Neighborhood government representatives may start making inquiries. Young, street-savvy "culture broker" types will get wind of an upcoming *tambor* and, however respectfully, crash the party. On occasion they appear with tourists they have befriended, having perhaps promised them an authentic religious experience. This happened on the night of Santiago's cumpleaños tambor. Although an entertaining story in its own right, what is most interesting in retrospect is the fact that Santiago expressly delegated the responsibility of dealing with the two Europeans to us. On the one hand, this was a clear case of "They're your people (i.e., white *estranjeros*); you deal with them." On the other, and as godchildren of the house, we were being asked to represent Santiago in a way that he would consider appropriate.

34. The prestigious *batá* are hourglass-shaped wooden drums that are graduated in size and have differently dimensioned heads at each end. Each of the drums—they come in families of three—is held horizontally across the lap and played with both hands. The largest, or mother drum (with which Yemayá is most often associated), is called the *iyá*. As the leader of the rhythms, this drum directs the other two. The batá played at Santiago's tambor were richly adorned. The heads of the iyá were ringed with dense clusters of bells and the body of the instrument wrapped in cowrie-studded indigo cloth. The midsize batá, the *itótele*, was swathed in purple, and the smallest, the *okónkolo*, clothed in vibrant red with black stripes. Parts of this description draw on Murphy (1994: 105).

35. In deference to their status as players of the sacred batá, the musicians are served before anyone else at a table set specifically for them. Everyone else eats with plates perched on their laps. The initial "drum calls" that the drummers perform at the entrance to the cuarto de los santos are known as the *oru seco*, or "dry sequence," because the rhythms are not accompanied by vocals. Hagedorn (2001: 100) elaborates: "The *oru seco* . . . is an essential performative tool because this series of rhythms speaks to the *orichas* 'in their own language,' letting them know that a ceremony is about to begin— alerting them to the possibilities of communicating with their human adherents." These rhythms, or toques, are resolutely secret in nature.

36. For an account of the critical role played by singing in ritual (and other) contexts, see Vélez (2000: 158–162). In this vibrant and sympathetic work, the author focuses on the life of Felipe García Villamil, an Afro-Cuban master drummer and practitioner of Santería, Palo Monte, and the Regla Abakuá, who emigrated from Cuba to New York in the Mariel exodus of 1980. A good portion of the book is in García Villamil's own words.

37. The tambor Santiago offered his orichas was in house and sacred in nature. As professional players of Afro-Cuban religious music have had to adapt to changing circumstances and an increased demand for folkloric presentations in secular settings, this has become more the exception than the rule. Hagedorn (2001) provides valuable information on Afro-Cuban drumming traditions and the changing contexts of musical performance in Cuba. For a Cuban musician's struggle with these same issues both in Cuba and the U.S., see Vélez (2000). Both authors explore the cultural and historical processes that have contributed to a blurring of boundaries between the sacred and the secular in contemporary music performance, albeit from different perspectives.

38. Murphy (1993 [1988]: 96) gives full credit for the English translation of this Lucumí song to Adetokunbo Adekanmbi of Georgetown University (165 n.5). We regret not being able to include more Lucumí songs (*suyeres*) in this chapter but we are nowhere near as familiar with them as we are with Palo, Congo, and spiritist songs. Those Lucumí songs that appear in the literature are rarely trans-

lated into either Spanish or English. J. Mason's (1992) book of praise songs, however rich in content, is rendered in a much more standardized Yoruba than the Lucumí sung in Santiago's house. For the difficulties that attend the transliteration and translation of Lucumí song texts, see Hagedorn (2001: 69–70 n.6, 122–123).

39. We owe the beautifully compact phrase "vocal aché" to Hagedorn (2001: 119).

40. Other, nonmonetary forms of tribute (gifts of food, flowers, and so forth) are also called derechos.

41. The seven scarves tucked into Yemayá's waistband may allude to her "seven skirts." According to Cabrera (1996 [1974]: 46), the "mannish" Yemayá closely associated with Ogún "has seven skirts but no one knows what is hidden beneath them."

2. *Ver Para Creer* (Seeing Is Believing)

1. Nso-nganga means "temple" or "house" of nganga (i.e., prenda) and designates the room dedicated to Palo ritualizing in Santiago's house. Metaphorically speaking, the term extends to Santiago's entire Palo family, both past and present. The words *nganga* and *prenda* are synonymous and are used interchangeably by Santiago when referring to his Palo spirit cauldrons. To avoid unnecessary confusion, however, we confine ourselves to the Spanish word prenda. It means "pawn, token, or treasure" and invokes the verb *prender*, "to arrest, fasten, take root." The actions encompassed by the verb form suggest the source of a prenda's power. Each of these impressive assemblages is driven by a spirit of the dead that has been seized or "arrested" and then ritually secured or "fastened" within the container.

2. Although el monte means "the forest," it connotes any wild, uncultivated space. In a strictly urban context, the patio behind a person's house may stand in for the forest. El monte's importance as a source of practical and mystical power cannot be overemphasized. For Santiago and other Palo practitioners, it is both a conceptual and a physical landscape, a state of mind as well as of nature.

3. *Crillumba* is a variant of the Congo-Cuban word *kiyumba*, meaning bones of the dead, skeleton, or skull (Díaz Fabelo, n.d.: 108). J. J. Figarola (2001a: 26), writes that the "krillumba" was a modest precursor of the modern-day prenda (see n.13 of the introduction, above). The term refers to human skeletons that were mystically charged with different earths, powdered plants, and animal elements. Once returned to the grave, krillumbas served as conduits to the world of the dead. The grave functioned as a kind of charm or prenda, a place where the living could invoke and communicate with these spirits "without arousing suspicion" (26). With this in mind, Santiago's description of the mpungus as orichas "on the path of crillumba . . . the Palo path . . . the path of sentiment," starts to make sense. Santiago is in effect extolling the Palo way of being in the world. The *camino crillumba* (path of the skeleton or skull) alludes to the ritual manipulation of skeletal remains with the objective of accessing the powers of the dead. The *camino de Palo* (Palo path) evokes the "trees of the forest" (literally, Palo Monte) and the rest of the spirit-infused natural world. The *camino de sentimiento* (path of sentiment) references the vibrant but conflicted realm of human emotion, the vicissitudes of life in the real world. Palo healers are particularly adept at helping people deal with existential problems. Of course, ultimately, the three dimensions of Palo spirituality that Santiago's words suggest—the cosmological (crillumba), the natural (Palo), and the personal (sentimiento)—collapse right back into each other. They are inseparable parts of a single reality, that is, Palo Monte.

4. When asked about the Brillumba and Kimbisa aspects of his spiritual heritage, Santiago makes one critical distinction. The Brillumba tradition was inherited from his *tata* (father), the Palo priest who fully initiated Santiago as a palero and presented him with his three spirit vessels. Santiago's Palo cauldrons are physically based on materials drawn from his tata's prendas, a form of material and spiritual inheritance that is discussed in chapter 3. While the Brillumba line is Santiago's ances-

tral tradition, he also embraces the ecumenical Regla Kimbisa. Founded by the charismatic Andrés Facundo Cristo de los Dolores Petit in the mid-nineteenth century, this Congo order is the most sweepingly inclusive. Petit deliberately set out to integrate aspects of the Congo, Lucumí, spiritist, and Catholic religions to better "overcome" (*vencer*) life's obstacles. The Congo influence has always been paramount. As one of Cabrera's (1986b [1977]: 3–4) informants expresses it, "If on the outside it [the Regla Kimbisa] wears the beautifully ornamented cape of the lucumí and the whites, it got the lining [of the garment] from the congo."

5. For a partial list of the "mpungu-oricha–Catholic saint" correspondences recognized by Santiago, see the first page of the glossary.

6. A number of scholars of African-inspired religions in Cuba and Haiti have noted that Kongo-derived traditions in both countries are rife with allusions to the New World slavery experience. Aspects of ritual behavior—the contractual nature of the relationship between a palero and the nfumbi that he "buys" to mobilize his prenda, for instance—amplify and reinforce the many tangible references to restraint and oppression. Chains, machetes, gunpowder, fire (and in Haiti the bullwhip, *fwèt kach*, and police whistles) feature prominently in the rituals and iconography associated with Palo Monte in Cuba and the Petwo pantheon of spirits in Haitian Vodou. For a fascinating, historically grounded discussion of these and other dimensions of Cuban Palo Monte, see Palmié (2002: 159–200). Though Palmié must overdraw the negativity associated with Palo Monte to make his argument, his overall analysis is brilliant. For brief, parallel considerations of Petwo traditions as they relate to the brutal reality of slavery in neighboring Haiti, see Deren (1983 [1951]: 60–61) and K. M. Brown (1979b: 112–113; 1995b: 22–26). Although Deren's and Brown's observations are similar, they draw different conclusions.

7. Cabrera (1986c [1979]: 166). This song text is also cited in J. Castellanos and Castellanos (1992: 144–145). In Congo-Cuban as well as KiKongo, *ndoki* means "witch." In Cuba it may also be used as a synonym for "sorcerer." Although the word has negative, even malevolent connotations, its meaning is ultimately context-dependent. Santiago often uses the word ndoki as an honorific to signal extraordinary power or a mastery of esoteric means. It features in a number of the praise names he gives new Palo initiates. Jesús Varona Puente, an accomplished ritual expert, babalawo, and friend living in Havana, says that the word *ndiambo* literally means matter or problem (i.e., a sorcerous matter in need of resolution).

8. The proximity of Santiago's spiritist and Palo altars also brings home the degree to which practitioners have selectively adapted the religions of Espiritismo and Palo Monte, especially in Oriente, where a complex blend of ideas and practices has evolved. Although on one level they form part of a coherent whole, a certain layering of belief is reflected in the very architecture of Santiago's nsonganga, with his spiritist altar above and his earthbound Palo shrine below. The spiritist dimensions of Santiago's religious practice are more fully explored in chapter 4.

9. When Santiago talks about spirits of the dead, he freely interweaves Palo and spiritist terms and ideas. In his ritual practice the interpenetration is less obvious. For example, the spiritual mass and celebration of the Congo dead described in chapter 4 form integral parts of a single evening ceremony. They are separated, however, by an abrupt "code-switching" shift in tempo and spiritual energy that marks a transition from ritualizing that is strongly Euro-Cuban in flavor to ritualizing that is patently Afro-Cuban. Furthermore, while the Congo dead are conceptually linked to the spiritist realm, they operate wholeheartedly in the material world. They are not Palo spirits and yet they are fed alongside them and often make an appearance on the night of the Palo matanza.

10. The prendas that embody Palo Monte's power have often been described as Afro-Cuban descendents of the Kongo power figures and objects once common in Central Africa. Known as *minkisi*

(sing. *nkisi*), these composite charms ranged from outwardly unassuming cloth bundles to dramatic, nail-studded figures. Regardless of their form, minkisi were packed with powerful medicines, having their primary source in the natural world, and fueled by spirits from the land of the dead. Like these Kongo power objects, Santiago's prendas serve as catalysts for healing, weighing the actions of other human beings, and protection, often in the form of mystic retaliation. The KiKongo term nkisi is alive and well in Cuba; Santiago often uses it when referring to his Palo cauldrons. See Thompson (1981, 1983, 1993a) for animated discussions of the visual and conceptual correspondences between Kongo and New World forms of aesthetic expression. For multiple references to Kongo ritual practices that parallel contemporary Palo practices in Cuba, see MacGaffey (1988, 1990).

11. It is hard to convey nuances of meaning in a literal translation of Santiago and Sarabanda's mutual praise name. For one, the Congo-Cuban word Ndiako remains elusive despite a number of thoughtful suggestions as to what it could mean. As Santiago explains it, the basic idea is that a strong, mystically accomplished sorcerer-warrior does not need to fight anyone or anything in order to win a battle. The day that Sarabanda Brillumba Acaba Mundo Buen Ndiako is forced to declare outright war—*beware*—the world will come to an end. Santiago's final words on the subject sum it up nicely: "Only Nsambia of the four winds [i.e., God Almighty] can destroy me." In addition to Sarabanda, there is one other major mpungu in the Palo religious system: Siete Rayos or "Seven Lightning Bolts." He is widely considered to be the Congo incarnation of the oricha Changó. The central position accorded one or the other depends on a palero's lineage within the Palo Monte religion.

12. Santiago proudly refers to Sarabanda as *el hombre que rayo*, "the man who cuts." The phrase refers to the spirit's role as an intrepid clearer of paths through the forest, but it is also a direct allusion to the Palo initiation known as the *rayamiento*. This ritual is discussed in chapter 3.

13. Santiago Castañeda Vera, recorded interview, November 2000.

14. Cabrera (1992 [1954]: 131).

15. Wyatt MacGaffey (1986: 81–82; 1993: 69, 71), the noted scholar of Central African Kongo culture, tells us that the power objects known as minkisi (see n.10 above) were generally associated with the sky, land, or water and considered to be either male or female. Sky, land, and male charms were temperamental, predominantly violent, and focused on moral retribution. Collectively referred to as "minkisi of the above," their signs included "lightning, fire, weapons, fierce animals, birds of prey, and the color red." "Minkisi of the below," on the other hand, were women-centered, "devoted to healing," and associated with earthly waters. The praise names of Santiago's prendas as well as their more visible components suggest a primary association with one (or more) of these natural domains. Sarabanda and Lucero definitely partake of the aggressive heat "of the above." Madre de Agua is more emphatically identified with water and the regenerative promise "of the below."

16. The cauldron for Santiago's Congo dead is currently home to three spirits: Pa Francisco, Pa Julian, and Pa Kanuko. He explains that in the past each had their own vessel, but that all three of them live together now: "There was a time when things weren't exactly easy here, and there was no way to find enough animals. So I spoke to them—they're brothers—and made them a single caldero over there in the corner."

17. Spiritist doctrine—Kardec's notion of a spirit-matter continuum, for instance—has had a pervasive if uneven influence on Afro-Cuban spirituality. Practitioners of Santería and especially, perhaps, Palo Monte selectively absorbed and transformed many of Kardec's original ideas. We are indebted to Kali Argyriadis's (1999: 222–226, 240–242) in-depth study of religious practices in Havana for shedding light on this rich entanglement of belief and ritual procedure.

18. While this loose classification suggests a hierarchy of the dead, the status of individual muertos is actually in constant flux. Human beings can either help dead souls evolve and "acquire more light"

or ensure that they remain tethered to this world, where they can be pressed into service. As a result of these ongoing interactions with the living, the dead can move from one plane of existence to another, both up and down. Argyriadis (1999: 240–241) suggests that in some instances they operate on several levels at once. Santiago's Congo spirits certainly range rather freely. They appear in various guises on his spiritist altar as well as in the Palo shrine below. While Santiago's Congo dead occupy a middle ground in the overall chain of being, he also calls on them as *muertos de batalla*, spirits of the dead that help him wage war against the adversaries of human beings. The fluidity of Santiago's take on the metaphysical world militates against any neat classification of the spiritual forces that inhabit it.

19. The term *chópi* is a Cuban adaptation of the English word "shopping." In 2002, all transactions at these government-run stores were in U.S. dollars. This changed in early 2005, when the dollar was once again declared currency non grata. For foreigners, everything (other than street food) must now be paid for in Cuban divisas, which are roughly equivalent to the euro. The national currency (moneda nacional) is the Cuban peso. Most Cubans do not have ready access to either dollars or divisas and, if they do, only in limited quantities.

20. Although this healing ritual was performed in the context of the Palo matanza, it is discussed in chapter 3.

21. In preparation for the rigorous physical and psychic demands of the evening's ritualizing, Santiago also fortifies himself in a variety of ways. Interestingly, although not surprisingly, these strengthening measures now include alternative forms of treatment, such as acupuncture and quartz crystal therapy (accounting for the dots visible on Santiago's body in many of the images in this book). Arnaldo, a certified naturopath, is one of many godchildren working in the medical profession. He is always present during the November ceremonies, as personal doctor and enthusiastic participant.

22. Select portions of the slaughtered animals are set aside and ritually prepared for the spirits. Most of the meat, however, is cooked and presented to Santiago's godchildren and guests before the next evening's ritual.

23. Sarabanda's greeting—*Sala malekum*—elicits an enthusiastic *Malekum sala* in response. This Palo salute is clearly Arabic in origin, perhaps through Islamized Africans brought to Cuba as slaves during the colonial period.

24. Originally spoken by slaves and other disenfranchised members of colonial society, bozal survived well into the twentieth century among rural blacks. It is the favored language of the Palo mpungus and Congo spirits of the dead.

25. Although flagrant disrespect is rare, the failure to participate fully in important ceremonies or to drop by periodically and visit with Santiago can provide grounds for punitive action. An obvious lack of interest on the part of a godchild is taken much more seriously because it threatens the integrity of Santiago's religious family. If at times the spirit Sarabanda is harsh with particular individuals, he is also (like his medium Santiago) fiercely protective of his children. The spirit's disciplinary measures can be seen as an attempt to preserve the cohesion of his human family.

26. The need for Santiago and, by extension, Sarabanda, to control potentially disaffected members of the ritual family is genuine. A tension both social and political is being acted out in these power plays.

27. Chapter 4 deals more specifically with Pa Francisco and other Congo spirits of the dead.

28. *¡Dió! ¡Mambe!* This pledge of allegiance to Palo Monte's power and authority is recited in various ritual contexts. Shouted out by members of the congregation, it reaffirms that they are one Palo family bound by the blood ties of initiation. The chapter title, "*Ver Para Creer*," is drawn from this pledge. By way of explaining some mystical point, Santiago will often say, "I believe it because I see

it." The declaration echoes that of the biblical Doubting Thomas, who refused to believe that the crucified Christ had risen from the dead until he laid eyes on him and actually touched his wounds. If one views the apostle Thomas's need for tangible proof through a Palo lens, it resonates in another way. What Santiago knows of his religion is not a matter of "blind" faith but of what he has physically apprehended and therefore knows to be true. "To the believer," such as Santiago, ". . . . belief is knowledge, that is, perceived and experienced fact." See MacGaffey (1986: 1). According to Varona Puente and the ethnographic scholar, Elliot Klein, the final lines of the pledge—mpaka with mpaka, ndúndu with ndúndu—describe pairings essential to Palo. The first refers to the two mystically mounted, visionary horns that every prenda must possess, "just as an ox has two horns." The second, spirit with spirit, speaks to the complementary nature of the living and the dead, of the muerto in a prenda and the palero who interacts with it.

29. *La buena noche, mi lemba*. This song of greeting (*mambo de saludo*) invokes the natural and otherworldly powers of the Palo universe. When Santiago sings *Buena noche, mi lemba*, he is addressing "his people," his corps of support or home team, as it were—the prendas that are the foundation or source of his power in the world. Varona Puente and Klein tell us that the enigmatic phrase, "new world of the dead," is in fact a lyrical description of a newborn prenda. The mambo then bids good evening to all the Palo mpungus—Sarabanda (Ogún), Lucero (Eleguá), Siete Rayos (Changó), Tiembla Tierra (Obatalá), Kuaba Ngenge (San Lázaro), Centellita (Oyá), Madre de Agua (Yemayá), Mama Chola (Ochún)—and a number of ritually charged locales: the savanna (*sabana ngombe*), the four directions represented by the crossroads (*cuatro nsila*), and the cemetery (*campo nfinda*). Finally, the song invokes all of the dead (*todo nfumbi*) and the *perros* or "dogs" of the house (which can refer to those who serve as mediums for the spirits but, in the present context, designates the spirits themselves). This mambo can be read as a celebration of Santiago's nso-nganga, a ritual and conceptual space that encompasses all these sacred beings and places in microcosm.

30. *Arriba nganga, Congo no cabá*. The essence of this dynamic mambo is that the healing power of Congo (i.e., Palo Monte) works without respite and is never-ending. We have translated the verb *acaba* (cabá in bozal) in several ways to reflect the nuances of meaning that it suggests. Embodied in *la naturaleza* (nature) and in all of the spirits and human beings mentioned in the previous song, the extraordinary reality of Congo cannot be contained. Santiago often uses the phrase *no acaba* to describe something that can never be fully known because it is in a state of constant evolution and therefore inexhaustible. On more of a day-to-day basis, it may be used to tell a prenda, "There's still work to be done: we haven't finished yet" (Varona Puente and Klein).

3. It's My War Now

1. *Vamo' a yimbulá un poco pa' yimbulá*. The essence of this song, according to Santiago, is that he is getting ready to do some Palo work (i.e., to manipulate objects and forces with tangible results in mind). Cabrera (2000 [1984]: 293) lists a closely related entry in her Congo-Cuban dictionary, "Yimbira, vamo, un poco yimbiraa. Ahora vamo a jugá" and glosses it as "to practice the magic rite [i.e., to work Palo]." Varona Puente insists that yimbulá can only mean "We're going to talk or have a conversation [as in a palero speaking with his prenda]." He goes on to explain that one converses with a prenda by singing to it. Klein adds that these songs constitute "the prelude to any ritual, including 'work.'"

2. Although more encompassing in focus, the collective ritualizing associated with the orichas' feast days and the November cycle of ceremonies is also powerfully therapeutic: it heals by reaffirming the fundamental interconnectedness of human beings with each other as well as with the spirit world.

3. Since the collapse of the Soviet Union in the early 1990s, the availability of pharmaceutical medicines in Cuba has declined while material hardship has drastically increased. The situation has spurred a

renewed interest in traditional plant-based healing methods that specifically address physical health issues. The medical establishment, for instance, has intensified research into the island's extensive natural pharmacopoeia. The impact of this dearth of medicines has been, very possibly, twofold. Cubans who might not otherwise consult a traditional healer may now be more inclined to do so.

4. In a fascinating book devoted to traditional medicine and therapy in Zaire, now the Democratic Republic of Congo, Janzen (1978: 194) says of the *nganga* healer (*nganga*, in Central Africa, denotes "ritual expert"), "His art is at once empirical and magical, traditional and experimental, physiological and social." A number of Janzen's observations apply to Santiago's healing art. Along similar lines, McNaughton (1979: 25) writes of the Bamana with whom he worked in Mali, "The West separates the scientific from the supernatural. The Bamana make no such distinctions and view their world in a way that provides a common ground for both phenomena." See McNaughton's lucid and insightful study, *Secret Sculptures of Komo: Art and Power in Bamana (Bambara) Initiation Associations*.

5. Modern and traditional approaches to healing in Cuba are largely complementary. Because each system has its unique competence, there is a certain amount of cross-referral that goes on. Santiago, for instance, may recommend that a client consult a medical doctor for physical and even mental health problems while he deals with other aspects of his or her illness. Santiago himself takes full advantage of Western medical treatment when necessary and openly embraces the alternative therapies practiced by one of his godchildren (see n.21 in chap. 2).

6. K. M. Brown (1991: 347). For an intimate account of the Vodou priestess Mama Lola's healing philosophy and practice, see Brown (1991: 344–350). We have gleaned many insights from this multilayered work. The passage just cited has helped us better understand and articulate Santiago's approach to his healing work.

7. Water gazing has been described as a form of "reflective divination." Santiago communicates with his spirits in a number of other ways as well. He may speak to them out loud or in his head, see them clairvoyantly, or feel their physical presence.

8. Ritual cures sometimes entail, as K. M. Brown (1991: 348) so clearly describes, putting "problematic human relationships in a tangible, external form where they can be worked on and ultimately transformed." The proverbial example of this is the use of cloth figures in some of the charms that Santiago constructs for clients who need to change the direction or quality of a particular relationship. These are ritualized with the client's full collaboration, a pooling of effort and energy critical to the charm's effectiveness.

9. Power is inherently ambiguous because of its destructive potential. For this reason Palo ritual experts and the work they do, which involves the forthright manipulation of power, are often viewed with ambivalence. The forces that Santiago handles are in fact morally neutral. It is how and under what circumstances he chooses to mobilize these energies that determines how his actions are perceived. Such measures are considered justified if undertaken for the right ethical reasons. By the same token, exploiting one's ritual powers to mystically harm someone without provocation or out of raw self-interest is very negatively viewed. Such abuses of power are also considered extremely dangerous. What goes around with purely vindictive or selfish intent often comes around with even greater annihilating force.

10. In a thoughtful discussion of Haitian Vodou as a moral-aesthetic system that embraces "plurality" and "contradiction," K. M. Brown (1987: 166) concludes that "the point [of Vodou ritualizing] is not to make conflict go away but to make it work for rather than against life." Santiago, as he activates and orchestrates conflicting energies in his healing work, is in a sense doing just this. His ultimate goal is to shift the balance of power so that situations of pain and contradiction can be made, ultimately, to "work for rather than against life."

11. That Santiago might, on some level, think of these Congo muertos as the spirits of fugitive slaves

on the defensive is an intriguing possibility, but we have never specifically broached this with him. Militant metaphors not only inform Palo work and spirituality. They are also prevalent in Cuban Espiritismo.

12. A Palo spirit cauldron expresses a definite ambivalence in terms of its conceptual elaboration as well as visually; it is, in essence, a cluster of mixed metaphors. McNaughton (1979: 1), in his monograph on art and power in the Bamana initiation association known as Komo, writes that "the masks and other types of sculpture used in *Komo* project a strong air of inaccessibility," and somewhat later (35) that these masks "assemble discordant organic elements that would never be so intimately associated in nature. For a society familiar with the bush and its inhabitants, the masks become a body of visual nonsequiturs grouped to create a kind of chimera." The animal and vegetable materials of which prendas are composed—forest branches, the feathers of avian predators, blood, earth from different locales, animal components, plants and roots, insects, human remains, and so forth—are powerfully disjunctive in a similar way. They embody, to borrow Fernandez's (1986: 183) evocative phrasing, "an argument of images." The Palo aesthetic, expressed in the organic accumulation of multiple teeming energies from different domains in nature, stands in stark contrast to Santería's aesthetic values, which are strongly culture based.

13. The phrase "doing of secrets" comes from Fernandez's (1984: viii) foreword to Beryl L. Bellman's *The Language of Secrecy: Symbols and Metaphors in Poro Ritual*.

14. "Assisting" ran the gamut from bolstering the singing during Palo initiations, to interpreting for a visiting family member or close friend during ritual cleansings, to serving as Santiago's personal secretary when lists of ingredients or ritual procedures needed to be written down for a client.

15. Cabrera (2000 [1984]: 251). Work intended to block another person's attempts to interfere in one's life—a "no contact order" of sorts—may also be called an *amarre*, from the verb meaning "to tie (up)" in Spanish.

16. Santiago insisted that we take part in all the cleansing aspects of the ritual to protect us from the potentially harmful energies released while he activated this heavy-duty work.

17. While botánicas in the United States often carry a broad range of religious paraphernalia in addition to the curative herbs that gave these specialty stores their name, their Cuban equivalents are minimally stocked and primarily with organic materials. This is the case in Santiago de Cuba at any rate.

18. A firma, a Spanish word that literally means "signature," is a mystically charged drawing that may be traced on the ground as well as on or within objects. Like the prendas themselves, these graphic avenues to power represent a microcosm of energies. While some call down the powers of individual spirits, others are work firmas used to channel spiritual forces toward very specific ends. Santiago drew a number of his firmas for us, carefully altering critical details so that they could not be misused. Details of these line drawings are used as a design element in this book.

19. As Santiago creates the object for his client, he is orchestrating all kinds of natural and supranatural forces. Although the contents of an nkange usually include specific plants, insects, types of earth, bird feathers, powdered substances, and the blood of one or more small animals, these are only the more tangible ingredients.

20. We owe the phrases "good to eat" and "good to think [with]" to Claude Lévi-Strauss (1963: 89). The original passage reads, "We can understand, too, that natural species are chosen not because they are 'good to eat' but because they are 'good to think.'"

21. Because cemetery earth has been in intimate contact with the dead it partakes of their essence. Thompson (1983: 117) uses the suggestive term "spirit-embodying" to describe such elements. He has written extensively about Kongo and Kongo-derived charms in Central Africa and the diaspora.

22. Thompson (1983: 118) glosses these plant and animal components as "spirit-directing" because they tell the nfumbi in a prenda what to do for its owner and how to do it.

23. Cabrera (1992 [1954]: 131). Her exact words are "prodigious eyesight" and "the exceptional stamina of its wings."

24. MacGaffey (1986: 263 n.17). The metaphorical thinking that underlies the selection of ingredients from the natural world is fascinating. Varona Puente has said that animals that "do not speak" (the turtle, for instance, or the majá snake) are critical players in Palo thought and ritual. Certainly they underscore the value placed on silence and discretion in the Congo reglas. The termites required for Luisito's charm seem to have attributes and powers similar to those of the destructive army ants (bibijagua) described by Lydia Cabrera. Emphasizing that these insects play an essential role in the mounting and activation of a prenda, Cabrera (1992 [1954]: 130) writes, "Ngangas are taught to work by burying them in a bibijagua anthill. Our blacks [sic] attribute supernatural intelligence and wisdom to these destructive, hard-working, indefatigable ants. . . . From the industrious bibijagua . . . the nganga acquires the same extraordinary capacity for work, assimilating its qualities of diligence and perseverance. It learns to demolish and to build. To demolish what belongs to others in order to build its own. . . . And all of this ntiti [refuse (basura), sorcery] is very valuable." See n.27 below.

25. McNaughton (1988: 59) refers to all of these elements as "amplifying substances." Breath and saliva animate the human body and are therefore inherently powerful. The blowing of cigar smoke and spewing of rum are common ways of transferring one's own energy or personal aché to an object or person. With regard to Luisito's charm, these acts are meant to further arouse the nkange and, subsequently, to direct this heat and aggression.

26. One of the verbs most commonly used to describe these acts of provocation is arrear (to heat up). Ritually insulting an nkange or a prenda, whether verbally or physically, has its roots in Central African religious culture. MacGaffey (1986: 142) tells us that nails and other, less tangible aggressive means (curses and so forth) were hammered into a certain type of figurative charm to "procure the punishment of an absent wrongdoer." The nailing "angered" the figure, which would then "go 'fix' (kanga) the person against whom it was directed." The explosion of gunpowder has a similar effect. Santiago often substitutes gasoline for gunpowder because the latter has become hard to find. It seems to be more readily available on the western end of island.

27. The basurero (garbage dump) is an appropriate and even auspicious place to bury what amounts to a mystical restraining order. The powerful ingredients used in the construction of Palo prendas and charms are often referred to as ntiti, the Congo word for vermin, garbage, or filth. See Díaz Fabelo (n.d.: 77). As McNaughton (1988: 18) eloquently puts it: "The apparent contiguity between power and filth implies the danger harbored by the power. The world's energy allowed to get out of hand could leave the world a fetid ruin. It is therefore of paramount importance that nyama [i.e., the energy of action] be controlled." Nyama is the Bamana equivalent of aché.

28. The configuration known as ulufia means "yes, it is possible, but nothing is assured." The sign is considered less stable than eye ife, the configuration of two cocos white side up and two white side down, which is interpreted as unconditionally positive. See Núñez (1992: 81).

29. Güiro, güiro mambo (Coconut, coconut speaks). This is a tentative and contested translation. According to Santiago, the Spanish word güiro is the term for coconut in a Palo setting. This is not, apparently, common usage. Güiro typically refers to the beaded-gourd instrument (also called a chekeré) played in many Cuban musical contexts and also, to the calabash tree. The rotund fruits of this tree (known as güiras), are used to make the half-gourd bowls so prevalent in Afro-Cuban religious practice. It is possible that Santiago's idiosyncratic use of the word güiro is based on this association; coconut shells are also used as containers. The Congo-Cuban word mambo denotes the high-energy

songs of Palo ritualizing. According to Díaz Fabelo (n.d.: 90), this meaning extends to other forms of vocal expression, such as speech. Our translation "coconut speaks" is at least contextually feasible because the fruit is being used to cleanse but also, when it is later smashed to the floor, as a divining instrument and mouthpiece for the spirits. Varona Puente and Klein note that the first line of this healing chant, however semantically transformed, clearly echoes that of the well-known Palo song, *Güiri, güiri mambo* (Listen, listen to the mambo).

30. In fact, many of Santiago's prescriptions fall under the heading of preventive medicine. Ritually charged objects (and other, less tangible "medicines") that safeguard the people who possess them by fortifying them internally and keeping harmful forces at bay are called *resguardos* (literally, safeguards). Talismans, invigorating baths, and all stages of religious initiation spiritually and physically protect the recipient. Santiago talks about the *rayamiento* (the first step in Palo initiation) as being one's best defense against hechicería, or "sorcery."

31. M. A. Mason (2002: 35).

32. Although in an ideal world Santiago would have a reserve of these necklaces, the demand is great and the different colored beads required are sometimes hard to come by. We have been involved in several beading marathons to generate new necklaces for persons about to undergo the collares initiation.

33. The Lucumí term for these necklaces is *eleke*(s). Before a necklace is bestowed, Santiago drops it to the ground. He then tells you to pick it up, kiss it, and return it to him. Although we have not confirmed the following interpretation, the gesture seems to symbolically place the necklace in contact with ancestral forces and other spirits of the dead before it is gathered back up and "received." It dovetails nicely with the frequently cited adage, "The dead gave birth to the saints" (*Los muertos parieron a los santos*). As M. A. Mason explains (2002: 100), "The widely held belief is that practitioners must 'work' the dead before they work the orichas to show respect to the dead and to have an open road with the orichas."

34. The cowrie shell mouth and eyes reference Eleguá's role as messenger for all the orichas and his ever-watchful connection to one's personal destiny. The tiny knife blade that projects from Eleguá's head proclaims his fundamental power as a warrior and "cutter of spiritual paths" (Murphy, 1993 [1988]: 71).

35. Santiago Castañeda Vera, recorded interview, 2002.

36. As of completing this book, neither of us has "made saint." For a fine article on the process of receiving the warriors, see M. A. Mason (1994). Most descriptions of full-fledged initiation into Santería are composite. For a brief but emotionally honest account of her own initiation, see Hagedorn (2001: 214–219).

37. If a person is considering full-fledged initiation into Santería but is also involved in Palo, he or she must be rayado before making saint. This seems to be one of the few absolutes in Afro-Cuban religious culture. Once again, "The dead gave birth to the saints" would seem to support this ritual sequencing. As Santiago explains it, "Your body cannot be cut in Palo [i.e., reopened] after having an oricha seated in your head." On some level the saying also honors and legitimizes the primacy of Santiago's lifelong involvement with spirits of the dead.

38. Although the rayamiento is a first step in Palo, the ritual differs significantly from the preliminary Santería initiations that we just described. It follows the classic pattern of a rite of passage, involving the symbolic death and rebirth of the person being initiated. In this respect and while condensed in terms of both time and space, the rayamiento is closer to the asiento, the highest level of Santería initiation.

39. The songs sung during the rayamiento do not just accompany the ritual. In many ways, they seem to

generate it. With regard to learning through performance, M. A. Mason (2002: 38) quotes a passage from John MacAloon: "Ritual action effects social transitions or spiritual transformations; it does not merely mark or accompany them" (MacAloon [1984]: 250).

40. *Menga va correr como corre tintorera (o guarironga).* The second half of this simile has been translated in various ways, although the essential meaning is clear: "Blood is going to flow forcefully like a torrent." *Tintorera* has been translated as "red dye" (Argyriadis, 1999: 156), and *guarironga* as "river, water current" (Bolívar Aróstegui and González Díaz de Villegas, 1998: 158). *Tintorera* is also the Cuban word for the ferocious female shark "who always attacks" (Sánchez-Boudy, 1999: 658). Loosely corroborating this last possibility, Carbonell (1990: 46) cites a variant of the initiation song—*ninguna* [blood] *va a corre como corre la tintorela*—and says that the *tintorela* is a fish. As Santiago chants his version, he uses a razor to lightly score the forehead, both sides of the upper chest and back, the backs of both hands (the meaty part of the fist) and lower legs, and the tongue of the person being initiated. Each cross-hatched configuration is unique but, at least in Santiago's Palo tradition, always consists of seven lines, Sarabanda's mystical number. Bolívar Aróstegui and González Díaz de Villegas (1998: 44) note that "the old Tatas" (the honorific for men who have attained the highest level of Palo initiation) would use the spur from a rooster or, better yet, that of a sparrow hawk. We cannot speak for what might be used in the more rigorous levels of Palo initiation in Santiago's nso-nganga.

41. This particular conception of the universe has its origin among among the Kongo and Kongo-related peoples of West Central Africa.

42. See MacGaffey (1986: 107).

43. Kimbisa is a potent, cane alcohol–based, ritual concoction used to "heat up" the spirits in Santiago's prendas and to fortify members of the congregation during Palo rituals. It is prepared with alcohol, the blood of sacrificial animals, pepper, garlic, ginger, cloves, assorted roots, and, according to Cabrera (1986c [1979]: 130), chili peppers, gunpowder, and the powdered branches of forest trees.

44. Mack (1994: 18). Mack's statement is based on an observation made by Poppi (1993: 198–199). Commenting on the paradoxical nature of secrecy in a West African initiation society, Poppi writes: "What initiates 'see' in initiation, the 'secret' they must protect, is not really an addition to their preexisting pool of information about the world: they 'look at' the same things as before. But they see different meanings attached to them, meanings generated by their newly acquired awareness. What they have learned is not a 'new world' but a way of looking at the old one through new interpretive means."

45. For an informative account of Palo initiation based on the author's observation of two rayamientos, see Bettelheim (2001). Also see González Bueno (1988: 68–70), one of Bettelheim's primary sources, for a personal testimony as to her Palo initiation in Santiago de Cuba. An English translation of the González Bueno article appears in Pérez Sarduy and Stubbs (1993).

46. *Nganga, mira relo.'* A palero addresses his prenda urging it to watch the hour. At midnight, when the watch hands read "above the nganga," it will be time to clock in and get to work. Klein elaborates, "the nganga is busy dozing (as they are inclined to do, which is why they have to be goaded into action). This is his midnight wake-up call. All prendas should have a pocket watch in them, the hands stopped at midnight. If they don't, it can only mean that none were available. The palero is literally asking the nganga to take a look at the watch by his side." According to Varona Puente, the phrase *ndiata mundo awé* means "daily struggle in the world," "the Congo fight," or "battlefield," a contentious arena "where things are worked on and perhaps resolved."

47. The mounting of a prenda is a complex mystical process that binds Santiago to the charm both physically and emotionally. He is an extension of the vessel's particular attributes and functions just as these same powers represent an extension of Santiago's will and physical being.

48. There are several nuances to the term *controversia* that richly play into Mariano's statement. In the most general sense, "controversy" does seem to define important aspects of the Palo ethos or worldview. The religion realistically recognizes conflict and social strife as an unavoidable part of reality and in many ways celebrates it (see n.10 above). This is reflected in the power assemblages or prendas that are the focus of ritual attention as well as in ritual performance. As will become evident in chapter 4, competition between paleros (or between a palero and a spirit) can be very intense and usually takes the form of an escalating vocal duel that calls into question the other's authority, depth of knowledge, and mystical means. These condensed forms of artistic expression are known as *cantos de puya*, or "challenge songs." Vélez (1998: 159) notes that the heated exchange of puyas during rituals are "competitions . . . known as *controversias*." This adds dimension to Mariano's statement. Given the extraordinary generative power accorded speech, and especially song, in the Congo reglas, it is worth looking at the Congo-Cuban word mambo (Palo ritual song). It has much the same meaning as the Spanish term controversia. Talking about the instrumental and dance music called mambo, Thompson (1993b: 61) tells us that the term is a creolized version of the KiKongo word *mambu*, meaning "quarrel," "argument," or, citing a Wyatt MacGaffey translation, "contested situation."

49. For an illuminating article on the relationship between Central African Kongo themes and Indian imagery and ritual in the Spiritual Church of New Orleans, see Wehmeyer (2000). In the preface to his endnotes (95), Wehmeyer writes, "As [Robert Farris] Thompson and [Jason] Berry have suggested, 'Indian' in New Orleans is often better read as coded 'African' than as 'Native American.'" Mariano's "Indian" warrior (see far right of Figure 123) is very Kongo in appearance, so much so that he suggests an nkisi (Kongo power figure) of the classic "hunter" (*nkondi*) type.

4. I Am Not from Here

1. *Congo mío, ven de los montes*. The verbs *jugar* (to play) and *trabajar* (to work) are often used interchangeably in a Palo-Congo context. They describe the ritual manipulation of natural and otherworldly forces, of objects and substances, with specific concrete ends in mind. The *mpaka* is a ritually charged animal horn, sealed with a mirror or "mystic eye" for seeing into the beyond. It is clear from the song lyrics that the work to be done is resolutely material rather than spiritual in nature and that it involves the assistance of less evolved but very effective spirits who incarnate themselves through possession.

2. Santiago calls his upper altar the bóveda espiritual, which literally means "spiritual vault" or "burial chamber." Like the individual prendas below it, the altar functions as a "symbolic tomb" (Thompson, 1981: 190). Although both spaces mediate Santiago's dealings with the dead, the nature of the spirits invoked and the tenor of his interactions with them are very different. The transition from the transcendent mass for the "dead of light" to the down-home celebration of the Congo dead captures some of this difference in energy and outlook.

3. The "dead of light" honored during the spiritual mass (*misa espiritual*) occupy the ephemeral heights of the spirit world. They are never fed the blood of sacrificial animals. For this reason, all references to the previous night's matanza have been either erased or masked.

4. The term "syncretic" is problematic because it is often used to imply an *unreflective* or *passive* blending of traditions. Redefining the conditions of its use, M. A. Mason (2002: 89) suggests that while it might be misleading to say that Santería (for instance) is a syncretic tradition, "it is accurate to say that many practitioners of the religion are *syncretic in their approach* to their religious activities" (emphasis added). Mason's statement situates the whole notion of syncretism where it should be, within the culture rather than outside of it. Practitioners of Afro-Cuban and other religions actively draw on and reshape elements from diverse sources, and the religions themselves have seen a great

deal of creative interplay and accommodation over the years. As many scholars have suggested, it is more accurate to think of these religions as creole (i.e., Cuban) phenomena with roots that extend back to both Africa and Europe.

5. Espiritismo is the term used to designate the religion of Spiritism as it has evolved in Cuba and elsewhere in the Spanish-speaking Caribbean. We have chosen to use the word "spiritist" when the adjectival form is needed. This is done for the sake of euphony as well as to avoid any confusion between the Spanish adjective *espiritista* and the use of this same word as a noun. Practitioners of Espiritismo are called *espiritistas*, whether they are women or men. For an inspiring, historically grounded account of Spiritism's nineteenth-century impact in the Spanish Caribbean and its ongoing relevance in Cuba, Puerto Rico, and the United States, once again see Fernández Olmos and Paravisini-Gebert (2003: 171–210, 232–237). A focus on communicating with the dead was not the only thing Palo Monte and Spiritism had in common. The "spiritual militancy" that characterizes Palo Monte and other Bantu-descended religious traditions in the New World also forms a fascinating dimension of Spiritism's history and transformation in the Spanish Caribbean. Martial metaphors and, to a lesser extent, ideology are common to both Espiritismo and Palo Monte.

6. Millet (1996: 22), in his booklet devoted to Espiritismo in Santiago de Cuba, describes the altar of an espiritista by the name of Loló. Of particular interest is the fact that Loló also has a light bulb, ever illuminated, that represents "the light of St. Hilarion."

7. The heavy knotted cord around Saint Francis's neck may represent an instance of European occult magic making its way to Santiago's bóveda. The saint's presence, at the same time, subtly honors the fact that Santiago has undergone a first step toward initiation as a *babalawo* (priest of the Ifá divination system), making him a godchild of Ifá and placing him under the immediate protection of Orula, the oricha counterpart of Saint Francis.

8. Although Santiago does not refer to them as such, the selection of saints featured on his altar loosely suggests the Seven African Powers (Siete Potencias Africanas) recognized by practitioners of Santería in Puerto Rico and the United States: Eleguá, Obatalá, Orula, Ochún, Changó, Yemayá, and Ogún in their Catholic incarnations. While many saints adorn Santiago's bóveda and a number appear in his front room, there is no Catholic statuary whatsoever in the room specifically devoted to Santiago's orichas.

9. San Lázaro's sacred objects (fundamentos) are also kept in the nso-nganga. The oricha lives in a clay vessel—formed by two bowls with one inverted as a lid—inside a low-lying cabinet to the right of Santiago's two-tiered altar complex. The perforated lid of the container holds an array of speckled guinea fowl feathers. Both the holes and the spotted feathers are said to evoke the sores that cover San Lázaro's body as well as his ability to cure and inflict dreadful skin diseases. Santiago often refers to San Lázaro as the *carretero* of the cemetery, the "cart driver" responsible for transporting bodies to their graves. The oricha-saint is intimately associated with death and decay.

10. Millet (1996: 59–62).

11. The spirit guides common in Cuban Espiritismo mirror successive waves of labor migration to the island, much of it involuntary. The multiethnic African presence in Cuba, the result of the slave trade, is the most enduring and obvious. The eastern end of the island, in particular, is also home to many Cubans of Haitian descent. A significant number of Creoles and French colonials who fled the Haitian revolution of 1792–1804, some with their slaves, found refuge in the eastern provinces of Cuba, profoundly affecting many aspects of culture in Oriente. In the mid-nineteenth century, as English pressure to abolish slavery increased—disrupting the horrific trade in human beings from Africa—laborers of non-African descent were imported to Cuba. Their status was, it appears, hardly better than that of the slave population. The following summary account of these migratory waves is based

on Brandon (1993: 79–80) and Argyriadis (1999: 48). In the early 1840s, Amerindians were brought from the Yucatan Peninsula to cut cane. Chinese contract laborers were introduced beginning in the 1850s, and in 1854 Galicians from Spain were imported to work under the same miserable conditions. In the decades following Cuban independence from Spanish colonial rule, the government encouraged black immigration from Haiti and the British West Indies (1913–1928) to provide seasonal wage labor. From Haiti alone, over 500,000 entered the country to cut cane during this period. Many Haitians and Jamaicans chose to remain in Cuba.

12. In his account of Spiritism's rapid "creolization" in Cuba, Brandon (1997 [1993]: 87) paraphrases Cabrera: "In Cuba Kardec's spirit guides frequently embodied the popular stereotypic images of Cuban ethnic, racial, and professional groups. Not only did Cuban espiritistas in their mediumistic trance manifest spirit guides that resembled themselves, both physically and in temperament, but both black and white mediums manifested spirit guides who were *Africanos de nación* [African-born slaves of a particular ethnic origin]. . . . None of this was in Kardec." In our experience, spirit guides stereotyped according to profession—Spanish clergymen, doctors, and so forth—seem to be more common in western Cuba than on the eastern end of the island.

13. Although it is tempting to link some of the imagery on Santiago's bóveda to possible Haitian or Haitian-derived influence (a suggestive cluster of old silverware, for instance, to similar iconography in the Petwo/Congo faction of Vodou spirits), this lies beyond the scope of the current work. Santiago is, on many levels, steeped in things Haitian. The culture forms part of his personal history and also stokes his imagination and religious views. For Santiago, Haiti is a place of superior mystical power. When he talks or sings about the country in a ritual context, it is evident that on some level he equates Haiti with Africa.

14. The use of water-filled glasses is common to both Cuban Espiritismo and American *Spiritualism*, a related practice that has deep roots in the American South (New Orleans in particular). Stephen Wehmeyer states that the use of such vessels "can be traced to the magnetic practices of Franz Mesmer. . . . Goblets of magnetized water were used for healing or as conductors of spirit." Online response to Judith Bettelheim re. Wehmeyer (2000), accessed 4 August 2005, pp. 2–3, http://www.findarticles.com.

15. This statement paraphrases a remark about Kongo cosmography made by Wyatt MacGaffey and cited in Fernandez (1986: 163). MacGaffey goes on to say that the permeable barrier that separates the living from the dead "may be identified in appropriate contexts with any physical body of water . . . and even a bowl of water or a mirror" (163). The imaging of the land of the dead as lying across a watery expanse is vividly evoked in "Leap over the Sea," the song that plays such a performative role in Palo initiation. It is discussed in chapter 3.

16. MacGaffey (1986: 116).

17. In a preliminary consideration of Brazilian Spiritism and its relationship to Afro-Brazilian religions (Candomblé in particular), Wafer (1991: 5) makes the following simple yet profound point: "Kardec's ideas have spread well beyond Kardecism—in part, no doubt, because they provide a Portuguese vocabulary (in translations of his works from French) with which to conceptualize dealings with the spirit world." In Cuba, of course, this same overarching vocabulary was adopted from Spanish translations of Kardec's work.

18. *Espiritismo integrado* or "integrated Spiritism" is the term preferred by the Cuban scholar José Millet (1996: 4).

19. Santiago says that every human being, regardless of religious affiliation (or lack thereof), has his or her own *cuadro espiritual* (spiritual cadre), a group of enlightened beings that has accompanied and watched over the person from birth.

20. There are many different types of mediums in Espiritismo. As González Wippler (1996 [1989]: 277) explains, they include those who "see" or "hear" the dead, those who become possessed by them, those who specialize in banishing harmful or malicious spirits, and those who have the gift of sight and predict the future.

21. In a very real sense these querulous but savvy old Congo slaves are reappropriated or reclaimed ancestors and, as such, represent a kind of patrimony of the spirit. Santiago appeals to them constantly, Pa Francisco in particular.

22. The opening prayer, taken from a booklet popular among Cuban espiritistas, is much longer than the brief passage cited here. For the complete Spanish text, see Kardec et al. (n.d.: 35–36).

23. This novena to the Virgin of Regla is taken from a book of popular prayers compiled and beautifully illustrated by the Cuban artist Zaida del Río (n.d.: 28), *Herencia Clasica: Oraciones populares ilustradas por Zaida del Río*.

24. Santiago refers to the monstrance on his bóveda as *El Santísimo* (The Holy Sacrament). These ornate vessels, surrounded by rays of light, are used to display the consecrated Host on Catholic altars. According to D. H. Brown (2003b: 248), they have long been featured on the domestic altars of santeros, paleros, and espiritistas. As a representation of the Eucharist (i.e., Body of Christ), the monstrance is, in a sense, a Christian version of a prenda or an oricha's sopera; it encloses a fundamento, a condensation of sacred power, in the form of the consecrated Host. El Santísimo may also allude to a particular camino of the oricha Obatalá. As Brown (248) tells us, "Obatalá and Christ each play the role of the 'son' of the Supreme Being," whether this be Olofi or Almighty God.

25. These unsettled and potentially harmful spirits fall into different categories, with evocative names such as *los intranquilos* (the restless ones) and *los perturbadores* (the disruptors).

26. Cabrera (1986b [1977]: 21). Santiago often recites this prayer, the oration of San Luis Beltrán, as he initiates a *despojo* (ritual cleansing).

27. Santiago's body language before his spiritual altar is identical to the "Congo" gesture of supplication—with both hands extended above the head, fingers spread wide—signaled by Thompson (1981: 176–177), who describes it as having "mystic overtones . . . in the sense of radiating forces." Santiago is indeed sending songs vibrating out into space. *Hay miles y miles* (There are thousands upon thousands [of these trasmisiónes]), he once crowed to us. Directly communicated to human beings by the "dead of light," these songs are literally vibrations, a form of "thought transmission."

28. The "Divine Manuel" is yet another reference to the Holy Sacrament, that is, the Host or Body of Christ. It is represented on Santiago's bóveda by the monstrance. See n.24 above.

29. Santiago calls this resonant finger slapping an "echo of imploration." This rather melancholy description captures the gesture's double-edged intent. While it sends out shimmering positive forces to further elevate the "dead of light," possession during the actual spiritual mass is strongly discouraged. The fact that a transcendent spirit should have to actively seek light through physical possession is not a good sign. Argyriadis (1999: 224) notes that such "incarnations" are thought to be "involuntarily harmful to the living."

30. Few of the songs appearing in this book are presented in their entirety, but we have tried to include enough text—and, when necessary, interpretive comments—to convey their spirit, mood as well as meaning. Most Palo and Congo songs are sung in call-and-response fashion. The lead singer often improvises; the congregation answers with a fixed refrain of one or more lines. At times call and response overlap, contributing to the propulsive energy of both song and ritual moment.

31. *San Hilarión, comisión Africana.* It is significant that Santiago should initiate the transition from the spiritual mass to the Congo part of the evening with this song. San Hilarión is the name of the cabildo or religious house-temple into which Santiago was born. As he explains, "Each cabildo had its

own name in accordance with what the muerto told you to call it." Virtually all cabildos were under the patronage of a particular saint. The mystics, martyrs, and warriors of the Catholic Church were especially popular. San Hilarión was a fourth-century hermit who, inspired by Saint Anthony's ascetic example, pursued a life of absolute solitude in the Gaza desert. Despite his reclusive nature, he acquired a remarkable reputation for his exorcisms and cures and was soon beset by would-be disciples and others seeking miraculous intervention (see Metford, 1983: 120). In art, he is pictured as naked, emaciated, and with a long beard in a harsh desert environment—evoking the wilderness or el monte. According to Santiago, San Hilarión "reports to" the "African commission" (comisión Africana). Not only is the language Santiago uses distinctly military, but the song "San Hilarión" starts out slow and then swells in volume and intensity: the purposeful, unvarying rhythm and gradual amplification even suggest a military drum corps approaching from the distance. Fernández Olmos and Paravisini-Gebert (2003: 232 n.3) write that Espiritismo's adoption of terms such as "spiritual cadre" and spirit "commissions" is "an indication of the influence of militarism in nineteenth-century Caribbean societies, particularly in Cuba and Puerto Rico, the two islands still under strict Spanish military control." The use of such terms suggests a form of spiritual warfare aimed at protecting human beings in times of heightened social strife (which included the violent struggles for independence from Spanish rule), blatant inequality, and generalized fear and anxiety.

32. Some possessions are encouraged; others, discouraged. If Santiago considers a person too fragile or the timing inappropriate, the individual is cooled off with fresh water. Frenzied, uncontrolled possession is emphatically discouraged at all times. It indicates that the person either lacks the experience to channel the spirit in a culturally appropriate way or that the individual is being assailed by an unwanted entity. This last type of possession falls in the category of "illness," one that needs to be diagnosed and treated by a ritual expert.

33. As Santiago explains it, Xiomara's spirit of the dead is muy bruta (wild and unsocialized). "She doesn't even know her muerta's name!" he exclaims. Because Xiomara's muerta is spiritually illiterate, she can neither "consult" (offer advice or guidance) nor "do good works" for other human beings. Xiomara would need to help her muerta evolve to a higher spiritual level.

34. Bombo siré, bombo naya. We have not yet found anyone who can translate the Congo-Cuban refrain of this mambo, although Díaz Fabelo (n.d.: 87, 42) defines the words mbombo and siré as "funeral song" and "justice," respectively. Moving to the body of the song, the singer describes looking for a Congo who works with a prenda named "Seven Lightning Bolts," a powerful spirit cauldron with a reputation for effecting sudden change. Siete Rayos is also the praise name of the Palo spirit considered to be the Congo equivalent of the oricha Changó. In a Palo context, the verb virar generally means "to topple, destroy, or vanquish." Spirits with a variant of this word in their praise name are, according to Santiago, strong, militant, and, other than by God, invincible.

35. Güiri, güiri, güiri ngó. The Congo-Cuban word ngó means "government, command, leadership" (Díaz Fabelo, n.d.: 85). Varona Puente has advised us that, in the context of this song, the word refers to the "micro-government of Palo." Considering the chain of command that "governs" the contentious forces that live in any prenda, this makes perfect sense. In a passage from El Monte, one of Lydia Cabrera's (1992 [1954]: 131) informants describes this extraordinary pecking order in language that evokes the dehumanizing reality of New World plantation slavery: "The ngangulero [i.e., palero], the master, commands the dead man: the dead man, who is the overseer, commands the [spirits of the] trees and the animals, who are the 'work crew' [or 'slave gangs,' '"cuadrillas" de esclavos']. The fúmbi [i.e., nfumbi] is the general of the forces."

36. Of Pa Francisco, Santiago says with pride, "That black man is bad" (Ese negro es terrible). Commenting on his muerto's universality, Santiago adds, "He's known all over the world . . . in any country you could think of going to."

37. *Congo de guinea soy. ¡Buena' noche' criollo'!* The designation criollo (Creole) was once applied to any person born in Cuba as opposed to Africa, Spain, or elsewhere. While it was certainly used more prevalently during the colonial era, it survives as a homespun way of describing a person as truly Cuban, born and bred. *Hacer caridad* (to do good works) presupposes the ability to help others resolve life's problems by channeling the healing energy of the dead, whether directly, through possession (considered a gift from God), or indirectly.

38. Pa Francisco will spray *chamba*, a ritual drink made with crude rum (*aguardiente*) that has been infused with chili peppers, gunpowder, herbs, and other ingredients (some maintain powdered bone) over the heads of his "children" as a form of blessing.

39. *Cuando yo vivo en tierra yesá, muchacho.* The phrase *tierra yesá* is a reference to Africa as in "land of origin": *yesá*, according to Varona Puente and Klein, is the Afro-Cuban equivalent of Ijesa, once a central Yoruba city-state and now a town in Nigeria. Some Congo spirits, when they first arrive among the living and are asked to identify themselves, will simply reply *Llamame como quieras* (Call me anything you like), hence the "Hey! My name is whatever" of the song text.

40. *En fiesta de gallina, cucaracha no puede entrar* is one of the metaphorically loaded barbs that Pa Francisco launches at Pa Julian. (At a party of hens, a cockroach best not enter—the implication being, of course, that it will be eaten.) The culture surrounding Congo spirits of the dead in Cuba in many ways parallels that of the *caboclos* (a class of primarily Indian spirits) in Brazil. Talking about a similar kind of rivalry between these spirits, Wafer (1991: 76) rather wryly concludes, "The tension in *caboclo* society is not between classes—*caboclo* culture is essentially egalitarian, since forest life does not provide much scope for the accumulation of capital—but between insiders and outsiders." This social dynamic seems typical of interactions between the Congo dead as well. Although they are equals, Pa Francisco is in a sense responding to an invasion of *his* "forest" territory by Pa Julian.

41. Some consultations are quite private, while others take place in front of everyone. Family members who persist in disapproved life paths or behavior are often singled out for this more public treatment, thereby serving as a warning to others.

42. These ritual gestures of dismissal speak volumes. Based on personal experience, the sensation is one of crossing multiple, hard-to-define boundaries. The spirit centers you with the cyclical movement, grounds you with the emphatic arm shake, and finally pushes you, newly fortified by the contact, back out into the world.

43. This arms-akimbo pose is, according to Thompson (1981: 171), an iconic Kongo stance. He describes it as a "challenge" pose: "stern, forbidding, intimidating, confrontational."

44. *Congo, conguito.* Conguito ("little Congo") is a term of affection. Cubans are second perhaps only to Haitians in their love and use of diminutives.

45. The Haitian spirit Ma Rufina is a muerta said to work closely with Oyá, the cemetery gatekeeper and temperamental oricha of wind and storm. Both are identified—Ma Rufina perhaps by association—with the lashing turbulence of the whirlwind. Santiago in fact describes Ma Rufina as a Congo manifestation of Oyá.

46. Cantos de puya are songs full of attitude, allusively delivered. The lyrics goad or provoke the person at whom they are directed, often (as in this case) a palero from outside one's ritual circle. The word *puya* is a Spanish bull-fighting term that refers to the wounding point of a picador's lance. These mocking challenge songs have been compared to the African American verbal art form of "signifyin(g)."

47. *Hacha con hacha no puede topar.* The verb *topar* literally means to set a pair of cocks to fighting or to butt heads, as when two rams do battle. The song is saying that as a rule, "equal forces cannot fight because neither will win: they repel each other" (Klein and Varona Puente). In this instance, however, the canto de puya is being launched as a direct challenge to another palero. The lines "I'm working

kimbisa, we're going to butt heads" suggest that the rival is from a different (i.e., non-Kimbisa) branch of Palo Monte. When two ritual experts confront one another, their respective energies go to war to determine who has the most power. A well-known Congo-Cuban proverb reads: "An ox [i.e., strong person] must not butt heads with another ox. And if they lock horns, the world comes to an end" (Díaz Fabelo, n.d.: 32).

48. *¿Pa' que me molestas?* Although in some ritual songs, the voice shifts back and forth—between human being and spirit, for instance—so that it can be hard to track "who" is singing at any one moment, these lyrics are sung entirely from a muerto's perspective. In it the spirit—who would rather be left to his druthers in the savanna—fretfully asks the palero: Why are you calling me, manigüero? Why are you bothering me? I work for you (i.e., "I make the prenda vibrate [from within] at the appropriate hour"), but there is a time and a place for everything. This gloss is based on Varona Puente's and Klein's comments.

49. *Santa María Madre.* In this fervent spiritist song, sung in call-and-response fashion, a practitioner is being enjoined to work her ability as a medium for enlightened spirits of the dead so that these disembodied beings can communicate with people in the material world.

GLOSSARY

The Palo spirits may be known by Congo-Cuban as well as Spanish praise names. Some of their names are a hybrid of both languages. According to Santiago, the basic system of correspondences between the Palo mpungus (spirits of Palo Monte), the Lucumí orichas (spirits of Santería), and the Catholic saints is as it appears below. The inventory is not exhaustive; a number of Santiago's personal orichas, for instance, are not included.

PALO MPUNGU	ORICHA	CATHOLIC SAINT
Lucero "Evening Star"	Eleguá	El niño de Atocha (Infant child of Atocha)
Sarabanda	Ogún	San Pedro (Saint Peter) Santiago (Saint James)
Madre de Agua "Mother of Water"	Yemayá	Virgen de Regla (Virgin of Regla)
Guinda Flecha	Ochosi	San Norberto (Saint Norbert)
Centella "Lightning Flash"	Oyá	Santa Teresa de Jesús (Saint Teresa of Avila)
Tiembla Tierra "The Earth Shakes"	Obatalá	Virgen de las Mercedes (Virgin of Mercy)
Brazo Fuerte "Strong Arm"	Agayu	San Cristóbal (Saint Christopher)
Mama Chola	Ochún	Virgen de la Caridad (Virgin of Charity)
Siete Rayos "Seven Lightning Bolts"	Changó	Santa Bárbara (Saint Barbara)
Kuaba Ngenge	Babalú Ayé	San Lázaro (Saint Lazarus)

All terms of non-Spanish origin used in Afro-Cuban religious practices are labeled accordingly. The general linguistic key is as follows: (C.) Congo (words of probable KiKongo origin); (Lu.) Lucumí (words of Yoruba origin). Occasionally the entry is a hybrid—Spanish/Congo (Sp./C.), for instance. Unless otherwise noted, the entry is in Spanish alone.

Abakuá (Carabalí): Afro-Cuban religious and mutual aid brotherhood. Considered one of the four religions of African origin in modern-day Cuba, the Abakuá order is concentrated in the western provinces of Havana and Matanzas. Its roots lie in the all-male secret societies prevalent among the Efik and Ejagham peoples of the Cross River delta, a coastal region in what is now southeastern Nigeria and western Cameroon. Originally formed by slaves from this West African region (who were known as the *Carabalí* in Cuba), the hierarchically structured brotherhood gradually opened itself up to mulatto and white membership in the course of the nineteenth century.

aché (Lu.): Vital transformative energy. The life force that permeates the natural world and resides in all spirits, people, things, plants, and animals. Experienced practitioners are able to harness and direct this power to benefit both humans and spirits. Although the word is of Lucumí (i.e., Yoruba) origin, aché is a fundamental concept shared by all adepts of Afro-Cuban religion. *Dar aché* (to give aché) means "to consecrate."

Agayu (Lu.): Fiery oricha of the volcano. Identified with the Catholic Saint Christopher (San Cristóbal), depicted as a powerful giant of a man ferrying Christ across the water, and in some Cuban traditions with Ánima Sola, the lonesome Soul engulfed by purgatorial flames. As a primordial force for destruction and renewal, Agayu is closely associated with the oricha Changó.

aguardiente: Strong, clear cane alcohol. Preferred ritual drink of the Congo spirits of the dead and the hot-tempered warrior spirits of the Santería and Palo Monte pantheons.

ahijado, ahijada: Godson, goddaughter. Ritual godchild of a priest or priestess who has initiated that person into the Afro-Cuban religions of Santería and/or Palo Monte. This spiritual elder is respectfully addressed as *padrino* (godfather) or *madrina* (godmother).

akpwón (Lu.): Term designating the lead singer in a Santería ceremony, who may also be called the *gallo* (Spanish for "rooster"). In a Palo context, the lead singer may be referred to by the equivalent Congo-Cuban word *nsusu*, which also means "rooster."

alafía (Lu.): One of five possible configurations that results when using the four-piece coconut divination system. Alafía is the name of the pattern wherein all four segments of the coconut land white (i.e., fleshy or concave) side up. It is interpreted as an affirmative but changeable sign. Alafía is less grounded than *eye ife*, which describes the combination of two coconut pieces that have fallen white side up and the other two white side down. Eye ife is considered unconditionally positive.

amarre: See *nkange*.

ángel de guardia: Guardian angel. Term designating a person's primary oricha, assigned by Olofi (the Lucumí High God) before birth. This oricha is considered to "rule" or to "own" the individual's head.

asiento: Literally, "seating." One of several expressions used to describe the highest level of initiation into Santería. The neophyte emerges from this major weeklong ceremony as a newly consecrated priest (*santero*) or priestess (*santera*) of the religion. This intensive series of rituals is also called *hacer santo* (to make saint) and, in Lucumí, *kariocha* ("putting the oricha on the head").

aura tiñosa: See *mayimbe*.

azucena: Fragrant, creamy white flower (*Polianthes tuberosa*) considered essential to spiritist ritual undertakings. Alongside other sensory elements, azucenas attract and strengthen the highly evolved "dead of light."

babalawo (Lu.): Literally, "father of the secrets." An initiated priest of the exclusively male order of diviners who manipulates the divination system known as *Ifá*. Babalawos do not divine with coconut pieces or cowrie shells but use either a divining chain or a carved wooden divination tray and palm nuts. The figures that result from the manipulation of the palm nuts are etched in a special powder that has been dusted over the tray. Orula or Ifá, as he is sometimes known, is the patron oricha of all babalawos.

Babalú Ayé (Lu.): Oricha-owner of epidemics and diseases, especially those that afflict the skin, and much-loved patron of the poor and the sick. He is the only Lucumí spirit more commonly referred to by the name of his Catholic counterpart, San Lázaro (Saint Lazarus). Babalú Ayé is a healer, but he can also infect with diseases that lay waste to the body, linking the spirit to the domain of death and decay as well as life. The last portion of his Lucumí name, *ayé*, is the word for "earth," further identifying Babalú Ayé with the home of the dead. He is said to have at least three different *caminos*, or "paths."

Bantu: The overarching linguistic and cultural term for a large group of African languages, and the peoples who speak them, in South and Central Africa. In Cuba, the term is used to refer to the language and expressive culture of peoples tracing their origins to the West Central African regions of Kongo and Angola. See *Congo*.

barrio: neighborhood.

basura monte: Literally, "forest refuse." Spanish translation of the Congo-Cuban phrase *ntiti nfinda*. The phrase refers, in the words of Cabrera (1992 [1954]: 130–131), "to a whole array of vermin — 'bugs,' insects, reptiles — connected with the forest and the dead and considered essential for a sorcerer's work." Obnoxious rodents and predatory birds are also considered basura monte. This creeping, crawling, burrowing, and flying "refuse" is considered valuable because it is inherently powerful.

batá (Lu.): Set of three consecrated double-headed drums used in Santería ceremonies. Played at both ends and with both hands, the batá are said to converse tonally with each other and to communicate directly with the orichas.

batea: Lathe-turned wooden vessel, often painted red and white, that holds Changó's sacred objects.

botánica: Specialized market for ritual goods such as herbs, forest branches, powders, candles, oils, and Catholic images and statuary.

bóveda espiritual: Literally, "spiritual vault" (as in cemetery vault for the dead). Term used by Cuban spiritists (*espiritistas*) to designate their private domestic altars, the focus of interaction with enlightened spirits of the dead.

bozal: Literally, "muzzle" (of a dog), "halter" (of a horse). A word used to describe an animal (or a human being) considered to be wild, unruly, or untamed. Bozal was the pejorative term applied to newly arrived African slaves during the colonial era and often used in opposition to the term *criollo* or island-born. Bozal is also the name of the Afro-Cuban Creole language elaborated by slaves of different ethnicities to communicate with each other. Although spoken more prevalently in the eighteenth and nineteenth centuries, bozal survived among rural blacks well into the twentieth. It lives on in the stylized speech of certain Lucumí and many Palo spirits. Interspersed with words of Bantu origin, bozal is especially favored by the rustic Congo spirits of the dead.

Brillumba (C.): A branch (*rama*) of the Palo Monte religion that combines aspects of Santería and Palo Monte.

brujería: Literally, "witchcraft." Mystical operations (i.e., *trabajo* or "work") aimed at healing and spiritual defense. Cuban religious practitioners often oppose the notions of brujería and *hechicería*, associating the former with the manipulation of power for the common good and the latter with more aggressive, sorcerous techniques intended to harm other individuals or undertaken for purely selfish reasons. The distinction between the two is in fact rather nebulous: the particular situation determines whether the course of action chosen is considered ethical or not. See *hechicería*.

cabildo(s): Associations of a religious, social, and mutual aid nature that were formed by slaves in colonial Cuba from the late sixteenth century onward. Officially recognized by church and state, each cabildo was placed under the patronage of a particular Catholic saint. Membership in these organizations originally consisted of African-born slaves grouped according to ethnic affiliation. Slaves born in Cuba (*criollos*) as well as free men and women of color were eventually admitted to their ranks. Historically, cabildos were forces for cultural resistance as well as accommodation to the dominant culture. Although cabildos no longer exist as such today, the remarkably independent religious "houses" of Santería and Palo Monte play similar if less formally structured roles.

caldero: Iron cooking pot, cauldron.

camino: Literally, "road" or "path." The term can refer to a specific incarnation of an oricha or to a person's path in life, in the sense of destiny. The dynamic principle of aché underpins all nuances of the word camino. As M. A. Mason (2002: 97–98) notes, if a person's road is blocked or closed, "ease of movement" and life potential are inhibited; obstacles must be removed so that the *aché* or life energy can once again flow unobstructed.

campo nfinda (Sp./C.): The forest-cemetery. In Congo-Cuban thought, there is a strong metaphorical link between the realm of the dead and the natural world. See *nfinda*.

camposanto: Literally, "holy ground." Cemetery, graveyard.

canastillero: Typically, an unassuming wooden cabinet equipped with shelves and doors. Used by priests and priestesses of Santería to house, and on ritual occasions to display, the porcelain vessels and other attributes of particular orichas.

canto(s) de puya: Richly allusive songs of provocation that metaphorically challenge another ritual expert's power and authority. See *puya*.

cargar: To "charge" or load an object or receptacle with ritually potent substances. Possible synonyms of this verb include *montar* (to mount) and *fundamentar* (to found).

casa de santo, casa de ocha: Literally, "house of saint," "house of ocha" (a contraction of the Lucumí word *oricha*). House serving as a temple for ritual activities in the Santería religion. Refers to the physical premises but also to the notion of an extended ritual family under the spiritual leadership of a single priest or priestess. See *ilé*.

cascarilla: A white chalk, traditionally made from crushed eggshell, that is used in all kinds of ritual work: the drawing of *firmas*, spiritual cleansings, as an ingredient in talismans and charms, and so on. When true cascarilla is unavailable, more conventional forms of chalk are substituted.

chamba (C.): Ritual drink made with raw rum that has been infused with other ingredients: fiery chili peppers, the blood of sacrificial animals, assorted roots, gunpowder, garlic, ginger, powdered tree branches,

and other elements. Associated with Palo ritualizing and the powers of the dead, chamba may include powdered human bone. Also called *kimbisa*.

Changó (Lu.): Dynamic oricha-king of fire, lightning, thunder, and virility. An inveterate womanizer and powerful sorcerer, Changó is a notorious rival in arms of the forest oricha Ogún. Changó's royal status, imagery, and symbolic colors of red and white have led to a primary identification with the Catholic Saint Barbara (Santa Bárbara), whose story and attributes recall aspects of the oricha's personal history. The spirit lives in a carved wooden container called a batea with a thunder-ax as his primary attribute. This versatile spirit is said to have at least twelve different paths (caminos).

chópi: A fairly recent Cuban neologism used to refer to the government-controlled and, for most Cubans, prohibitively expensive "dollar stores" that sell goods not otherwise commercially available. Variously spelled and pronounced, chópi is an adaptation of the English word "shopping."

clavos de linea: Railroad spikes. These large metal "nails" are an essential component in cauldrons dedicated to the oricha Ogún and to his counterpart in Palo, Sarabanda.

(los) cocos: Literally, "(the) coconuts." Popular type of divination performed by casting four pieces of coconut meat to the ground. The resulting pattern (*letra*) reveals the spirit's answer to a previously posed question. Called *obí* in Lucumí. See *alafia*.

collares: Color-coded and numerically sequenced beaded necklaces that have been consecrated to the orichas. Typically "received" as the first step of initiation into Santería, these protective symbols of the orichas' presence are called *elekes* in Lucumí.

comisión: Group of spirits that works together synergistically. *Comisiónes* (plural) are often grouped according to ethnicity (e.g., African, Indian, Chinese, Lucumí, Congo, etc.) or, in a strictly spiritist context, according to function.

Congo: Generalized colonial-era designation for slaves from the Bantu-speaking areas of West Central Africa. Today the term Congo is used to describe ritual, linguistic, and cultural practices of perceived Bantu origin and as the umbrella term for the various branches of Palo Monte, known as the Congo orders (las Reglas Congas). More specifically, it refers to the spirits of former slaves from this region—the unpolished but mystically powerful "Congo dead"—who come down to possess the living during communal as well as private healing rituals. Although the terms Congo and Palo can be used to refer to distinct spirit entities and ritual songs, they are also often used interchangeably.

consulta: Consultation with a religious specialist who, through divination, acts of clairvoyance, and/or possession, gets to the underlying cause of a person's illness or misfortune and prescribes a course of action to address the problem. Also called *registro*.

criollo: Literally, "Creole." A person born on the island of Cuba rather than in Africa or Spain, for example. D. H. Brown (2003b: 368) finesses this definition: "*Criollo* has historically been applied to island-born social and cultural practices, most simply referring to mixtures of, for example, European and African elements, making for something uniquely 'Cuban'" (i.e., creole).

cuadro espiritual: Literally, "spiritual cadre." A key set of spirits assigned by the Lucumí High God Olofi before birth to protect and guide an individual. A person's cadre usually includes ancestral spirits (deceased relatives or ritual family members); spirit guides grouped according to social, ethnic, or professional stereotypes—Congos, Lucumís, Gypsies (gitanas), Indians (Indios), Arabs, physicians, and so forth; and sometimes, spirits of the dead who, looking for light, may "attach" themselves to an individual.

cuarto de los santos: Literally, "room of the saints." Area reserved in a Santería practitioner's home for the vessels and attributes of his or her "saints" (i.e., orichas). Often transformed into a ritual space.

cuatro nsila (Sp./C.): Literally, "four roads." A hybrid Spanish/Congo phrase that designates the crossroads, that meeting of paths that stands in for the potentially dangerous intersection of the worlds of the living and the dead.

cumpleaños en santo: Literally, "birthday in saint." Refers to the annual anniversary celebration commemorating a person's initiation as a priest or priestess of the Santería religion.

derecho: Literally, "duty." Monetary or other form of offering left in tribute to the principal oricha(s) of a santero or santera sponsoring a ritual celebration. These offerings may be placed at the foot of a throne (temporary altar installation) constructed for the spirit(s) being honored. The term derecho is also used to designate the nominal fee paid for a ritual consultation as well as the token amount left when a plant is removed from the forest.

despojo: Literally, "stripping or clearing away." Spiritual cleansing that removes impurities and dispels harmful influences, thereby fortifying the person who is the object of the ritual.

don de gracia: Literally, "gift of grace." Natural ability or skill; God-given gift.

egun (Lu.): Spirit of the dead in the Santería religion. According to D. H. Brown (2003: 368), this category of the dead refers, strictly speaking, "to blood family ancestors and deceased members of one's priestly lineage (*rama*)." Called *muerto(s)* in Spanish.

Eleguá (Lu.): Messenger of the orichas; canny trickster spirit of chance and disorder; guardian of thresholds and crossroads; the entity responsible for opening an individual's path in life. After the dead, Eleguá is the first to be honored in any ceremony. Mischievous and childlike, he is identified with the Catholic Holy Child of Atocha (el Niño de Atocha) or Saint Anthony (San Antonio de Padua), who is depicted holding the Christ Child. Of all the orichas, Eleguá has the largest number of individual paths or caminos, with twenty-one being the most conservative estimate. Bolívar Aróstegui (1990: 41–53) cites well over a hundred.

elekes (Lu.): See *collares*.

Espiritismo: Spanish name for Spiritism as enriched and transformed (i.e., creolized) in Cuba and other Spanish-speaking Caribbean countries. A metaphysical movement heavily influenced by the mid-nineteenth-century explorations and doctrinal writings of the Frenchman Allan Kardec. Philosophical, religious, and healing notions combine in Espiritismo. The religion focuses on mediumistic communication with spirits of the dead to help resolve the problems of the living.

espiritista: A practitioner of Cuban-inflected Spiritism or Espiritismo. See *Espiritismo*.

estranjero, estranjera: Foreigner, tourist. See *yuma*.

eye ife (Lu.): See *alafía*.

firma: Literally, "signature." General term used for the mystically charged line drawings that Palo and other ritual experts—practitioners of Abakuá, for instance—trace on the ground as well as on or within objects to focus energy. Some invoke the powers of individual spirits, while others are more narrowly defined as work firmas and used to manipulate spiritual forces to very specific ends. Every Palo expert has his or her own jealously guarded repertoire of these energy-laden drawings. Firmas have been referred

to as "cosmograms" in the literature (R. F. Thompson) because each represents a miniaturized world of forces. They not only invoke but also transmit energy.

fula (C.): Gunpowder. An essential ingredient of many Palo ritual operations; commonly used to incite different categories of spirit to action. It is also employed in a traditional form of divination unique to the Palo Monte religion. MacGaffey (1986: 194) notes that the original KiKongo word *fula* refers to the use of a bellows "to forge" and that its general meaning is "to breathe on, or to animate."

fundamento(s): Literally, "foundation, basis, essentials." Typically refers to the sacred objects—the consecrated stones, branches, shells, and so forth—that distill and transmit a spirit's power (aché). When used as an adjective in the phrase *de fundamento*, it refers to a person's or an object's spiritual lineage within a particular tradition. In Palo Monte, the *nganga fundamento* (foundation nganga) refers to a *palero* or *palera*'s main *prenda*. Specific elements are drawn from this prenda in order to "found" (*fundamentar*) a new spirit cauldron for someone undergoing the advanced level of initiation into Palo.

gallo: Literally, "rooster." See *akpwón*.

gitana/gitano: Literally, "gypsy." A kind of spirit guide (*guía*) reputed to have extraordinary psychic powers.

(los) Guerreros: Literally, "(the) Warriors." Formidable first set of orichas that a person receives upon entering the Santería religion. Considered brothers, the Warriors are represented by the forest orichas Eleguá, Ogún, and Ochosi and the guardian of one's personal destiny, Ósun. This powerful quartet protects and confers strength upon the person receiving them.

hacer caridad: "To do good works." In the context of Cuban Espiritismo, this principle (originally put forth by Allan Kardec) means to place one's innate abilities as a medium for spirits of the dead at the disposal of others to help them resolve life's problems. The "good work" of serving as a spirit medium is in theory undertaken *sin interés* "without [personal or financial] interest."

hacer santo: Literally, "to make saint." Phrase commonly used to describe full-fledged initiation into Santería. As noted by M. A. Mason (2002: 128), to make saint can mean either to undergo or to perform the complex series of rituals that consecrate a new priest or priestess of the orichas. See *asiento*.

hechicería: Literally, "sorcery." In Afro-Cuban religious culture, hechicería is often understood as the dark or malevolent counterpoint to brujería (witchcraft). Although both are viewed with ambivalence, brujería is generally interpreted as the positive defensive use of mystical means. Hechicería, on the other hand, is usually seen as destructive or antisocial work done with the intent to inflict harm rather than to protect against it. See *brujería*.

herramientas: Tools and other symbols associated with a particular oricha. Although often made of metal, some are fashioned out of wood. These attributes rest either within or on top of an oricha's lidded vessel.

hierbero: Herbalist.

hijo de santo, hija de santo: Literally, "son or daughter of saint." Gendered terms used to describe the kinship between a person and his or her principal oricha, as in "I'm a daughter of Yemayá" (*Soy hija de Yemayá*).

Ibeji (Lu.): Capricious twin spirits of the Lucumí pantheon and the special protectors of children. Often represented by two diminutive carved dolls—one dressed as a boy, the other a girl—the Ibeji are asso-

ciated with the inseparable Catholic twins, Saints Cosmos and Damian. In Cuba, the Ibeji are also called *los Mellizos* or *las Jimaguas*.

Ifá (Lu.): Name of the complex divination system used by consecrated priests of Ifá (babalawos) and the oricha-diviner Orula. Readings are performed by a babalawo, who uses either a divining chain or a divination tray in conjunction with sixteen palm nuts.

ikú (Lu.): Death. Lucumí concept of death. The phrase *Ikú logbi ocha*, meaning "The dead gave birth to the orichas," is an often-cited Lucumí adage.

ilé (Lu.): Literally, "house." Extended religious family under the moral and spiritual leadership of an experienced priest or priestess of the orichas. The equivalent term in Palo Monte is *nso-nganga*. See *casa de santo*.

Indio: Spirit of a deceased Amerindian who protects and guides an individual, often from birth. One of many categories of spirit guides recognized in Cuban Espiritismo, Indios are known for their courage and physical and spiritual strength.

Inle (Lu.): Oricha-healer known as "the divine doctor." Inle lives and hunts in the water and is the patron of fishermen as well as physicians. His primary attribute is a cruciform metal staff featuring intertwined snakes (reminiscent of the caduceus, the symbol of Western medicine) and pendant fish. Inle is associated with the Catholic Archangel Raphael (San Rafael), whose iconography may include a staff and a fish.

iyalocha (Lu.): Literally, "mother of the oricha." Honorific used to describe a priestess who has initiated another person as a santero or a santera. See *madrina*.

iyawó (Lu.): Literally, "younger wife." For the first year after full initiation into Santería a consecrated priest or priestess must observe special restrictions relating to his or her new status. During this period, he or she is called an iyawó.

jícara: Vessel made out of a halved gourd or coconut. These organic containers are used in all Afro-Cuban religious rituals.

(las) Jimaguas: See *Ibeji*.

jugar: Literally, "to play." To manipulate material objects and mystical forces in a Palo context. The terms jugar and *trabajar* (to work) are often used interchangeably.

kariocha (Lu.): See *asiento*.

kimbisa (C.): Ceremonial drink used to "heat up" or energize the spirits of the dead that animate a palero's prendas. Also used to fortify members of the congregation during Palo rituals. For a list of ingredients, see *chamba*.

letra: Literally, "letter." Nonspecific term for any figure generated through coconut, cowrie shell, or any other form of divination. Each letra has its own name and inherent message. See *alafia*.

libreta(s): Notebook(s) used to record information of a religious nature. Libreta also designates a Cuban family's ration book, which entitles its members to specified quantities of staple foods such as rice, sugar, and beans.

licensia: Permission.

Lucero: Literally, "bright star." Palo spirit (*mpungu*) associated with the night sky. Lucero ("Evening Star") is considered to be the Palo camino of Eleguá, the clairvoyant guardian of the crossroads. In Congo

cosmology, stars are considered the children of the moon, who is in turn "the godmother of sorcerers" (Cabrera, 1992 [1954]: 119–120).

Lucumí: Yoruba-derived liturgical language used by practitioners of Santería. It is also the Afro-Cuban ethnic term used to designate people and cultural traditions with origins in Yoruba-speaking regions of West Africa.

luz (coger y dar luz): Literally, "light (to take and to give light)." Spiritist concept that describes the nature of the exchange between the living and the dead. By "acquiring" or "taking" light from the living, spirits of the dead continue to evolve on the spiritual plane. Human beings "give light" by offering up spiritual masses (*misas espirituales*) and they, in turn, receive light and guidance.

Madre de Agua: "Mother of Water." Palo spirit (*mpungu*) associated with earthly waters, the ocean in particular. She is the Palo incarnation of Yemayá.

madrina: Godmother. Term of respect used by an initiate to address the priestess who has initiated him or her in any aspect of Santería or Palo Monte, from entry level on up.

malafo (C.): Congo-Cuban word for crude rum.

mama nganga (Sp./C.): Literally, "mother of the nganga." See *tata nganga*.

mambo (C.): Palo ritual song. Sung in a dynamic call-and-response fashion by a lead singer (*nsusu*), who often improvises, and a chorus provided by members of the congregation.

manigua: Wild, uncultivated terrain; sometimes translated as "bush" or "wilderness." Although manigua does not have the rich multiplicity of meanings associated with the forest (*el monte*), it may be used in a roughly synonymous way.

mano de Orula: Literally, "hand of Orula." Ceremony that constitutes a first step toward initiation as a babalawo, making the recipient a godchild of Ifá and placing him or her under the immediate protection of the oricha-diviner Orula. This preliminary initiation is the highest level that women can aspire to in relation to Ifá. They cannot become babalawos.

Ma Rufina: Name of a female Congo-Haitian spirit of the dead. The Ma Rufina known to the authors does not speak but moves with the furious energy of the whirlwind and is said to work in the "commission" of Oyá.

matanza: Literally, "killing." Refers to the ritual sacrifice or slaughter of birds and/or four-legged animals for the spirits, that is, the giving of life in order to receive life.

matari (C.): Stone. In a Palo context, these stones are often consecrated.

(lo) material: Spiritist concept that denotes the concrete material world as opposed to the transcendent spiritual plane of existence. To "work the material" means to physically manipulate objects and substances in the interests of achieving tangible results in the real world.

mayimbe (C.): Congo-Cuban word for the mystically powerful, carrion-eating black buzzard or turkey vulture (*aura tiñosa*). All parts of this scavenger's body—feathers, claws, even the "sleep" in its eyes (said to impart second sight)—are significant. Different mayimbe elements are used in a variety of charms, including a palero's prendas.

mayombero, mayombera (C./Sp.): Consecrated priest or priestess of Palo Monte (more formally known as Palo Monte *Mayombe*). See *palero, palera*.

mayor: Elder man or woman (plural *mayores*). Although often linked to physical age, in the context of Afro-Cuban religion, any person of higher spiritual rank is one's elder.

mbele (C.): Congo-Cuban word for machete. In a Palo ritual context, mbele designates any cutting edge—from the spirit Sarabanda's machete to the knife, razor, or other sharp object used to score a person's body during Palo initiation.

(los) Mellizos (Lu./Sp.): See *Ibeji*.

menga (C.): Congo-Cuban word for blood. MacGaffey (1986: 194) translates the original KiKongo word *menga* as "to heat red in the fire."

mi gente: Literally, "my people." Euphemism used by Santiago to refer to his spirits: the *nfumbis*, Palo spirits, and Congo *muertos* that constitute his workforce and support system.

misa espiritual: Literally, "spiritual mass." A uniquely Cuban spiritist ceremony that invokes ancestral spirits and other "dead of light" (*muertos de luz*). The participants attract these entities and transmit light to them with radiant songs (known as *trasmisiónes* or "transmissions"), candlelight, clear water, cigar smoke, fragrant flowers, and perfume.

moforibale (Lu.): Literally, "I bow my head to the ground." Prostration performed by full-fledged initiates in Santería to honor their ritual elders and the orichas.

montar: To mount. Used metaphorically to describe how a spirit possesses a practitioner, that is, by "mounting" his or her "horse" (*caballo*). Also used as a synonym of the verb *cargar*, which means "to charge" or "consecrate" an object or a container (including the human body) with powerful substances.

(el) monte: Literally, "the forest." Can also refer to the mountains, the bush, or any expanse of wild vegetation, including an urban area designated as such—the patio behind a palero's house, for instance, or an overgrown tract of land in the immediate neighborhood. El monte's meaning, however, extends far beyond such definitions. For practitioners of Palo Monte in particular, it is a sacred ancestral place inhabited by the spirits of the dead and the mpungus. It is also the source of all the leaves, plants, trees, and other materials essential to a palero's religious practice.

mortero, mortera: A man or woman who has finely honed skills in communicating with and "working" spirits of the dead. Often perceived to be an innate ability. See *pasar muertos*.

moyuba (Lu.): Invocational prayer recited before any important ritual undertaking in the Santería religion. M. A. Mason (2002: 130) notes that this litany is "named for the repeated phrase *mo yuba*, meaning 'I pay homage to' or 'I show reverence for.'" Addressed to Olofi (the Lucumí High God) and to one's blood relatives and spiritual kin, both living and dead, the prayer asks their permission to proceed with the ritual in question.

mpaka (C.): Animal horn packed with powerful medicines and sealed with a mirror. The mpaka plays an important role in the first stage of Palo initiation, the *rayamiento*, and is an essential power object in all prendas. Palmié (2002: 336 n. 48) notes that the mpaka may be used "to monitor the nfumbi's [spirit of the dead] progress when sent out on mystical errands or to enable the *tata nganga* [palero] to see with the spirit's eyes."

mpungu(s) (C.): Principal spirits of the Palo Monte religion; entities strongly associated with one or more elemental domains in nature (earth, water, air, or fire). Within the "crossed branches" of the Palo religion, the mpungus are thought of as the Congo counterparts of the major Lucumí orichas.

muerto: Spirit of the dead. There are many different categories of the dead in the various Afro-Cuban religions as well as Espiritismo. See *egun* (Lu.) for Santería; *nfumbi* (C.) for Palo Monte; and *muerto de luz* and *muerto oscuro* for Espiritismo. See *Congo* entry for the Congo spirits of the dead.

muerto de luz: Literally, "dead of light." Spiritist term describing a highly evolved spirit of the dead. The ancestral and other spirit guides assigned prenatally by Olofi (the Lucumí High God) to protect a person throughout his or her life are all considered enlightened dead. See *cuadro espiritual*.

muerto oscuro: Literally, "dark or opaque spirit of the dead." A muerto who is spiritually unevolved and therefore potentially malign. Operating on the fringes of the physical world, muertos oscuros can easily be coerced into contractual arrangements or manipulated to do harm. Alternatively, a religious practitioner may choose to uplift the disadvantaged spirit by helping him or her "acquire light" through more mainstream spiritist channels.

ndoki (C.): Literally, "witch." Although this Congo-Cuban word has negative, even malevolent connotations, Palo practitioners often use it as an honorific to signal extraordinary power and sorcerous abilities. Díaz Fabelo (n.d.: 112) defines ndoki as "the commanding entity in a prenda" and "a spirit of the dead that the tata nganga uses as an ndoki and with whom, to a degree, he identifies."

ndúndu (C.): Palo guardian spirit. Designates all of the spirit forces in a palero's prendas. Collectively, they protect the palero and, by extension, his entire ritual family. Jesús Varona Puente (recorded interview, 2006) stresses that whereas the term *nfumbi* denotes a single spirit of the dead, ndúndu describes a *conjunto* or ensemble of spirits (recalling Santiago's use of the phrase, *mi gente*).

nfinda (C.): Congo-Cuban word for forest. Nfinda may also designate a cemetery, as in *campo nfinda*, a hybrid Spanish/Congo term that underscores the sacred nature of the forest in Congo-Cuban thought: *Camposanto* or "holy ground" is the Spanish literary term for graveyard or cemetery. Cabrera (1992 [1954]: 117–118) notes that the forest is the "complementary equivalent" of the cemetery.

nfumbi (C.): The opaque, unevolved spirit of a dead person that animates a palero or palera's prenda. The relationship is based on a contractual arrangement between spirit and Palo expert, one that forces the nfumbi to submit to his or her control.

nganga (C.): Congo-Cuban word that is synonymous with the terms *prenda* (Spanish) and *nkisi* (of KiKongo origin). All three refer to the receptacle, often a large metal cauldron, containing a seemingly chaotic amalgam of powerful organic and other substances. See *prenda*.

ngangulero, ngangulera (C./Sp.): Palo ritual expert (i.e., one who works with an *nganga*). Largely synonymous with *palero, palera* and *mayombero, mayombera*.

nkange (C.): Congo-Cuban word meaning "to capture" or "arrest." A charm or power object created by a palero to mystically block another human's attempts to interfere in a client's life. The related Congo-Cuban phrase *nkanga nsila* translates as "to tie the road." An nkange charm is called an *amarre* in Spanish, a noun based on the verb *amarrar*, "to tie up (or down)."

nkisi (C.): See the synonymous terms *prenda* and *nganga*.

Nsambia Mpungu (C.): Supreme God and creator of the universe in the Palo religious system.

nso-nganga (C.): Literally, "house of nganga." Room within a palero's house or an area adjacent to it that houses his prenda(s) and serves as a temple for ritual activities, both communal and private. Like the Lucumí concept of ilé (house), nso-nganga refers to much more than a physical space; it connotes a reli-

gious community that encompasses the palero's ritual family and the realm of the spirits—the mpungus and spirits of the dead.

nsusu (C.): See *akpwón*.

ntiti nfinda (C.): See *basura monte*.

Obatalá (Lu.): Wise spirit elder of the oricha pantheon; associated with whiteness, purity, creative intellect, and tranquility. Obatalá has many avatars, both male and female. Some diverge rather markedly from his overall profile; Obatalá Ayaguna, for instance, is a young, headstrong warrior type. In his role as a senior oricha, Obatalá is overwhelmingly identified with the Catholic Virgin of Mercy (Virgen de las Mercedes). Other caminos of Obatalá are associated with Christ, Saint Joseph, and Saint Sebastian.

Obba (Lu.): Oricha patron of marital fidelity and courageous, long-suffering wife of Changó, whose affections were usurped by Obba's rival Ochún. A solitary denizen of the graveyard and guardian of tombs, Obba is also linked to the death cycle. Both of the Catholic saints with whom she is associated embody extraordinary self-sacrifice: the austere and pure Saint Catherine of Siena and Saint Rita of Cascia, the patient "patron of the impossible" and "advocate of desperate causes" (Coulson, 1957: 658).

obí (Lu.): Literally, "coconut." Popular form of divination in which four pieces of coconut meat are cast to the floor. Frequently used during Santería rituals, the obí are always thrown before an animal or other substance is offered up to an oricha. The resulting pattern reveals whether the proposed sacrifice is acceptable. The equivalent and often-used Spanish term is *(los) cocos*.

Ochosi (Lu.): Oricha-hunter, "owner" of prisons, legal arbiter, and avenger of injustice, whose signature attribute is a metal crossbow. As one of the oricha Warriors, Ochosi is received along with his spirit brothers Ogún, Eleguá, and Ósun in an important preliminary initiation into Santería known as (los) Guerreros. Ochosi is conflated with the Catholic Saint Hubert, patron saint of hunters, or Saint Norbert.

Ochún (Lu.): Honeyed and seductive oricha of fresh river water and romantic love. Ochún has a great many caminos (paths), some of which contradict her image as a luxurious, light-skinned mulatta. Nonetheless, Ochún is strongly identified with the Virgin of Charity (la Virgen de la Caridad), the patron saint of Cuba. Ochún owns all yellow metals (gold, brass, and copper). Other emblems of her sophistication and beauty are mirrors, fans, coral, and peacock feathers.

Ogún (Lu.): Intense oricha of iron (he is the patron of all those who work with metal objects), war, and el monte. Ogún has a vast knowledge of the secret powers of leaves and forest animals. Solitary and unpredictable, this rugged mountain man is also a tireless trailblazer. Rustic implements of work and war fill his iron cauldron: cannon balls, keys, pistols, railroad spikes, machetes, anvils, hammers, spades, padlocks, and so forth. Ogún has five major caminos, with many others radiating out from these, some notoriously violent. The oricha is variously linked to the key-wielding Saint Peter (San Pedro), Saint James (Santiago), Saint Michael Archangel (San Miguel), and others.

Oke (Lu.): Dependable oricha of hills, mountains, and all that exists in elevation from the time of creation, Oke works closely with Obatalá. According to Bolívar Aróstegui (1990: 88), Oke was revered in the encampments of escaped slaves during the colonial era. Apparently without caminos, Oke is sometimes associated with the apostle Saint James Major (who is depicted witnessing Christ's transfiguration on top of a mountain).

Olodumare (Lu.): See *Olofi*.

Olofi (Lu.): The High God of the Lucumí (i.e., Santería) religious system. Also referred to as Olodu-mare.

Olokun (Lu.): Mysterious oricha who lives in the ocean depths and embodies the sea in its unknown, terrifying aspects. Described as male, female, or androgynous, Olokun is too powerful to be "made," that is, to be a person's primary oricha, and never possesses anyone. This spirit may be received, however, under the auspices of Yemayá. Murphy (1993 [1988]: 2) writes that Olokun is said to have protected slave ancestors during the horrific Middle Passage from Africa to the New World.

omiero (Lu.): Cooling herbal liquid concoctions prepared using assorted herbs, macerated leaves, the powdered fragments of trees, and other elements such as pepper, honey, or perfume. The context of the omiero's ritual use determines its composition.

oración: Prayer, oration.

orí (Lu.): Literally, "head." The spirit of an individual, conceived as residing inside his or her physical head.

oricha (Lu.): Afro-Cuban spirit belonging to the Santería pantheon. Also called "saints" (*santos*) in Spanish. Each oricha "rules" a specific natural and cosmic domain as well as different aspects of human life. See *Santería*.

Oricha Oko (Lu.): Lucumí spirit of the earth responsible for its agricultural yield; also associated with human fertility. This chaste and responsible oricha is identified with Saint Isidore (San Isidro), the devout but impoverished farm laborer depicted kneeling by his plough in the fields. Oricha Oko's attributes include a curved Spanish roof tile painted with white and red stripes, and a cart with a parasol drawn by two oxen.

Oriente: An encompassing term used to designate the eastern end of the island of Cuba—specifically, from the city of Camagüey on. The largest city in the region is Santiago de Cuba. Oriente is demographically and geographically distinct from the western end of the island, and religious and other cultural traditions have evolved under different sociohistorical circumstances. They may differ appreciably from those prevalent in the western provinces of Havana and Matanzas.

Orula (Lu.): Temperate and wise oricha of divination who controls and interprets the secrets of the Ifá oracle. Orula is considered the patron of all babalawos (the exclusively male priests of Ifá), and he communicates with and advises humankind via the oracle. Orula is associated with Saint Francis of Assisi (San Francisco de Asís) because of the saint's rosary, which resembles the divining chain used by priests of Ifá. See *Ifá*.

oru seco (Lu./Sp.): Sequence of sacred batá drum rhythms, characterized as "dry" (*seco*) because they are not accompanied by vocals. Played to invoke or call the orichas "in their own language" at the beginning of a *tambor* (ritual drumming for the Lucumí spirits).

Osaín (Lu.): Solitary forest oricha of all leaves, herbs, and plants for which he knows the medical-mystical properties and uses. He shares this deep knowledge of the forest (el monte) with Ogún. Whenever a plant is taken from el monte, a token payment (derecho) is left to propitiate Osaín so that the plant does not lose its inherent power, or aché. Herbalists in Cuba are known as *hierberos* or *osaínistas*. Osaín is described as having a mutilated montage of physical features: he is one-legged, one-eyed, and one-armed with an enormous ear that is deaf and a second tiny one that hears preternaturally well. He is associated with Saint Sylvester (whose name means forest) or the hermit Saint Anthony, who lived an abstinent and isolated life in the deserts of Egypt.

osaínista (Lu./Sp.): Herbalist. See *Osaín*.

Ósun (Lu.): Ever-vigilant Lucumí spirit who oversees one's personal destiny and is received as one of the Warriors. Represented by an elevated metal cup charged with protective medicines and topped by a rooster, Ósun warns of impending danger. The oricha, considered a messenger of Olofi, is associated with Saint John the Baptist (the Holy Spirit or dove hovering above the saint is linked to the bird imagery on Ósun's vessel).

otanes (Lu.): Aché-laden sacred stones that form the core of an oricha's sacred objects or fundamentos.

Oyá (Lu.): Turbulent, aggressively independent woman warrior, who has dominion over wind and storm and oversees the gate of the cemetery. Oyá is said to accompany Changó in battle, decimating enemies with her swords and lightning flashes (*centellas*). She is invoked by shaking the long saberlike seedpods of the flame tree. Oyá wears a skirt of nine distinct colors (her sacred number) and spins with the unleashed fury of the whirlwind when she dances. She is variously identified with Saint Teresa (Santa Teresa), Our Lady of Candlemas, who is associated with candle-lit processions (La Virgen de la Candelaria), and other Catholic saints.

padrino: Godfather. Term of respect used by an initiate to address the priest who has initiated him or her in any aspect of Palo Monte or Santería, from entry level on up.

Pa Francisco: Name of a male Congo spirit of the dead. The rustic and wily Congo spirit with whom Santiago works most closely.

Pa Julian: Name of a male Congo spirit of the dead. The Pa Julian known to the authors is a paragon of swaggering machismo and joviality.

palero, palera: Consecrated priest or priestess of the Palo Monte religion; also *mayumbero, mayumbera* or *ngangulero, ngangulera*.

Palo Monte: Literally, "trees of the forest." Afro-Cuban religion that traces its origins to Bantu-speaking peoples of Kongo and Angola in West Central Africa. Palo Monte's primary focus is on communicating with and pragmatically working spirits of the dead and other forces inherent in the natural world. El monte (the forest) is the natural and supranatural source of materials and ideas central to Palo practice. The *prenda* (Palo spirit cauldron) is an extraordinary visual summation of these principles. The term Palo Monte or just Palo is commonly used to designate any of the various branches of Bantu-derived religion in Cuba. See *Congo*.

pasar muerto: Literally, "to pass a spirit of the dead." Describes the human ability to channel a muerto through possession.

perro-nganga (Sp./C.): Literally, "nganga-dog." Term used to designate one of two entities: the spirit of the dead (*nfumbi*) that animates a prenda (also called the *perro-prenda*) or a human being serving as a vehicle for a spirit of the dead. As is often the case in Afro-Cuban human-spirit relationships, the distinction between possessed person and possessing entity is blurred in this mirrored definition.

prenda: Literally, "pledge, pawn, precious object." As the central icon of the Palo Monte religion, the prenda is a cauldron or other vessel containing human bones, animal remains, different earths, forest branches, and other elements that have been prepared and consecrated by a Palo ritual expert. This formidable concentration of power is animated by an nfumbi, or spirit of the dead, who has been "bought" in exchange for total submission to the palero who owns it. The cauldron also serves as the home of a

particular Palo spirit (mpungu). A prenda must be carefully attended to maintain its strength and capacity for ready action. See *nganga*.

protector: Protector spirit, ancestral or otherwise (plural *protectores*).

puya: Literally, "lance-like point." A gibe or taunt. Puya is a bullfighting term that designates the barbed tip of the picador's lance used to goad or incite the bull into fighting mode. See *canto de puya*.

rama: Literally, "branch." Spiritual line of descent to which a particular religious house belongs.

rayamiento: Literally, "scoring or scratching." Name given to Palo Monte initiation, both entry level and advanced. The initiate's body is scored or cut in ritually significant places and consecrated during these initiations.

registro: See *consulta*.

regla: Literally, "law or order." Spanish word often used in conjunction with African-derived terms to designate the different Afro-Cuban religions as well as any branches of these same religions.

Regla de Ocha (Sp./Lu.): Literally, "order of the o[ri]chas." Official—and, some maintain, more "authentic"—name of the Afro-Cuban religion popularly known as Santería. See *Santería*.

Regla Kimbisa: A branch or rama of the Congo-Cuban religion of Palo Monte. This Congo order was founded in the mid-nineteenth century by Andrés Petit, who purposefully set out to combine elements of the three most prominent Afro-Cuban religions—Palo Monte, Santería, and, to a lesser extent, the Abakuá order—with aspects of Catholicism and Spiritism. The Congo influence is predominant.

sabana: Literally, "savanna." Bush or scrubland. In Congo-Cuban thought, the sabana stands in contrast to the forest (el monte), perhaps as a space that mediates between absolute wilderness and civilized space, "nature" and "culture."

sala malekum–malekum sala (Arabic/C.?): Quintessential Palo greeting (and response) used by those initiated in the Palo Monte religion. This ritual salute has possible Congo as well as more obvious Arabic origins, possibly through Islamized Africans brought to Cuba as slaves.

Santería: Literally, "the way of the saints." Afro-Cuban religion with its primary origins in the Yoruba-speaking cultures of West Africa. The primary focus of Santería is interaction with a rich and multifaceted pantheon of spirits known as the orichas or the "saints." Also called la Regla de Ocha.

santero, santera: A consecrated priest or priestess of the orichas. Title bestowed on someone who has undergone full initiation into Santería.

santo: Saint. Commonly used as a synonym for oricha, the Lucumí term for the spirits of the Santería religion.

Sarabanda (C.?): Principal Palo spirit (mpungu) of the Brillumba branch of the Congo religious orders. Sarabanda is considered to be the Congo counterpart of the belligerent Lucumí spirit Ogún.

sopera: Literally, "soup tureen." Lidded vessels of porcelain or ceramic that are used to contain the orichas' sacred objects: stones, shells, metal tools, and so forth.

suyere (Lu.): Ritual song in the Lucumí religion of Santería.

tambor: Literally, "drum or drumming." A celebration honoring one or more orichas that features the consecrated batá drums in ritual performance.

tata nganga (C.): Literally, "father of the nganga." Term of respect for a Palo priest who is the spiritual and pragmatic head of a house-temple and community. Tata nganga status is based on experience, personal charisma, and the ability to fully initiate and indoctrinate others in the religion of Palo Monte. As an honorific, it implies enormous parental responsibility. *Mama nganga* is the equivalent term for a Palo priestess of this standing.

tinaja: Large clay jar used to house the sacred objects of water spirits such as Yemayá, Olokun, and Ochún. According to D. H. Brown (2003b), tinajas were historically used as storage vessels for water and other liquids.

toque: A specific pattern drummed for an oricha. Each Lucumí spirit has a certain number of these rhythmically rich and individually named toques.

trabajo: Literally, "work." The manipulation of materials, objects, and forces in ritual operations that seek tangible results in the real world. The Spanish words *labor* (labor) and *obra* (work) are sometimes used in a spiritist context to distinguish purely spiritual work—which eschews all forms of physical manipulation and never involves blood sacrifice—from such material endeavors.

trasmisión: Literally, "transmission" (plural *trasmisiónes*). Spiritist songs sent out to irradiate and elevate spirits of the dead.

trono: Literally, "throne." Elaborate temporary altar installation, largely made of extravagant cloth, that a Santería practitioner creates to honor a particular oricha and his or her spirit entourage. Considered a powerful form of offering to the orichas.

uria (C.): Congo-Cuban word for food. In a Palo ritual context, the term typically refers to the blood of sacrificial animals, the only food strong enough to nourish and revitalize a palero's prendas.

Yemayá (Lu.): Oricha of the sea, source of all life, and universal mother. In Lucumí cosmology, Yemayá is a central figure in the creation of the world. Although profoundly maternal, she is capable of violent anger and her punishments can be severe; Yemayá is protean, as variable as the ocean itself. While her caminos are many and complex, Yemayá is strongly identified with the black Virgin of Regla (Virgen de Regla).

yuma: Term that may be used by Cubans to refer to a person from the United States; as an adjective, it is applied to American cultural and other products. This Cuban neologism was inspired by the 1957 Glenn Ford Western entitled *3:10 to Yuma*.

BIBLIOGRAPHY

Anderson, Martha G., and Christine Mullen Kreamer. 1989. *Wild Spirits Strong Medicine: African Art and the Wilderness*, ed. Enid Schildkrout. Exhibition catalogue. New York: Center for African Art; Seattle: University of Washington Press.

Argyriadis, Kali. 1999. *La Religión à la Havane: Actualité des représentations et des pratiques cultuelles havanaises*. Paris: Editions des archives contemporaines.

Balbuena Gutiérrez, Bárbara. 2003. *Las Celebraciones Rituales Festivas en la Regla de Ocha*. Havana: Centro de Investigación y Desarrollo de la Cultura Cubana Juan Marinello.

Barnet, Miguel. 1997. "La Regla de Ocha: The Religious System of Santería." In *Sacred Possessions: Vodou, Santería, Obeah, and the Caribbean*, ed. Margarite Fernández Olmos and Lizabeth Paravisini-Gebert, 79–100. New Brunswick, N.J.: Rutgers University Press.

———. 1995. *Cultos Afrocubanos: La Regla de Ocha, La Regla de Palo Monte*. Havana: Ediciones Unión, Unión de Escritores y Artistas de Cuba.

Bettelheim, Judith. 2001. "Palo Monte Mayombe and Its Influence on Cuban Contemporary Art." *African Arts* 34, no. 2 (Summer): 36–49, 94–96.

Bolívar Aróstegui, Natalia. 1990. *Los orichas en Cuba*. Havana: Ediciones Unión, Unión de Escritores y Artistas de Cuba.

Bolívar Aróstegui, Natalia, with Carmen González Díaz de Villegas. 1998. *Ta Makuende Yaya y las reglas de Palo Monte: Mayombe, Brillumba, Kimbisa, Shamalongo*. Havana: Ediciones Unión.

Brandon, George E. 1997 [1993]. *Santeria from Africa to the New World: The Dead Sell Memories*. Blacks in the Diaspora series. Bloomington: Indiana University Press.

———. 1990. "Sacrificial Practices in Santeria, an African-Cuban Religion in the United States." In *Africanisms in American Culture*, ed. Joseph E. Holloway, 119–147. Blacks in the Diaspora series. Bloomington: University of Indiana Press.

Brown, David H. 2003a. *The Light Inside: Abakuá Society Arts and Cuban Cultural History*. Washington, D.C.: Smithsonian Institution Press.

———. 2003b. *Santería Enthroned: Art, Ritual, and Innovation in an Afro-Cuban Religion*. Chicago: University of Chicago Press.

———. 1996. "Toward an Ethnoaesthetics of Santería Ritual Arts: The Practice of Altar-Making and Gift Exchange." In *Santería Aesthetics in Contemporary Latin American Art*, ed. Arturo Lindsay, 77–148. Washington, D.C.: Smithsonian Institution Press.

———. 1993. "Thrones of the *Orichas*: Afro-Cuban Altars in New Jersey, New York, and Havana." *African Arts* 26, no. 4 (October): 44–59, 85–87.

Brown, Karen McCarthy. 1995a. "Serving the Spirits: The Ritual Economy of Haitian Vodou." In *Sacred Arts of Haitian Vodou*, ed. Donald J. Cosentino, 204–223. Los Angeles: UCLA Fowler Museum of Cultural History.

———. 1995b. *Tracing the Spirit: Ethnographic Essays on Haitian Art*. Davenport, Iowa: Davenport Museum of Art; Seattle: University of Washington Press.

———. 1991. *Mama Lola: A Vodou Priestess in Brooklyn*. Berkeley: University of California Press.

———. 1989. "Systematic Remembering, Systematic Forgetting: Ogou in Haiti." In *Africa's Ogun: Old World and New*, ed. Sandra T. Barnes, 65–89. Bloomington: Indiana University Press.

———. 1987. "Alourdes: A Case Study of Moral Leadership in Haitian Vodou." In *Saints and Virtues*, ed. John S. Hawley, 144–167. Berkeley: University of California Press.

———. 1984. "Balance: A Moral Art Form for a Nuclear Age." *Drew Gateway* 55, no. 1: 1–14.

———. 1979a. "The Center and the Edges: God and Person in Haitian Society." *Journal of the I.T.C.* (Fall): 22–39.

———. 1979b. "Olina and Erzulie: A Woman and a Goddess in Haitian Vodou." *Anima* 5 (Spring): 110–116.

———. 1976. "The Vèvè of Haitian Vodou: A Structural Analysis of Visual Imagery." Ph.D. dissertation, Temple University.

Cabrera, Lydia. 2000 [1984]. *Vocabulario Congo (El Bantú que se habla en Cuba): Español-Congo y Congo-Español*. Miami: Ediciones Universal.

———.1996 [1974]. *Yemayá y Ochún: Kariocha, Iyalorichas y Olorichas*. Miami: Ediciones Universal.

———. 1992 [1954]. *El Monte: Igbo-Finda, Ewe Orisha-Vititi Nfinda: Notas sobre las religions, la magia, las supersticiones, y el folklore de los negros criollos y el pueblo de Cuba*. 7th ed. Miami: Ediciones Universal.

———.1986a [1957]. *Anagó: Vocabulario Lucumi (El Yoruba que se habla en Cuba)*. Miami: Ediciones Universal.

———.1986b [1977]. *La Regla Kimbisa del Santo Cristo del Buen Viaje*. 2nd ed. Miami: Ediciones Universal.

———.1986c [1979]. *Reglas de Congo, Palo Monte Mayombe*. 2nd ed. Miami: Ediciones Universal.

Canizares, Raúl. 1993. *Walking with the Night: The Afro-Cuban World of Santeria*. Rochester, Vt.: Destiny Books.

Carbonell, Walterio. 1990. "Secretos del Palo Monte." *Unión* 3: 9, 43–49.

Carmen Muzio, María del. 2001. *Andrés Quimbisa*. Havana: Ediciones Unión.

Castellanos, Isabel. 2001. "A River of Many Turns: The Polysemy of Ochún in Afro-Cuban Tradition." In *Òsun across the Waters: A Yoruba Goddess in Africa and the Americas*, ed. Joseph M. Murphy and Mei-Mei Sanford, 34–45. Bloomington: Indiana University Press.

———. 1996. "From Ulkumí to Lucumí: A Historical Overview of Religious Acculturation in Cuba." In *Santería Aesthetics in Contemporary Latin American Art*, ed. Arturo Lindsay, 39–50. Washington, D.C.: Smithsonian Institution Press.

Castellanos, Jorge, and Isabel Castellanos. 1992. *Cultura Afrocubana*. Vol. 3, *Las Religiones y las Lenguas*. Miami: Ediciones Universal.

———. 1994. *Cultura Afrocubana*. Vol. 4, *Letras-Musica-Arte*. Miami: Ediciones Universal.

Coulson, John, ed. 1957. *The Saints: A Concise Biographical Dictionary*. New York: Guild Press.

Delgado, Héctor. 1997. "From *The Sacred Wild* to the City: Santería in Cuba Today." In *Sacred Possessions: Vodou, Santería, Obeah, and the Caribbean*, ed. Margarite Fernández Olmos and Lizabeth Paravisini-Gebert, 79–100. New Brunswick, N.J.: Rutgers University Press.

Deren, Maya. 1983 [1951]. *Divine Horsemen: The Living Gods of Haiti*. New Paltz, N.Y.: McPherson.

Díaz Fabelo, Teodoro. n.d. *Diccionario de la Lengua Conga Residual en Cuba*. Santiago de Cuba: Departamento de Publicaciones, Casa del Caribe.

Drewal, Margaret Thompson. 1992. *Yoruba Ritual: Performers, Play, Agency*. Bloomington: Indiana University Press.

Edwards, Gary, and John Mason. 1985. *Black Gods: Orisa Studies in the New World*. Brooklyn, N.Y.: Yoruba Theological Archministry.

Fernandez, James W. 1986. *Persuasions and Performances: The Play of Tropes in Culture*. Bloomington: Indiana University Press.

———. 1984. Foreword to *The Language of Secrecy: Symbols and Metaphors in Poro Ritual* by Beryl L. Bellman, vii–ix. New Brunswick, N.J.: Rutgers University Press.

Fernández Olmos, Margarite, and Lizabeth Paravisini-Gebert. 2003. *Creole Religions of the Caribbean: An Introduction from Vodou and Santería to Obeah and Espiritismo*. New York: New York University Press.

Fernández Robaina, Tomás. 1997 [1994]. *Hablen Paleros y Santeros*. Havana: Editorial de Ciencias Sociales.

Figarola, Joel James. 2001a. "Para un nuevo acercamiento a la nganga." *Del Caribe*, no. 35: 22–31.

———. 2001b. *Sistemas mágico-religiosos cubanos: Principios rectores*. Havana: Ediciones Unión.

Galembo, Phyllis. 1993. *Divine Inspiration: From Benín to Bahia*. Albuquerque: University of New Mexico Press.

González Bueno, Gladys. 1988. "Una Ceremonia de Iniciacion an Regla de Palo." *Del Caribe* 5, no. 12: 68–70.

González Wippler, Migene. 1996 [1989]. *Santería: The Religion; Faith-Rites-Magic*. St. Paul, Minn.: Llewellyn.

Hagedorn, Katherine J. 2001. *Divine Utterances: The Performance of Afro-Cuban Santería*. Washington, D.C.: Smithsonian Institution Press.

Janzen, John M. 1982. *Lemba, 1650–1930: A Drum of Affliction in Africa and the New World*. New York: Garland.

———. 1978. *The Quest for Therapy in Lower Zaire*. Berkeley: University of California Press.

Janzen, John M., and Wyatt MacGaffey. 1974. *An Anthology of Kongo Religion*. Lawrence: University of Kansas Press.

Johnson, Paul Christopher. 2002. *Secrets, Gossip, and Gods: The Transformation of Brazilian Candomblé*. New York: Oxford University Press.

Kardec, Allan, and other spiritist authors. n.d. *Oraciones Escogidas*. N.p. (This is a popular booklet widely circulated on the streets of Cuba and, possibly, in some *botánicas* in the United States. Kardec's writings, prayers, and so forth are more widely available in other publications.)

Lago Vieito, Ángel. 2001. "El espiritismo en la region oriental de Cuba en el siglo xix." *Del Caribe*, no. 35: 72–79.

Lahaye Guerra, Rosa María de, and Rubén Zardoya Loureda. 1996. *Yemayá a Través de sus Mitos*. Havana: Editorial de Ciencias Sociales.

Larduet Luaces, Abelardo. 2001. "Las firmas paleras." *Del Caribe*, no. 35: 61–61.

Lévi-Strauss, Claude. 1963. *Totemism*. Translated by Rodney Needham. Boston: Beacon Press.

MacAloon, John. 1984. "Olympic Games and the Theory of Spectacle in Modern Societies." In *Rite, Drama, Festival, Spectacle: Rehearsals toward a Theory of Cultural Performances*, ed. John MacAloon. Philadelphia: Institute for the Study of Human Issues.

MacGaffey, Wyatt. 1993. "The Eyes of Understanding: Kongo Minkisi." In *Astonishment and Power: Kongo Minkisi and the Art of Renée Stout*. Exhibition catalogue, 18–103. Washington, D.C.: Smithsonian Institution Press.

———. 1990. "The Personhood of Ritual Objects: Kongo Minkisi," *Etnofoor* 3, no. 1: 45–61.

———. 1988. "Complexity, Astonishment, and Power: The Visual Vocabulary of Kongo Minkisi." *Journal of Southern African Studies* 14, no. 2: 188–203.

———. 1986. *Religion and Society in Central Africa: The Bakongo of Lower Zaire*. Chicago: University of Chicago Press.

Mack, John. 1994. Review of *Secrecy: African Art That Conceals and Reveals*, ed. Mary H. Nooter. *African Arts* 27, no. 1 (January): 14–18.

Mason, John. 1992. *Orin òrìsà: Songs for Selected Heads*. Brooklyn, N.Y.: Yoruba Theological Archministry.

Mason, Michael Atwood. 2002. *Living Santería: Rituals and Experiences in an Afro-Cuban Religion*. Washington, D.C.: Smithsonian Institution Press.

———. 1994. "'I Bow My Head to the Ground': The Creation of Bodily Experience in a Cuban-American Santería Initiation." *Journal of American Folklore* 107, no. 423: 23–39.

Matibag, Eugenio. 1996. *Afro-Cuban Religious Experience: Cultural Reflections in Narrative*. Gainesville: University Press of Florida.

McNaughton, Patrick R. 1990. Review of *Wild Spirits Strong Medicine: African Art and the Wilderness* by Martha G. Anderson and Christine Mullen Kreamer. *African Arts* 23, no. 3 (July): 22–32.

———. 1988. *The Mande Blacksmiths: Knowledge, Power, and Art in West Africa*. Bloomington: Indiana University Press.

———. 1979. *Secret Sculptures of Komo: Art and Power in Bamana (Bambara) Initiation Associations*. Working Papers in the Traditional Arts No. 4. Philadelphia: Institute for the Study of Human Issues Publications.

Metford, J. C. J. 1983. *Dictionary of Christian Lore and Legend*. London: Thames and Hudson.

Millet, José. 2000. "El Foco de la Santería Santiaguera." *Del Caribe*, no. 32: 110–119.

———. 1996. *El Espiritismo: Variantes Cubanas*. Santiago de Cuba: Editorial Oriente.

———. 1994. *Glosario Mágico Religioso Cubano*. Santiago de Cuba: Editorial Oriente.

Murphy, Joseph M. 1994. "Cuban and Cuban American Santería." In *Working the Spirit: Ceremonies of the African Diaspora*, ed. Joseph M. Murphy, 81–113. Boston: Beacon Press.

———. 1993 [1988]. *Santería: African Spirits in America*. Boston: Beacon Press.

Nooter, Mary H., ed. 1993. *Secrecy: African Art that Conceals and Reveals*. Exhibition catalogue. New York: Museum for African Art.

Núñez, Luis Manuel. 1992. *Santería: A Practical Guide to Afro-Caribbean Magic*. Dallas: Spring Publications.

Palmié, Stephan. 2002. *Wizards and Scientists: Explorations in Afro-Cuban Modernity and Tradition*. Durham, N.C.: Duke University Press.

Pérez Medina, Tomás. 1998. *La Santería Cubana: El camino de Osha. Ceremonias, ritos y secretos*. Madrid: Editorial Biblioteca Nueva.

Pérez Sarduy, Pedro, and Jean Stubbs, eds. 1993. *Afrocuba: An Anthology of Cuban Writing on Race, Politics and Culture*. Melbourne: Ocean Press.

Poppi, Cesare. 1993. "Sigma! The Pilgrim's Progress and the Logic of Secrecy." In *Secrecy: African Art That Conceals and Reveals*, ed. Mary H. Nooter. Exhibition catalogue, 196–203. New York: Museum for African Art.

Ramos, Miguel "Willie." 1996. "Afro-Cuban Orisha Worship." In *Santería Aesthetics in Contemporary Latin American Art*, ed. Arturo Lindsay, 51–76. Washington, D.C.: Smithsonian Institution Press.

Río, Zaida del. n.d. *Herencia Clasica: Oraciones populares ilustradas por Zaida del Río*. [Havana]: Ediciones Pontón Caribe.

Rodríguez-Mangual, Edna M. 2004. *Lydia Cabrera and the Construction of an Afro-Cuban Cultural Identity*. Chapel Hill: University of North Carolina Press.

Sánchez-Boudy, José. 1999. *Diccionario Mayor de Cubanismos*. Miami: Ediciones Universal.

Thompson, Robert Farris. 1993a. *Face of the Gods: Art and Altars of Africa and the African Americas*. Exhibition catalogue. New York: Museum of African Art.

———. 1993b. "Illuminating Spirits: 'Astonishment and Power' at the National Museum of African Art." *African Arts* 26, no. 4 (October): 60–69.

———. 1983. *Flash of the Spirit: African and Afro-American Art and Philosophy*. New York: Random House.

———. 1981. "The Structure of Recollection: The Kongo New World Visual Tradition." In Robert Farris Thompson and Joseph Cornet. *The Four Moments of the Sun: Kongo Art in Two Worlds*, 141–210. Washington, D.C.: National Gallery of Art.

Thompson, Robert Farris, and Joseph Cornet. 1981. *The Four Moments of the Sun: Kongo Art in Two Worlds*. Exhibition catalogue. Washington, D.C.: National Gallery of Art.

Vélez, María Teresa. 2000. *Drumming for the Gods: The Life and Times of Felipe García Villamil, Santero, Palero, and Abakuá*. Philadelphia: Temple University Press.

Wafer, Jim. 1991. *The Taste of Blood: Spirit Possession in Brazilian Candomblé*. Philadelphia: University of Pennsylvania Press.

Wehmeyer, Stephen C. 2000 "Indian Altars of the Spiritual Church: Kongo Echoes in New Orleans." *African Arts* 33, no. 4 (Winter): 62–69, 95–96.

Wirtz, Kristina. 2000. "Las Funciones Trópicas del Parentesco en la Santería Cubana: Un estudio antropológico lingüistico." *Del Caribe*, no. 32: 65–71.

INDEX

authors: acceptance of, by ritual family, 152; collaboration between, 199–201; collaboration of, with Santiago, 6–8; collares (necklaces) of, 141; contributions of, to ceremonies, 7, 75–76; Guerreros (Warrior orichas) of, 141, 143f120; involvement of, in healing practices, 121–22; 141; preparations for rituals by, 7, 123; relations of, with Santiago, 6–9, 140

"Ave Maria" (song), 34, 40f35, 207n24

babalawo (Ifá priest), 221n7, 229, 234, 239

Babalú Ayé and Saint Lazarus (San Lázaro), 26, 45, 158–60, 183f134, 205n3, 208n29, 221n9

Balbuena Gutiérrez, Bárbara, 207n24

Bantu (language), 13, 221n5, 229, 240

basurero (garbage dump), 126–27, 217n27

batá drums, 58, 58f49, 60, 209n34, 209n35, 229, 239, 242

Berry, Jason, 220n49

birds: buzzards (mayimbe), 5f5, 21, 72–73, 126, 235; in cleansing rituals, 138f116; in consecration rite, 51f42; feathers of, 45, 53f44; in nkange (power bundle), 124–25, 126; rooster imagery and Ósun, 143f120, 144; sparrow hawk, 123, 124

bird sacrifices, 42–44, 45f38, 46, 49f40, 50f41, 52f43, 53f44, 55f47, 102f83, 126

blood: aché in, 42, 91f76; drained over nkange, 126; drained over orichas' vessels, 10f6, 44, 45, 79; at rayamiento, 148, 219n40. See also animal sacrifices; matanza

body movements: dancing, 60, 61f52, 151, 177–78; gesture of supplication, 167, 223n27; of Ma Rufina, 176–77, 188–89ff140–43; moforibale (ritual prostration), 53f44, 57, 208n32, 236; twirling, 23, 104–5ff86–88, 168, 175, 179. See also gestures

bóveda ("spiritual vault"), 157–58, 160, 163, 166–68, 183f134, 184f135, 185f137, 220n2, 229

bozal (language often spoken by Congo spirits of the dead), 81, 174–75, 213n24, 229

Brandon, George E., 207n25, 222n12

Brillumba (branch of Palo Monte), 68, 210–11n4, 230

Brown, D. H.: on Afro-Cuban thrones, 207n19, 208n31; on Babalú Ayé, 205n3; on egun (spirits of the dead in Santería), 232; on Lucumi creation myth, 205n5; on monstrances, 223n24; on origins of Santería, 204n8; on puerta de la calle, 26, 205n2; on "receiving" additional orichas, 206n11; on ritual uses for cloth, 207n23; on soperas (porcelain soup tureens), 207n21; on tinajas, 242

Brown, Karen McCarthy, 117, 203n2, 206n12, 215n8, 215n10

buzzards (mayimbe), 5f5, 21, 72–73, 126, 235

cabildos (associations of mutual aid), 19, 168, 203n4, 223–24n31, 230, 232, 241

Cabrera, Lydia, 69, 211n4, 214n1, 217n23, 217n24, 224n35, 229, 237

camino crillumba (in the path of crillumba), 210n3

canastillero (cabinet), 26, 27, 43f37, 48f39, 59f50, 63f56

cantos de puya (challenge songs), 178, 193, 194f151, 220n48, 225n46, 225n47, 230, 241

Carbonell, Walterio, 219n40

Castañeda Vera, Santiago. See Santiago Castañeda Vera

Catholicism, 9; "Ave María" and, 34, 40f35, 207n24; cross imagery and, 127, 129f107, 145, 146f47, 148, 160–61, 183f134, 184f135; Holy Sacrament of, 167, 223n24, 28; misa espiritual (spiritual mass) of, 158–59, 165–66, 185ff136–38; Palo Monte and, 68, 160–61, 210n4, 211n5, 223n24; Regla Kimbisa and, 68, 210–11n4; Saint Lazarus (San Lázaro) and, 158–60, 183f134, 184f135, 205n3, 208n29, 221n9; syncretism and, 9, 68, 164–65, 223n24

cauldrons: for Congo dead (caldero de muertos) 73–74, 78, 212n16; for los Guerreros (Warriors), 85, 144; at matanza, 78; spirits in, 72–73, 212n16. See also prendas

cemeteries, 27, 45, 69, 123, 124, 206n7, 216n21, 225n45, 237, 238, 240

"Change direction" palo, 125, 126

Changó, 231; necklaces of, 140; Obba and, 27, 45, 206n7, 238; offering to, 45; Saint Bárbara and, 158; Siete Rayos and, 212n11, 224n34

charms, 121–22, 124–26, 128f105, 216n15, 216n21, 217nn25, 26; cloth figures as, 119f102, 215n8

Christ imagery, 223nn24, 28

cigar smoke: attraction of "dead of light" by, 166, 183; blessing a godchild with, 139f117, 179; in cleansing ritual, 131, 135f112, 139f117, 179; in healing ritual, 125, 127; as transfer of aché, 103f84, 217n25

cleansing rituals (despojo): birds in, 138f116; cigar smoke in, 131, 135f112, 139f117, 179; with coco, 127, 135f112, communal setting for, 130–31, 132–36ff108–14; definition of despojo, 232; *Güiro, güiro mambo*, 134, 217–18n29; in healing ritual, 119, 126, 136f115, with honey, 127, 135f112, leaf-infused water in, 20f15, 23, 46, 167, 218n30; Pa Francisco and, 130–31, 132–36ff108–14, 134f109, 137f115, 139f117, 179–80; prayer in, 166, 223n26; *rompimiento*, 130–31, 132–36ff108–14; Sarabanda and, 138f116

cloth: batá drums and, 209n34; figures made of, 119f102, 215n8; preparation of fishnet and, 32, 33; for thrones, 35–38ff19–33, 57, 63f56, 207n23, 242; for Yemayá, 59–60, 64f57, 210n41

cocos, los (coconut divination), 43–44, 50f41, 130–31, 135f113, 217n28, 217n29, 228, 231, 234

coger y dar luz (to give and get light), 163, 235

collares (necklaces): of ahijados, 42, 54f46; as oricha-specific, 42–43, 140, 141; refreshed, 54f46, ritual feeding of, 43 48f39, in Santería initiations, 140–41, 144, 218n33; Yemayá and, 28f17, 31, 140

concealment: in African art, 207n22; of altars, 207n22; of lighting, 34, 207n23; of orichas' thrones, 33–34; of sacred objects (*fundamentos*), 27, 207n22

Congo dead, 19; arrival of, at misa espiritual (spiritual mass), 187f139, 211n9; cauldrons for, 73–74, 78, 212n16; language of, 229; Palo matanza and, 105ff86–88, 106f89, 107ff90–91, 109f93; references to slavery and, 163, 204n12, 211n6, 223n21, 231. *See also* Ma Rufina; misa espiritual (spiritual mass); Pa Francisco; Pa Julian; Pa Kanuko; Palo Monte; Pa Lucero; Santiago Castañeda Vera

Crillumba, 68, 204n13, 210n3. *See also* prendas

Criollos (Creole), 172, 225n37, 230, 231

cross imagery, 127, 129f107 145, 146–47f121, 148, 160–61, 166, 183f134, 184f135

cuadro espiritual (spiritual cadre), 162–63, 222n19, 231

cuarto de los santos (room of the saints), 13, 26–27, 32–33, 40f35, 43, 57, 207n23, 232

Cuba: ethnic diversity in, 160, 221n11; migration patterns in, 160, 221n11; origins of Espiritismo in, 16, 160, 221n11, 222nn12, 13; political instability and religious expression in, 204n20, 224n31; special period in, 22; Triumph of Revolution in, 6, 22

cumpleaños (birthday in saint) commemoration, 56f48, 57, 58–61, 61f52, 62f53

dance, 61f52, 151, 166, 177–78

dead, the: caldero de muertos (cauldron of the dead) and, 73; cemeteries, 27, 45, 124, 206n7, 216n21, 225n45, 237, 240; coger y dar luz (to get and to give light), 163, 235; Congo spirits of, 72–74, 211n6, 212n16; control of, 19; crillumba, 68, 204n13, 210n3; egun (spirit of the dead), 232, 237; in *La buena noche, mi lemba*, 90, 214n29; manipulation of skeletal remains of, 210n3; moyuba (prayer), 47, 208n30, 236; nfumbi, 68–69, 72–74, 211n6; orichas and, 27, 45, 206n7, 225n45, 238, 240; in Palo Monte, 13; power of, 17; *prenda/nganga*, 13, 16; Spiritism and, 17; water as barrier between living and, 222n15; water imagery and, 160, 220n49, 222nn14, 15. *See also* Espiritismo; Palo Monte

"dead of light": cigar smoke and, 166, 183; transmission to, 163–64, 185f137, 242

derechos (payment/offerings), 57, 59–60, 61, 64f57, 210n40, 232, 239

Deren, Maya, 203n2, 207n18

Diaz de Villegas, González, 219n40

Díaz Fabelo, Teodoro, 218n29, 237

¡Dio! ¡Mambe! (pledge of allegiance), 84, 213n28

discretion, 3, 184f135, 217n24

divination, 50f41, 206n11; of babalawo (Ifá pirest), 229; los cocos, 43–44, 50f41, 130–31, 134–35, 217n28, 217n29, 228, 234; Ifá, 221n7, 229, 234; water gazing, 119, 215n7

Divine Manuel, 167, 223n28

dolls: on bóveda, 183f134, 185f135; color coding of, 26; of Ibeji twin spirits, 27, 45, 205n8, 206n6, 233; orichas represented by, 28f17,

dolls (*continued*)

161f129, 184f135; in Palo spirit cauldrons, 4f4; spirits represented by, 67; on spiritual altar, 166; Yemayá represented by, 29f18, 33, 35f21, 36ff22–25

Drewal, Margaret, 208n26

drums: batá drums, 58, 58f49, 60, 209n34, 209n35, 229, 239, 242; evening of misa espiritual (spiritual mass) and, 170; Ma Rufina and, 177; oru seco, 209n35, 239; tambor (ritual drumming), 58, 209n33, 209n34, 242

egun (spirit of the dead, in Santería), 232, 237

Eleguá: bird sacrifices to, 44, 55f47; Catholic saints and, 232; characteristics of, 26, 44, 218n34, 232; drum call (toque) for, 58; in los Guerreros initiation, 141, 142f118, 143ff119–20; Lucero (Lucero Que Toque Mayimbe) and, 70ff60–61, 72–73, 74, 234; necklaces of, 140, 141, 218n33; preparation of, 142f118, 143f119

Elvira (ritual family member), 152–53, 152f124, 154–55ff125–26

Espiritismo (Spiritism), 9, 16, 17, 232; crossed rites in, 68, 161, 210–11n4; cuadro espiritual (spiritual cadre), 162–63, 222n19, 231; dar y coger luz (to give and get light), 163, 235; doctrines of, 21, 73–74, 112n17; espiritismo de caridad (spiritism of charity), 161–62, 186f138; ethnic spirit guides in, 160, 221–22n11; human-spirit relationship in, 163; Allan Kardec and, 16–17, 160, 212n17, 222nn12, 17; material world and, 204n18; militarism in, 221n5, 224n31; muerto de luz (the "dead of light"), 73, 162, 166, 237, 183f134 185f137; origins of, 16, 160, 204n14, 221n11, 222nn12, 13; Palo Monte and, 17, 69, 73, 158, 160–61, 180, 204n17, 204n18, 211n8, 211n9, 212n17, 221n5; Santiago's apprenticeship in, 21, 162; spirits of the dead in, 73, 74, 162, 237; use of term, 221n5; transmisiónes (spiritist songs), 163, 167, 168, 223n27, 185f137, 186f138, 242; written doctrine of, 162. *See also* Kardec, Allan; misa espiritual (spiritual mass)

Fernandez, James W., 216n12, 222n15

Fernández Olmos, Margarite, 221n5, 224n31

Figarola, Joel James, 204n13, 210n3

fire, 82, 125, 127, 217n26, 233

firmas (ritual ground drawings), 108f92, 118f101, 123–24, 125, 161, 216n18, 230, 232

forehead, 44, 100f81, rayamiento, 219n40. *See also* gestures

fundamentos (sacred objects): concealment of, 27, 207n22; feathers scattered over, 45, 53f44; in initiations, 21; monstrances, 223n24; removal of, from vessels, 48f39; of San Lázaro, 221n9; Sarabanda's anvil, 125–26; stones as, 27, 31, 206n10; of Yemayá Okute, 31

García Villamil, Felipe, 209n36

gestures: of challenge, 176, 225n43; of dismissal, 175, 225n42; finger-slapping, 167–68, 223n29; moforibale (ritual prostration), 53f44, 57, 208n32, 236; pressing hand on forehead, 100f81; of respect, 43, 45, 236; of supplication, 167, 223n27

goats: in cleansing ritual (rompimiento), 130–31, 132–36ff108–14; paseando el niño, 86–87ff68–69; purchase of, 76–77, 77f63; sacrifice of, 79, 81f66, 88–89ff70–72, 91f73. *See also* animal sacrifices, matanza; prendas

godchildren. *See* ahijado/ahijada

Guerreros, los, 26, 44, 85f67, 142f118, 143f119, 120, 144, 205n2, 218n34, 233. *See also* Eleguá; Ochosi; Ogún; Ósun

Guibel, Ángel Felipe, 60f51, 165, 168, 208n30

hacer caridad (to do good works), 161–62, 225n37, 233

hacer santo (to make saint), 21, 144, 204n20, 218n37, 233

Hagedorn, Katherine J., 208n26, 209nn35, 37

Haiti, 68, 172, 203n1, 206n12, 211n6, 222n13

healing practices: alternative therapies, 213n21, 215n5; burial of animal remains in, 126–27; camino de sentimiento, 210n3; cloth figures used in charms and, 119f102, 215n8; conflict and healing force in, 120, 215n10; consultations, 175, 225n41; conventional medicine, 116, 213n21, 215nn4–5; diagnosis, 117; hacer caridad, 161, 225n37, 233; herbal medicines in, 116, 214n3; ingredients for nkange, 123f104, 124–25, 217n24; initiation rites and, 119, 204–5n20 218n30; for interpersonal relationships,

misa espiritual (spiritual mass), 11f7, 164f131, 184–86ff136–38; bóveda, 157–58, 160, 163, 167–68, 183f134, 220n2, 229; Catholic elements in, 157, 164–66; *coger y dar luz* (to give and get light), 163, 235; Congo muertos possession at, 163–64, 169–80, 187f139,188–89ff140–43, 190ff144–45, 192–93ff147–50, 196–97ff153–57, 223n31, 224n32, 224n33, 224n36, 225nn37–45; dancing at, 177–78; prayers at, 164–66, 185f136; trasmisiónes (spiritist songs), 163, 167, 168, 223n27, 185f137, 186f138, 242. *See also* Congo dead; Ma Rufina; Pa Francisco; Pa Julian; Pa Lucero

moforibale (ritual prostration), 53f44, 57, 208n32, 236

money offerings (derecho), 56f48, 57, 59–60, 61, 64f57, 210n40, 232, 239

monstrances, 223n24

monte, el (the forest), 26, 68, 69, 144, 204n13, 210n2, 236, 237, 239

moyuba (prayer), 47, 208n30, 236

mpaka (ritually charged animal horn), 84, 145, 148, 214n28, 220n1, 236

mpungus (Palo spirits), 16; *La buena noche, mi lemba*, 90, 214n29; description of, 210n3, 236; Lucero (Lucero Que Toque Mayimbe), 70, 72–73, 74, 234; Madre de Aqua, 70–71f60, 72, 74, 102f83, 235; orichas compared with, 68, 72; of Santiago, 67, 68, 72; Siete Rayos, 212n11, 224n34. *See also* prendas; Sarabanda

muertos/muertas (spirits of the dead): confrontations between, 174, 225n40; Congo dead, 19, 68–69, 70–71f62, 73–74, 78, 157–58, 163, 204n12, 211n6, 212n16, 223n21, 229, 231; defined, 231–32, 237; hierarchy of, 73, 74, 212–13n18; muertos de batalla ("fighting dead"), 120, 215n11; muertos de luz (dead of light), 162–63, 167–68, 223n27, 223n29, 237; pasar muerto (to become possessed by a spirit of the dead), 240; as "spiritually illiterate," 170, 224n33. *See also* Ma Rufina; misa espiritual (spiritual mass); Pa Francisco; Pa Julian; Pa Lucero

Murphy, Joseph M., 209n38, 239

music performance: for cumpleaños (birthday) celebration, 58–60, 209n34, 209n35, 209n36, 209n37, 229, 239, 242; as public event, 58–59;

secularization of, 209n37; for Yemayá's feast day, 34, 40f35, 207n24

names: in healing rituals, 124, 125; personal energy in, 125; of praise, 57, 72–73, 211n7, 212n11; in rayamiento, 149; transformative power of, 124

natural world: in *La buena noche, mi lemba*, 90, 214n29; minkisi, 211–12n10, 212n15; Ogún, 238; orichas, 12, 27, 45; in Palo Monte, 13; prendas, 153; Sarabanda, 72; urbanization and, 204n13

ndoki (witch), 69, 211n7, 237

ndúndu (Palo guardian spirit), 237

nfumbi (spirit of the dead), 237, 240; as animating force, 68–69, 74, 211n6; in healing work, 120; mpaka, 84, 145, 148, 220n1, 236

nganga (Palo cauldron), 149, 217n24, 219n46, 240, 242. *See also* prendas

Nina (ritual family member), possessed by Pa Julian, 163, 173, 174–75f132, 212n16, 225n40, 240

nkange (Congo charm), 121–22, 125–26, 216n15, 216n19, 217n26, 237

nkisi, 72, 211–12n10, 237. *See* minkisi objects

Nooter, Mary H., 207n

November ceremony/ritual cycle, 7, 74, 115, 123, 130, 214n2. *See also* matanza

nso-nganga ("house of nganga"), 67–68, 78, 205n3, 210n1; definition of, 237–38; in *La buena noche, mi lemba*, 90, 214n29; in Palo initiation rites, 144–45

ntiti (garbage). *See* ritual refuse

numbers, sacred, 206n11, 219n40, 240

Obatalá (Virgin of Mercy), 27, 45, 140, 158, 205n5, 238

Obba (Saint Rita), 27, 45, 206n7, 238

Ochosi (Saint Hubert), 44, 143f120, 144, 238

Ochún (Virgin of Charity), 63f56; attributes of, 26, 27, 45, 206n8, 238; necklaces of, 140; Our Lady of Charity, 158; sacrificial offerings to, 53f44; vessels of, 33, 48f39

Odudúa (the creator of earth), 205n5

Ogún (Saint James): attributes of, 26, 238; clavos de linea, 231; collares (necklaces) of, 141; interspirit dynamics of, 44; in los Guerreros

thrones (*continued*)

35–39ff19–33, 40f35, 207n19, 207n20, 207n22, 207n23, 242. *See also* Orichas; Santería

tinajas (clay vessel), 27, 242

toques (ritual drumming pattern), 58, 209n35, 242

trabajo ("work"), 124. *See also* nkange

Vamo' a yimbulá un poco pa' yimbulá, 114f100, 214n1

Varona Puente, Jesús: on African references in song, 225n39; on components of a nkange, 217n24; on ndiambo, 211n7; on ndúndu, 237; on Palo songs, 213n28, 214n1, 214n29, 218n29, 219n46, 224n35

Vélez, María Teresa, 209n36, 220n48

Virgen de la Caridad del Cobre (Virgin of Charity of Cobre), 27, 158, 206n9, 238

Virgen de las Mercedes (Virgin of Mercy), 158, 238

Virgen de Regla (Virgin of Regla), 27, 31, 32, 158, 206n9, 223n23, 242

Vodou, Haitian, 19–20, 68, 172, 203n1, 203n2, 206n12, 211n6, 222n13

Wafer, James, 204n16, 222n17, 225n40

Warriors, the (los Guerreros), 26, 44, 85f67, 142f118, 143ff119–20, 144, 205n2, 218n34, 233. *See also* Eleguá; Ochosi; Ogún; Ósun

water: as barrier between living and dead, 148; *brinca la ma'* (leap over the sea), 144, 148;

as conductors of spirits, 158, 160, 183f134, 222n14; water gazing (divination), 119, 215n7

Wehmeyer, Stephen C., 220n49, 222n14

Whippler, González, 223n20

Xiomara (ritual family member): feeding the oricha and, 43–44, 50f41, 53f44; possession of 169–70, 187f139, 224n33

Yemayá Okute, 30–32, 45, 64f57, 207n18, 210n41

Yemayá (Virgin of Regla), 12–13, 242; altar for, 28f17, 31; collares of, 140; colors of, 33, 59; cumpleaños (birthday) commemoration for, 56–65; cumpleaños (birthday) throne for, 56f48, 62–63ff53–56; derechos (money offerings) to, 59–60; dolls representing, 29f18, 33, 35f21, 36ff22–25; feast day celebration for, 34, 40–41; fish tank, 26, 60f51; fundamentos of, 27; in Lucumí cosmology, 208n29; Madre de Agua and, 70–71f60, 72, 102f83, 235; money offerings to, 59–61; possession of Santiago by, 58–61, 64f57; praise name for, 57; ritual dress of, 59–60, 64f57, 210n41; sacrifice to, 45; Santiago's relationship with, 30–32; tambor for, 58–61, 64–65ff57–58; throne for feast day celebration of, 24f16, 32–39, 35–39ff19–34; vessels of, 33, 48f39; violin offering for, 34, 40f35, 207n24; Virgin of Regla (Virgen de Regla) and, 27, 31, 32, 158, 206n9, 223n23, 242. *See also* Yemayá Okute

Yoruba peoples. *See* Lucumí; Santería

Claire Garoutte is assistant professor of photography at Seattle University and program coordinator at the Photographic Center Northwest in Seattle. Her work has been exhibited internationally and has appeared in numerous anthologies. She is the author and photographer of *Matter of Trust* (1996).

Anneke Wambaugh is an independent scholar of African and Afro-Caribbean ritual art and an award-winning photographer who has worked extensively in Haiti and Cuba. She is the author of *Marion Munson* (1990).

Library of Congress Cataloging-in-Publication Data

Garoutte, Claire

Crossing the water : a photographic path to the Afro-Cuban spirit world /

Claire Garoutte and Anneke Wambaugh.

p. cm.

Includes bibliographical references and index.

ISBN-13: 978-0-8223-4020-1 (cloth : alk. paper)

ISBN-13: 978-0-8223-4039-3 (pbk. : alk. paper)

1. Cuba—Religion—20th century. 2. Cuba—Religious life and customs. 3. Afro-Caribbean cults—Cuba.

4. Santeria—Cuba. 5. Blacks—Cuba—Religion. I. Wambaugh, Anneke. II. Title.

BL2566.C9G37 2007

299.6'74097291—dc22 2007015031